LAW

— IN —

AMERICA

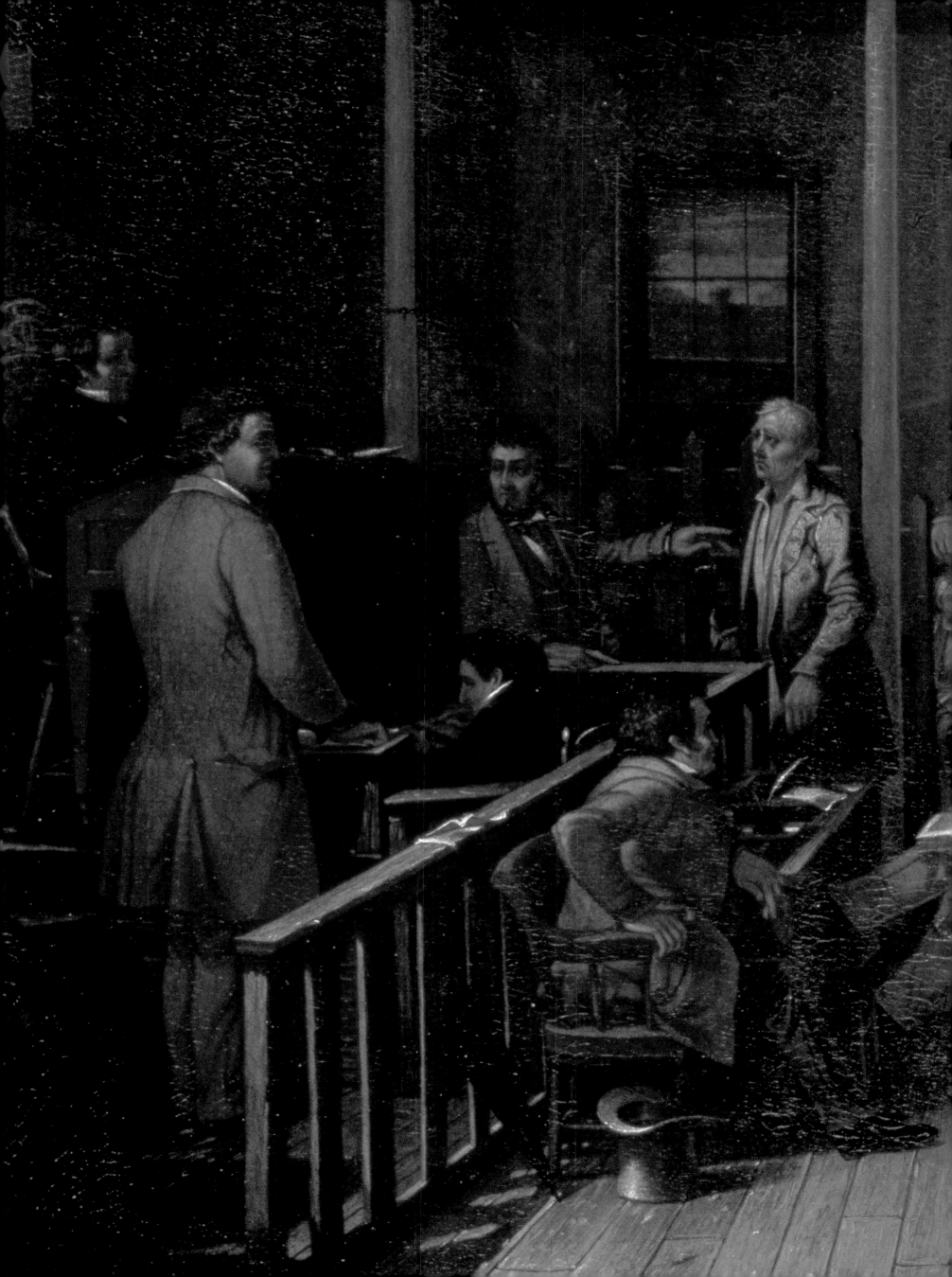

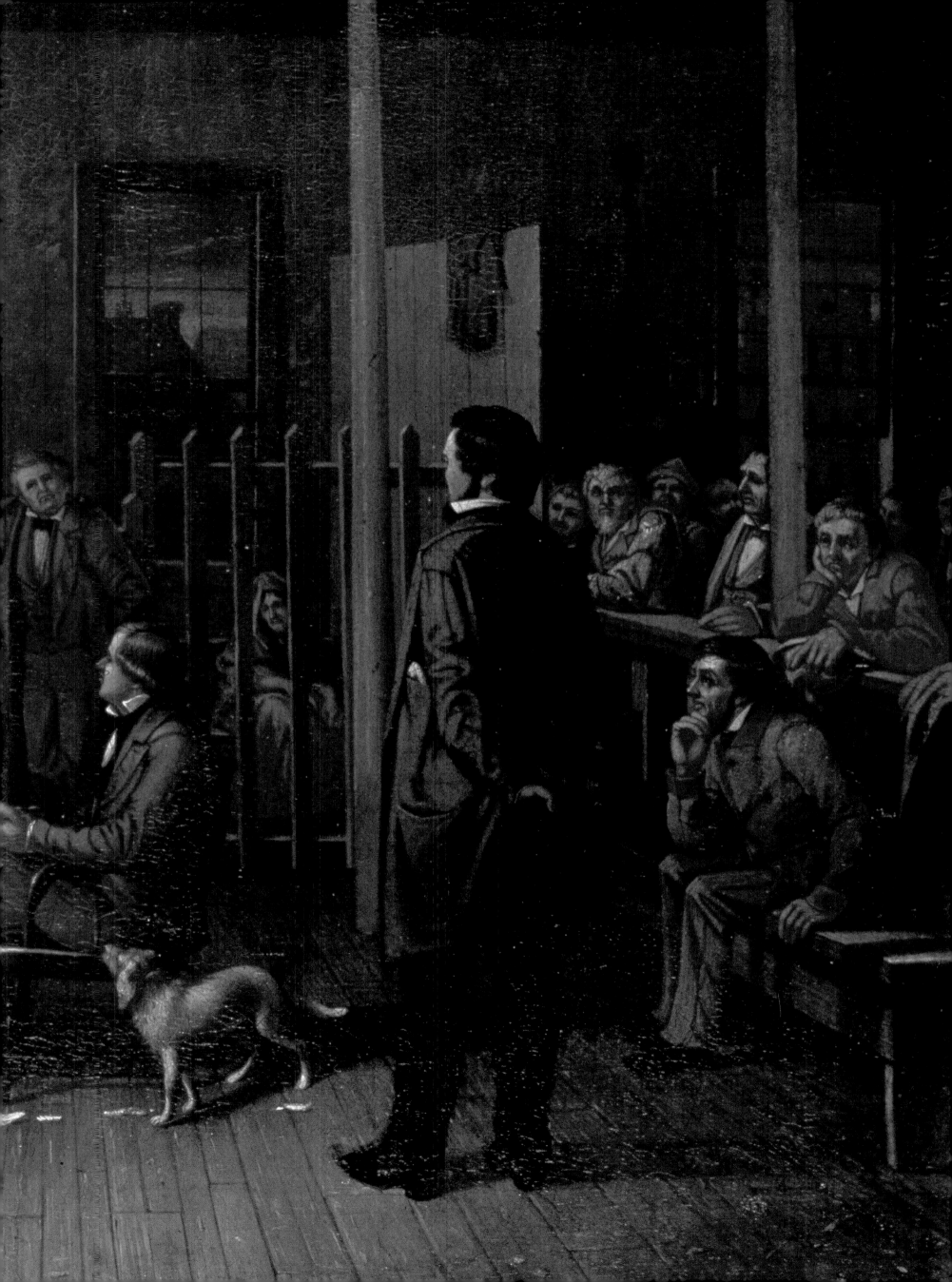

LAW
IN
AMERICA

An Illustrated Celebration

BLAIR KAUFFMAN
BONNIE COLLIER

UNIVERSE

Published by Universe Publishing
A Division of Rizzoli International Publications, Inc.
300 Park Avenue South
New York, NY 10010
www.rizzoliusa.com

Design by Ziga Design
Photo research by Jeanne-Marie Perry Hudson
Project direction by Ellin Yassky and Jeanne-Marie Perry Hudson
Editorial production by Deborah Teipel Zindell

2008 2009 2010 2011 / 10 9 8 7 6 5 4 3 2 1

Printed in China

ISBN-13: 978-0-7893-9974-8

Library of Congress Catalog Number: 2008922559

Pages 2–3: William Josiah Brickey. Missouri Courtroom. 1852. Oil on canvas. National Museum of American Art, Smithsonian Institution, Washington, D.C./Art Resource, New York.

Page 8: Liberty. c. 1800–1820. Oil on canvas. 29 ⅞ x 20 1/16 in. (75 x 50 cm). National Gallery of Art, Washington, D. C. Gift of Edgar William and Bernice Chrysler Garbisch. Photograph © 2001 Board of Trustees, National Gallery of Art, Washington, D.C.

ACKNOWLEDGMENTS

This is a book that owes its existence to a number of talented and cheerful people, whose enthusiasm and good sense propelled it forward, though not as quickly as our patient, very smart, and long-suffering editor, Ellin Yassky, would have liked. Jeanne-Marie P. Hudson did stupendous image tracking and Charles Ziga's design talents are evident throughout. Our thanks to Deborah Zindell for her help with the manuscript. Hugh Levin, who sparked the project, deserves heartfelt thanks.

Linda Janke, Brian Mendez, Jennifer McCormick, James Orlando, Karen Cheney, George Abdelnour, and Christopher Collier did such excellent work that our shortcomings were in the end obscured. The Yale Law School was generous in supporting research help for us, and both Patricia Ernest and Shana Jackson of that institution were always ready to lend a hand.

We dedicate this to our children, Christopher Z. Collier, Ashley Kauffman, Stephanie Kauffman, and Cameron Kauffman.

BLAIR KAUFFMAN
BONNIE COLLIER

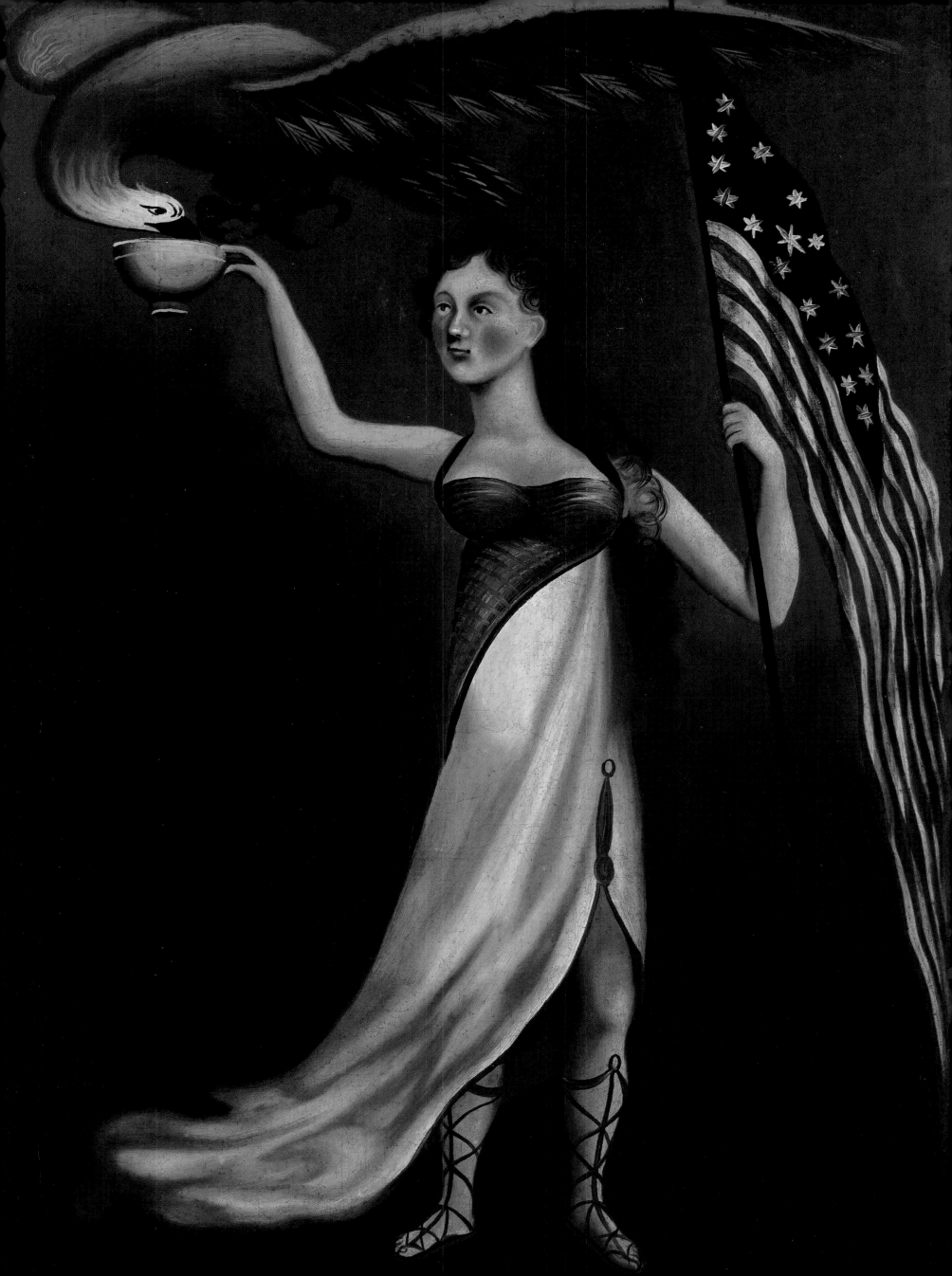

CONTENTS

LAW
IN
AMERICA

INTRODUCTION

Well over two hundred years after the ratification of the Constitution, the United States boasts a legal system that is the envy of the world. Based on the concept of the rule of law, the American system holds as its central ideal the notion of equal treatment of all people before the law. Immigrants throughout history have sought to come here to live under this system, and they still do, often at the risk of great sacrifice and danger.

Though deeply derivative of the English legal system, the structure of American law is in its essence unique because of its foundation on a written constitution. Both the English and the American are common law systems, rather than civil law systems, in which the customs and long-standing practices of life and living are incorporated into the established law. The notion of stare decisis, the application of established principles to freshly encountered cases, becomes crucial then to the process of maintaining the existence of commonly held principles over time. In other words, consistency in the law is sustained.

Opposite: Katherine Westphal. Unveiling of the Statue of Liberty. 1964. Fabric: batiked, quilted, and embroidered. 92 ¾ x 66 ½ in. (235.5 x 168.9 cm). Smithsonian American Art Museum, Washington, D.C. / Art Resource, N.Y. Gift of Katherine Westphal Rossbach.

Right: Robert Reid. James Otis Arguing the Writs of Assistance in the Old Towne House. 1901. Oil on canvas. Courtesy Commonwealth of Massachusetts Art Commission.

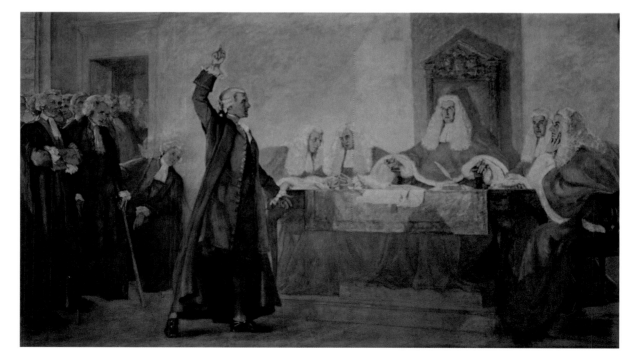

Another unique characteristic of American law, one that seems elusive to those not familiar with it, is the balance between federal law and the laws of the fifty states. The dual nature of this arrangement results in a constant natural tension between the two sovereign entities. It has been primarily left to the courts to negotiate the sometimes delicate, sometimes brittle relationship between the states and the federal government. Some of the weightiest Supreme Court cases having focused on this concept of federalism. Dualism, perhaps a repeated theme in American law, is seen in the classification of substantive law, the regulation of rights, and procedural law, pertaining to the rules governing the administration of substantive law, as well as in the categorization of public law and private law.

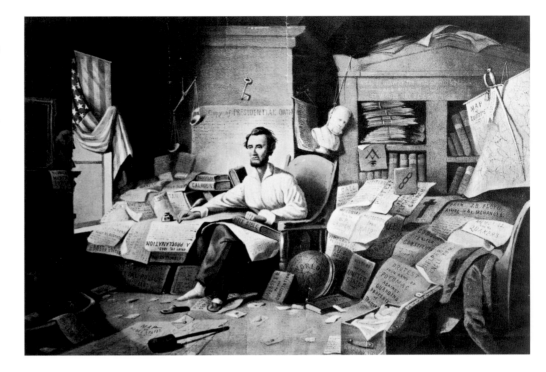

Lincoln Writing the Emancipation Proclamation. *1864. Lithograph.*
In the years between log cabin and White House, the self-taught Abraham Lincoln practiced law in Springfield, Illinois, where he was noted not only for his shrewdness and common sense, but also for his fairness, honesty, and literary genius.

But the Constitution itself represents the most distinctive and original element of the American legal system. Ever flexible, it has proved capable of standing as a written document for the guidance of eighteenth-century government, as an anchor during the development of the United States as an industrial and commercial leader in the nineteenth century, a bulwark of freedom in the twentieth-century fight for civil rights, and a model of success to the developing world of the twenty-first century. The Constitution has also laid down fundamentals: that a common citizen can have access to the highest court of the nation, that minorities can find protection and equality, that basic rights are articulated, and that judicial review allows for the reinterpretation of the law by succeeding generations. All these and more constitute the most respected, most imitated system of law in the world. As a document outlining law as well as delineating a whole structure of government, the Constitution has allowed American democracy to flourish well beyond what its framers might have imagined. Despite wrenching and persistent problems of race and poverty, no nation in the world can claim a deeper commitment to the freedom and democracy that springs from its system of laws.

People at all levels of government and within many aspects of the law help to make the system run. Lawyers, who took part in building the scaffolding of American law, have had a long and interesting history in this country. In addition to their usual workplaces in law offices and courtrooms, lawyers in America today can be found working in a myriad of professions and occupations. Because the law offers training that can be applied to a broad and varied field of interests, lawyers are equipped to function successfully throughout the marketplace of professional experience. As legal practitioners, lawyers seem to find their

way into public view. It is not surprising, then, to see them in such varied postures as leaders in politics; symbols in popular culture; characters in novels, movies, and television sit-coms; figures in celebrity litigation; objects of jokes; commentators on public policy issues; and journalistic pundits. Lawyers, it seems, are ubiquitous.

This, of course, has not always been the case. In seventeenth-century colonial America, it was not possible to earn a living lawyering, and most legal work was done as a part-time activity. After the Civil War, and continuing on into the early years of the twentieth century, the rise of national industrial corporations and transcontinental railroads stimulated a turn to the law and the need for lawyers. These early corporate lawyers bore little resemblance to the still-active, rough-hewn frontier lawyer. One notable bridge between these two worlds was Abe Lincoln, whose emergence from small-town lawyer to advocate for the railroad companies spans the two extremes of the law at mid-century. The twentieth century, and the New Deal in particular, saw an increase in the number of government-employed lawyers, foreshadowing a general increase in lawyers after World War II. And the entrance of women into the profession swelled the ranks further, most of the growth beginning in the 1970s.

In this book, we have attempted to give a full account of the influence of the law in American culture. A chapter on the symbols of the law touches on the mythical nature of images of the law, as well as the design and architecture of the buildings in which lawyers, judges, and legal scholars have discharged their functions over the years. We outline the progress of legal education, from the earliest colonial training methods to the modern law school, and then devote a chapter to the multifaceted practice of the law, from country lawyer to contemporary statesman. We trace famous trials, those that may not have transformed the course of legal history but are recognizable to most people of their day, and after. The courts, the backbone of American law, are described, followed by the development of the law through landmark cases—those that stand at the core of our legal system. The dramatic cases that hit the headlines, what we call media sensations, are sprinkled through American cultural history, and we devote a chapter to these, then move on to a discussion of the lawyer's image through popular culture—fiction, television, movies, and cartoons.

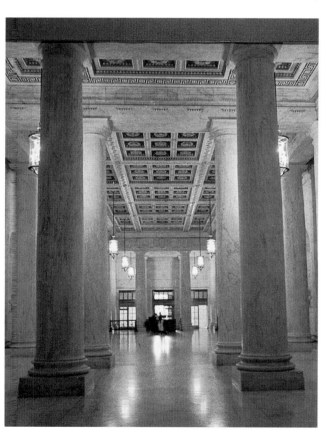

The Great Hall in the United States Supreme Court, Washington, D.C.

The law infuses American cultural, intellectual, business, and popular life. It is how we organize human activity and how we transform our sense of a just, fair, and productive way of living into a framework to guide our actions. It regulates everything from the simple act of crossing a street to our relationships with foreign nations; it proclaims and protects America's understanding of what is right and what is wrong. Essentially, it brings order to the disarray of human life.

CHAPTER I

SYMBOLS OF JUSTICE

The concept of Justice is the foundation upon which the American legal system rests, and it is the principle held most dear by the citizens and leaders alike of the United States. Yet, while the last words of the Pledge of Allegiance, ". . . with liberty and justice for all," are repeated across the country every day, words are not the only constant reminders of this abstract and complex ideal. The cultural value that Americans place in the concept of Justice is also artfully crystallized in images, sculpture, and architecture that serve as accessible, tangible, and memorable symbols of Justice in America.

Although the day-to-day workings of the justice system, its rules and customs, are largely obscured from Americans behind courthouse and prison walls, the buildings and their painted or sculptural decorations are meant to be outward signs, both reassuring and foreboding, of the far-reaching grasp of Justice. These representations, old and new, are historically important examples of the ways in which a young nation borrowed from and adapted ancient images to forge a national identity based on the democratic ideal of Justice.

SYMBOLS AND ALLEGORIES OF JUSTICE AND LAW

Neither an American nor even a European invention, the image of Justice is over two thousand years old and in her various guises has been imbued with political and religious significance by diverse cultures. Like most other allegorical figures, Justice is female and first appeared as a goddess in ancient Egypt,

Opposite: Statue of female Justice with sword and scale, in front of the U.S. Constitution.

Right: Engraving of Justice, blindfolded, holding scale and sword.

Greece, and Rome. With the rise of Christianity, Justice was no longer a goddess, but became a personification of one of the Cardinal Virtues. One of Justice's most notable representations was executed by the Renaissance artist Raphael for the Vatican in Rome. Here, *Justicia* is a sweet-faced maiden in classical garb who raises a sword with one hand and holds a balance in the other. The *putti* that surround her serve to increase the tenderness of Raphael's allegory. The artist portrays her as a gentle protector of the less powerful.

Yet Justice is not always represented as a nurturing figure. Rather, in many images she is intimidating and even fierce as she wields her sword, one of her primary attributes, which represents her willingness to use force to achieve her ends. Some images are gruesome and depict Justice maimed, often with severed hands. Among Justice's other common attributes are scales (a symbol of decision-making), a crystal ball (an emblem of truth), and a blindfold (a sign of impartiality).

Even after the passage from goddess to allegorical figure, Justice remained a female figure with classical features and drapery. There is irony in the representation of Justice as a woman, since women have only recently been able to participate in the institutions that distribute justice, and even today that participation is unequal. Yet it is that very fact that may explain Justice's gender: a female figure dressed in ancient garments represents a timeless ideal, removed from the reality of historical specificity, to which individuals and governments can aspire.

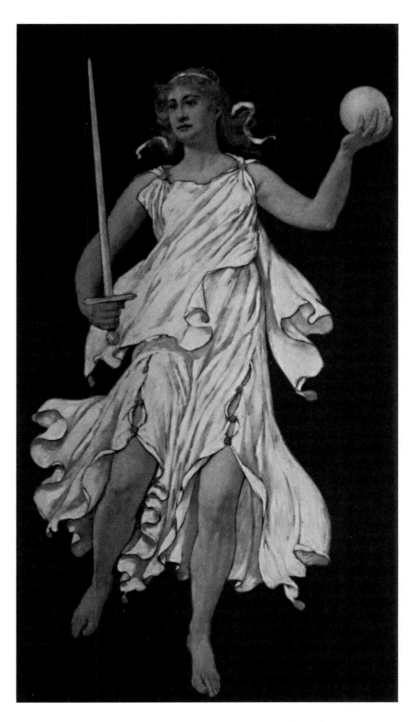

George Willoughby Maynard. Justice. 1896. Mural, located in the Thomas Jefferson Building, Great Hall, of the Library of Congress. One of eight female figures, each 66 in. (167.6 cm) high. Photograph courtesy Architect of the Capitol.

With the boom in the erection of courthouses, other civic buildings, and monuments in the United States during the nineteenth century, both painted and sculptural depictions of Justice proliferated. While other symbols of the law often adorned these structures as well, the allegorical figure of Justice was seen as a particularly appropriate subject that fit into the iconography of a young America that wished to associate its law with justice. The figure of Justice itself became interchangeable with what it represented, and as a result of this transformation became all the more powerful.

In American murals of the late nineteenth century, female figures were used to depict positive abstract ideas, including Justice. As public murals depicting civic ideals became popular in the United States, artists shifted their representations of female allegories

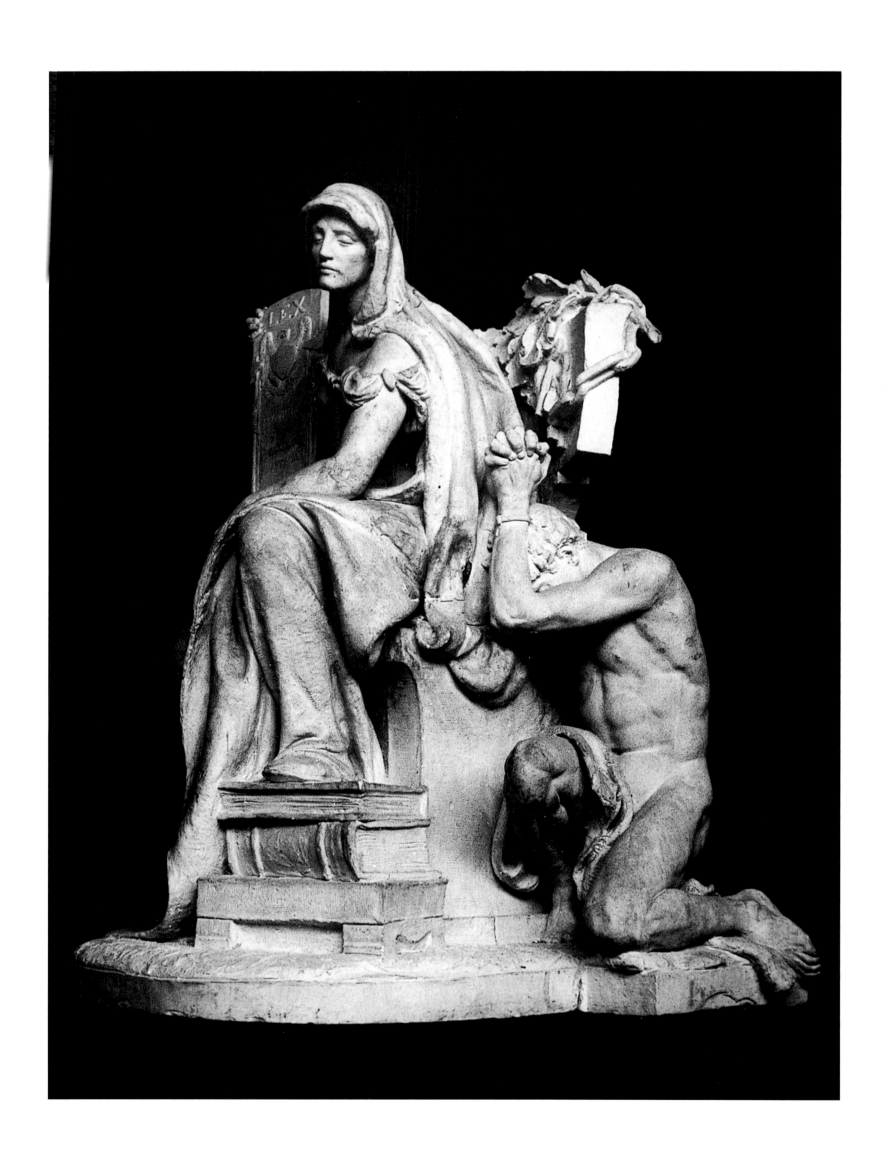

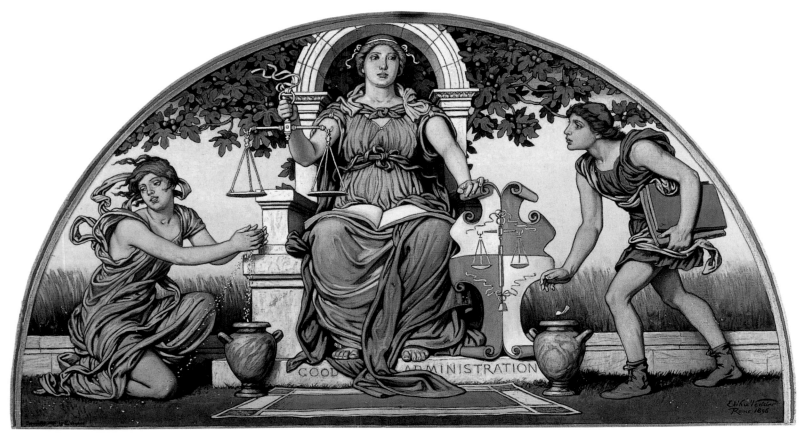

from beautiful, lyrical, decorative, and passive figures to heroic, epic, energetic, and "masculine" types that they believed better suited their official setting. Edward Simmons's *Justice* in the Criminal Courts Building in New York demonstrates this preference for the new dynamic female type. An art critic of the day described the powerful figure: "[it] is extraordinarily imposing; an abstraction . . . a figure so vitalized that it looms impervious in its place, touches the imagination, and stirs the emotions, as is seldom the case with the Justitia of pictorial or decorative art." The artist himself explained how he adapted the allegory to a specifically American context:

> My classifications were as clear as any botanists . . . as to family she was a Justice of America and carried the flag. In the Middle Ages she was always represented as being blind, but in a glorious democracy she should be clear eyed. As to genus, she was of the state of New York and therefore should bear its coat of colors; as to species, she was of the city of New York and should bear its emblem. On one hand, she carried the scales for weighing the facts offered and, as either innocence or guilt must pre-dominate or there is no decision, the pans were uneven. In the other hand she carried the crystal ball, emblem of truth, surmounted by a cross, for she was a Christian Justice.

As in earlier civilizations and cultures that employed the ostensibly timeless allegory of Justice to more specific political, social, and cultural ends, American artists also fashioned Justice to suit an American context. Thus, Justice was identifiable by her attributes of sword and scales but was often accompanied by more specific accessories that identified her as exclusively American.

Above: Elihu Vedder. Study for Lunette in Library of Congress: Good Administration. *1896. Oil on canvas mounted on wood. 24 3/16 x 44 11/16 in. (63.6 x 124.5 cm). Williams College Museum of Art, Williamstown, Massachusetts. Gift of John Hemming Fry, 38.1.2.*

Page 19: Daniel Chester French. Jurisprudence. *1906. Plaster. Approximately 5 ft. (152.4 cm) high. Chesterwood, a National Trust Historic Site, Stockbridge, Massachusetts. Photograph: A.B. Bogart. One of two groups by D. C. French flanking the entrance to the Federal Building, Cleveland, Ohio. The seated figure represents Justice; the manacled supplicant, perhaps a malefactor.*

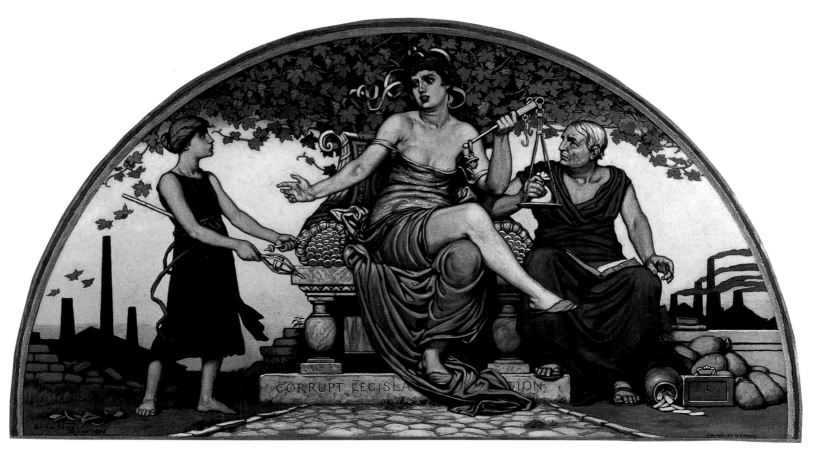

Elihu Vedder. Study for Lunette in Library of Congress: Corrupt Legislation. *1896. Oil on canvas mounted on wood. 24 ³⁄₁₆ x 44 ⅝ in. (63.6 x 124.5 cm). Williams College Museum of Art, Williamstown, Massachusetts. Gift of John Hemming Fry, 38.1.4.*

In addition to the dynamic image of Justice in the nineteenth century, an alternate mode of representation appeared simultaneously, that of the iconic presence. In these images, such as Edward Simmons's *The Justice of the Law* mural (c. 1895) for the Appellate Courthouse in New York, Justice appears as a solid, immovable figure. As one critic has suggested, these iconic figures assumed a role associated with women in the nineteenth century: "pillars of stability or 'repositories of moral and cultural authority.'" Here, Justice protects rather than leads, as one critic of 1902 points out: "We are reminded that Justice is not always majestic and fearful, but has a side wherein she is filled with mercy and kindness, so that she can be easily approached by the most timorous, when her protecting arms will fold softly around weak women and tender babes, and widow and the orphan will find succor at her hands."

While female allegories in America were mostly positive representations of virtue, artists occasionally employed female figures to represent Justice's negative counterpart, Injustice. In the depiction of vices, the classic ideals of feminine beauty and virtue were abandoned for a more contemporary representation of femininity gone awry. For example, in Elihu Vedder's murals *Good Administration* and *Corrupt Legislation*, the difference between Justice and Injustice is striking. In *Good Administration,* Justice is represented as an iconic, solid figure clad in classical drapery, who holds scales steadily in both hands. By contrast, Injustice in *Corrupt Legislation* appears as a contemporary "fallen woman." While Justice wears classical robes that mark her as an ideal figure set apart from the corrupt world, Injustice is wholly a part of imperfect contemporary life. Her dress is decidedly *un*classical, with plunging décolletage. Her disheveled hair, her exposed breasts and legs, and her indecorous manner of sitting suggest the opposite of ideal nineteenth-century womanhood, her dangerousness represented via sexuality. Despite the power of images

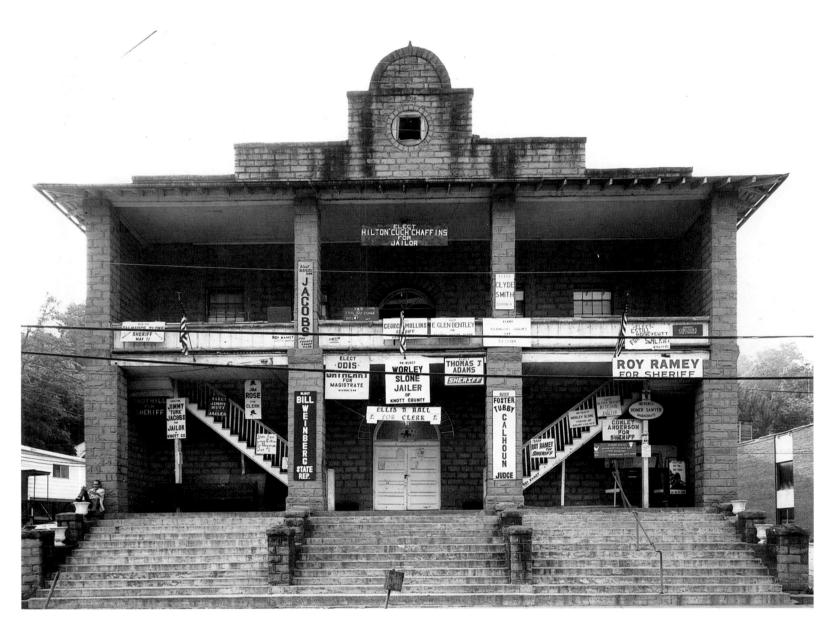

like these, positive representations of Justice dominate public and official spaces in the United States. Injustice and Justice Maimed, allegories whose force depends upon the esteem in which the idea of Justice is held, have functioned both as warning and critique of a justice system that has strayed from its ideals.

Courthouses, often signboards for the county, were local in flavor and architecture. Knott County Courthouse, Hindman, Kentucky. c. 1930.

Justice often reigned supreme as the lone virtue depicted in American courthouses during the nineteenth century, although her popularity waned by the turn of the century as tastes shifted. As the nationalistic mood heightened, the demand increased for more representations of national and local history. As the nation matured, its citizens preferred scenes and historical narratives specifically addressed to their cities, counties, and states. But while other images related to the law and justice have appeared—gavels, judges, and historic legal events—the allegory of Justice has prevailed as the most recognizable symbol of an ideal legal system.

COURTHOUSE ARCHITECTURE AND ORNAMENT

The American courthouse is the site where allegories of Justice are most likely to be found and a place with which every U.S. citizen probably has contact at some point in his or her life. Apart from the decorations that may adorn its exterior or interior, the

courthouse itself, no matter how grand or humble, has had and continues to have an important symbolic function for the communities it serves. Historically, it has been an important gathering place—the location of celebrations, religious services, dances, and town meetings. It was, and is, a place for the storage and protection of official documents. In fact, in the early days of the nation it was the construction of a local courthouse that defined a settlement as a town. The courthouse was usually the largest and most prominent building in a town, positioned on a square at the city's center. The great American author, William Faulkner, wrote of the transformation that occurred when a courthouse was built: ". . . there was no town until there was a court house, and no court house until . . . the floorless lean-to rabbit-hutch housing the iron chest was reft from the log flank of the jail and transmogrified into a by-neo-Greek-out-of-Georgian-England edifice set in the center of what in time would become the town square."

A bare-bones courthouse interior still contains the essential elements: a witness stand, judge's bench, table for the attorneys and clients, and jury seating. Harlan County Courthouse, Harlan, Kentucky c. 1918–21.

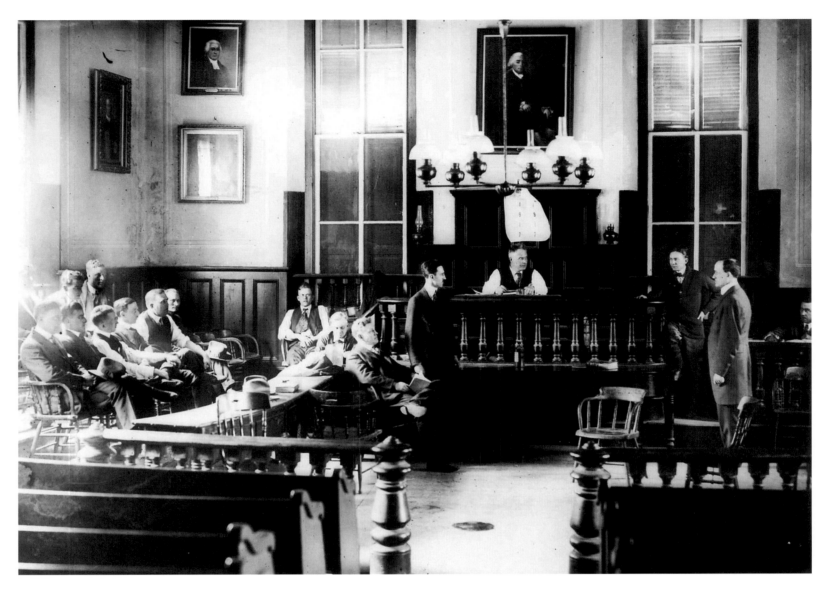

The most important role of the courthouse, however, is as a house of justice, and as such, its architecture often conveys this primary function at a symbolic level. Edifices that looked to the architectural styles of antiquity, particularly those of Greece and Rome, superceded the first courthouse buildings, constructed during colonial times. The Gothic style, used in many other building types, was rejected as too ecclesiastical and therefore inappropriate for

Above: Fairfax Courthouse, Fairfax, Virginia. 1920s.

secular government buildings. The early American republic adopted the architectural vocabulary of ancient Greece as a way to connect the virtues of the first democracy with the ideals of a newly formed democratic nation. Thus, the Greek temple became the model for American "temples of Justice" and a visual metaphor for democracy.

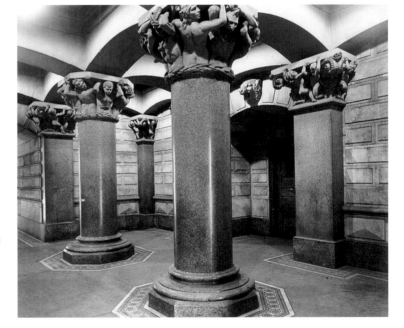

Early courthouse architecture was local in character primarily because it was intended to please those who saw it most often. Yet courthouses were also signboards for the county, so using a particular architectural vocabulary became important in distinguishing a region from its surrounding neighbors. As a result, a diversity of styles proliferated, although stylistic trends prevailed at certain times and

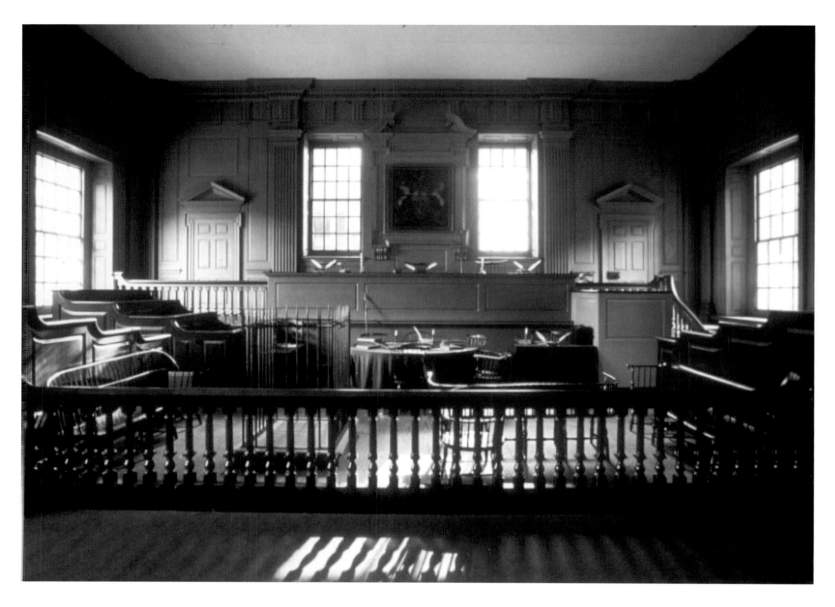

within certain regions. The directness of courthouse architecture as well as its openness
and free-spirited design have been labeled "distinctly American." Interestingly, despite the
courthouse's role as a county centerpiece, county courthouse architecture was nearly
always behind the times. And because the buildings were intended as focal ornaments of
the towns in which they stood, their interest was often restricted to their exteriors.

Yet despite the vast differences in the simplicity or grandeur of courthouse interiors, the
basic elements of the courtroom, the essential center of the American legal system, remain
the same. Whether ornately decorated with paintings, marble, and burnished wood, or
furnished with the bare essentials, every courtroom has the same contents: a clerk's desk,
tables for the attorneys and their clients, a witness stand, a jury box, and the judge's bench.
The judge is always the focus of the courtroom, and the judge's bench is elevated to denote
the dignity of his or her role and to designate symbolically his or her impartiality.

The earliest American courthouses date from the eighteenth century. In colonial times,
builders employed an English Georgian vernacular style. At this time, churches and
courthouses were barely distinguishable. After the Revolution, however, the new
Americans increased their efforts to construct monumental courthouses suitable for
the new republic. In their symbolic identification with the democracy of ancient

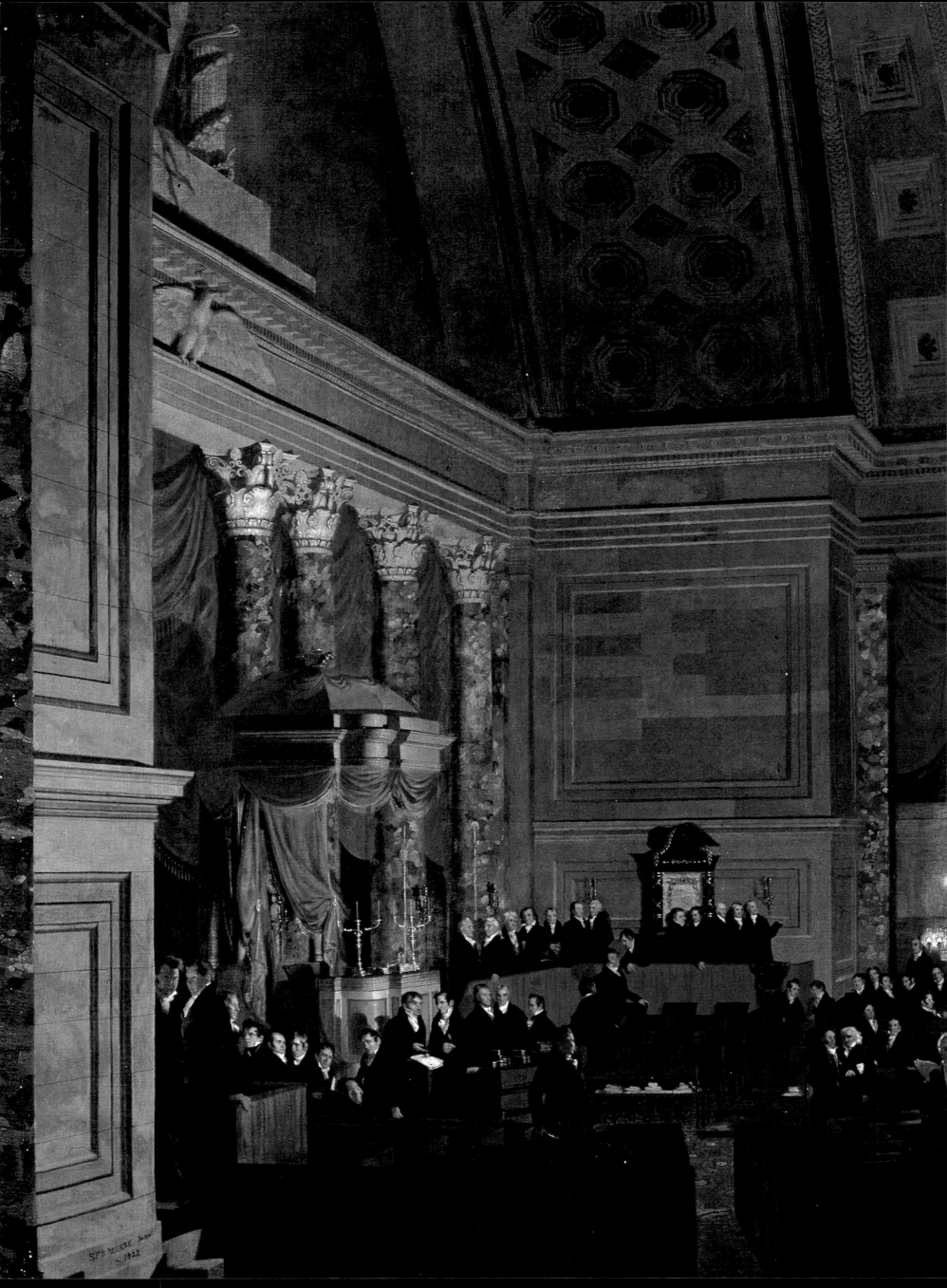

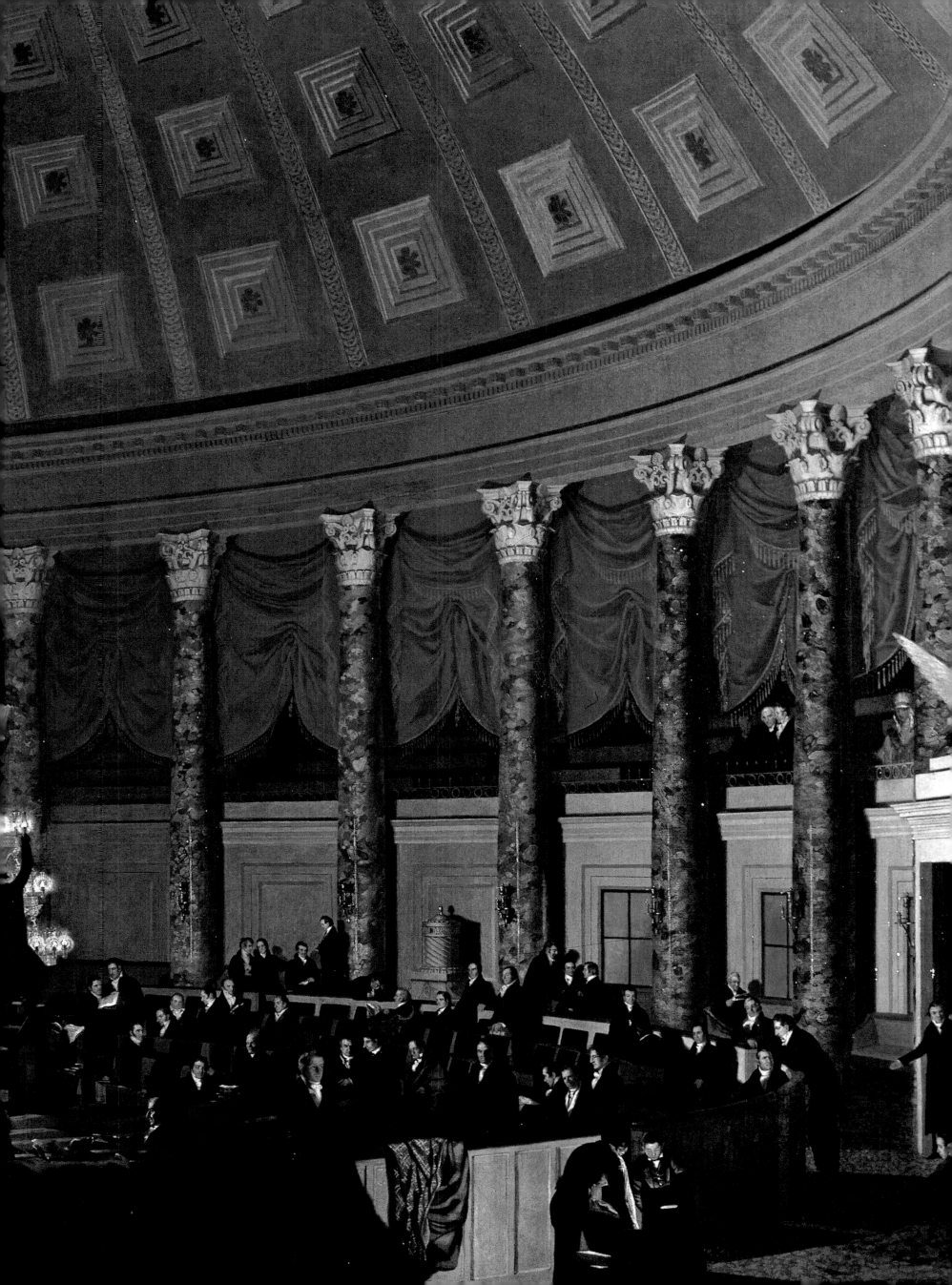

Greece, the federal government adopted the Neoclassical style as a national style. American cities preferred the slightly different Greek revival.

A series of eclectic styles dominated the nineteenth century. Often, architects combined a pastiche of European influences, including Romanesque, Gothic, Italianate, and Beaux-Arts. Some cities, such as Philadelphia, whose town hall is also its courthouse, employed the Second Empire French Style of the 1860s. Yet this was considered too metropolitan for many towns. Citizens of each county seat had their own idea of how they wished to represent themselves. Large cities, which also accommodated state and federal courthouses, tended to employ the monumental Neoclassical style on a grand scale, and these buildings included lush interiors. The Midwest and Texas, unfettered by a colonial history and eager to showcase their regional pride, often produced lavish courthouses in academic styles. Texas architecture was particularly brash, fueled by the wealth of the

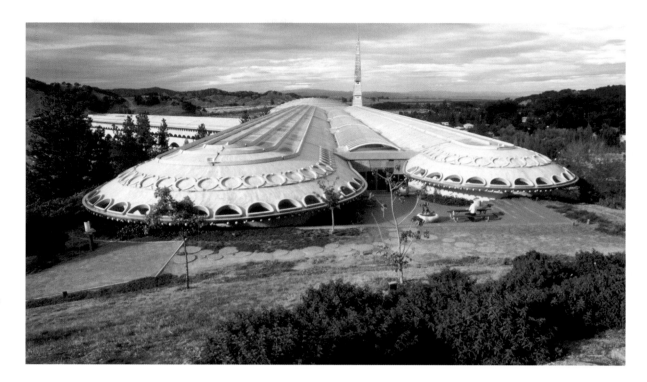

Marin County Civic Center, designed by Frank Lloyd Wright. San Rafael, California.
Frank Lloyd Wright accepted the commission for the Civic Center in 1957 at age ninety. The groundbreaking occurred two years later, shortly after Wright's death in 1959, and building commenced under the direction of Taliesin Associates.

bcom years of the late 1860s and early 1870s. The architect Henry Hobson Richardson, designer of the Allegheny County Courthouse in Pittsburgh, Pennsylvania, exerted a major influence on courthouse design in the late nineteenth century. His solid, Romanesque-influenced style was copied throughout the country, particularly in the old Hennepin County Courthouse in Minneapolis, Minnesota.

At the beginning of the twentieth century, courthouses everywhere were growing larger as county business increased. Though still designed largely as public monuments, the emphasis was shifting as the needs of county office buildings expanded. Interestingly, the birth of the Chicago skyscraper, marking one of the innovations of Middle Western architecture, initially was rejected for courthouse use, as county officials continued to use European models. In the Far West, courthouses sought to suggest regional influences, such as the Spanish Missionary style in California, Arizona, and New Mexico. By the end of the 1920s, academic styles were losing their appeal and courthouses in cities were becoming public office buildings more and more. These changes in scale and function encouraged the modification of the written rule of "traditional" design. Finally, skyscrapers—of the New York rather than the Chicago variety—became a viable design option. Architects gave up their use of the Classical orders in favor of a more abstract vocabulary. While there were no new developments in courthouse design during the World War II years, courthouses constructed during the postwar economic recovery saw the influence of the European International style.

The rejection of ornament and the disappearance of the suggestion of the courthouse's traditional public function in the second half of the twentieth century provoked a crisis in courthouse design that continues today. Frank Lloyd Wright's Marin County Civic Center of 1957–69 in San Rafael, California, attempted to answer the need for a new American architectural style that would address both the practical and symbolic needs of a modern justice system, but his innovations have not been copied.

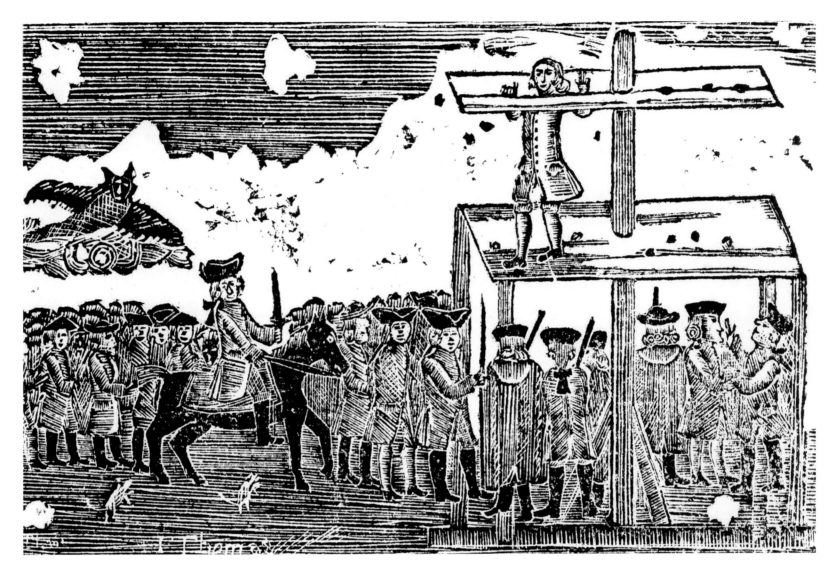

CRIME AND PUNISHMENT

In a democratic society one of the greatest powers a government has over its citizens is the right to punish them for breaking its laws. The gravity of this power is heightened when the punishment involves imprisonment or capital punishment. While punishment obviously is administered to the convicted, it has significant symbolic effects on the wider law-abiding population as well. In colonial and early America, before imprisonment was the primary mode of punishment, corporal and capital punishment were public spectacles. The methods of punishment were meant to "fit the crimes" of the offenders and were also intended as warnings and admonishment to the citizenry who watched.

Representations of punishments were also common in public buildings and in popular culture. Broadsides advertised public punishments and executions, and often featured gruesome representations and moralizing texts. An eighteenth-century document emphasizes the symbolic nature of the punishment of counterfeiters in Charleston who were sentenced to one hour in the pillory, to have one of their ears cut off, and to be whipped twenty times at the public whipping post. The poem accompanying an engraving of the scene of punishment indicates that the public spectacle is meant both to humiliate the convicted and warn the onlookers. The text speaks of the desire of self-righteous spectators to further punish the prisoners by throwing eggs and stones and hurling insults. Yet it warns as it explains a symbolic aspect of the punishment:

A broadside depicting the Pillory at Charlestown. The Historical Society of Pennsylvania (HSP), acc. AB 1767-2.

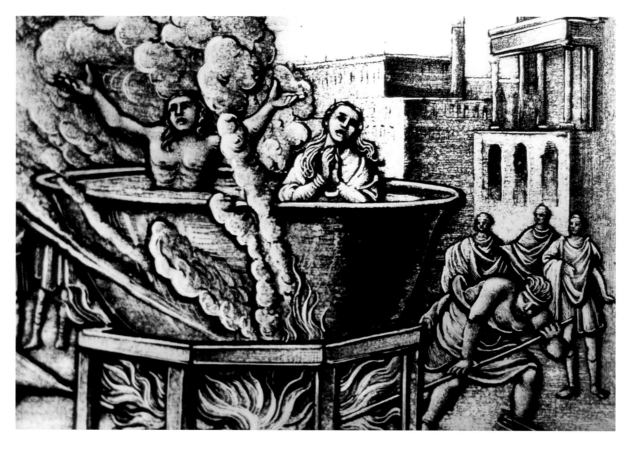

But pray consider what you do
While thus expos'd to public view.
Justice has often done its part,
And made the guilty rebels smart;
But they went on did still rebel,
And seem'd to storm the gates of hell.
To no good counsel would they hear;
But now each one must loose an ear,
And they although against their will
Are forc'd to chew this bitter pil;
And this day brings the villains hence
To suffer for their late offence;
They on th'Pillory stand in view:
A warning sirs to me and you!

From their disgrace, now warning take,
And never do your ruin make
By stealing, or unlawful ways;
(If you would live out all your days)
But keep secure from theft and Pride;
Strive to have virtue on your side.
Despise the harlot's flattering airs,
And hate her ways, avoid her snares;
Keep clear from Sin of every kind,
And then you'll have true peace of Mind.

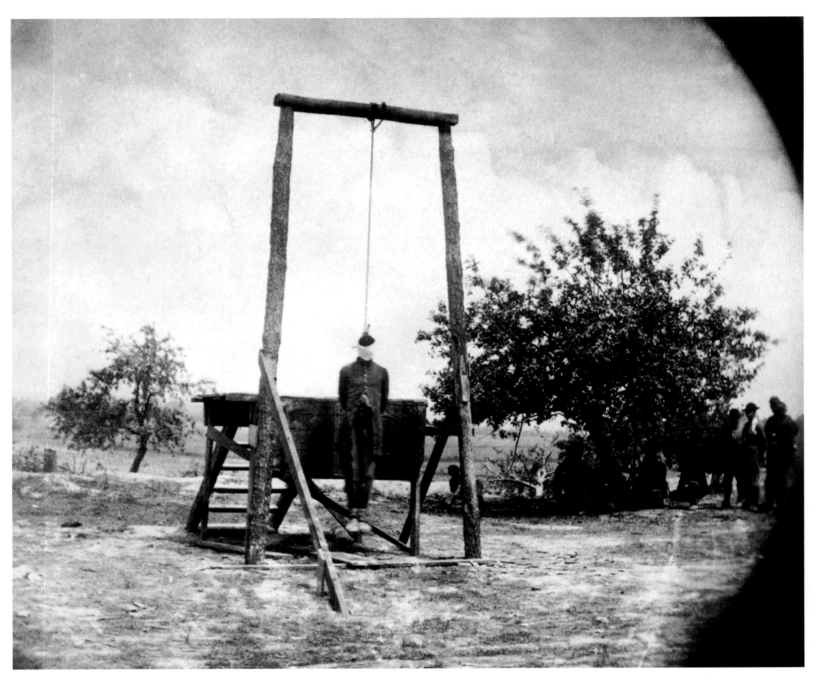

As reforms took hold in Europe, the American justice system often followed suit, although, as many images attest, the symbolic and public aspects of punishment still prevailed. Executions were carried out by means such as hanging, firing squads, burning at the stake, and crushing for serious crimes such as murder, manslaughter, rape, and kidnapping, and sometimes for morals offenses such as idolatry, witchcraft, blasphemy, and adultery. Mutilation, branding, and whipping, which left scars on the bodies of criminals, were permanent symbols of the wrath of justice. Lesser crimes were punished by public humiliation. Towns maintained stocks and pillories in public gathering places. Gossips, thieves, and other petty criminals were exposed to ridicule and stares.

The execution, by hanging, of an African-American Union soldier convicted of molesting a white woman. 1864.

As confinement became the dominant mode of punishment in the United States, prisoners were moved out of the public eye, and prison architecture was designed to be symbolic of American society's attitude toward crime and punishment. The concept of the necessary "terror of punishment" influenced prison architects for decades. Jails and proto-prisons in colonial America were modeled on the workhouses and prisons of

England. Inmates of both sexes, sometimes even children, who were convicted of a range of offenses, were thrown together in overcrowded rooms. In 1775, Connecticut established a prison in Simsbury in an abandoned copper mine. Conditions were abominable; prisoners were chained in crowded underground cages. America's first prison structure was Philadelphia's Walnut Street Jail. It was arguably the world's first penitentiary because incarceration was the means of punishment. There was a rudimentary system of classification and individual cells, which were intended as places for penance.

Prison reformers like William Penn and Benjamin Rush influenced changes in prisons that reflected their attitude that incarceration should bring about the reform of the convicted. Pennsylvania's Newgate prison, established under the influence of Penn's reforms, was the prototype of the modern penitentiary, whose philosophy was that criminals were

A shirtless black slave stands with his hands tied to a whipping post as a white man, possibly his master, prepares to begin a beating.

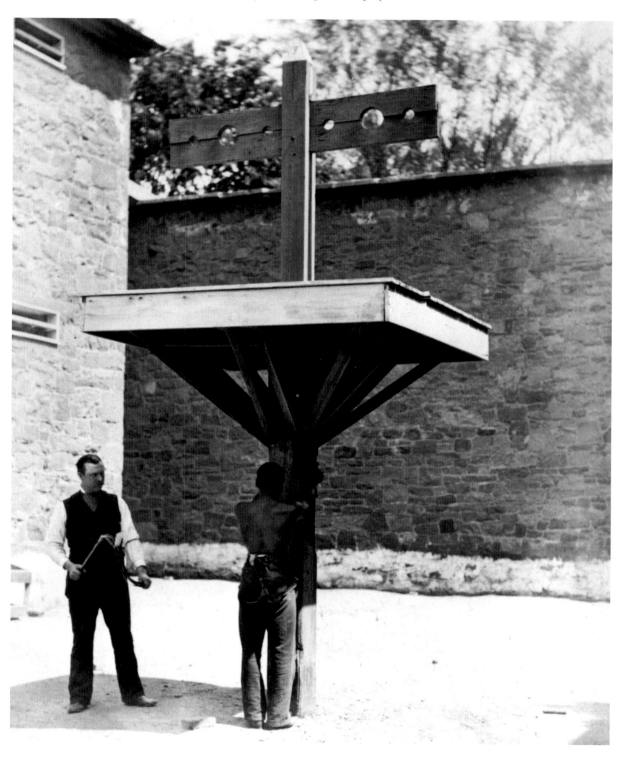

redeemable and could be reformed. Architects often employed European building styles, such as fortress-like medieval turrets, to create a sense of imposing surveillance upon the prisoners.

As different attitudes about incarceration and prisons emerged, prison architecture changed. In the nineteenth century, many law-enforcement officials believed that solitary confinement was the most conducive method for reforming offenders and preventing recidivism. They reasoned that time alone would enable convicts to reflect on their misdeeds and pray for redemption, and that less exposure to other inmates, who could encourage more criminal and anti-social behavior, was essential to forming new attitudes. These "Separate System" prisons featured cellblocks that radiated from a central point like spokes of a wheel. At the same time, another philosophy of incarceration competed with the Separate System. This was known as the Congregate or Auburn system because it was first implemented at the prison in Auburn, New York. Because prisoners spent only the evening hours in their cells, individual accommodations were much smaller than those of the Separate System. Groups of inmates together posed disciplinary problems, so Auburn-style penitentiaries imposed strict measures to maintain control, including striped uniforms for inmates. Architecturally the Auburn prisons were very different from the Separate System buildings. Cellblocks were grouped in long, multitiered rows of double cells. Surrounded by a corridor or range—entirely enclosed within a larger building—cells did not have exterior walls. Congregate System architecture tended to be on a grand scale. Fortress-like walls and Gothic styling provided security and also made a significant symbolic statement about the authority of the state.

A third prison style was the Panopticon design, originated by the British scholar and philosopher Jeremy Bentham in 1791. Bentham reasoned that his design could improve security and enhance the goal of the penitentiary—moral reflection and reform. The Panopticon model featured multiple levels of outside cells facing onto an interior

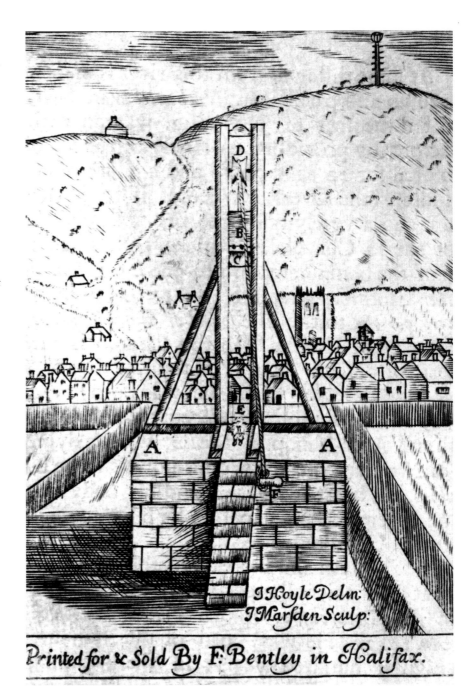

Above: Diagram of a guillotine, used for beheading criminals convicted of grievous offenses . c. 1800.

Opposite: Lewis Miller. "Went to the City of Lancaster, To See Loechler Hung. . ." c. 1840. Ink and watercolor on paper. 13 ⅛ x 10 ½ in. (33.2 x 26.7 cm). The Historical Society of York County, York, Pennsylvania.

Went To the City of Lancaster. To See
Loechlor Hung. In — October 24th 1822.
In the Carriage of Clemon Stilinger. in Company.
with Peter Rupp. And John Armpraster. Charles
Stilinger, was the Driver, Loechlor hung for Shooting
Hacks wife after Night, in her bed, hack made to
free with Loechlors wife, and to Reveage himself,
he Shoot, Hacks wife out of mistake, he was in the
Kitchen and Shot through the door with his Pistol.
Hack and his wife where both in bed, the hearing him
out Side Rattle, And made A noise.
Loechler Killing his wife the Same night.

The Gallows had A Trapdoor, on the platform,
And when the Sheriff, give the Word the trapdoor
fell, Loechlor was Seting on A Chair upon the
door, Oh! What A Croud of People to See A poor
Sinner of a Creature hung at the Gallows.

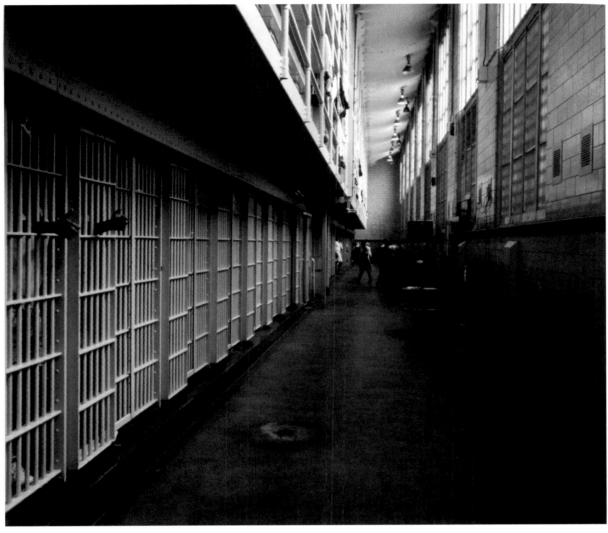

courtyard or well that housed a guard's station. Since every cell was visible from a central vantage point, inmates, knowing they were constantly watched, were supposed to become more self-reflective and to internalize better behavior. Prison officials could also broadcast various religious and self-improvement messages to an entire cellblock at once. A number of nineteenth- and early-twentieth-century American prisons were built according to this model.

In the late twentieth century, law enforcement officials and prison architects at once moved toward the future and returned to the past. To increase security and efficiency in an increasingly crowded prison system, designers and architects employed advanced technology to monitor and control prisoners. At the same time, in a "get tough on crime" political climate, legislators, judges, prosecutors, and members of the general public suggested measures that would symbolically return inmates to earlier, less "criminal-friendly" times. These proposals included hard labor, striped uniforms to publicly humiliate inmates, corporal punishment, increasingly harsher sentences, and wider application of capital punishment.

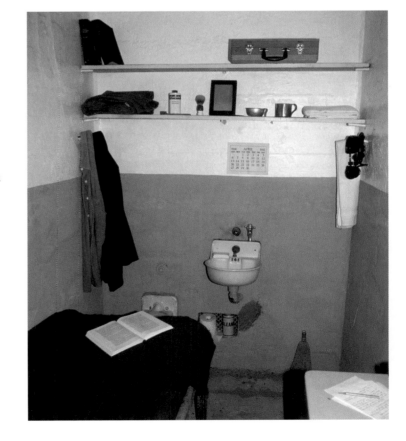

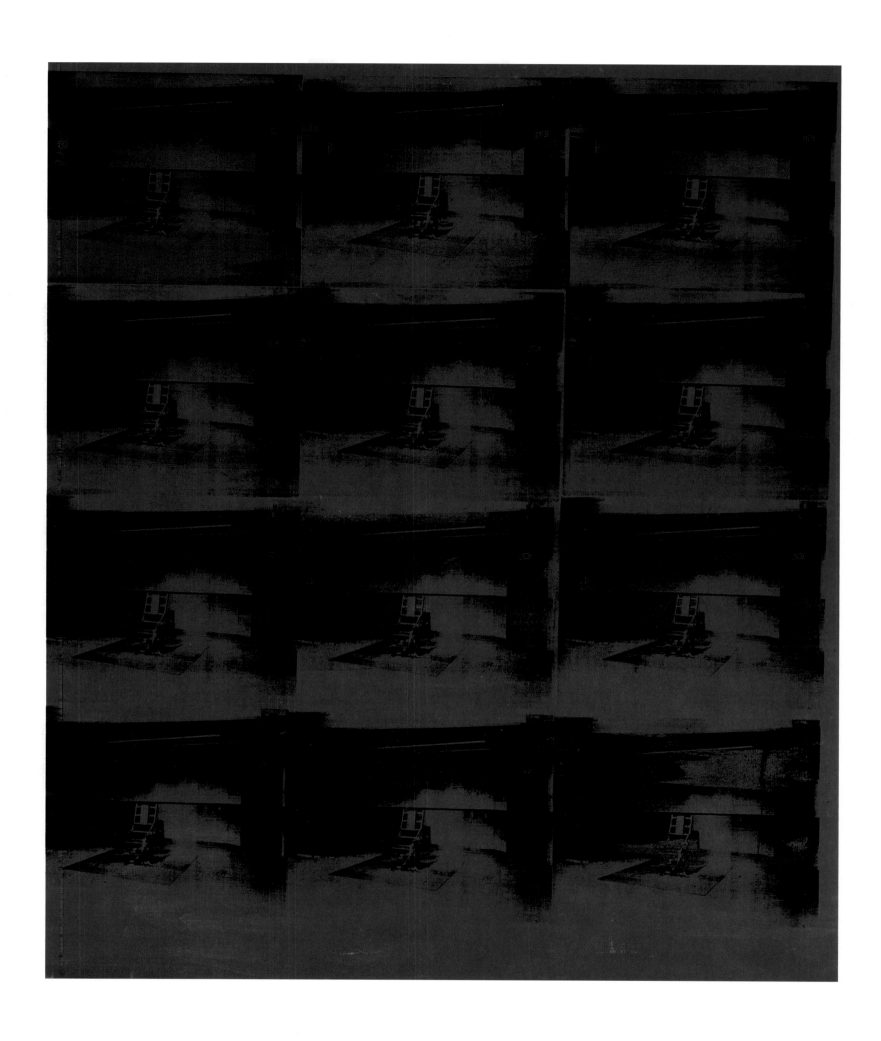

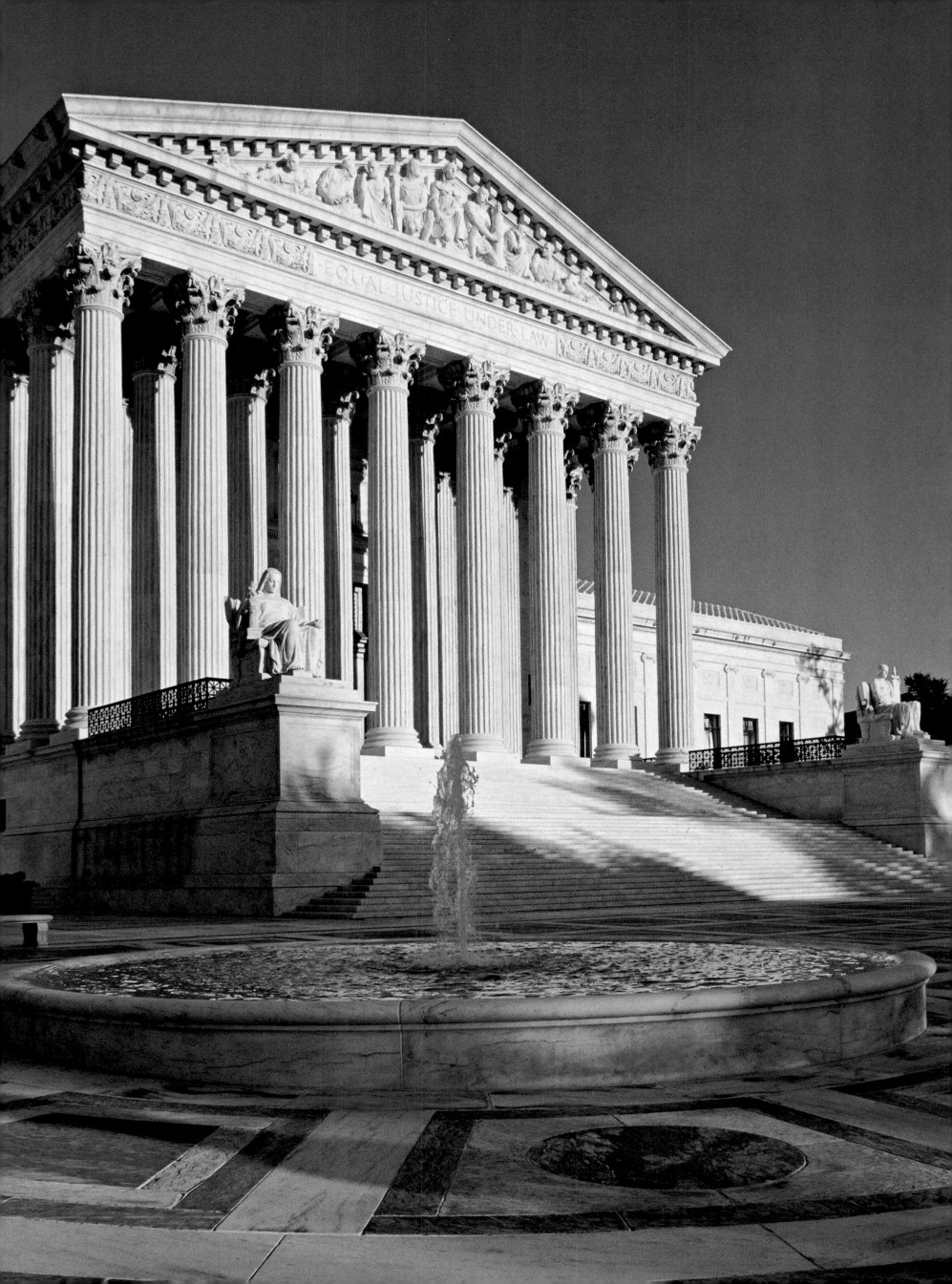

THE SUPREME COURT

Today, the Supreme Court of the United States, the nation's highest judicial body, coequal with the executive and legislative branches of government, is housed in a spectacular Neoclassical structure in Washington, D.C. Yet despite the importance of the Court to the functioning of our government, the Supreme Court did not find its current home until 1935. The Supreme Court originally held its sessions in the Merchant Exchange Building in New York City. The building, which was not designed for legal proceedings, had none of the symbolic significance of the Court's current, permanent home. In addition, there was little ceremony or formality to accompany these historic meetings. Since there were no antechambers or robing rooms for the justices, they put their robes on in full view of everyone. Visitors could come and go as they pleased. In fact, Court sessions became known among habitués as opportunities to meet the opposite sex. The Court moved with the Capitol to Philadelphia in 1790, then relocated to Washington, D.C. in 1800. It spent its first decade in Washington meeting in numerous places on Capitol Hill, including a tavern on First Street.

It was not until 1819 that the Supreme Court met for the first time in a place built specifically for its use. The Old Supreme Court Chamber, as it is now called, was designed by the architect Benjamin Henry Latrobe. In November 1806, Latrobe undertook the rebuilding of the Capitol's north wing and planned a room on the ground floor for the Supreme Court. The room served many purposes: it was a committee room, a law library, a meeting room, and a storage room. In the chamber the justices' desks were raised one foot higher than the central floor. A plaster relief over the fireplace depicts the figure of Justice—without blindfold—flanked by Fame, who holds the U.S. Constitution under the rays of the rising sun, and an eagle that rests one foot upon law books. Although the Court met for decades in this chamber, it was nevertheless considered temporary housing.

In 1860, the Supreme Court moved from the Old Supreme Court room to a vacated Senate chamber. The former meeting room became the Court's law library. Despite the lack of permanency of its lodgings, the Court established several traditions, including the symbolic judicial handshake, which indicated

the justices' unity of purpose, and the placing of twenty quill pens on counsel tables each day the Court was in session. The Court attracted a great deal of attention from Washington society, who considered attending court sessions a fashionable pursuit.

After seventy-five years in "temporary" housing, the Supreme Court finally got a permanent home, the building that stands today in Washington, D.C. In 1929, Chief Justice and former president William Howard Taft persuaded Congress to authorize a separate and permanent home for the Supreme Court.

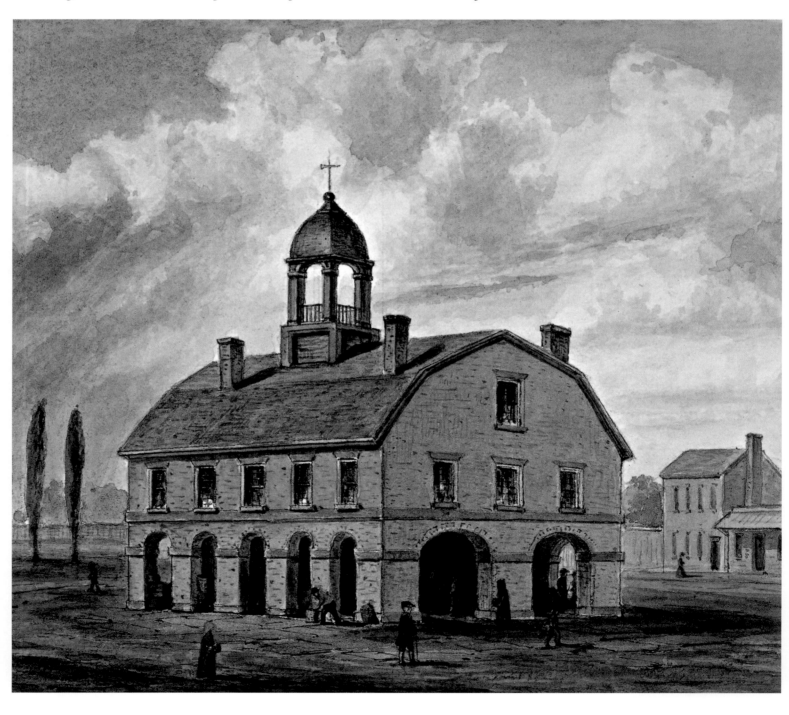

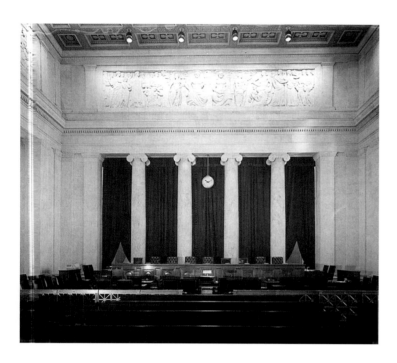

Above: Interior of the U.S. Supreme Court.

Below: James E. Fraser. The Contemplation of Justice. *U.S. Supreme Court*

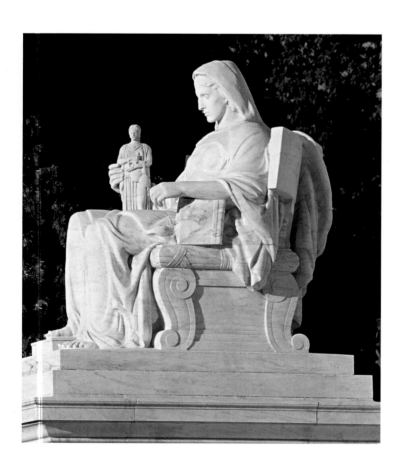

Construction began in 1932 and was finished in 1935. Its monumental Neoclassical design suggests the dignity and importance of the Court as a coequal branch of the U.S. government.

The building is a veritable temple of Justice, measuring 385 feet from east to west and 304 feet from north to south. At its greatest height, it is four stories tall. Sixteen marble columns of the Corinthian order form the majestic porch of the Court's main entrance. On the portico frieze the words "Equal Justice Under Law" are engraved. To either side of the grand staircase sit two sculptural allegories executed by James Earle Fraser. To the right of the steps sits the *Guardian* or *Authority of Law*, a male figure who holds a tablet of law. Behind the table appears a sheathed sword that indicates enforcement through law. The left-hand figure is the *Contemplation of Justice.* This female statue carries a book of laws under her left hand and in her right hand holds a small figure of a blindfolded Justice. A sculptural relief by Robert Aiken decorates the triangular pediment. Entitled *Liberty Enthroned Guarded by Order and Authority*, the group features allegories of Liberty, Order, and Authority as well as representations of prominent American legal figures and those involved in the creation of the Supreme Court.

The interior is equally monumental. In the column-lined Great Hall that leads to the Court's chamber, busts of all of the former chief justices adorn the walls. The chamber itself is grand, with a 44-foot ceiling and twenty-four marble columns. The justices sit behind a raised bench, the focal point and symbolic center of the chamber.

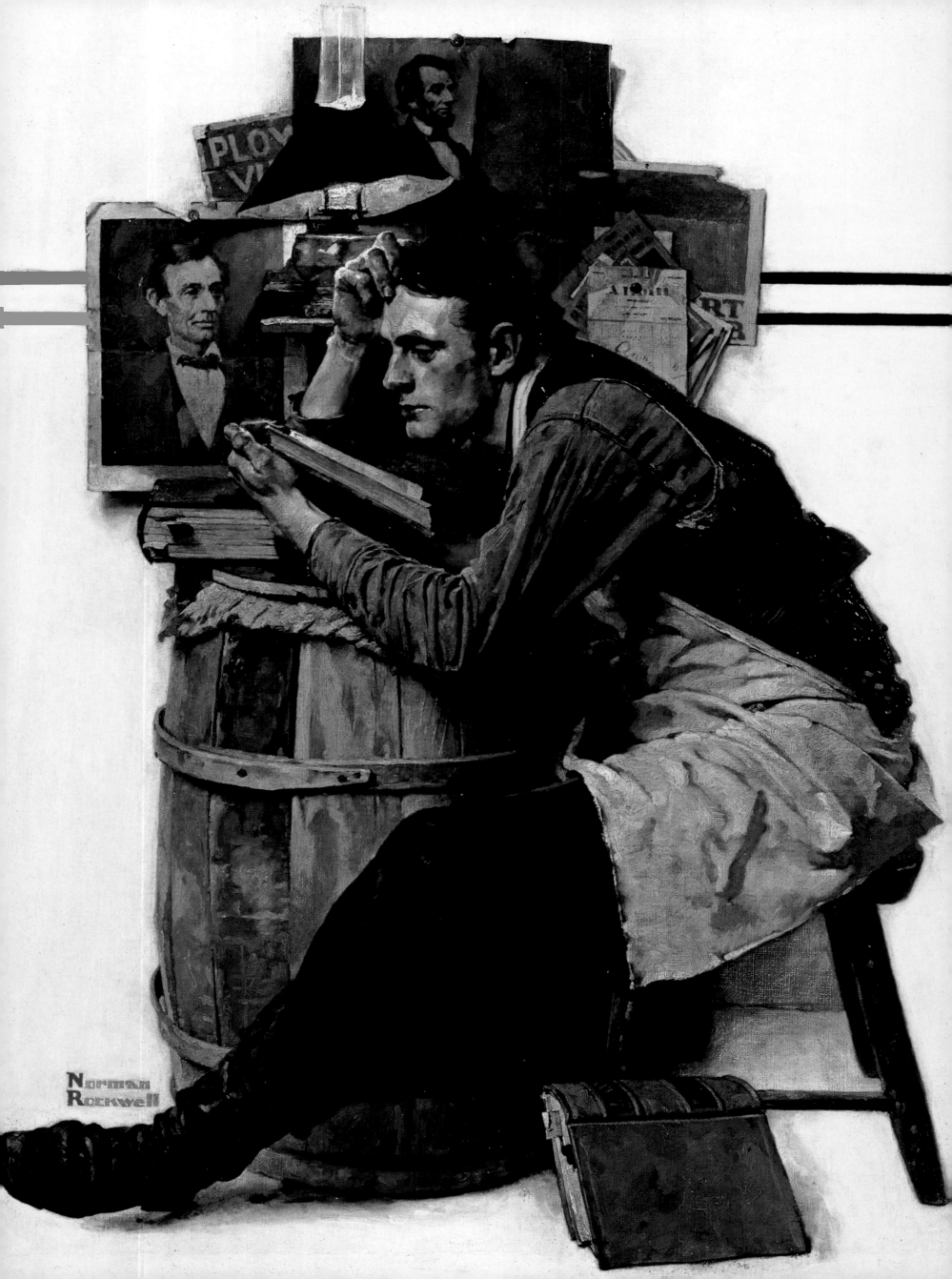

CHAPTER II

LEGAL EDUCATION IN AMERICA

At the time of its founding, the United States had no law schools and few lawyers. This dearth of lawyers was by no means considered an unfortunate situation. In fact some colonial New Jersey residents attempted to induce new settlers from England by promoting the lawyer shortage as one of the premier benefits of moving to the New World. Obviously much has changed since, and few would argue that there is a shortage of either lawyers or the law schools where they are trained. Indeed, some now joke that at the rate American law schools are turning them out, in another fifty years there will be more lawyers in the United States than humans.

EARLY AMERICAN LEGAL EDUCATION

In early America, those who wished to pursue a career in law had limited opportunities for formal study. A few obtained training abroad, by studying at the English Inns of Court, and some may have studied Roman law at Oxford and Cambridge. Although most of the colonies rejected the stratified English bar of barristers and solicitors, legal training in early America largely followed the example of England. Law was considered a trade, and entry to the profession often required a period of apprenticeship, followed by a formal examination.

In England, the apprenticeship took place in the Inns of Court. In America, it was more often in the offices of a local attorney and required a substantial commitment of time. For example, in Massachusetts one was required to undergo a five-year apprenticeship prior to examination for the bar. Giving some recognition to the value of higher education, the apprenticeship period was reduced for college graduates, and the requirement varied widely among the different colonies, as it later did among the states. Sometimes these required periods of apprenticeship were overlooked, as in the case of John Adams, who, after completing his undergraduate education at Harvard, was not questioned about his mere two-year apprenticeship program with Massachusetts attorney James Putnam when he was presented for admission to the Massachusetts bar by several distinguished Boston practitioners in 1758. But Adams continued a course of prescribed readings after his bar admission and eventually became a successful colonial lawyer, and

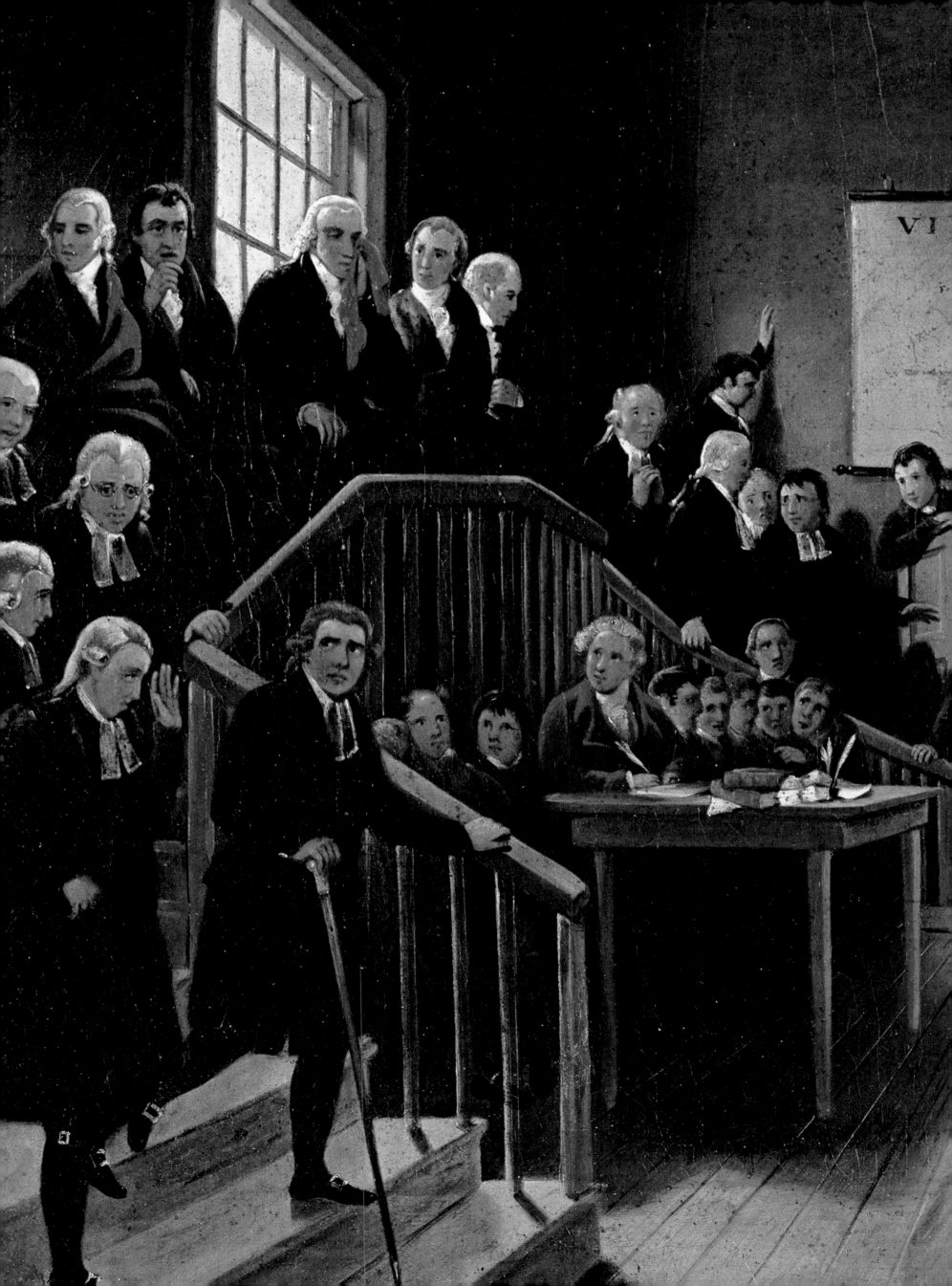

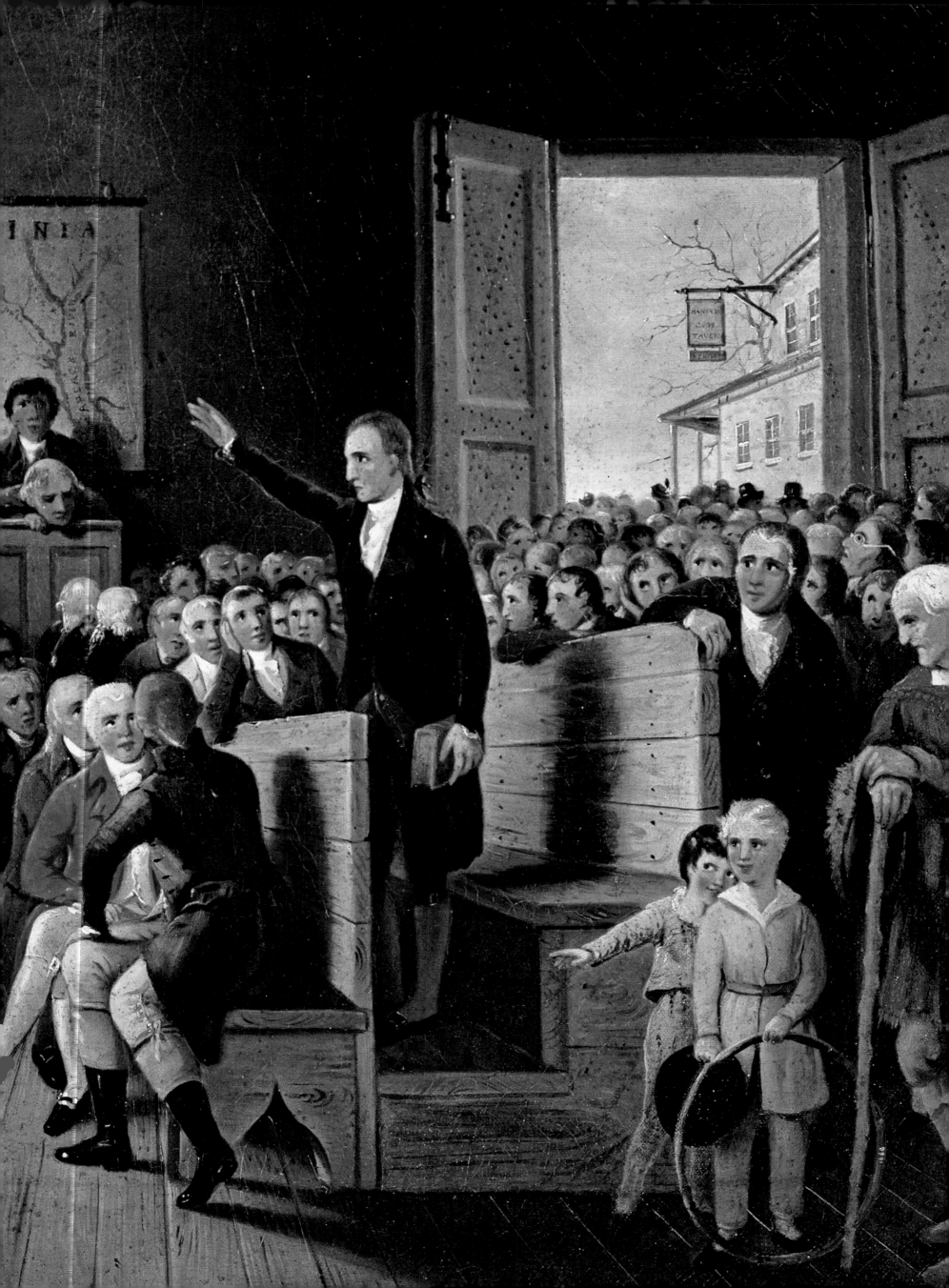

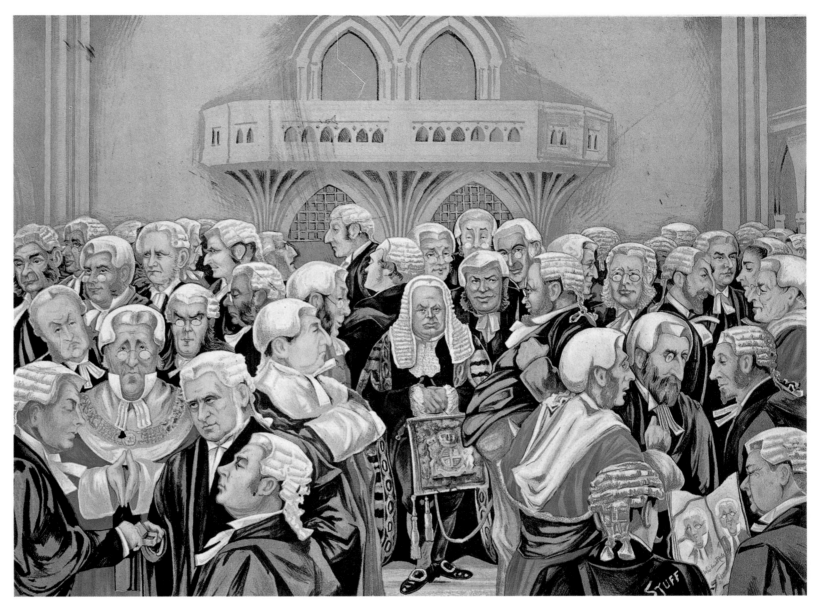

the second U.S. president. A host of other famous early American lawyers learned the law by apprenticing and reading in the office of a practitioner, including John Marshall, Patrick Henry, Thomas Jefferson, William Livingston, Daniel Webster, James Kent, and Joseph Story. Of course, John Marshall went on to become the nation's fourth chief justice, while James Kent and Joseph Story eventually became celebrated commentators on the law and great legal educators for a generation of lawyers.

The training and attention given to apprenticing students was uneven at best. Working under the close guidance of a well-intentioned master of the law offered an opportunity for a superior legal education, but these students were often ignored or exploited. This was the experience of Joseph Story, who eventually became an associate justice of the U.S. Supreme Court and later the first Dane Professor of Law at Harvard. Justice Story apprenticed in the offices of Samuel Sewell, a distinguished counselor of law in Massachusetts, but the young Story was often left totally alone and ignored for up to six months at a time, as Sewell attended to business elsewhere, including his duties as a U.S. senator. Likewise, John Adams learned law largely on his own, although he was technically apprenticed to James Putnam. During his apprenticeship, Adams complained, "Now I feel the disadvantages of Putnam's

Spy (Sir Leslie Ward). Bench and Bar (with the Earl of Marsbury). Vanity Fair *supplement, December 5, 1891. Colortype. 13 ¾ x 19 ½ in. (35 x 49.5 cm). Courtesy of Art & Visual Materials, Special Collections, Harvard Law School Library. American colonists who wished to study law often obtained formal training abroad by apprenticing with English barristers and solicitors.*

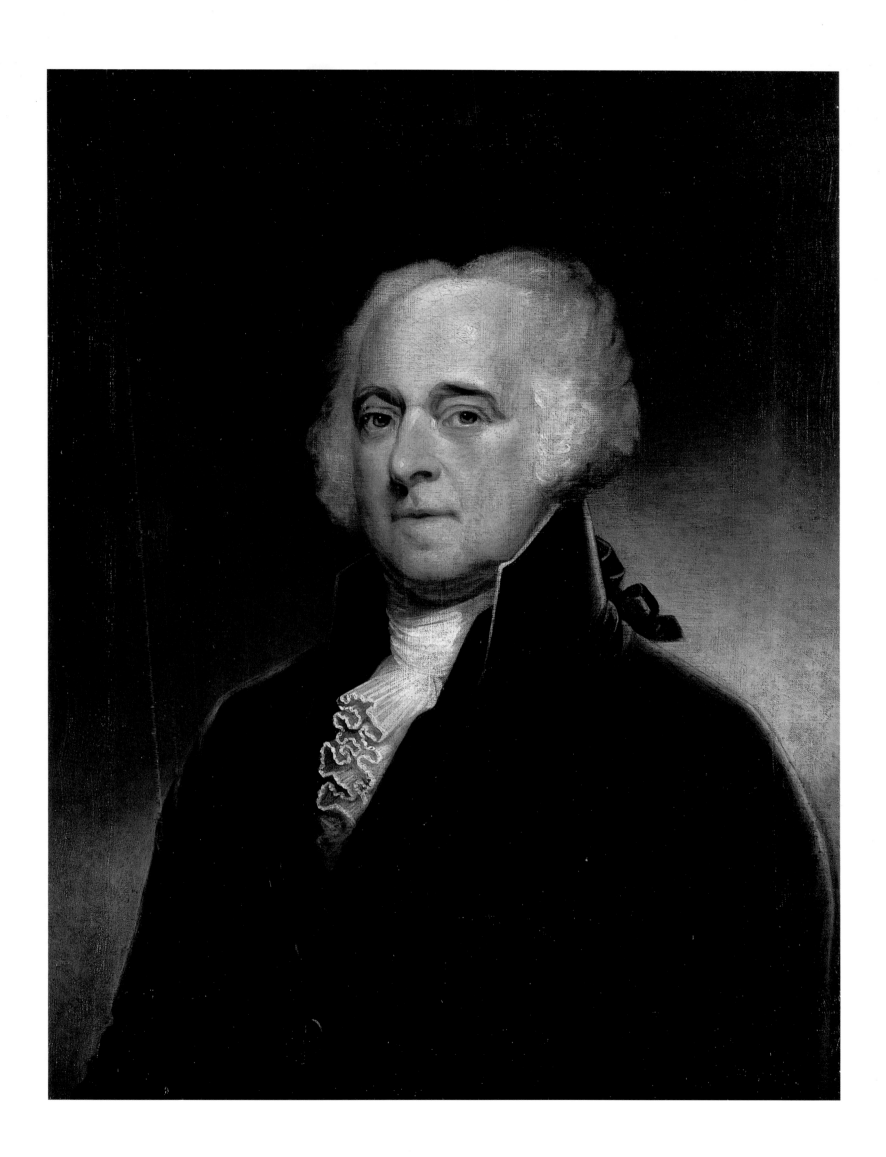

insociability and neglect of me. Had he given me now and then a few hints concerning practice, I should be able to judge better at this hour than I can now." The ultimate professional success of both Story and Adams was due largely to their drive to learn law on their own by reading extensively through their masters' libraries. Indeed, it was access to a good law library that often brought apprentices to the offices of a particular lawyer, and the roots of some modern law schools can be traced from their libraries. Yale Law School, for example, began in the law offices of a New Haven lawyer named Seth Staples, who in 1800 boasted one of the finest law libraries in New England. Eventually, Yale acquired both the library and the law school, and a number of other law schools followed a similar path.

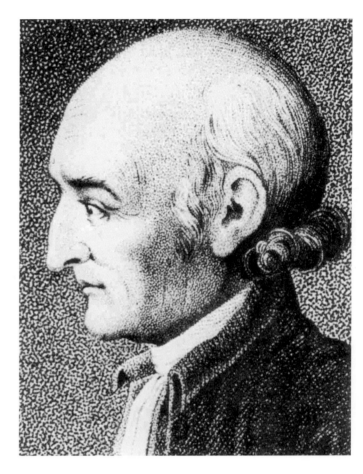

The course of study in an apprenticeship varied, but often consisted of extensive readings from a list of accepted texts. For example, John Marshall's apprenticeship with the highly regarded legal scholar George Wythe required him to first read *Blackstone's Commentaries,* a mainstay in early American law offices, followed by *Coke on Littleton.* He found Blackstone elegant, but the experience of reading the obsolete *Coke on Littleton* was so painful it actually brought Marshall to tears. Nevertheless, he eventually came to enjoy it. While hard to imagine, he claims to have plowed on with relish through repeated perusals of titles such as *Saunders's Reports,* and read with admiration intricate titles such as *Fearne on Contingent Remainders and Executory Devises.* He complained about the growth in legal materials, which required him to read more than his predecessors in order to master existing law, but the number of printed legal texts available then was trivial compared to what was soon to follow. Later in life, Marshall reflected back fondly on this period and credited the at-first painful readings with helping to discipline his lawyerly mind.

Thomas Jefferson, who like Marshall studied law for five years in the offices of George Wythe, understood that apprenticeship programs also were subject to abuse. In later correspondence Jefferson advised, "All that is necessary for a student is access to a library, and directions in what order the books are to be read." Jefferson then went on to suggest an entire library of readings for an aspiring lawyer, ranging from general studies in math, sciences, and languages to relatively specialized titles in law, together with the order in which they should be studied. Jefferson's course of study recommended spending six hours daily on reading law and another six to eight hours reading on related topics, such as history, politics, ethics, physics, oratory, poetry, and criticism, leaving little time for anything else in life, including sleep!

The success and popularity of some practitioners in apprenticing would-be lawyers led to the establishment of the first American law schools in the late eighteenth century. A

Above: Drawing of George Wythe, highly regarded legal scholar appointed in 1779 as professor of the nation's first university-based law program, at the College of William and Mary, Williamsburg, Virginia. Courtesy William and Mary Law Library.

Page 47: Gilbert and Jane Stuart. John Adams. *Begun in 1798 by Gilbert Stuart and completed in 1828 by Jane Stuart. Oil on canvas. 30 x 24 in. (76.2 x 61 cm). National Portrait Gallery, Smithsonian Institution/Art Resource, New York.*

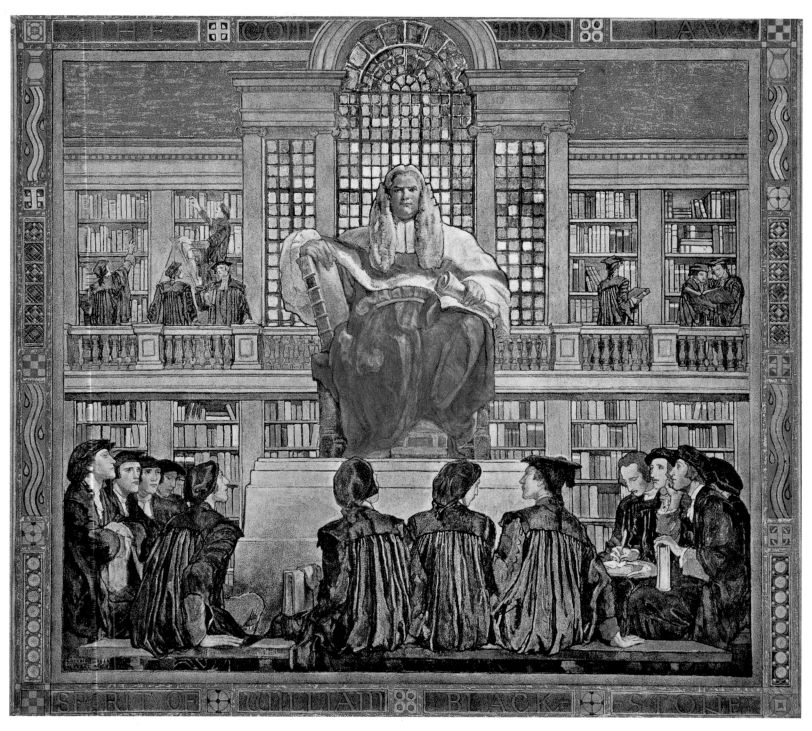

Violet Oakley. The Common Law: The Spirit of William Blackstone. Plate 9 from her illustrated book, "The Law Triumphant." 1932. Photogravure. 8 ½ x 9 ¼ in. (21.6 x 23.4 cm). Courtesy of The Pennsylvania Academy of the Fine Arts, Philadelphia. Archives.

number of local proprietary law schools opened during this period, but America's first law school with a national presence was founded in Litchfield, Connecticut, in 1784. This law school operated with great success for nearly fifty years and served as a model for a number of other early ventures in American legal education. However, apprenticing with a seasoned practitioner remained the primary avenue for entry into the legal profession for the next one hundred years.

America's first university-based law program began in Virginia. In 1779, Thomas Jefferson appointed his former law tutor, George Wythe, as professor of law and police at the College of William and Mary, five years prior to the founding of the Litchfield Law School. Wythe remained in this post for twelve years, and the William and Mary law program continued to operate uninterrupted until the Civil War in 1861. Wythe was a highly regarded legal scholar and had tutored numerous aspiring young lawyers prior to this appointment to the post of

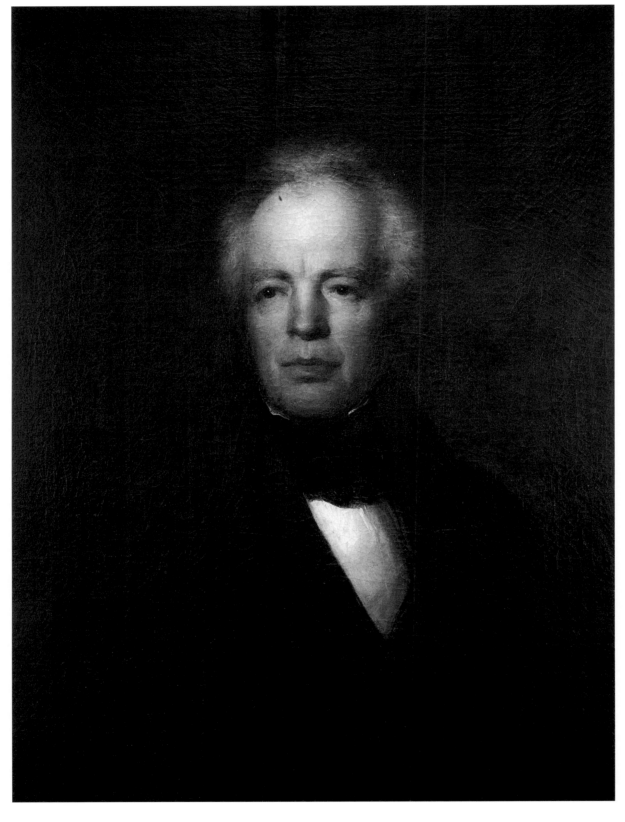

Asher Brown Durand.
James Kent. c. 1836. Oil
on canvas. 30 ³⁄₁₆ x 25 ³⁄₁₆ in.
(76.7 x 64 cm). Courtesy of
Art & Visual Materials,
Special Collections, Harvard
Law School Library.
James Kent was a lawyer,
jurist, and the first professor of
law at New York's Columbia
College (now Columbia
University) in 1794.

professor. His approach to studying law broadly and his appreciation of Latin, Greek, and the classics made him a good fit for university legal education, where students undertook the study of law as part of a larger educational experience and not necessarily to pursue law as a profession. He also injected the flavor of his practice into his lectures, as he continued to be an active participant in Virginia's legal affairs.

A number of famous early American lawyers and statesmen studied under Wythe. In addition to Jefferson and John Marshall, his many students included Edmund Randolf, James Monroe, and Henry Clay. Following the death of his wife and some unpleasant

university politics, Wythe resigned from his teaching post at William and Mary in 1791 and was succeeded by St. George Tucker. In a rush to prepare quickly for his new role, Tucker took a short cut and based his lectures on *Blackstone's Commentaries*. Of course, the *Commentaries* had been prepared by William Blackstone for a similar purpose when Blackstone was appointed as the first Vinerian professor of English law at Oxford in 1758. Later, Tucker published his own annotated version of *Blackstone's Commentaries*, adapting them for contemporary American usage and contributing his scholarly input for the broader use of the legal community. Also under Tucker's reign, the first known American law degree was finally awarded at William and Mary in 1793, to William H. Cabell, who later became governor of Virginia and presiding judge of the Virginia Court of Appeals.

The influence of the legal education program at William and Mary quickly spread to other colleges and universities, with the creation of similar professorships in law. For example, in 1799, Transylvania University in Kentucky appointed one of William and Mary's graduates, George Nicholas, as professor of law and politics. The Transylvania program continued throughout much of the nineteenth century, at times flourishing. During the same period, professorships in law appeared at a number of other American universities, including most significantly the appointment of James Kent to professor of law at New York's Columbia College (now Columbia University) in 1794.

Kent launched an ambitious series of law lectures at Columbia, but it's fair to say he was a failure as a teacher, as students quickly stopped signing up for his lectures after the first term. Some said his lectures were too professional to attract and hold the attention of an audience of mostly undergraduate students and too academic for members of the practicing bar. When no students appeared for his third semester of lectures, Kent resigned from his teaching post and soon began a distinguished career as a judge. Kent joined the New York Supreme Court in 1804, and a decade later was appointed chancellor of New York. While on the bench, Kent contributed immensely to the development of systematized court reporting in the U.S., including the practice of submitting written opinions for every case that came before him, during a period when written judicial opinions were rare. When he left the post of chancellor in 1823, his published series of *Chancery Reports* influenced the development of equity law across the nation and set a new standard for court reporting. Chancellor Kent returned to Columbia in 1824 in a brief attempt to revive his lectures, but lasted only two years and did not lecture again after 1826. While Kent's name remained in the Columbia catalog until his death in 1847, like fellow law professor St. George Tucker at William and Mary, Kent's primary impact on legal education was through his scholarship. Using his lectures as a basis for more expansive scholarly endeavors, Kent published a four-volume set of *Commentaries on American Law* between the years 1826 and 1830. This was a hugely ambitious work and has been compared in scope to Justinian's *Institutes* and *Blackstone's Commentaries*. Numerous editions were published here and abroad, and this work was immensely influential on the subsequent development of American law.

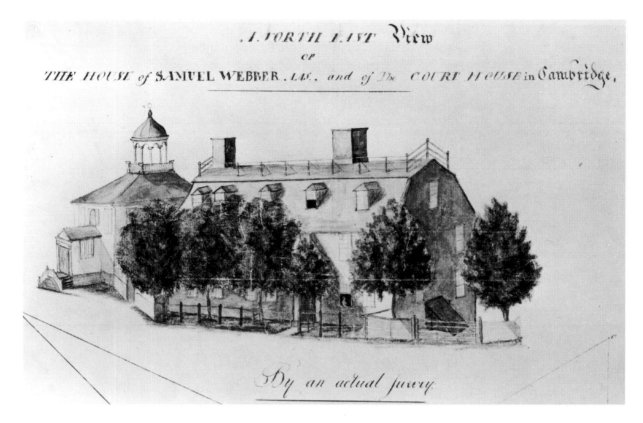

HARVARD AND THE BIRTH OF MODERN LEGAL EDUCATION

James Kent was among the nation's generation of legal scholars sometimes referred to as the great commentators whose scholarship contributed to shaping and developing American law. Another important commentator was Joseph Story, his great influence bestowed on the program at Harvard. But unlike Kent, Joseph Story had a distinguished legal career long before venturing into the realm of legal education, including serving as associate justice of the United States Supreme Court from 1811 through 1845. Obviously, the work load of Supreme Court justices was far lighter during Story's tenure, as it is impossible to conceive of a current member of the U.S. Supreme Court having time to simultaneously take on the responsibilities of a full-time law school faculty member.

Before Story came on the scene at Harvard, that institution began its venture into legal education with the creation of the Royall Professorship of Law in 1816. Massachusetts chief justice Isaac Parker was appointed to this new professorship and was given wide latitude in fulfilling his role. The basic requirement was to deliver a series of not fewer than fifteen lectures covering law and government ". . . and generally those topics connected with law as a science which will lead the minds of the students to such inquiries and researches as will qualify them to become useful and distinguished supporters of our free systems of government, as well as able and honorable advocates of the rights of the citizens." Parker sought to avoid James Kent's practice at Columbia of lecturing to a mixed audience of both undergraduates and professionals, and pleasing neither. Rather, Parker chose to use his new professorship as an opportunity to create an entire school specifically designed for training lawyers, much in the same style as the Litchfield Law School. Moreover, the law school envisioned by Parker was to be a graduate school, modeled after the schools of theology, that was to provide instruction to "resident graduates in jurisprudence" and not compete with the

Harvard College undergraduate program for students. This was a radical departure from the simple law professorships begun at other universities, including those at Columbia and William and Mary.

Harvard supported key elements of Parker's plan and allowed him to move forward in developing a somewhat financially independent professional law school. The following year the law school was launched under the direction of Asahel Stearns, an out-of-office politician. Stearns was formerly appointed University Professor of Law, but this position was to be supported entirely from student fees, as were most of the school's other expenses. Parker's plan to make the law school a graduate program and to limit enrollment was defeated in the interest of financial expediency. Students were needed to finance the school, and admission was thrown open to anyone. The program at Harvard, therefore, was less different from the Litchfield school than Parker had envisioned, although it soon was recruiting more new students than Litchfield: in its third year of operation, Harvard had nineteen students, against Litchfield's eighteen.

Other universities followed Harvard's precedent of conferring the prestige of its name on fairly independent professional schools. Several years after the founding of the Harvard Law School, Yale began its affiliation with a law school in New Haven, which was operated in conjunction with the law offices of Staples and Hitchcock. In 1824, Yale appointed a member of that firm, Senator David Daggett, to its vacant professorship of law, and the names of his thirteen students were included in the Yale catalog. Like Parker at Harvard, Daggett became a member of his state's highest court, and management of

Artist unknown. Dane Hall. 1832. Lithograph. 5 ¾ x.7 in. (14.6 x 17.7 cm). Dane Hall housed Harvard Law School from 1832–1883. Courtesy of Art & Visual Materials, Special Collections, Harvard Law School Library.

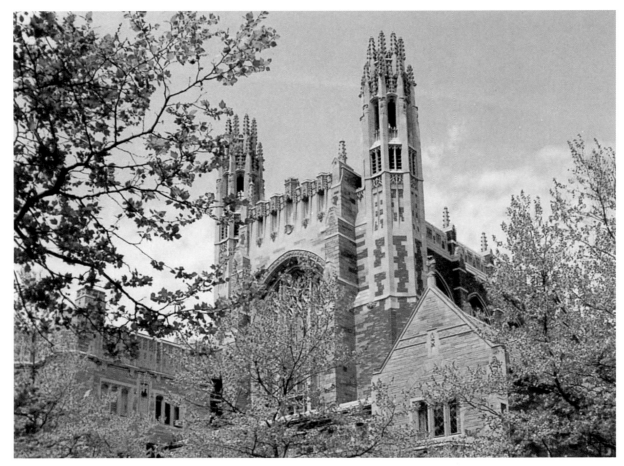

the law school's daily operations fell to his junior associate. It took several more decades before the law school at Yale was more fully incorporated into the university, and during the interim it made no pretensions of limiting its program to those courses appropriate for university training. Rather, the program at Yale was unabashedly a full practitioner's course, which lacked the graduate level aspiration and vision of the one attempted by Parker at Harvard. However, during this early period the two law schools were similar in what they offered their students.

Another early American legal scholar, Nathan Dane, provided additional resources for Harvard to expand the development of its law school. Dane was the author of an *Abridgement of American Law*, which was similar in design to Charles Viner's English Abridgement, titled *General Abridgement of Law and Equity*. Further following the example of Viner, who endowed a professorship in English common law at Oxford first filled by William Blackstone, Dane offered to fund a chair in law at Harvard, with the provision that the first incumbent be the highly regarded American jurist Joseph Story. Dane also stipulated that Story should be allowed time to publish as well as teach, perhaps having the work of Blackstone and Kent in mind. Story accepted the appointment in 1829, and immediately retained assistance for the practical business of running the law school by hiring John Hooker Ashmun, a legal educator from a proprietary law school in Northampton, Massachusetts, modeled after the one at Litchfield. Ashmun brought students to the program, and Justice Story's reputation helped attract even more. By 1844, just before Justice Story's death, Harvard's enrollment reached 163 students, which was huge by contemporary standards. Prior to Story's appointment, Harvard had averaged only nine students per year. However, admission standards to the Harvard law program remained lax,

and students who would not have been accepted into Harvard College were able to enroll and come and go as they pleased, the tone of instruction under the initial direction of Ashmun being that of a trade school. Nevertheless, Joseph Story's appointment as law professor, and the freedom he was given to produce scholarship in that role, added a new level of prestige to the Harvard program and set it on a course to be the preeminent law school in America. During Story's tenure at Harvard he produced a wealth of legal treatises, on topics ranging from constitutional law to equity. These commentaries helped define the course and direction of American law, and set the style for producing legal scholarship over the following years. The new holder of Harvard's Royall chair, Simon Greenleaf, also wrote legal treatises in addition to his role in the classroom, reinforcing the dual role of university law professors as both teachers and legal scholars.

The success of the law program at Harvard under Story and Greenleaf signaled a major change in American legal education. The elite of the bar were no longer being trained in law office apprenticeship programs or proprietary law schools, but more often were studying law at university-based programs, such as the one at Harvard. In 1855, Abraham Lincoln noted this change in reply to a question of why he was still studying law when he was already at the head of his profession in Illinois:

> Oh yes, I do occupy a good position there, and I think I can get along with the way things are done there now. But these college trained men, who have devoted their whole lives to study, are coming West, don't you see? And

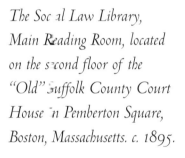

The Social Law Library, Main Reading Room, located on the second floor of the "Old" Suffolk County Court House in Pemberton Square, Boston, Massachusetts. c. 1895.

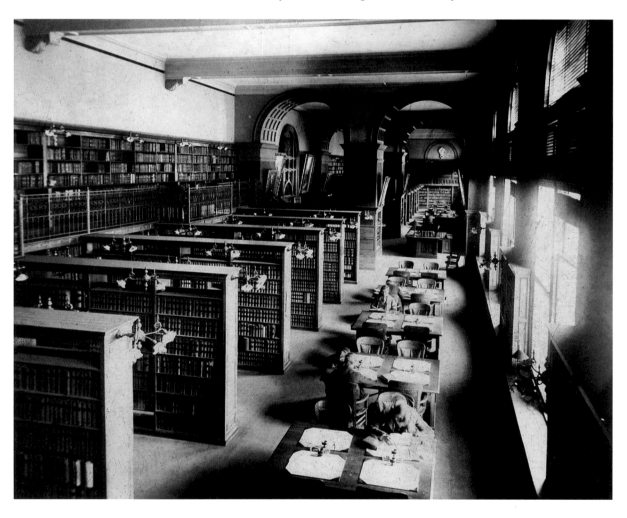

they study their cases as we never do. They have got as far as Cincinnati now. They will soon be in Illinois. I am going home to study law. I am as good as any of them, and when they get to Illinois I will be ready for them.

For all the changes in the education of America's lawyers, the method of instruction at all of these university-based programs remained remarkably similar and dull. From the newly re-established law program at the University of Pennsylvania to the more interdisciplinary program of study at the University of Virginia, the professors lectured from dry monologues. Students continued to read Blackstone and Kent, augmented by the texts of Story, Greenleaf, and others. All of this would soon change for the better, with the appointment of Christopher Columbus Langdell to the newly created post of dean at the Harvard Law School in 1870.

The growth in university-based legal education accelerated following the close of the Civil War, and the number of degree-granting programs expanded from just fifteen in 1850, to twenty-two in 1860, to thirty-one in 1870. These included new part-time programs at institutions like Columbian (now George Washington) and Cincinnati Law School, in Ohio, and a new law school for African-Americans at Howard University in Washington, D.C. In terms of size and influence, the most significant of these programs included the one at the University of Michigan, which shortly after the Civil War boasted the largest enrollment in the country with nearly four hundred students, and Columbia's law school, which ranked second in enrollment with two hundred law students in 1870. The popular lecture-based system of instruction developed by Columbia's Theodore Dwight helped boost enrollment at that institution to more than five hundred students by 1872, pushing it ahead of Michigan. During this period, Harvard remained the most prestigious law school in America, but following the end of Justice Story's reign its enrollment had slipped to fourth place, and it appeared to be losing its position of leadership. Further, university legal education in general retained its trade school approach, consisting of one to two years of instruction by lecture and lacking the requirement of even an undergraduate degree for admission.

The appointment of Charles Eliot as the new president of Harvard in 1869, and Christopher Columbus Langdell as the first dean of the Harvard Law School in 1870, helped propel Harvard back into a clear leadership role and transform American legal education lasting well into the next century. Improvement of professional education at Harvard was at the top of Eliot's goals when appointed president, and being trained as a chemist he readily supported Langdell's belief that law should be studied as a science. In turn, Langdell subscribed to Eliot's goal of improving the state of professional education. While other legal educators, including Columbia's Theodore Dwight, shared Langdell's scientific notions of legal study, Langdell's approach was entirely different. Dwight's maxim was principle before practice, and through his lectures he sought to teach his students the principles and classification schemes of law in the same manner that Linnaeus classified plants. His system of instruction was to recite lectures outlining lists and rules illustrated by cases, which his

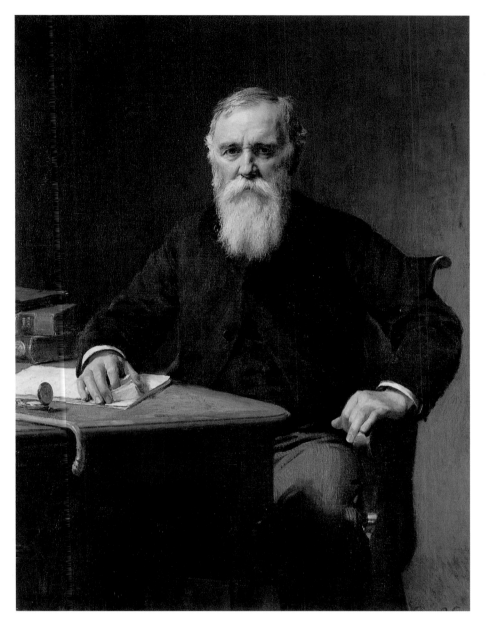

students were required to memorize. In contrast, Langdell's approach to law study and teaching was to have students go directly to the cases. Instruction consisted of analyzing the reasoning of these cases in class through employment of the Socratic method, whereby students engaged in a dialogue with the instructor. A former student librarian at Harvard's law school, Langdell later wrote in the *Law Quarterly Review* (1887) ". . . law is a science, and . . . all of the available materials of that science are contained in printed books." He further added, ". . . the library is the proper workshop of professors and students alike; . . . it is to us all that the laboratories of the university are to the chemists and physicists." Surely, these are words to warm the hearts of all librarians, and they did as much to spur the development of law school libraries as they did to transform legal education. The library at Harvard Law School, which had been sharply criticized in several reports prior to Langdell's appointment, grew rapidly in size and scope of coverage, although with Langdell's focus on case law, statutes were not collected until some years later.

Frederick Porter Vinton. Christopher Columbus Langdell *1892. Oil on canvas. 5c ⅛ x 40 ¼ in. (127.3 x 102 cm). Courtesy of Art & Visual Materials, Special Collections, Harvard Law School Library.*

Langdell's deanship at Harvard continued for twenty-five years, from 1870 to 1895, during which period the rapidly expanding industrial economy of America demanded more highly skilled lawyers to manage the intricacies of an ever-expanding body of legal regulations. Langdell was able to institute a number of changes, which soon became commonplace in law schools across the nation and helped shape legal education for the next century. Beyond his case approach to studying law, and the Socratic question-and-answer method of instruction, these changes included extending the program of study from eighteen months to two years (and in 1899 to three years), increasing the standards for admission, as of 1909 requiring graduation from college as a prerequisite for admission, and lastly, implementing rigorous annual examinations. By 1900, there were 102 law schools in the United States, and 40 percent of these came into operation within the previous ten years. The size and influence of Harvard was so powerful that most other university-based law programs soon followed suit. Even Columbia's law school turned to the case method of instruction, with the appointment of William Keener in 1890, which led a number of Columbia faculty, including Dwight, to resign in protest. With the appointment of Harvard's Thomas Swan as dean at Yale in 1916, it became clear that the Harvardization of legal education was near complete.

Left: Georgetown University Law Center, E Street Building. c. 1920. Photograph courtesy Office of Public Relations, Georgetown University Law Center, Washington, D.C.

ALTERNATIVE MODELS FOR AMERICAN LEGAL EDUCATION

As the Harvard model for legal education spread, so did the number of law schools. But some of the newer law schools were established in reaction to the Harvard model or to serve the legal education needs of those excluded from Harvard and similar mainstream law school programs. For example, when Theodore Dwight's followers resigned in protest from Columbia, they founded a new non-university-affiliated law school in 1891 known as New York Law School, which continued to employ Dwight's lecture-based method of instruction. Similarly, the law school at Boston University was founded in 1876 by those who disagreed with the Harvard case method and sought to establish a more practice-oriented system of instruction. Further, while Harvard and other programs modeled after Harvard served a full-time student body of white males, alternative law school programs serving other groups of potential students including women, minorities, and working immigrants, began appearing in the latter half of the nineteenth century. It is notable that the New York Law School, in addition to offering an alternative to the case approach of studying law, also provided a part-time evening division to cater to the needs of working students.

Part-time legal education expanded rapidly near the end of the nineteenth century, appearing first just after the Civil War in Washington, D.C., and later in major cities across the country. The first part-time law school was founded at Columbian College in 1865 to teach federal employees. Rival programs opened at two other Washington universities soon after, including Georgetown University. The success of the part-time program at Georgetown eventually led to that law school becoming the largest in America, a position it maintains to this day. Part-time law school programs in other

Opposite: Nellie Mathes Horne. Portrait of Belva Ann Lockwood. 1913. Oil on canvas. 69 ¾ x 40 in. (177 x 101.6 cm). National Portrait Gallery, Washington, D.C./Art Resource, New York.

cities helped open the doors of legal education to working immigrants who sought entry to the legal profession as a sure way to advance in America. Metropolis Law School (later absorbed by New York University) and Chicago College of Law (later to become Chicago-Kent) both opened successful part-time programs in 1888. Many of these law schools would not have succeeded without part-time programs, and by the end of the nineteenth century, the 7,631 students enrolled in part-time law school programs was nearly double the number of those enrolled in full-time programs.

The Young Men's Christian Association (YMCA) entered the field of legal education near the end of the nineteenth century, and by 1920, it was operating law schools in ten American cities. These programs were designed to open the doors of legal education to the worthy poor and were a small part of a much larger role played by the YMCA in education, courses in law being offered among courses in a variety of other subject areas, from automobile repair to stenography and business. Many of the YMCA law schools were quickly absorbed into other educational institutions, but some continued to operate as distinct YMCA entities well into the latter half of the twentieth century. Today a number of contemporary law schools trace their roots to YMCA evening law schools, including Northeastern University in Boston, which began in 1897 as the Lowell Institute, and the University of Toledo Law School, which began as the Toledo YMCA Law School in 1908.

Women were largely excluded from American law schools and generally from the practice of law until late in the nineteenth century. Langdell opposed the admission of women at Harvard's law school, and like many other law schools that institution did not finally admit women until the middle of the twentieth century. Alice Ruth Jordan was allowed admission to the Yale Law School in 1886 by noting that there was nothing in the Yale catalog barring women, but the following year the Yale Corporation inserted language that specifically excluded women. Prior to the late nineteenth century, the few women who did become lawyers learned the law mostly through the apprenticeship system, often working for a spouse. For example, Ellen Spencer Mussey, a co-founder of the Washington College of Law (now American University's law school) learned law by assisting in her husband's practice when

Ellen Spencer Mussey (above) and Emma Gillett (below), co-founders of the Washington College of Law.

he became ill, and she was admitted to the Washington, D.C., bar in 1893 without the benefit of a formal legal education. The notion that women were inherently unfit for the practice of law because of their gender was supported by the U.S. Supreme Court in an 1869 case. That case upheld Myra Bradwell's denial of admission to the Illinois bar despite her stellar reputation in the Illinois legal community, stemming in part from her highly regarded editorship of the *Chicago Legal News*. The court stated in part that "the natural and proper timidity and delicacy of the female sex evidently unfits it for many of the occupations of civil life," such as practicing law. With the growing women's suffrage movement and the agitation for expanded women's rights this ruling did not stand for long, and in 1878 Belva Lockwood was successful in opening the federal courts to women attorneys. Also, the same year that Myra Bradwell lost her battle to join the bar, Arabella Mansfield became the first woman admitted to practice when she was allowed to join the Iowa bar, not so surprising considering that the University of Iowa, established as the first law school west of the Mississippi in 1868, began admitting women students as early as 1869, well before the vast majority of America's other law schools. Howard University's law school, the nation's first law school for African-Americans, was equally progressive, and from the time of its founding in 1868 admitted women. An early woman graduate of Howard's law school, Emma Gillett, later joined Ellen Spencer Mussey, in 1898, to found the Washington College of Law in Washington, D.C., the nation's first law school for women.

Although most law schools continued to refuse admission to women during the last part of the nineteenth century, the number of women attorneys expanded substantially. The census reported only five women lawyers in 1870, and seventy-five in 1880, but by 1900 over one thousand women lawyers were listed. There were enough women lawyers in New York City in 1899 to form the Women Lawyer's Club of New York. This group began an unsuccessful effort to admit women to the Harvard Law School, and when that failed the nation's second women's law school was founded in Boston, in 1908, known as the Portia Law School. Unlike the co-educational Washington College of Law, founded ten years earlier, the Portia Law School initially was intended as a separate but equal institution for aspiring women attorneys; however, probably due to financial considerations, Portia soon opened its doors to male applicants as well. It was only another ten years before women were admitted as members to the American Bar Association, and major law schools like Fordham and Yale began admitting female applicants. But it was not until the 1970s that women entered American law schools in force.

Not surprisingly, entrance to the legal profession was even more difficult for African-Americans than it was for women. During the period when apprenticing was the main road to becoming a lawyer, African-Americans faced the challenge of finding a practitioner willing to take on a black person as a student. Not many were willing. And the few law schools that existed in early America were not ready to accept African-Americans as students, perhaps fearing it would drive away their mainstream students, especially those from the South. Even those African-Americans who did manage to gain a

legal education privately still had to face the gauntlet of a hostile group of bar examiners. Those who succeeded were few in number, and were usually those whose skin color helped them pass for white.

Maine was possibly the first state to admit a black applicant to its bar when Macon Bolling Allen became a lawyer in 1844. Allen was a native of Indiana, but came to Maine and studied law under the sponsorship of a prominent abolitionist lawyer named General Samuel Fessenden, who was reputedly the most powerful lawyer in the state. Shortly thereafter, Allen also was admitted to practice in Massachusetts, where in 1847 he was appointed to the post of justice of the peace by an anti-slavery governor named George Briggs. Thus, Allen has the dual distinction of being both the first African-American lawyer and the first African-American judge. The number of other African-Americans admitted to law practice prior to the Civil War might easily be counted on one hand. Included in this meager number was another black Massachusetts lawyer named Robert Morris, who was admitted to the bar in 1847 after working for a Boston abolitionist lawyer named Ellis Gray. Obviously ahead of his time, Morris later initiated the first case to challenge public school segregation, in *Roberts v. City of Boston.* This case made it all the way to the Massachusetts Supreme Judicial Clerk, where Morris deferred to Charles Sumner, his politically connected white co-counsel, for oral argument. Morris and Sumner lost this early challenge to school segregation, but the arguments they made in their brief were widely circulated in a pamphlet and were successfully made again a century later in *Brown v. Board of Education.*

Washington College of Law, Washington, D.C., the nation's first law school for women. c. 1920.

Prior to the Civil War, African-Americans who attempted to gain a legal education by attending law school generally were out of luck, unless they could pass for white. This was the experience of John Mercer Langston, a well-qualified aspiring black lawyer who attempted to gain admission to a proprietary law school in Saratoga, New York, shortly after Macon Allen was admitted to the Maine bar. Langston was a graduate of Oberlin College and had worked for an abolitionist lawyer before deciding on pursuing law as a career. The New York law school rejected Allen's application purely on racial grounds, fearing his presence as a black man would offend southern white students; however, Langston was informed that he would be admitted if he would be willing to pass himself off as "a Spaniard or Frenchman from some part of the Americas." Langston refused this humiliation and applied to several other law schools, with similar results. Finally he apprenticed himself to a politically active former Ohio judge named Philemon Bliss. Afterward, Langston reportedly staggered the Ohio bar examiners with his proficiency in the law, but even at that a majority of the examiners opposed his admission to the bar,

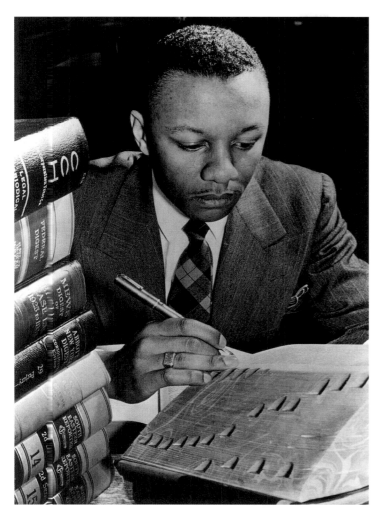

Law student studying at Howard University, Washington, D. C. c. 1942.

purely on racial grounds. However, the political power of Bliss was such that with his prodding, the examiners agreed that Langston's skin color was white enough for him to be admitted to practice, and Langston finally became a member of the Ohio bar in 1854.

Langston eventually became the inaugural dean of Howard Law School, which opened in Washington, D.C., in 1868 as the first American law school for African-Americans. For a time, Howard helped increase the numbers of African-American attorneys, and other black law schools soon followed Howard's lead. Several were opened—and most were eventually closed—during the last half of the nineteenth century, including Lincoln University Law School (1870–1873), Shaw University Law School (1878–1916), and Central Tennessee (1879–1921). Howard's success was partially due to its location in the nation's capital and its ability to draw on the large pool of government employees interested in studying law, but all of these schools lacked resources and funding, and as the standards for legal education increased, marginal schools were pushed out of business. For example, Howard fell on hard times when the District of Columbia moved to increase the training requirements for lawyers from two to three years, while also stipulating that none of Howard's government subsidy could be used to support its professional schools. Howard barely survived this move toward tightened standards, with enrollment dropping to a mere twelve law students in 1887, and other black law schools gradually fell by the wayside. Thus, the growth in black lawyers stalled at the end of the century, with only 728 black lawyers reported in the 1900 census.

PROFESSIONAL ASSOCIATIONS AND THE DEVELOPMENT OF ACCREDITATION STANDARDS

The American Bar Association (ABA) was founded in 1878 as a voluntary professional association of lawyers, and almost immediately began agitating for increasingly higher standards in legal education. Of course, the ABA had no real direct power to legislate bar admission standards in any American jurisdiction, but it was a powerful lobbying group, and its persistence met with success. Largely due to its efforts, minimal standards for law schools increased throughout the late nineteenth and twentieth centuries. These standards guided law schools to become three-year graduate programs, taught by a minimal ratio of well-qualified faculty, with access to substantial libraries and other relevant resources. Graduation from law school programs approved by the ABA eventually became the accepted minimal standard for taking the bar examination in most American jurisdictions, but these changes came gradually.

The ABA's efforts to improve legal education began in 1881, when the organization tried to get all American jurisdictions to accept time spent in law school as the equivalent of time in a law office apprenticeship program. Within the following decade, the ABA was recommending that law school education be treated as the preferred method for entry into the profession, while it also strived to improve the minimal standards for an acceptable law school education, introducing the notion that law school should be a three-year graduate level program.

The establishment of the Association of American Law Schools (AALS) in 1900 put still more pressure on law schools to raise their standards. The AALS grew out of the ABA's Section on Legal Education, which had fallen under the control of academic lawyers. Its membership was open only to law schools rather than individuals, and member institutions were required to meet certain minimal standards, such as those pertaining to faculty resources, student admission policies, libraries, and length of study program. For example, initial requirements for membership in the AALS included admitting only students who had at least a high school education, running a program that lasted at least two years (of thirty weeks each), providing access to a library with U.S. and local state reports. By 1907, law schools with less than a three-year program were denied membership in the AALS. But in its early years, the AALS represented only a small proportion of the law schools in America, and professional standards for bar admission were determined by the individual states and the federal courts, not the professional associations. Thus, despite the efforts of these organizations, as of 1917 no single state even required graduation from law school as a prerequisite for becoming a licensed lawyer.

During the early twentieth century, the number of law schools and law students steadily increased, from 102 law schools with 12,516 students in 1900, to 146 law schools with 24,503 students in 1920. Many of these were part-time evening programs operating with minimal standards. Needless to say, these newer marginal law schools were not members of the AALS—they did not come close to meeting the AALS membership requirements—and as a result the AALS represented fewer and fewer of the total number of American law schools. However, these part-time programs were especially attractive to new immigrants and other working students of lesser means as a gateway for moving up in America. But to those in the ABA and AALS who had worked to establish stronger standards for law schools, the breadth of American legal education opportunities merely emphasized their failure to set higher standards for the education of America's lawyers. The requirements espoused by these organizations had failed to close down schools that refused to adopt them. It was in this atmosphere that the ABA and AALS moved to further strengthen their standards and to convince the various state boards of bar examiners into enforcing them.

This tightening of standardized requirements by the ABA and AALS established a pattern that would persist for the remainder of the century, with AALS membership

Opposite: Mary Franklin. A Class at the University of Pennsylvania Law School. 1879. Oil on canvas. 42 x 30 in. (106.7 x 76.2 cm). Collection of the Honorable Morris S. Arnold.

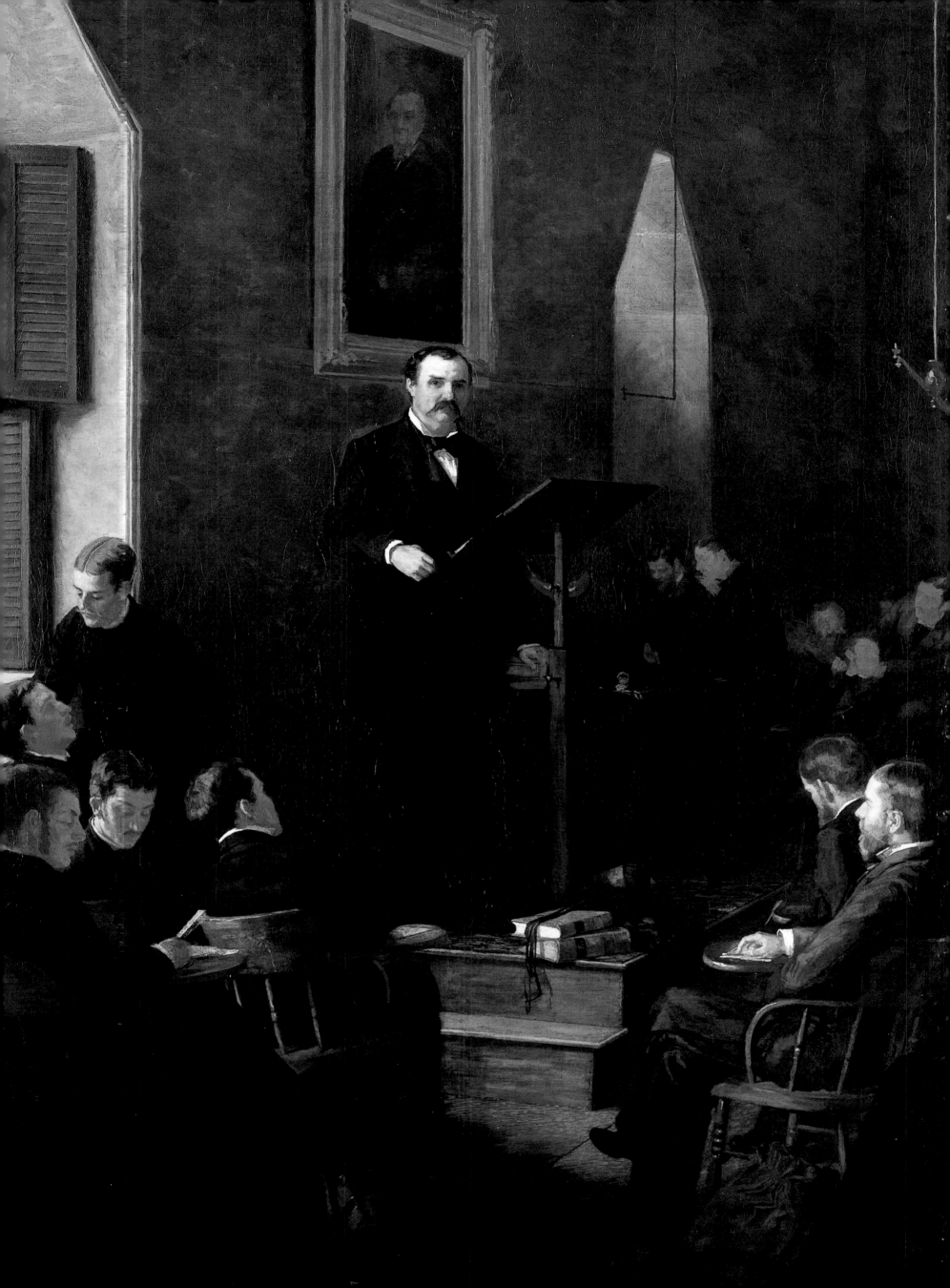

standards always a bit tougher than those of the ABA. The ABA also invested its Council on Legal Education with the power to accredit law schools. These new standards included a minimum of two years of college for admission to law school, three years of full-time law study for graduation, and four years in a part-time evening program. In order to make these new standards for accreditation more than merely persuasive, the ABA sponsored a conference of state and local bar associations the following year and obtained their endorsement. In this manner, graduation from an ABA-accredited law school eventually became a prerequisite for taking the bar examination in most American jurisdictions. Membership in the AALS continued to be voluntary and served to enhance the status of those schools who cared to become members.

Accreditation and membership standards of the ABA and AALS continued to evolve throughout the remainder of the twentieth century, and the financial barriers for meeting these standards often served to keep newer and marginal law schools from continuing their operations. The organizational

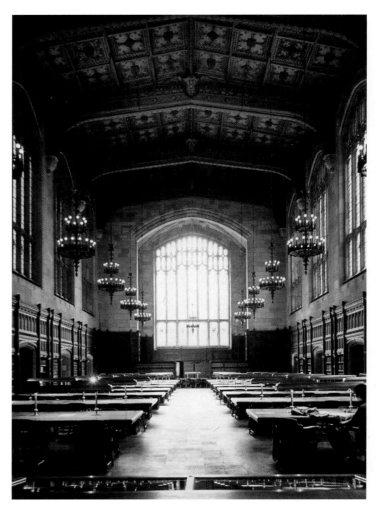

University of Michigan Law School Reading Room. Photograph: Gary Quesada. © Korab/Hedrich-Blessing. Courtesy University of Michigan Law School.

standards now require investment in a substantial library and physical plant, tough admission standards for new students, and a highly qualified faculty offering a breadth of courses. By the end of the century, only a couple of jurisdictions—notably Massachusetts and California—permitted graduates of non-ABA accredited programs to register for the bar examination. Perhaps explaining its low bar passage rates, California actually had more non-ABA accredited law schools than fully accredited programs. These schools, carrying names like the Peoples School of Law, provide legal education opportunities for those who would not be admitted to an accredited law school, while simultaneously providing a profit for their owners. But with 180 fully accredited law schools operating nationally, and an increasingly competitive marketplace for new lawyers, most states have tightened their bar requirements and closed down those law schools unable to meet the minimal standards of the ABA. Legal challenges brought by would-be law schools turned down for ABA accreditation have largely failed, although the ABA's accrediting authority continues to be under fire by those who believe the ABA requirements serve to limit competition.

CONTEMPORARY LEGAL EDUCATION

Today more than 180 accredited law schools operate in America, all growing from the visions of Harvard Law School's founders, later refined by realists at Columbia and Yale, and mandated by progressively tougher standards adopted by the ABA and AALS. It is fair to say that a student at any accredited American law school has an opportunity to gain a first-rate legal education, but these law schools differ widely in the constituencies

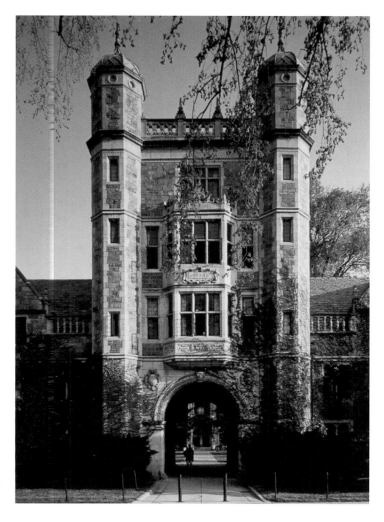

University of Michigan Law School Tower entrance into the Law Quadrangle. Photograph: Gary Quesada. © Korab/Hedrich-Blessing. Courtesy University of Michigan Law School.

they serve and the programs offered. The elite law schools, such as Harvard, Yale, Michigan, and Berkeley, generally are the hardest to gain admission to and serve as the primary conduit for positions in the nation's major law firms, which are willing to pay huge salaries for their graduates. These law schools draw on a highly competitive national pool of applicants, and offer their students access to many of the nation's better known legal scholars, in addition to some of the premier research libraries in the world. However, the local and regional law schools at the other end of the scale may attract some equally strong students who for one reason or another are bound to the community or otherwise feel connected to the institution. These law schools often have powerful connections in their region and typically count numerous successful practitioners in the community among their alumni. Students at these law schools have access to outstanding teachers, and some are also great scholars. The quality of law school libraries is strong at all American law schools, with the average law school library now exceeding 225,000 volumes, so that no law student is likely to suffer from a lack of adequate research materials at any accredited law school. All of these law school libraries are further supplemented by access to major commercial online resources, such as LEXIS and WESTLAW , and by other related online materials via the Internet. Some of America's better known lawyers are graduates of its lesser known law schools.

It should be noted that even among the elite schools, the differences are many. Harvard and Michigan law schools, for example, are relatively large institutions with student bodies of nearly two thousand each. Georgetown, however, lays claim to being the largest law school in America, primarily due to its substantial part-time evening division. And of course, Harvard is private, while Michigan receives some minimal support from the state of Michigan. The state institutions typically offer students from their states a nice break on tuition, but non-resident tuition at the better state institutions often approaches the cost of a private school. Yale, Stanford, and the University of Chicago are a bit more intimate, with each having no more than about six hundred students, but the smallest law school in America is at the University of Wyoming, which has an enrollment of fewer than two hundred students. The larger law schools are able to offer their students a wider breadth of course offerings and extra-curricular activities, while the smaller ones are able to provide students with a better sense of community.

While most accredited American law schools are affiliated with a university, the free-standing law school is still alive and well. These include some of the largest law

schools in America and are typically found in major metropolitan areas, such as New York Law School, John Marshall in Chicago, and Southwestern in Los Angeles. An exception is the relative newcomer, Thomas Cooley Law School, which is located in Lansing, Michigan. Cooley, with its open admissions policy, may be the largest of the group, but most of the free-standing law schools have enrollments well in excess of one thousand students each. While most of these institutions are private, California has a free-standing law school supported by the state: Hastings in San Francisco. The recent trend has been for many of these free-standing institutions to affiliate with a larger university, perhaps for reasons of prestige or financial stability. Thus the establishment of the free-standing Detroit Law School recently affiliated with Michigan State, South Texas (in Houston) with Texas A&M, Dickinson School of Law with Pennsylvania State, and Delaware Law School with the private Widener University in Pennsylvania. Some of these affiliations seem to be tenuous, such as that between McGeorge Law School in Sacramento, California, and the University of the Pacific in Stockton, California, where the two institutions are not even located in the same community. A major advantage held by the remaining free-standing law schools is their administrative freedom from a higher university authority, which often assesses a large fee as administrative overhead. Fortunately, the ABA accreditation process helps protect law schools from being unfairly taxed for administrative overhead by cash-strapped universities.

Harvard Law Review editors, 1899–1900. Courtesy of Art and Visuals, Special Collections, Harvard Law School Library.

Affirmative action efforts of the late twentieth century helped improve the racial complexion in most of America's law schools, as is evident when one looks at the annual Harvard Law Review group photos, but blacks continue to be under-represented in relation to their percentage of the population. The situation is much different for women, whose entry into the law school mainstream began with earnest in the early 1970s and continued until the end of the century until they comprised nearly half the total law student population. Indeed, the entry of women into law schools may be the single most important factor contributing to the increase in America's lawyer population at the end of the century.

The Lucille Stewart Beeson Law Library, Cumberland School of Law, Samford University, Birmingham, Alabama. Photograph: Owen Stayner for Cumberland School of Law.

Today, completion of the standard three-year accredited law school program leading to a Juris Doctor (JD) degree is a prerequisite for taking the bar examination and entering the legal profession in most U.S. jurisdictions. Graduation from any of these programs (and an acceptable character investigation) will entitle the degree holder to take a bar examination in any U.S. jurisdiction. A few states, like California and Massachusetts, also have state-accredited law schools, which allow graduates to take the bar examination in those states. Unlike the undergraduate LL.B. degree awarded to law graduates in an earlier era and still the norm in the United Kingdom, the J.D. is a post-graduate degree, which typically requires successful completion of a college undergraduate program and an acceptable score on the Law School Admissions Test (LSAT) to be admitted. Each year, 40,000 to 50,000 new students enroll in an American law school to pursue the Juris Doctorate, and a similar number graduate and take a bar examination. Additionally, post-J.D. programs at a smaller number of law schools provide advanced legal education opportunities offering students specialized training in areas such as tax and environmental law. These advanced-degree programs enroll another 6,000 students at more than ninety law schools. Many of the students in these post-graduate programs are lawyers from other countries seeking to gain a better understanding of U.S. law. For example, two of the current members of the International Court of Justice hold graduate law degrees from Yale Law School: Judge Rosalyn Higgins of the United Kingdom, and Judge Shigeru Oda of Japan. The current vice president of the People's Republic of China's Supreme Court, Wan Exiang, also is a

Moot courtroom, Columbus School of Law, Catholic University, Washington, D.C. Courtesy SmithGroup, Inc.

graduate of this program. More typically, lawyers continue with graduate legal education to enter the teaching profession, and hundreds of law professors around the globe hold graduate degrees from U.S. law schools.

In most states there is at least one state-supported law school providing relatively low-cost tuition to residents. Some states support four or more law schools, including Ohio (with five) and California (with four, and a fifth one in planning). A few of the multiple state-supported law schools in the South are predominantly black institutions, created as by-products of the separate-but-equal era. These include Texas Southern University's Thurgood Marshall Law School in Houston, Southern University's law school in Baton Rouge, Louisiana, and North Carolina Central's law school. They suffer from a legacy of poor funding and seem anachronistic, but loyal alumni have argued to keep them open and improve funding.

Law schools are not evenly distributed across America, although most major metropolitan areas have at least one or more. Every state (except Alaska) has at least one accredited law school. California holds the record with a total of nineteen. New York is second, with fifteen. Illinois and Ohio each have nine. A number of the nation's law schools have a religious affiliation. These include twenty-five Catholic law schools, ranging from Georgetown and Catholic University law schools in Washington, D.C., to Notre Dame, Boston College, and St. Louis University law schools. This number does not include two more Catholic law schools soon to be applying for accreditation: Ave Maria in Michigan, and St. Thomas in Minnesota. A smaller number of Baptist, Methodist, Lutheran, and Christian fundamentalist–affiliated law

Pepperdine Law School, Malibu, California. Courtesy Pepperdine University School of Law.

schools also operate with ABA approval. The Baptist-affiliated institutions are concentrated in the south and include Mercer in Georgia, and Mississippi College and Baylor in Texas. The Methodist schools are primarily located in the middle of the nation and include SMU in Texas, and Hamline in Minnesota. A relatively recent law school was started by the Christian fundamentalist Oral Roberts University in Oklahoma, and then transferred to Regent University in Virginia. And perhaps the law school with the best ocean view is the Christian fundamentalist Pepperdine University, located in Malibu, California. Finally, there are two accredited Jewish law schools operating in New York: Touro and Yeshiva.

With over 175 accredited American law schools, the United States trains more lawyers per capita than any other country. America literally seems to have an accredited law school for every major constituency, but thanks to the accreditation process they all offer a common core of instructional offerings and extracurricular activities. Most have a first-year program that looks remarkably similar, with core courses in contracts, torts, property, procedure, and Constitutional law. All offer electives in such major areas as tax, business organizations, criminal law, and domestic relations. All require a course in professional ethics. Most base grades on the results of an exam or paper due at the end of the course. All offer some form of clinical education experience, whether with live clients or through simulation. Many offer a combination of both. All provide opportunities to enter moot court and appellate advocacy competitions. All provide opportunities to write on one or more student-edited law journals. All provide access to superb library collections. And all provide opportunities for their students to gain a legal education that exceeds anything available anywhere else in the world.

THE LITCHFIELD LAW SCHOOL:
America's First Venture in Formal Legal Education

America's first law school with a national presence was founded in Litchfield, Connecticut, in 1784 by Tapping Reeve, a former chief justice of Connecticut who had a special knack for teaching. At that time, Litchfield was close to the geographic center of the nation and therefore conveniently located for many of its students. The Litchfield Law School prospered for thirty-six years under Justice Reeve's leadership, and continued another thirteen years, until 1833, under the leadership of Justice Reeve's student, co-teacher, and successor, Judge James Gould. The list of more than one thousand students who attended Litchfield during this period includes many of the major legal figures of that generation, including Aaron Burr (who incidentally was Reeve's brother-in-law), Samuel Chase, George Mason, John Calhoun, and Augustus Hand (great-grandfather of the famous twentieth-century jurist, Learned Hand).

A major attraction of the Litchfield Law School was its promise to train its students for law practice in the relatively short period of fourteen months, including two vacations of four weeks each. Tuition was $100 for the first year

Litchfield Law School, Litchfield, Connecticut, first law school in the United States. Collection of the Litchfield Historical Society, Litchfield, Connecticut.

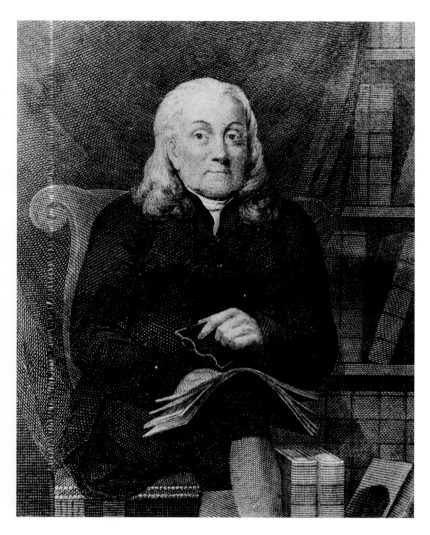

Peter Maverick. Judge Tapping Reeve. *Before 1831. Engraving after a painting by George Catlin. Collection of the Litchfield Historical Society, Litchfield, Connecticut.*

and $60 for the remaining period. That certainly had to sound more attractive and financially appealing than apprenticing for five years! An additional attraction included a nearby girl's boarding school, from where it was said to the young Augustus Hand "the young ladies all marry law students."

The method of instruction consisted of daily lectures by Justice Reeve that were dutifully transcribed by each of the students. The lectures attempted to embrace every principle and rule of law, following a taxonomy devised by Reeve that categorized the legal universe into forty-eight distinct titles. The lectures were given in the morning and lasted for about one and a half hours each. Afterwards, students would use the library to read cited authorities from the lecture and neatly rewrite their notes in a form that later could be used as a permanent reference source in their law practice. Additionally, weekly moot courts were held, requiring two students to argue a case relevant to the week's discussion. To bring the week to a close, exams were held every Saturday morning by a local lawyer who would introduce examples from his practice to illustrate the week's topic in his questions. A major strength of the Litchfield program of study was its teaching of law as a "system of rational connected rational principles" rather than a "code of arbitrary, but authoritative, rules and dogmas." The legal education program at Litchfield served as a model for other early ventures in American legal education, including the Harvard Law School, which drew on the skills of another proprietary legal educator, John Hooker Ashmun, when it began developing its law school in earnest in 1829.

Completion of the program at Litchfield did not entitle the graduate to bar admission in a number of states, however, and often only counted as part of the period of required apprenticeship. It wasn't until the American Bar Association exerted its influence in the late nineteenth century that years spent studying law at a law school were given equal treatment to time spent in an apprenticeship by those states that required apprenticing as a condition for entry to the bar.

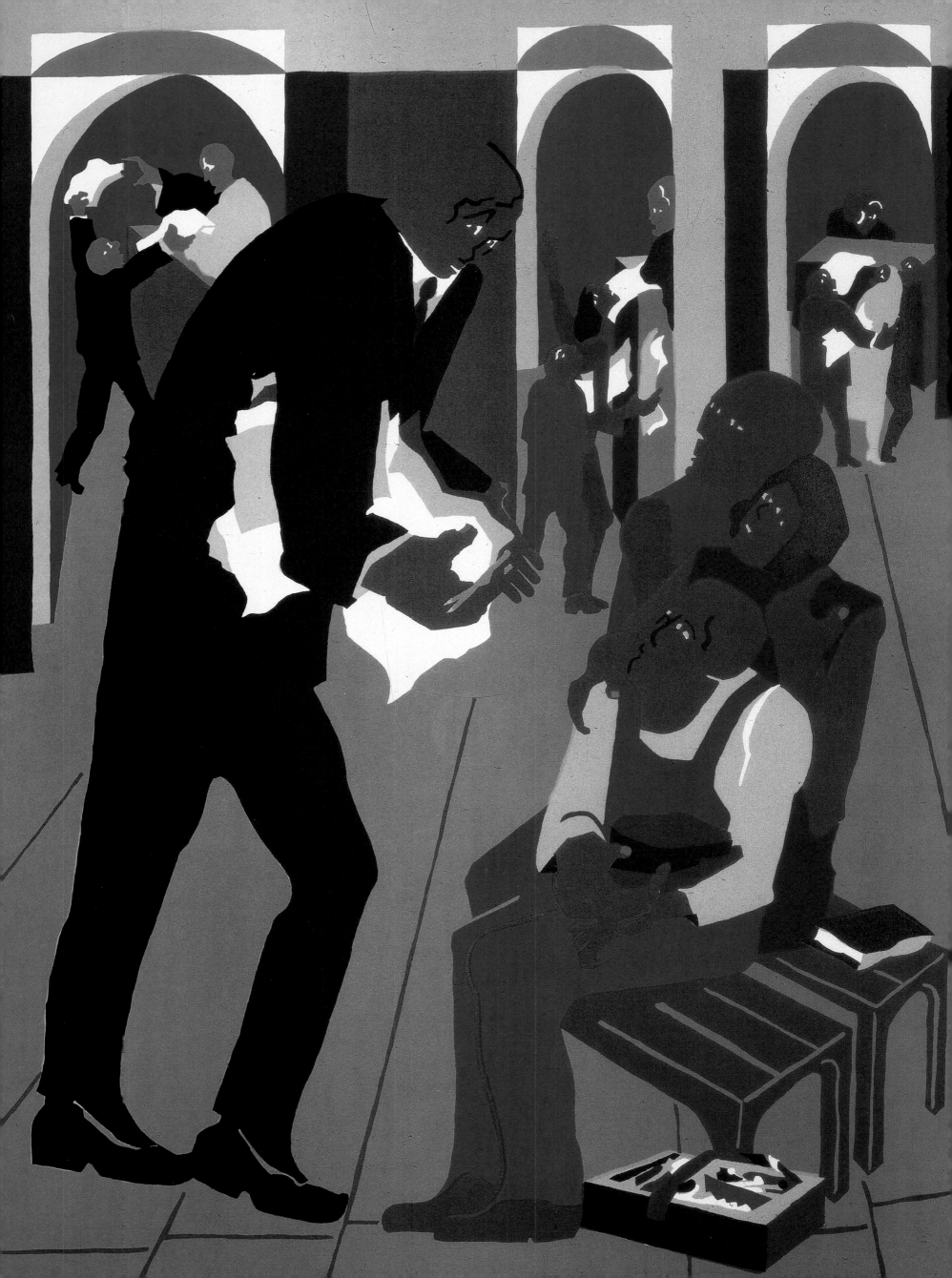

CHAPTER III

THE PRACTICE OF LAW IN AMERICA

Opposite: Jacob Lawrence.
To the Defense. *1989.*
Lithograph. 32 x 24 in.
(81.2 x 61 cm). Courtesy of
the estate of Jacob Lawrence
and the Francine Seders
Gallery, Seattle, Washington.
Photograph: Mike Spafford.

Forms of contemporary legal practice in America range from single lawyer law offices to global firms with a thousand or more attorneys. Included are the famous trial attorney, the corporate lawyer, the local general practitioner, and a score of variations in between. Unlike attorneys in some other countries, American lawyers are not formally divided into groups according to their roles in the legal system. The British tradition, historically America's precursor, draws a distinction between solicitors, who consult with clients and draft legal documents, and barristers, who represent clients in court. In America, an attorney admitted to the bar can perform any element of legal representation. A small-town lawyer may draft a will, record a land transaction, incorporate a business, defend a traffic ticket charge, appear in court, and

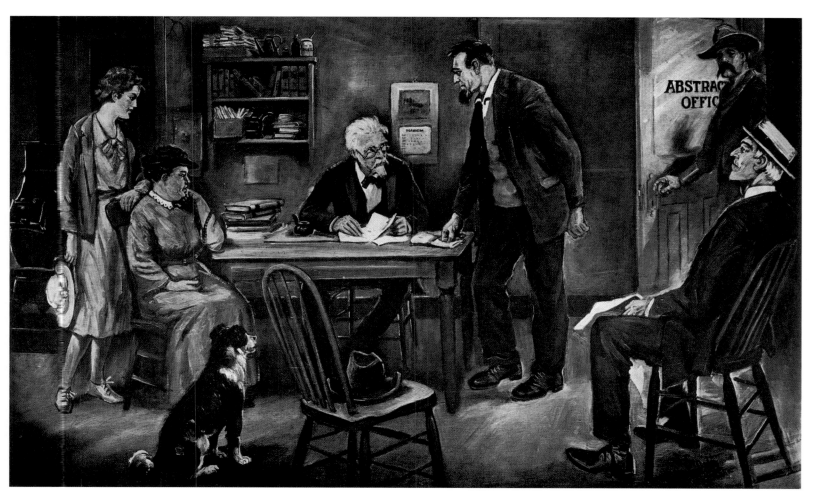

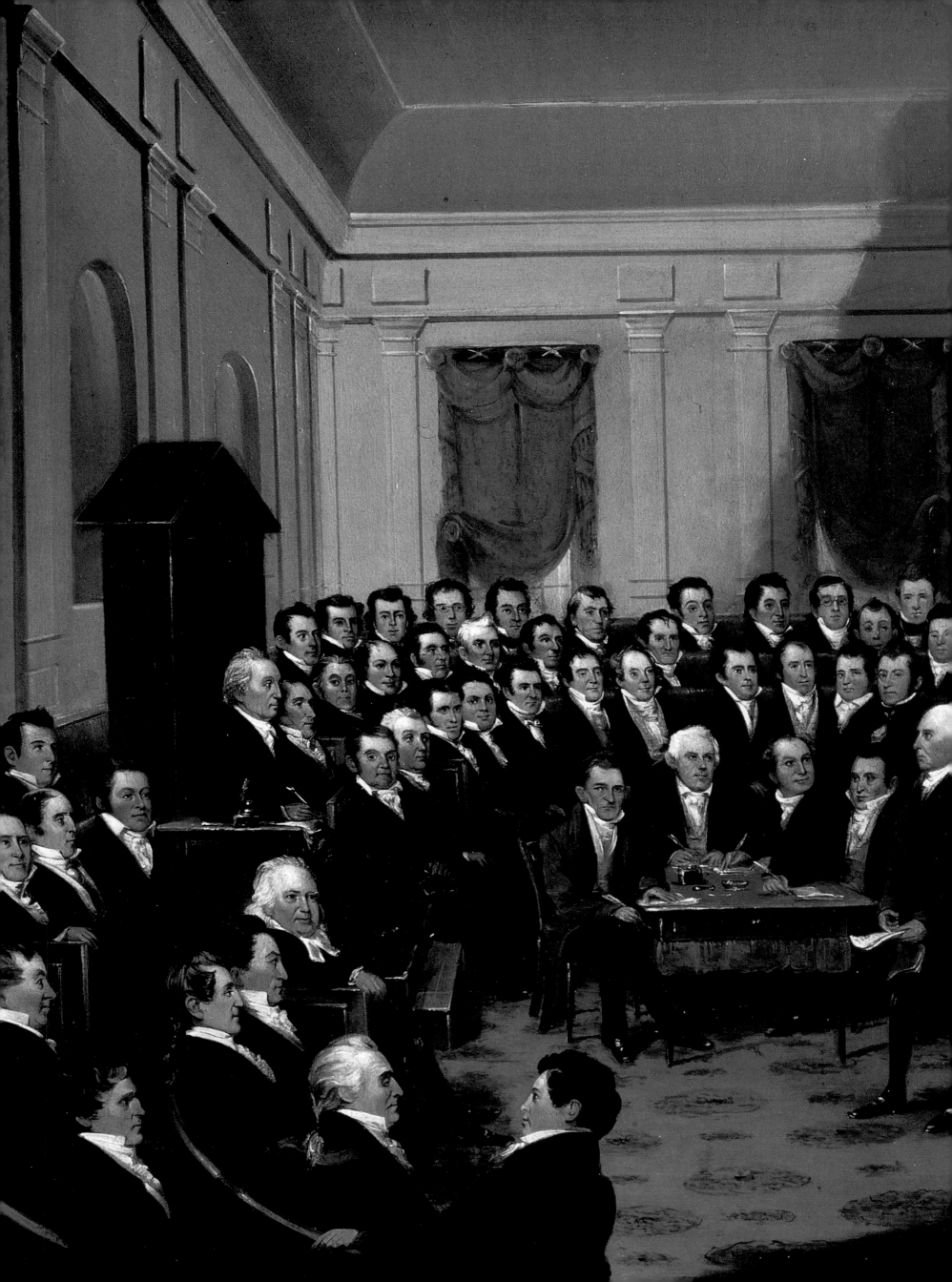

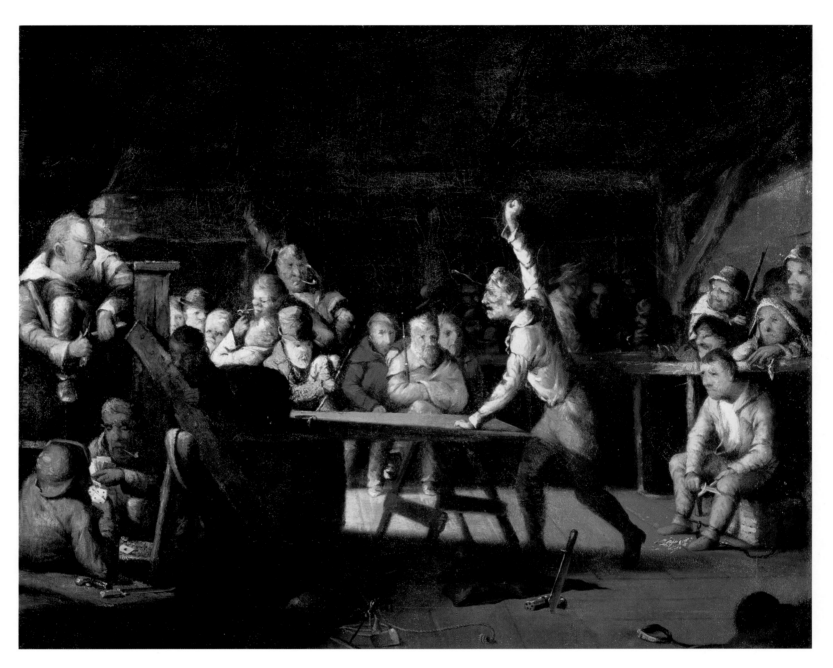

even argue cases on appeal—all the way to the U.S. Supreme Court. While an attorney in a larger urban practice may specialize only in assisting business formations, mergers, or dissolutions, the lawyers in both of these positions are legally permitted to perform all aspects of the practice of law.

During the colonial era, American attorneys commonly specialized in land law, inheritance, and simple business matters. Given the new settlement's emphasis on agriculture, both attorneys and citizens alike were interested in who owned land, and how that land would be conveyed, measured, and taxed. Despite a common focus on land law, the practice of law varied widely from colony to colony. For example, the demand for legal services depended upon whether a colony required a litigant to have the representation of an attorney. Some colonies closely followed the English legal system, where the participants were not allowed to plead their cases directly in court, but required the presence of a lawyer to act as an advocate. In colonies that rejected the English legal system, parties were allowed and even encouraged to act on their own behalf.

Page 75: Clearing the Title. *Print after engraving by J. H. Smith. Courtesy of Art & Visual Materials, Special Collections, Harvard Law School Library.*

Pages 76–77: George Catlin. The Virginia Constitutional Convention of 1829–30. *Oil on canvas. 24 ½ x 33 in. (62.2 x 83.8 cm). The Virginia Historical Society, Richmond, Virginia.*

Some early colonial settlements attempted to administer justice without resort to lawyers or courts of law, based on a widespread suspicion of the professional lawyer. Perhaps as a result of American society's disdain for the legal profession, pay was low, and many attorneys needed to take second jobs to support their families. When he first began to practice law, future chief justice of the United States Supreme Court Oliver Ellsworth took manual labor jobs to supplement his income of three pounds sterling per year. Some colonies even passed laws forbidding attorneys from receiving fees for their services. An early Virginia law, for instance, allowed a client to refuse to pay his attorney a portion of the fee. Perhaps in response to this law, Thomas Jefferson, Patrick Henry, and five other Virginia lawyers announced in a newspaper advertisement that they would only give legal advice for cash payment in advance, and they required a client to pay one-half the fee prior to beginning any litigation.

Lawyers' contributions to society and their status began to change during the Revolutionary period as they increasingly rose to prominence in town meetings or state assemblies. Indeed, out of the fifty-six signers of the Declaration of Independence,

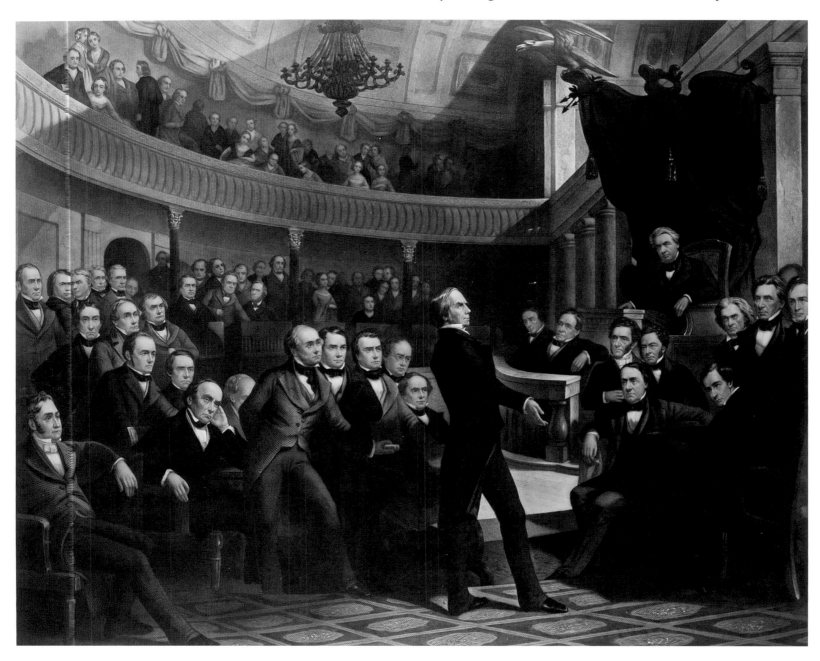

twenty-five were trained lawyers, and thirty-one of the fifty-five delegates to the Constitutional Convention were attorneys. Thomas Jefferson later claimed that the American legal profession was "the nursery of our Congress." During this period, lawyers also began to oversee the professionalization of the practice of the law, principally by controlling access to the profession by setting standards of practice and creating bar associations. By the first decade of the 1800s, most states had developed a cadre of trained lawyers practicing a relatively settled body of law in accordance with agreed-upon rules of practice, at least in the higher courts.

This growth in the professionalization of the legal profession, which had peaked around the years of the American Revolution, began to decline during the early years of the nineteenth century. By the 1830s, Americans wishing to become lawyers found it relatively easy to enter the profession since educational requirements and admission standards had been lowered in many states. An unfortunate consequence of these lower standards was that many lawyers were inexperienced and often corrupt. By the mid-nineteenth century, requirements for admission to the bar were practically nonexistent in a number of states. By 1840, only eleven of thirty jurisdictions retained any

Above: T. H. Matteson. Justice's Court in the Backwoods. *1850. Oil on canvas. 31 ¾ x 44 in. (80.6 x 112 cm). New York State Historical Association, Cooperstown. Photograph: Milo Stewart.*

Pages: 80–81: John Mulvaney. Preliminary Trial of a Horse Thief. *Chromolithograph. 21 ⅛ x 28 ½ in. (53.7 x 72.4 cm). Courtesy of the Bancroft Library, University of California, Berkeley.*

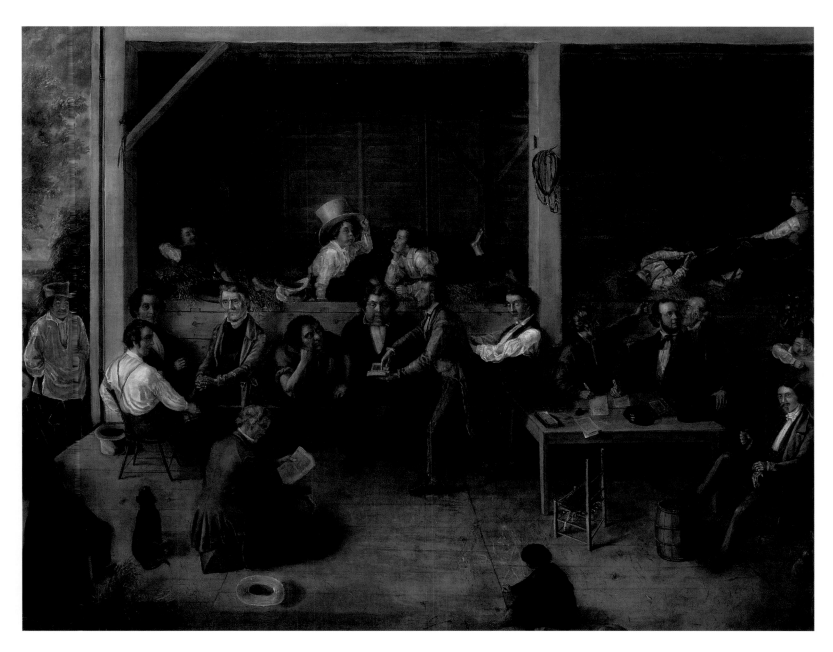

provisions concerning a minimum period of legal study. In addition to a lack of
control over education and admission requirements, the legal profession also lacked
supervisory controls over admitted lawyers. Since bar examinations were largely a
formality, and no regulations governed practicing attorneys, the legal profession
attracted reputable practitioners as well as charlatans.

Legal practice on the American frontier in the nineteenth century also evidenced a
disdain for formal regulations on the profession. Many early Western lawyers and judges
were uneducated men without training in even the fundamentals of law or procedure. As
a consequence of this lack of legal knowledge, there was little conformity in judgment or
procedure between courts or between similar cases. Judges, lawyers, and jurors either
ignored or were ignorant of precedent and the written law, which led to a practice based
more on common sense ideas of fairness rather than codified laws or procedures. For
example, in Indiana a prominent lawyer invoked the "great English common law" to
support his argument. In response, the opposing attorney objected, "If we are to be
guided by English law at all, we want their best law, not their common law. We want as
good a law as Queen Victoria herself makes use of; for, gentlemen, we are sovereigns here.

But we don't want no English law. United States' law is good enough for us; yes, Indi-a-na law is good enough for an Indiana jury."

The legal activities of frontier lawyers mirrored the business occupations of the frontier: farming, mining, land disputes, and fur trading. Given the lax requirements of the time, it is not surprising that legal practice was often informal. Litigation tended to be relatively simple, so specialized learning or skills were not necessarily required. Consequently, competition for business was fierce since many people could claim to have the relevant skills. And since court sessions were infrequent, many lawyers practiced law as a part-time venture.

Those Western lawyers who did practice full-time found themselves pursuing an arduous profession. Since the judges rode circuit, attorneys also rode circuit in order to appear in as many courts as possible. In order to raise their professional profile and attract business, Western attorneys had to cover as much ground as possible. At the time, riding circuit meant that attorneys traveled by horseback, with a change of clothes and a few legal books in their saddlebags. In sparsely settled areas with a few inns, judges and lawyers often slept together around a campfire. When they reached the town, the lawyers and the judge would change into their "court clothes" and

On February 2, 1880, Hiram Revels became the first African-American admitted before the Supreme Court. c. 1880. Print.

convene in the courthouse. The lawyers would find clients among the parties at the courthouse, the sheriff would corral some jurors, and the judge would begin the proceedings.

In some frontier towns, Court Day was more than a chance for residents to conduct legal business—it was also a form of entertainment and social interaction. Towns that did not have courthouses used whatever was available, from saloons to open-air pastures. At times, witnesses' testimonies were drowned out by a noisy audience or non-court activities taking place elsewhere in the room. Some judges were conscious of their role in the entertainment and encouraged fistfights between the attorneys. The circus-like atmosphere, as well as the lack of jails, encouraged summary punishment in the courtroom. Whipping was a common punishment for felonies and would be carried out immediately by the sheriff.

Despite the often chaotic nature of the legal proceedings, in those days the judges and legal

Engraved portrait of American social reformer and lawyer Belva Ann Lockwood, the first woman to practice before the Supreme Court. 1879.

community shared a camaraderie rarely seen today. This legal fraternity developed for several reasons. The lawyers and the judge traveled together, ate together, entertained each other, and lodged together on the circuit. In more urban environments, lawyers had offices at or near courthouses and would spend their days in each other's company. In a typical town, the lawyers would study together, and then practice together. The competition between lawyers was often friendly since there was enough routine legal work. This closed fellowship could lead to favoritism, but it also functioned to create an informal administration of justice that kept costs low and ensured speedy trials.

As Americans continued to move west and settle the frontier, the national economy industrialized at a rapid rate. Older areas of law grew as new types of contracts, torts, and crimes developed. Early in the nineteenth century, the domain of American contract law expanded considerably to govern most economic transactions, so that even leases and business associations were treated as basically contractual arrangements. With industrialization, tort law exploded in the late nineteenth century, both in England and America, and huge new treatises appeared on this topic. Concepts such as liability for extrahazardous activities and contributory negligence were adopted from England, but were more fully developed in America. At the same time, criminal law changed considerably, with the adoption of state and federal penal codes, which replaced the concept of common law crimes. Efforts were made to simplify rules of practice and procedure in America, and in 1848, New York became the first state to adopt a code of

civil procedure, which became an important step in organizing American law. In the early 1870s, the entire legislative product of the federal Congress was first organized into the multi-volume code known as the Revised Statutes of the United States. This was replaced in 1925 by the United States Code, which remains in effect today.

The changes in business practices after the Civil War led to the growth of corporations, and concomitantly the growth of law firms specializing in representing corporations. The late 1800s saw the rise of Wall Street firms that practiced a different law from the "storefront" lawyers. Major New York law firms were founded, beginning a trend away from small firms and sole proprietorships to large firms with salaried employees and multiple partners. Specialization in different practice areas and courts grew as these Wall Street firms expanded. Rather than initiating or responding to litigation, some firms specialized in advising clients on mergers, bond issues, shareholder relations, and labor matters, as well as how to avoid lawsuits.

The late 1800s also saw the development of another form of practice: the in-house counsel. For example, the Prudential Insurance Company developed an exclusivity

Men wearing hats and suits stand in between members of the Ku Klux Klan at an initiation ceremony, 1920s. Their power in Southern politics dissipated following the active role of lawyers in the civil rights movement of the 1960s.

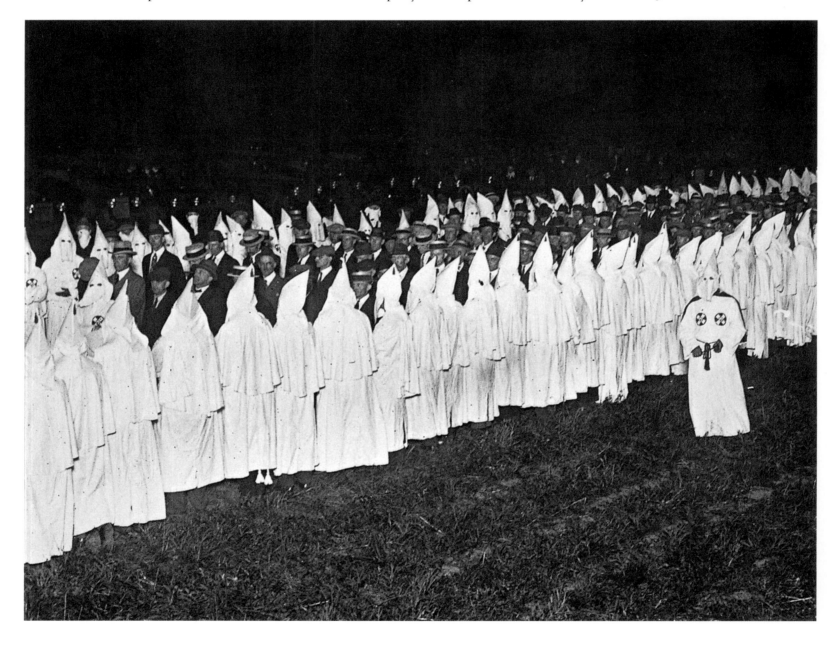

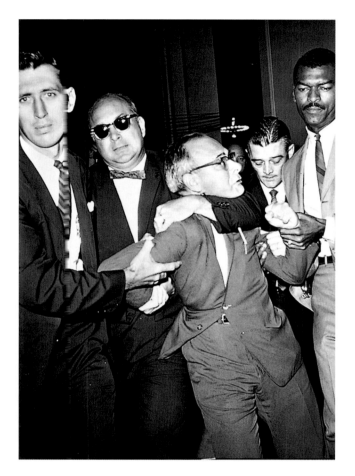

Lawyers often risk physical harm in their advocacy of unpopular causes. American Civil Liberties lawyer, Arthur Kinoy, is pulled from the House of Un-American Activities Committee hearing room in Washington, D.C., August 17, 1966.

arrangement that resulted in attorneys whose sole client was the corporation. Eventually, in-house counsel came to mean attorneys employed by a corporation or organization to handle legal matters for the corporation. Corporate attorneys grew increasingly important and powerful, to the point where judges would resign to become in-house counsel for corporations, particularly the railroads.

Another area of practice that developed during the late nineteenth century was designed to address civil legal issues of the indigent. The Legal Aid Society of New York began in 1876, and by 1913, similar organizations funded by private contributions and volunteer lawyers existed across the nation. Additionally, specialized legal groups such as the American Civil Liberties Union and a variety of Legal and Education Defense funds were founded to advocate for specific causes or political groups.

Growth in the law was reflected in a corresponding growth in the number of lawyers. Prior to the Civil War there were fewer than 25,000 practicing lawyers. That number quadrupled to over 100,000 by 1890. Legislatures and the legal profession responded to the increased numbers of lawyers by attempting to control access to the profession by instituting new requirements for legal education and entrance to the bar. This new professionalization was accomplished through the organization of national and state bar associations. For example, the American Bar Association (ABA) was founded in 1878 as a national voluntary professional organization of lawyers, and almost immediately began lobbying for higher standards for admission to the practice. The local Association of the Bar of the City of New York was organized even earlier, in 1870. Similar state and local bar organizations were formed during the same period all across America, and worked toward tightening standards of practice. However, these were voluntary professional associations, and it was not until 1921 that the first legislation was passed requiring practicing lawyers to be members of New York's state bar. By 1923, every state and territory had a bar organization. In fact, the growth was so rapid that by 1930, there were over a thousand city and county groups. These bar associations also sponsored increased legal services by providing lawyer referral services and encouraging private voluntary representation, or pro bono work.

The American Bar Association was based upon the model of the Association of the Bar of the City of New York. It was not a federation of state bars, but an entirely separate organization. Like most bar associations at that time, the ABA consisted of a selective group of individuals, comprising about 18 percent of practicing lawyers. In 1936, the National Lawyers Guild was organized to provide a national bar organization of progressive, liberal, and radical attorneys. During its early years the Lawyers Guild was instrumental in representing citizens accused of Communism or arrested during mass

protests. Guild attorneys returned to national prominence a second time during the Vietnam protest era of the late 1960s.

An unfortunate consequence of the increased formalization of legal education was that women and minorities were largely excluded from the practice of law. Modern lawyers might be surprised at the number of female attorneys who practiced during the unregulated colonial period. In every colony but Maryland, a wife could act as her husband's lawyer. Women not only acted under a husband's power of attorney, they sometimes acted as legal representatives or attorneys for non-related parties. After the Revolution, women's presence in law practice languished until the late 1800s. While universities such as the University of Michigan admitted women to study law as early as 1870, they were rarely able to practice law after graduation. As more law schools began to admit women in the 1970s, the number of practicing women grew. In 1960, less than 3 percent of practicing attorneys were women; in 1995, approximately 25 percent of practicing attorneys and 42 percent of law school students were women. Women now comprise 15 percent of partners in the nation's law firms.

People of color faced similar barriers to the legal profession. Prior to the Civil War, people of color were only occasionally able to become lawyers. For example, John Mercer Langston, the son of a slave, became an attorney in Ohio in 1854 and eventually became the first dean of Howard Law School. Immediately after the Civil War there was a small increase in the number of African-American attorneys, thanks largely to law schools such as Howard, but these gains soon dwindled, and by 1965, less than 2 percent of law students and practicing attorneys were African-American. Even those few African-Americans who were able to gain a legal education and admission to the bar had a difficult time acquiring clients and building a practice. Law firms tended to be even more discriminatory than law schools when it came to hiring non-white attorneys, so people of color often practiced in small firms or specialized areas. This racial discrimination existed in many legal organizations. For example, the ABA, after mistakenly admitting three African-Americans to membership, changed their admission forms to require applicants to state their race, in the hopes of preventing any further "mistakes." The ABA has since become open to all American lawyers, and has even developed sections devoted to different minority groups.

The American legal profession continued to grow and diversify in the last half of the twentieth century. As of 1996, there were 900,000 attorneys admitted to the bar of one or more U.S. jurisdictions, although not all were practicing law. Most of these attorneys were, and as the twenty-first century opens still are concentrated in metropolitan areas, with over 25 percent of all attorneys practicing either in New York or California. Less than 0.1 percent of the bar are in "public interest" firms, while more than 75 percent of all practicing attorneys are in private practice. In fact, the majority of attorneys today practice in firms, with over 25 percent of these attorneys working in large firms of over a hundred attorneys, or with offices in more than one state. More than sixty firms in the

Legal clinic of Jacoby and Meyers, Los Angeles. 1974.

United States have more than four hundred attorneys each, with the largest firm having over two thousand attorneys. Even as mammoth law firms continue to expand, the number of small "boutique" firms (firms specializing in a narrow practice areas) also continue to grow. However, less than half of the attorneys in private practice are in sole proprietorships.

The remaining American lawyers are in a mix of private businesses, government services, the judiciary, or education. The practice of law extends beyond acting as an advocate on behalf of a client. Lawyers have always worked for federal, state, and local governments, representing the governments' interests through litigation, as elected representatives, and as advisors to legislative bodies. Currently, nearly eight thousand attorneys work for the United States Department of Justice alone. In addition to serving as prosecutors, some government attorneys may work in the government-funded public defender system, developed largely as a result of the Warren Court's extension of the Federal Constitution's Bill of Rights to the states. An additional form of government practice resembling private practice developed in 1974, when the Legal Services Corporation was chartered by Congress. The Legal Services Corporation attempted to fulfill the legal needs of the indigent by providing access to government-funded legal offices, supplementing or replacing the privately funded legal aid societies. Funding for Legal Services was cut during the Reagan era, but the program continued.

Traditionally, legal practice was local in nature, and today, even America's most famous lawyers can only practice in a state or court where they have been admitted. While the practice of law in America remains local, the issues or clients are becoming increasingly global. The United States has been engaged in international trade since its inception. While colonial lawyers like Alexander Hamilton dealt mostly in admiralty law, modern lawyers must deal with international law within a new context and in new courts. More and more twenty-first-century clients will be global organizations, and twenty-first-century American lawyers must, in turn, engage in global competition and develop global legal practices. The rapid development of new technologies, from computer codes to genetic engineering, is expanding the importance and changing the shape of laws governing intellectual property. Digitization of information and expansion of the internet is forcing a rethinking of copyright law and licensing agreements. The ready availability of public records online brings into sharp focus the conflict between concepts of free access to information and the right to privacy. And the ability to use new technologies such as DNA analysis to track criminals is changing our concept of reasonable doubt and sometimes freeing wrongfully convicted citizens.

The practice of law is now a $130 billion per year industry. A legal practice is run more as a business, with attendant business strategies regarding market development, advertising, and outsourcing. Electronic technology has affected every aspect of the practice of law—from communicating with clients, to research, from drafting documents, to presenting evidence, and from filing motions, to billing the client. How legal services are marketed and delivered has begun to require cutting-edge technology. For a traditional profession, this rapid pace of change can have a dizzying effect on attorneys' compensation, competence, client bases, billing methods, and law office management. While today's professional law journals discuss the same quality-of-life issues addressed during colonial times—the long hours required, clients that expect high-quality legal work but are unwilling to pay for it, and of course the nasty jokes about the profession—modern front-page articles talk about increased attorney compensation as well as tell horror stories about demands for increased billable hours.

Despite the accelerating rate of change in the elements of practicing law, some essential aspects remain the same. The lawyer must still identify the client's legal issues, advocate on the client's behalf, and draft legal documents. The practice of law serves a dual purpose: its fundamental principles support a methodology to govern new forms of commerce or family relationships, and its adaptability serves to regulate those new forms as they develop. As methods of financing business change, so does the practice of law that enables and often regulates the change. As new areas of business develop, so do new areas of law. In resolving controversies within a community, whether on a personal or a global scale, those who practice law shape human conduct and therefore the development of American jurisprudence.

Opposite: Horace Bundy. Vermont Lawyer. 1841. Oil on canvas. 44 x 35 ½ in. (111.8 x 90.2 cm). National Gallery of Art, Washington, D.C. Gift of Edgar William and Bernice Chrysler Garbisch.

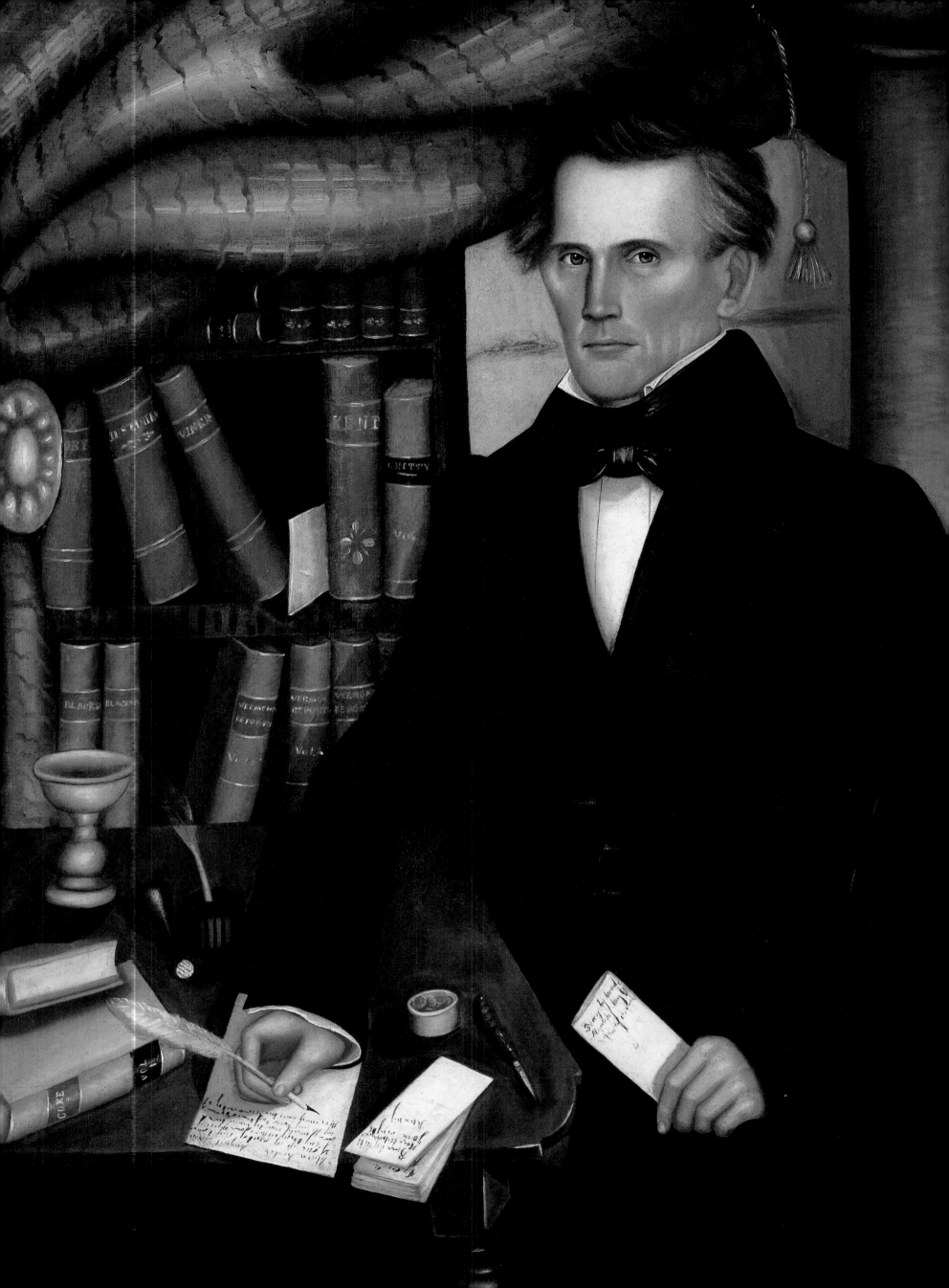

THE ASSOCIATION OF THE BAR OF NEW YORK CITY

The Association of the Bar of New York City is the oldest and arguably the most interesting professional association of lawyers in America. It was founded in 1870, six years before the formation of the New York State Bar Association and eight years before the founding of the American Bar Association, starting a trend in the formation of state and local bar associations throughout the nation. By 1916, over six hundred bar associations were in operation at all levels of state and local practice in America. The Association of the Bar of New York City served as a model, but paradoxically it was both more elite and exclusive, while also far more progressive and socially engaged than other bar associations. Today, it is a more open association, but continues a tradition of progressive legal reform.

The impetus for creating a professional association of lawyers in New York City came from a series of well-publicized scandals involving members of the bench and bar. More highly regarded members of the bar, such as Dudley Field and Samuel Tilden, gained public praise for fighting corruption. These leaders in the legal profession recognized a need for self-regulation in order to preserve New York City as the nation's commercial and monetary capital. Tilden expressed his sentiments in a well-received speech noting that for New York City to retain its position: "It must establish an elevated character for its Bar, and a reputation throughout the whole country for its purity in the administration of justice." Others spoke on the need for a library and other related matters that could improve the practice of law. Within two weeks, a constitution and by-laws were drafted and a slate of officers proposed.

The Association of the Bar of New York City began and continued as a highly exclusive organization well into the late twentieth century. In 1950, it included only about one-fifth of the practicing bar and continued to maintain a rigorous admissions process (a prospective member had to be recommended by a current member and then be interviewed by the admissions committee), perpetuating its mostly WASP membership and culture, while sister organizations, like the American Bar Association, were open to all lawyers in good standing. As late as 1973, the New York City association was referred to as the "organization of Brahmins of the bar." Up until that time, nearly every one of its presidents was a partner in a major New York City law firm, two had been U.S. presidential candidates, and one a former justice of the U.S. Supreme Court.

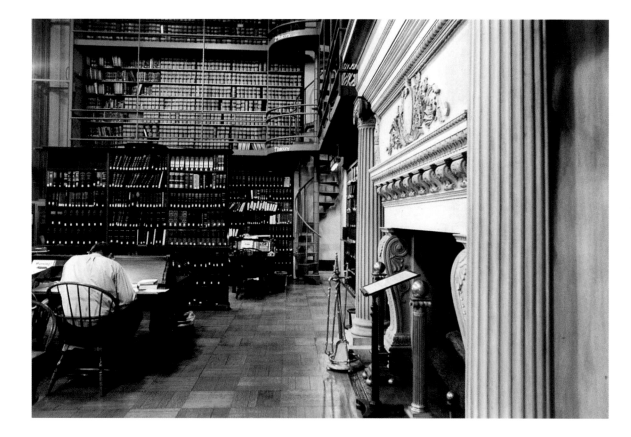

Library of the Association of the Bar of New York City.

Although the association was restrictively elitist, it remained actively engaged in reform throughout its long, illustrious history. One of its first acts was to launch a campaign to defeat corrupt judges and to establish standards of conduct for lawyers. In the early twentieth century, the association stood up against intolerance by fighting against expulsion of Socialist members from the New York State Assembly, in 1919. Similarly, it opposed McCarthyism in the early 1950s, and in 1970, over 1,200 members of the association descended on Washington, D.C., to brief members of Congress and the Nixon administration on the illegal status of the Vietnam War.

By the late 1970s, perhaps reacting to changes in the larger legal culture, the association's restrictive admissions policies were relaxed and membership doubled within a decade. Broader representation also is now apparent in the association's leadership, which currently includes a number of women and minorities.

The newer association also reflects changes in social consciousness. It is now more engaged with the work of related organizations in an effort to be involved in the "helping and healing side of the law," addressing problems of the homeless, immigrants, welfare recipients, and similar oppressed groups. Similarly, new programs recognize the needs of its less fortunate members, with programs for unemployed lawyers and attorney substance abusers. In these respects, the Association of the Bar of New York City continues to serve as a progressive model for other bar groups throughout America.

CHAPTER IV

FAMOUS TRIALS

Opposite Thomas Hovenden.
The Last Moments of
John Brown. *Oil on canvas.*
77 ⅜ x 53 ¼ in. (196.5 x
160.6 cm). The Metropolitan
Museum of Art, Gift of Mr.
and Mrs. Carl Stoeckel, 1897
(97.5). Photograph © 1982
The Metropolitan Museum
of Art.

 Courtroom drama has captured the imagination of the American public—
from the witchcraft trials of the late seventeenth century to the twentieth-
century struggles over presidential impeachment. Each of these trials
dominated contemporary public attention, each stirred controversy and debate, and each
featured a dramatic episode with the courtroom at center stage. In one sense, these
famous trials have little in common. They took place in a variety of venues, from the
religious, to state and federal courts, or within the political arena. But despite their
differences, all these trials reveal something about our values as a society, what we wish
to punish, how our judicial system functions, and what is considered a "fair" trial.
Following are cases whose notoriety has been lasting, not momentary as with Media
Sensations (see Chapter 7), but also not constitutionally important, as with Landmark
Cases (see Chapter 6.) The cases presented here, rather, focus on, and are grouped
according to vital issues that occupy American legal thought: race and prejudice,
politics, labor, and radicalism.

RACE & PREJUDICE

Page 98–99: T. H. Matteson.
Trial of George Jacobs,
August 5, 1692. 1855.
Oil on canvas. 39 x 53 in.
(99 x 134.6 cm). Courtesy
Peabody Essex Museum.
A patriarch of Salem,
Massachusetts, during the
witch craze, George Jacobs
ridiculed the trials;
consequently, he too was
accused, tried, and executed.

THE SALEM WITCH TRIALS

In 1692, in the small town of Salem, Massachusetts, a conflict evolved into one of the
most notorious witch-hunts in history, and ended with the hanging of nineteen people.
The trouble in Salem began when young girls claimed that witches had tortured them
and cast spells upon them. The girls captured the town's attention by twitching, yelping,
and shouting, and then provided names of those responsible, eventually accusing dozens
of local women.

The hearings of three of the accused witches were set to begin in March 1692. The
prosecuting counsel based his case on the Biblical statement, "Thou shalt not permit a
witch to live." The prosecutors learned from contemporary scholars that witches' bodies

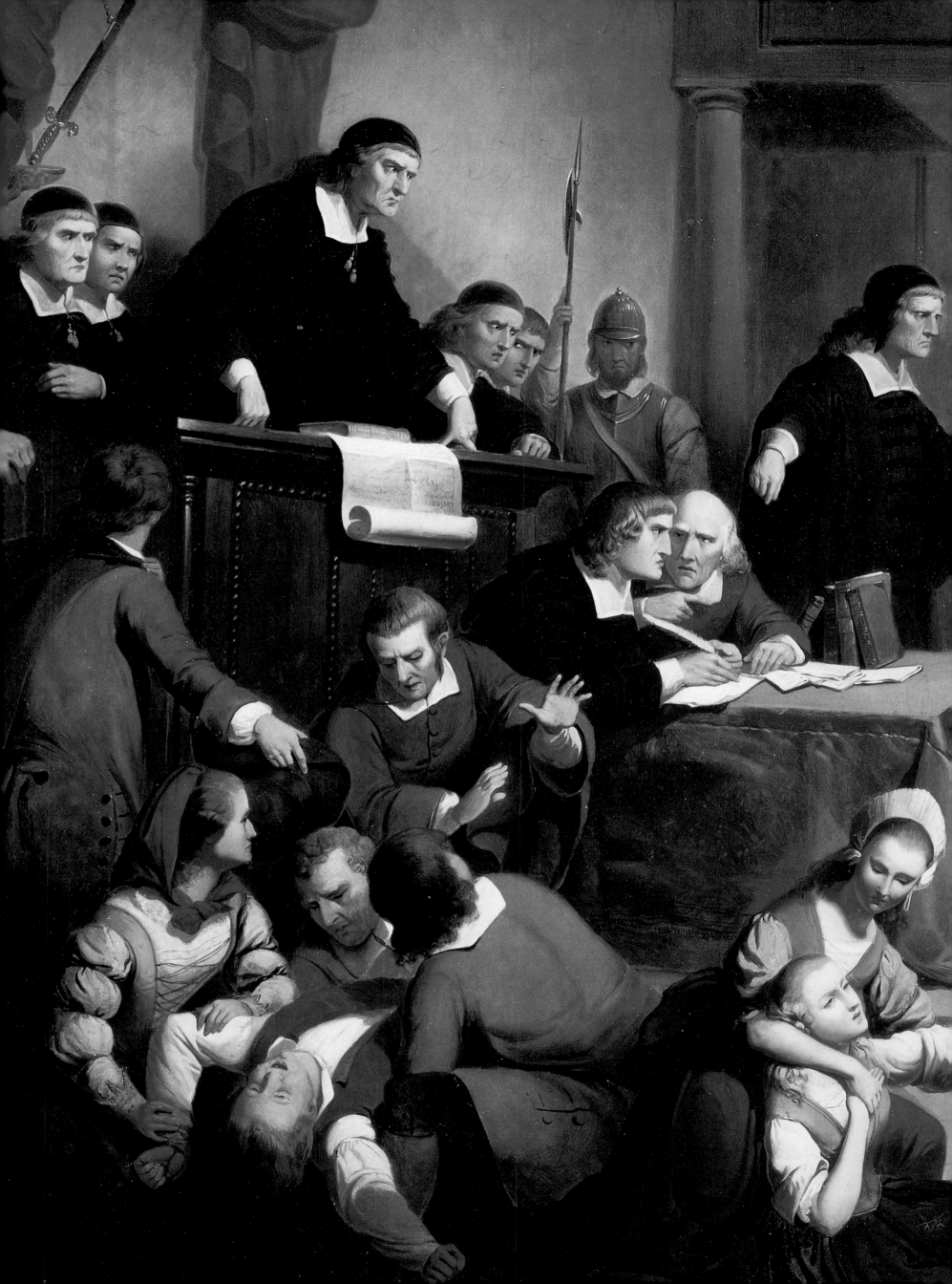

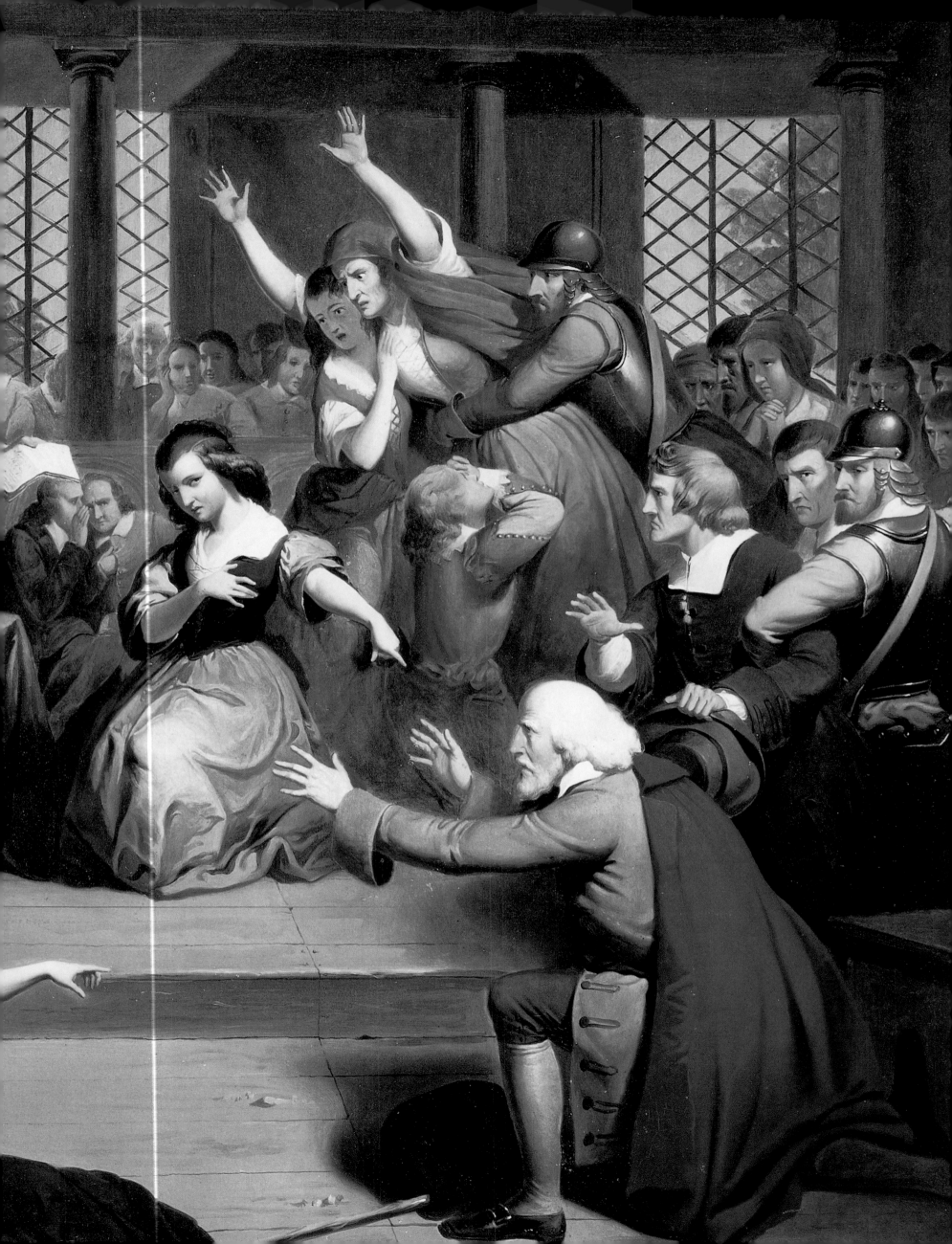

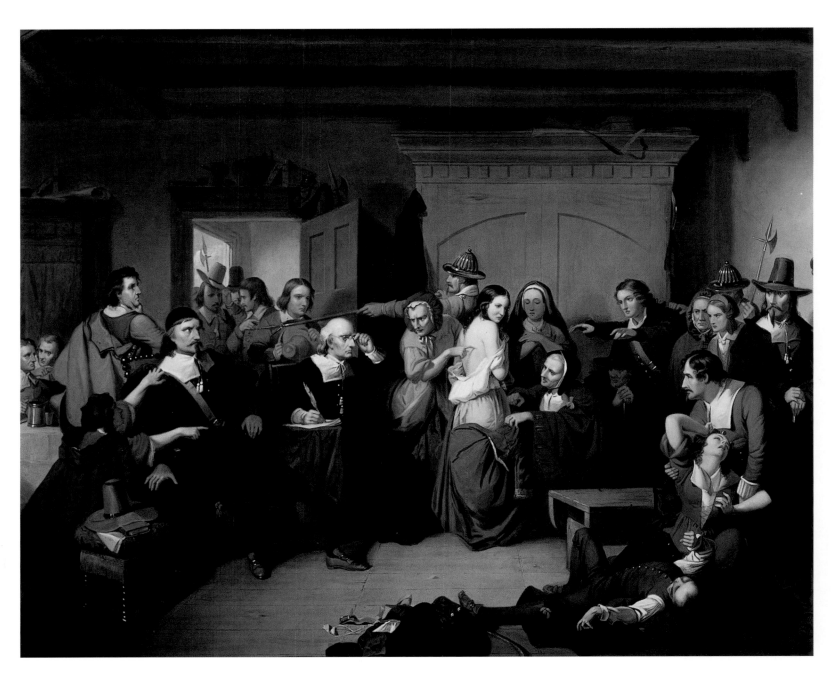

bore a "devil's mark," which could be any suspicious mark or lump. Also, if a person's "shape" was seen harming another person, it indicated guilt, the townspeople believing that the devil could not acquire an innocent person's "shape." After the hearings in Salem, all three women were sent to Boston for trial, where they were convicted without a defense. The trials then spurred a rash of accusations during the summer of 1692, and resulted in hundreds of people being imprisoned.

Scholars have proposed several theories to explain the witch-hunts of Salem. Some historians suggest that the adolescent accusers fabricated their stories because they relished being the center of attention and enjoyed the life-or-death power they gained from making such claims. During a time when young women lived under male authority from both fathers and ministers, the chance to speak in public and cause such a sensation was captivating indeed. Historians have also analyzed the patterns of accusation and concluded that the women who were branded "witches" were generally middle-aged, and were vulnerable targets because of peculiarities like pipe-smoking or muttering to themselves. Others have interpreted the episode as a local class dispute.

T. H. Matteson.
Examination of a Witch.
1853. Oil on canvas. 39 x
53 in. (99.1 x 134.6 cm).
Courtesy Peabody Essex
Museum. Photograph:
Mark Sexton.

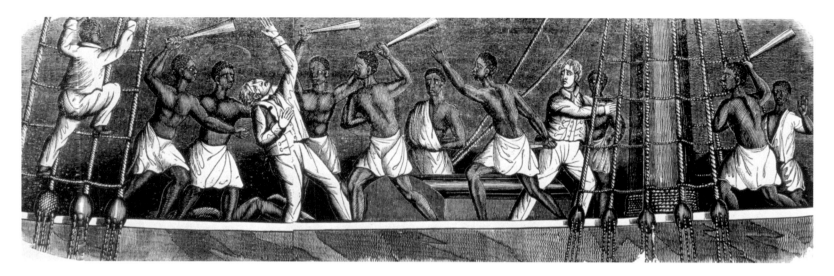

The *Amistad* Mutiny, showing the Death of Captain Ferrer, Captain of the *Amistad*. July, 1839.

THE *AMISTAD*

In late August 1839, the schooner *Amistad* dropped anchor off the coast of Connecticut. A group of hungry, thirsty men in tattered clothing went ashore to seek food, water, and information. Although they did not speak English, they did communicate through pantomime to inform the spectators they were from Africa and needed some help to sail home. However, communication broke off the next morning when a U.S. Navy brig, commanded by Lieutenant Thomas Gedney, sailed into view. Gedney suspected the *Amistad* was engaged in piracy or smuggling, so he boarded the ship and discovered a group of armed black men and three Cuban prisoners. A Cuban named Ruiz told a story of mutiny and mayhem that riveted the nation's attention.

Ruiz related that the *Amistad* had departed Havana on June 28, but its cargo of slaves, produce, and textiles never reached its destination on Cuba's north coast due to a violent slave rebellion. He told how fifty-three black men on board managed to free themselves from their chains, and using knives found in the hold, killed the captain and took command of the ship. In his story, Ruiz neglected to mention that the slaves were

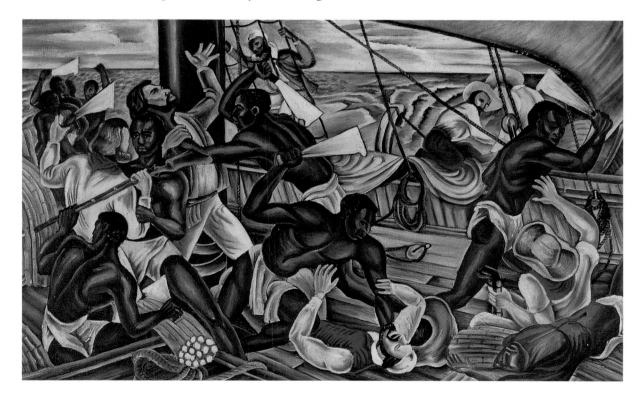

Hale Woodruff Mutiny on the Amistad. *c. 1940. Oil on canvas. The New Haven Colony Historical Society. Gift of the Estate of George W. Crawford, 1973. NHCHS #1973.20a. Photograph: William K. Sacco.*

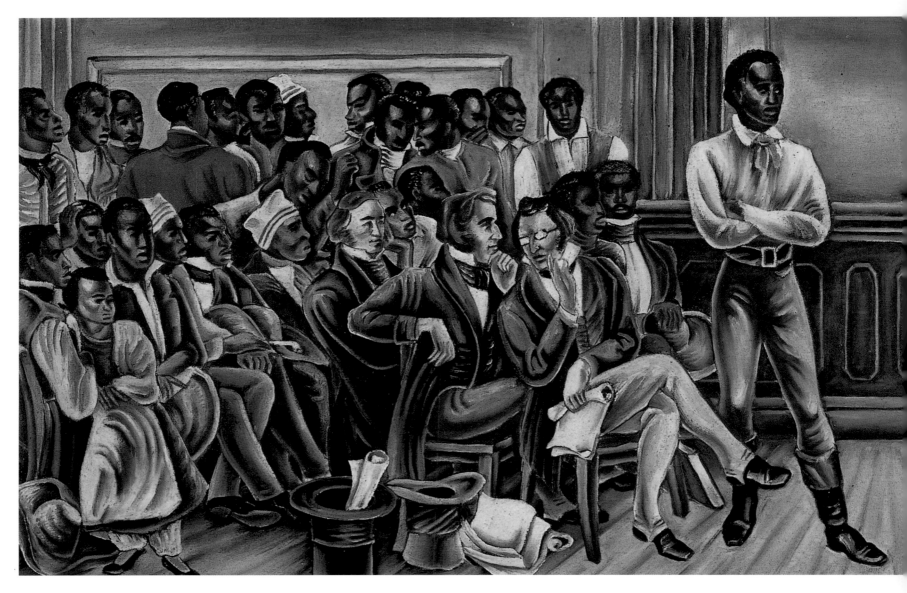

recently brought from Africa, because although slavery was legal at the time, importing slaves had been banned by America in 1808, and by Spain and Britain in 1817.

The slaves who seized command of the *Amistad*, led by a young man called Cinque, forced the Cubans to sail toward Africa. The Cubans, fearing for their lives, tricked the Africans and attempted to sail toward the southern United States, where they believed the Africans would be recaptured. However, due to weather and problems with navigation, the *Amistad* landed near Connecticut, bringing with it a host of legal and ethical questions concerning the status of the rebellious slaves.

The Africans were arrested on charges of murder and piracy, and were held in the county jail in New Haven, Connecticut. As public interest grew and thousands of people filed through the jail each day to stare at the Africans, interested parties began to debate their fate. Abolitionists, or those who favored the end of slavery, seized upon the *Amistad* incident as a way to garner public sympathy for their cause. The Spanish government also entered the debate, arguing that since the Africans were Spanish property, the ship and the Africans should be returned to Cuba to undergo trial there. The Cubans who survived the rebellion filed claims asserting the Africans were their property. Similarly, Lieutenant Gedney maintained that he was due one-third of the value of the *Amistad* as salvage.

Hale Woodruff. Trial of the Captive Slaves. c. 1940. Oil on canvas. The New Haven Colony Historical Society. Gift of the Estate of George W. Crawford, 1973. NHCHS #1973.20b Photograph: William K. Sacco.

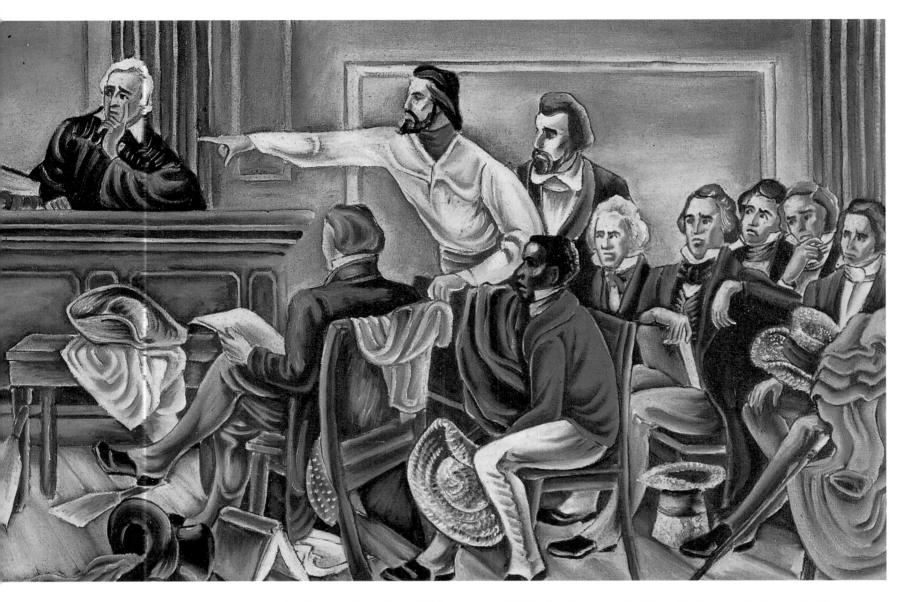

In September, the trial began in a U.S. circuit court in Hartford, presided over by Judge Smith Thompson, also an associate justice of the United States Supreme Court. Thompson quickly disposed of the issue, ruling that the United States did not have jurisdiction over the murder and piracy charges because the offenses occurred in a Spanish ship sailing in Spanish waters. After that ruling, following the accepted procedure of the time, the property issues would be decided in a district court, under Judge Andrew Judson.

The key to resolving the question of whether the *Amistad* Africans were anyone's property was to examine whether they were recently imported from Africa, which would mean they were illegally traded. In order to argue for that position, the abolitionists finally found a translator who could help the Africans communicate. The story the Africans told was a horrific tale of the transatlantic slave trade. Although President Van Buren pressured the judge to rule in Spain's favor, Judson ruled that the *Amistad* Africans were "born free and ever since have been and still of right are free and not slaves." The United States attorney filed an immediate appeal, and the case of the *Amistad* was destined for the United States Supreme Court.

The Supreme Court began to hear the case in February 1841, with former president John Quincy Adams vigorously defending the Africans. He criticized the Van Buren

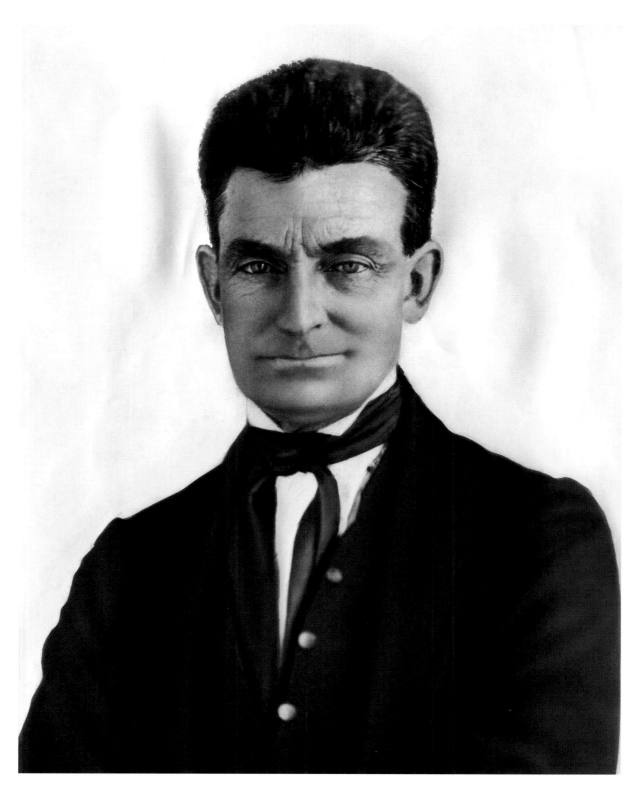

administration for acting as Spain's agent, and argued that to return the Africans to Cuba would serve to satisfy the vengeance of blood-thirsty slave traders. When the Court returned its verdict, with one dissent, they ruled that the Africans had been kidnapped, illegally transported, and had mutinied in self-defense. They were free men, and all chose to return to Africa.

Although this decision freed the *Amistad* Africans, it did not set any precedent that would be relevant to the millions of American slaves. In fact, the Dred Scott ruling would follow sixteen years later and establish that American slaves were indeed property. The *Amistad* ruling did, however, attract national attention to the pain and misery of slavery, while lending respectability to the cause of abolitionism.

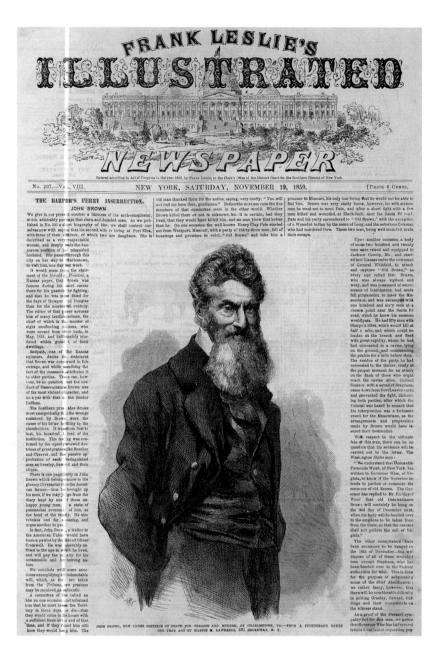

Inside the image (newspaper masthead and article):

FRANK LESLIE'S ILLUSTRATED NEWSPAPER

No. 207.—Vol. VIII. NEW YORK, SATURDAY, NOVEMBER 19, 1859. [PRICE 6 CENTS.

THE HARPER'S FERRY INSURRECTION.
JOHN BROWN

Portrait of John Brown, America's abolitionist (1800–1859). Engraving from Frank Leslie's Illustrated Newspaper, *October 16, 1859.*

JOHN BROWN'S RAID

Events like those surrounding the *Amistad* mutiny caused Americans to question the continuing existence of slavery. John Brown, a strict abolitionist, felt passionately and violently that he must personally fight to end slavery. He settled in Kansas in 1855 to help win the territory's admission to the Union as a free state, and believed that slavery would end only through the use of violence. In the late 1850s, Brown hatched a radical plan to abolish slavery by gathering arms and invading the southern United States, freeing slaves along the way. Brown hoped to create a stronghold in the Blue Ridge Mountains that would function as a sanctuary for freed slaves. The first step in Brown's plan was to launch his army by seizing arms from the federal arsenal in Harper's Ferry, Virginia.

Brown began his raid in the middle of the night of October 16, 1859, but by dawn, people from the surrounding area had joined the battle. After a day and night of intense fighting, Brown peered from the engine house where he had barricaded himself and his men to see a detachment of U.S. Marines under Colonel Robert E. Lee. The Marines stormed Brown's fortress and overwhelmed the men inside, seriously wounding Brown in the process. John Brown's raid lasted only thirty-six hours, but it claimed seventeen lives.

Brown and his men were tried within a week of capture on charges of conspiracy to cause insurrection, murder, and treason against the Commonwealth of Virginia. Eighty armed men were needed to guard the prisoners as they were escorted to trial. Brown protested the trial in the first place, arguing that not only did his wounds make a trial impossible for him, he also believed that the entire proceedings were a sham, evidenced by the fact that his appointed defense counsel were two proslavery lawyers from Virginia. But the trial went forward. A jury of twelve slave owners was selected, with no objections from Brown's lawyers.

The plea was not guilty to all charges, and Brown's lawyers argued that Brown should be tried in a federal court, since the planning for the raid occurred in other states and the armory was under federal jurisdiction. The prosecution did not answer these points, but instead focused on re-telling the events of the raid, relying on the dramatic testimony of witnesses. No defense witnesses appeared, even after being subpoenaed, yet the judge refused to grant Brown's plea for a delay.

The jury deliberated less than an hour before finding Brown guilty on all charges. Before sentencing, Brown proclaimed that had a clean conscience, and that he considered himself "chosen by God to free men." Sentenced to hang on December 2, 1859, Brown wrote on the day of his execution, "[T]he crimes of this guilty land will never be purged away but with blood." These final words would prove to be prophetic, as the United States was plunged into and torn apart by the Civil War only sixteen months later.

THE SCOTTSBORO NINE

Although the Civil War would forever emancipate the slaves, issues of racial equality would continue to be debated in the American legal system. In fact, more than sixty years later, in the 1930s, the issues that polarized the nation during John Brown's trial remained unresolved and surfaced again in another trial, held in Scottsboro, Alabama, where the so-called Scottsboro Boys, a group of nine African-American men, had to fight for their lives in a justice system entirely controlled by white Southerners.

Horace Pippin. John Brown Going to His Hanging. 1942. Oil on canvas. 24 ⅛ x 30 ¼ in. (61.3 x 76.8 cm). Courtesy of the Pennsylvania Academy of the Fine Arts, Philadelphia. John Lambert Fund.

During the height of the Great Depression, the "Scottsboro Boys" were riding the rails in search of a job. When their train pulled into Paint Rock, Alabama, a group of sheriff's deputies swept through and yanked everyone out of the boxcars, including nine African-American men and two white women named Ruby Bates and Victoria Price, who then accused the black men of rape.

The first trials began less than two weeks later, and are generally regarded as a farce, since the un-paid defense attorneys were ill-prepared and offered a weak cross-examination and closing arguments. The prosecutor grimly summed up one case by appealing to the jury, "Guilty or not guilty, let's get rid of these niggers." Not surprisingly, eight of the nine were sentenced to die, with thirteen-year-old Roy Wright receiving life in prison because of his young age.

Samuel Leibowitz with the Scottsboro Boys in Morgan County Jail, 1933. Morgan County Archives, Decatur, Alabama.

This trial attracted attention when the International Labor Defense (ILD), a wing of the Communist Party, and the National Association for the Advancement of Colored People (NAACP) jockeyed for the right to represent the Scottsboro Nine in their appeal. The attorneys compromised and submitted a joint appeal to the Alabama Supreme Court, arguing that the trial had been hasty and unfair. The state court, however, upheld the convictions. But, in 1932, the United States Supreme Court 7–2 decision in *Powell v. Alabama* overturned the verdict on the grounds that the Scottsboro boys had not enjoyed their Sixth Amendment right to adequate legal counsel in a capital crime.

The Scottsboro Nine would face another trial, but this time it would be held in Decatur in the hope that a change in venue would produce a different result. This time they were represented by Samuel Leibowitz, a highly regarded New York criminal defense attorney hired by the ILD. Excitement built as Leibowitz gave a vigorous defense, concluding with a surprise appearance by Ruby Bates, who admitted she had lied, and that no rape had occurred. Attempting to discredit the defense witnesses by insinuating they had been misled by Northerners, the county prosecutor roared at the jury, "Show them that Alabama justice cannot be bought and sold with Jew money from New York." The trial of the first defendant ended in another death sentence. Judge Edwin Horton, who had

become convinced that the Scottsboro Nine were innocent, set aside the verdict and ordered yet another new trial. Public interest remained high, as rallies were held in northern states and three thousand people protested in front of the White House.

After two cases were transferred to a juvenile court, seven of the Scottsboro Boys stood trial again in late 1934, this time before a judge who was not sympathetic to the defense, resulting in yet another death sentence. In appealing this case to the Alabama Supreme Court, Leibowitz attempted to demonstrate that African-Americans had been systematically excluded from juries. The court denied this appeal, suggesting that failure to seat African-Americans on juries was not a sign of bias, merely an unintended consequence of Alabama's desire to fill juries with "men of intelligence, character, and sound judgment."

Haywood Patterson, defendant at the Scottsboro Trial on April 4, 933.

The United States Supreme Court did not agree. Leibowitz was able to show that no African-American had served on a jury in Decatur, Alabama, for more than sixty years. In *Norris v. Alabama* and *Patterson v. Alabama*, the Court reversed convictions on the grounds that African-Americans had been excluded from the jury. Yet another group of trials was held in 1936 and 1937, which resulted in guilty verdicts for Haywood Patterson, Clarence Norris, Charlie Weems, Ozie Powell, and Andy Wright.

New appeals were filed, but more importantly, behind-the-scenes negotiations in 1937 resulted in charges against four of the defendants—Olen Montgomery, Willie Roberson, Eugene Williams, and Roy Wright—being dropped. People in Alabama were beginning to tire of the incessant negative publicity they were receiving over these cases. Six years later, Weems and Norris were paroled, Powell was released in 1946, and Patterson escaped in 1948. And in 1960, after serving more than nineteen years in prison for a crime he did not commit, the last Scottsboro defendant, Andy Wright, was released. It was not until 1976 that the state of Alabama granted Clarence Norris, the only remaining living "Scottsboro Boy," a full pardon.

Although these Supreme Court decisions did not prevent the Scottsboro defendants from serving time in prison, the decisions stimulated closer federal scrutiny of state practices. Unfortunately, they also signaled the persistence of radical discrimination and *de jure* segregation throughout the South. Not until the civil rights movement of the 1950s and '60s would these racial hierarchies begin to change.

THE ASSASSINATION OF MEDGAR EVERS

Medgar Evers was a leader in the civil rights movement in Mississippi until he was shot in the back while standing in his own driveway, just after midnight in June of 1963. The murder weapon, a 1918 vintage rifle, was recovered along with a clear fingerprint and the fatal bullet. The FBI agent who conducted the investigation linked the rifle and fingerprint to a former U.S. Marine, Byron De La Beckwith. Thirty years after an all-white jury decided the Scottsboro cases, an all-white jury took up the case of the man who assassinated Medgar Evers.

Although the amount of physical evidence was overwhelming, the prosecution faced a jury unsympathetic to the civil rights movement, including the prosecutor himself, who told the jury, "Evers was engaged in things that were contrary to what you and I believe in." The defense capitalized on such sentiment, and a deadlocked jury was the result, 7 to 5 for acquittal. The second trial produced another deadlock, this time four out of eight jurors favoring acquittal. Beckwith was released, and his hometown of Greenwood, Mississippi, celebrated by appointing him an auxiliary policeman with the authority to patrol black neighborhoods while carrying a gun.

Twenty-five years later, Evers's murder again attracted national attention. In the fall of 1989, the *Clarion Ledger* published secret documents from the Sovereignty Commission,

a Mississippi state–funded agency that had intimidated and harassed civil rights workers from 1956 to 1973. Although the files were supposed to be sealed, documents were leaked demonstrating that the commission had worked for Beckwith's defense. Times had changed since Beckwith's first trial, and outraged people in Mississippi called for a new trial.

Beckwith, who was sixty-nine years old, faced a more vigorous prosecutor named Bobby DeLaughter in his 1990 trial. Although the transcripts from the original trials were "missing" from official records, Evers's widow had kept copies. The prosecutor worked to generate new evidence of Beckwith's guilt. For example, he located a 1990 Ku Klux Klan publication in which Beckwith boasted, "Killing that nigger gave me no more inner discomfort than our wives endure when they give birth to our children."

Beckwith's lawyers tried to prevent the trial from happening at all. They argued that Beckwith's right to a speedy trial had been violated by the long delay. Even though

NAACP activist Medgar Evers during a television interview in 1962. He was assassinated in Jackson, Mississippi, June 12, 1963. .

evidence like the bullet was missing, and many witnesses had since died, the Mississippi Supreme Court allowed the case to go forward, and their decision was upheld by the United States Supreme Court.

The jury selected for the 1990 trial looked little like the first jury; it contained eight African-Americans and four whites. Though many of the witnesses were elderly, their evidence was as powerful as it had been thirty years earlier. The case against Beckwith was sealed when a guard at the Louisiana State Penitentiary testified that while Beckwith was serving time for another crime, Beckwith told him that it was only his personal connections that prevented him from being imprisoned for "getting rid of that nigger Evers." The jury deliberated for five hours before returning a verdict of guilty, and Beckwith was sentenced to spend the rest of his life in prison.

The Evers case, which spanned twenty-seven years, shows that although justice has not always prevailed for African-Americans, Americans' views on racial justice have thankfully changed.

Funeral procession for Medgar Evers through the streets of Jackson, Mississippi, June 18, 1963.

POLITICS

THE LIBEL TRIAL OF JOHN PETER ZENGER

Famous trials can also tell us something about American political values, particularly when one focuses attention on the improper conduct of prominent politicians. In the case of a poor and unknown printer in colonial New York, the issue would center around the press's right to publish information about politicians.

John Peter Zenger was arrested and imprisoned on the charge of printing libelous material about the colonial administration and the governor of New York, William Cosby. Zenger's arrest sparked a vigorous debate about the clash between a citizen's right to criticize his government, and the government's desire for public order and safety.

Zenger was drawn into the fray because he owned his own printing press, unusual in New York in 1735. He agreed to work with members of the opposition to Cosby's governorship, and he published articles, editorials, and letters critical of Cosby's corrupt

behavior, which included nepotism, rigging elections, and tampering with the courts. Zenger published these unsigned writings under the heading of *The New York Weekly Journal*, Peter Zenger, Printer.

The *Journal* rapidly attained a wide circulation and contributed to the growth of the opposition movement. Governor Cosby ordered that copies of the paper be publicly burned, and city officials were commanded to witness the burning. No one showed up for the big event, and the papers were set ablaze in an empty street, which caused the incident to be dubbed "Cosby's Folly." In response, a furious Cosby decided to punish Zenger, the person responsible for printing the *Journal*.

Zenger's situation began to look grim when, on the first day of trial, the judge disbarred his attorneys and appointed Zenger a new defense counsel. The prevailing common law required only that the jury decide if Zenger had in fact printed the articles in question. The judge would then rule on whether the material violated libel laws, defined broadly at the time to include any printed comment casting disfavor on the government.

Soon after the trial got underway, those present were shocked to hear a voice from the back of the courtroom. Andrew Hamilton, an eminent Philadelphia attorney and a revered legal mind, rose and walked forward, announcing his intention to act as Zenger's attorney. Hamilton began by adopting a novel approach. Acknowledging that Zenger had published the alleged libels, he argued rather that Zenger had a right to print *true* statements about the government. Libelous statements were those that were purposefully false and seditious. The prosecution's case relied on the prevailing understanding that true statements *could* be libel if the judge perceived them to be.

The judge instructed the jury to rule only on the question of whether Zenger had published the statements, but after less than ten minutes of deliberation, the jury returned with a verdict of not guilty, apparently persuaded that libel should exclude the publication of truthful statements. New Yorkers celebrated the victory, and Zenger's published narrative of the trial became a guide used by those accused of censorship in future years. Moreover, Zenger's acquittal allowed citizens to criticize politicians and other elected officials without fear of reprisal, an important right incorporated into the First Ammendment.

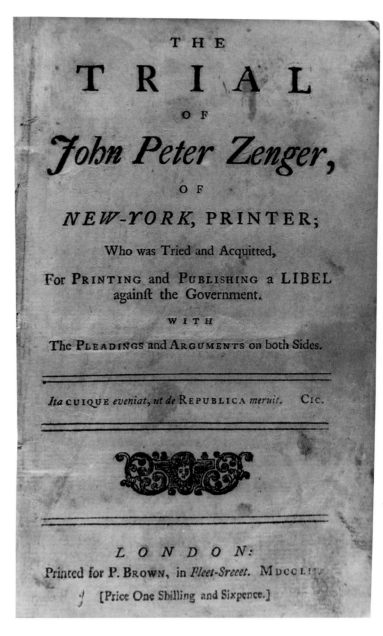

Title page of the report of the trial of John Peter Zenger. Printed in London by P. Brown. © Collection of The New-York Historical Society.

Theodor R. Davis. The Senate as a Court of Impeachment for the Trial of President Andrew Johnson. *Harper's Weekly.*

THE IMPEACHMENT OF PRESIDENT ANDREW JOHNSON

Political issues of a different sort were at stake during the impeachment trial of President Andrew Johnson in 1868. After President Lincoln was assassinated in 1865, Johnson assumed the presidency and began to face the daunting task of restoring order in a country torn apart by the Civil War. The Congress and President Johnson soon clashed over how to accomplish this task. Over Johnson's veto, Congress passed the Military Reconstruction Act of 1867, which established military rule over the defeated southern states, and allowed Congress to implement their plans to ensure that African-American men could vote. Johnson, on the other hand, preferred to restore government in former Confederate states without disturbing Southern institutions. Johnson's plan placed former Confederates in positions of power and gave them the ability to thwart black voter registration.

During the same session in 1867, Congress attempted to limit Johnson's ability to undermine their Reconstruction plans by passing the Tenure of Office Act. This law required congressional approval before Johnson could remove any Senate-confirmed official holding a position in the federal government. In 1868, Johnson decided to formally challenge the constitutionality of this law, and he dismissed the secretary of war, who had been a Lincoln appointee.

The House of Representatives reacted by beginning the process of impeachment, that is, bringing formal charges of misconduct against a sitting president of the United States. The House overwhelmingly found Johnson guilty on eleven counts of

Left: Ticket of admittance to the impeachment trial of President Johnson. April 6, 1868.

misconduct, most stemming from his violation of the Tenure of Office Act. After the House impeached the president, the Senate, presided over by Chief Justice Salmon P. Chase, took up the trial proceedings, and in the end, was one vote short of the two-thirds majority needed to remove the president from office. Although many agreed that Johnson had violated the law, moderates were reluctant to impeach over what they felt was a policy disagreement. Johnson remained in office, but was defeated politically, and Congress was able to direct Reconstruction without interference from the Oval Office.

Below: Cover of the New York Post *the day President Richard Nixon resigned from office due to the Watergate scandal. August 8, 1974.*

THE WATERGATE HEARINGS

Unlike President Johnson, Richard Nixon avoided impeachment only by resigning the office of the presidency after his illegal and corrupt activities were revealed. During Nixon's first term, his staff members began to use "dirty tricks," such as opening mail and tapping phones, to discover information that was used to embarrass, harass, and discredit Nixon's opponents. During the 1972 presidential election campaign, the Committee to Re-Elect the President, or CREEP, continued with the same tactics. In fact, five inept burglars hired by CREEP would make history when they broke into Democratic National Headquarters at the Watergate Hotel and set in motion the downfall of a president.

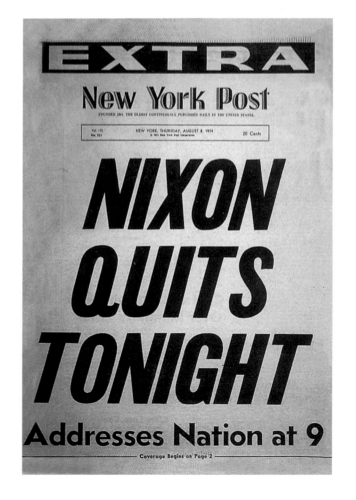

Nixon, concerned that this "third-rate burglary attempt" would connect directly to CREEP, ordered the FBI to participate in a cover-up, supposedly due to reasons of national security. The burglars were convicted, but kept silent by White House pressure and $400,000 in hush money. Unfortunately for Nixon, however, the cover-up soon began to unravel as the judge pressured the

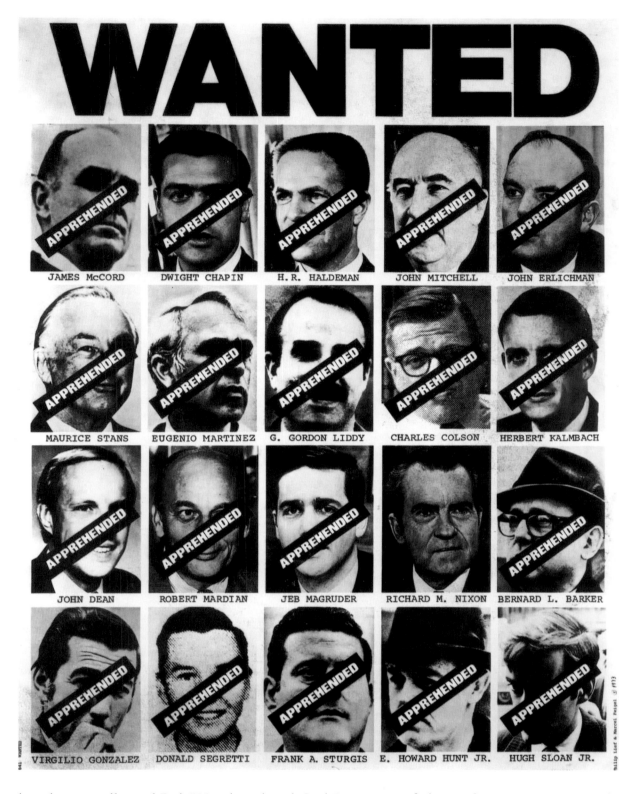

burglars to talk, and Bob Woodward and Carl Bernstein of the *Washington Post* continued to investigate. White House counsel John Dean warned Nixon that the cover-up had become a "cancer on the presidency." Soon thereafter, Nixon accepted the resignations of H. R. Haldeman and John Ehrlichman. Nixon also fired Dean.

Attention shifted to the hearings of the Senate Select Committee on Presidential Campaign Activities. Millions of Americans watched on television as John Dean implicated Nixon in the cover-up and another staffer revealed the existence of a taping system Nixon used to record conversations in the Oval Office. A constitutional crisis ensued as Nixon sought to block the release of the tapes, citing executive privilege and the separation of powers. Next, in what became known as the "Saturday Night

Massacre," Nixon fired the special prosecutor and the attorney general instead of compromising on the issue of the tapes. Finally, when Nixon agreed to release the tapes, they had been heavily edited and important material was missing. On July 24, 1974, the U.S. Supreme Court ordered Nixon to release sixty-four tapes, which then revealed that Nixon had directly participated in the cover-up and had been lying to the American people.

At the same time, Congress began impeachment proceedings and voted to impeach Nixon on three charges: obstruction of justice, abuse of power, and acting in a way subversive of the Constitution. Richard Nixon resigned on August 8. One month later, President Ford granted Nixon a pardon to "any and all crimes" he committed, sparing him from a trial.

THE IMPEACHMENT OF PRESIDENT WILLIAM CLINTON

Just like the airing of Nixon's dirty laundry, President Bill Clinton's impeachment trial would result in the American public learning of dramatic and damaging information about the president's conduct. But before the impeachment, and before Monica Lewinsky, there was the lawsuit. In 1994, Paula Jones filed a lawsuit alleging that then-governor Bill Clinton had sexually harassed her in a hotel room in Arkansas. After years of legal maneuvering, political spin, and lurid tabloid banter, the lawsuit ended with a fizzle when Judge Susan Webber Wright dismissed it in early 1998. Within the mass of

President William Jefferson Clinton addresses the nation December 11, 1998, to apologize to the American public for his misleading statements regarding his relationship with White House intern Monica Lewinsky. A congressional panel approved a perjury article of impeachment only moments after this public address.

material generated by that case were the seeds of a much greater scandal—the president's affair with a young White House intern named Monica Lewinsky.

The central figures and events of the next year were to absorb the country like no other political drama in American history. Linda Tripp, Kenneth Starr, and David Kendall became household names. Americans found themselves debating over the semantics of the verb "is." Internet smut took on a whole new meaning with the release of the special prosecutor's report, and a certain blue dress became the most talked-about article of clothing in recent memory.

Surrounded by cameramen, former White House intern Monica Lewinsky arrives at her lawyer's office in Washington, D.C., July 1998.

Then there was the impeachment. Part political theater, part serious attempt to address the president's untruthful statements, the trial of the president ended in acquittal along straight party-line votes. This famous trial gave Americans much to debate, particularly the question of how much the American public deserves to know about the private conduct of a president.

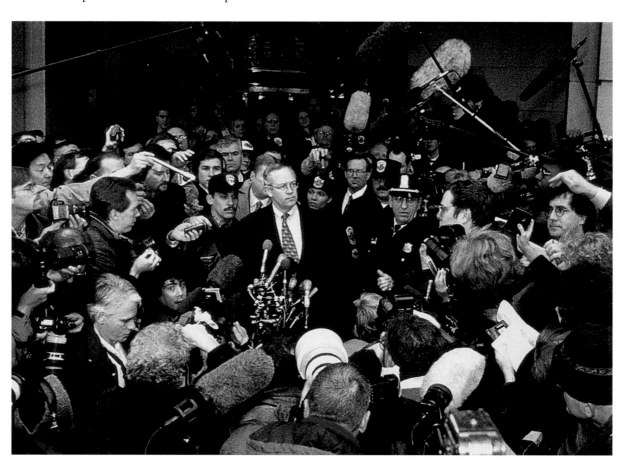

Special Prosecutor Kenneth Starr, standing outside of the Justice Department, answers questions regarding the probe into the White House sex and perjury scandal. January 22, 1998.

LABOR

HAYMARKET SQUARE

American labor history is filled with drama. One emotional episode erupted during the period known as the Gilded Age, when great fortunes were being amassed, though not by the laboring man. Working-class people living in Chicago in the 1880s struggled with economic depression and unemployment, and many workers were active in the labor movement.

A small group of workers became convinced that the only solution was to bring an end to the capitalist system, using violence if necessary. In May of 1886, more than forty thousand workers went on strike, causing city officials to fear an outbreak of violence. Labor activists held mass meetings and gave fiery speeches to raise the spirits of the striking workers.

A large gathering was planned for the night of May 4, and was advertised with the headlines "Revenge!" and "Workingmen, to Arms!" Over a thousand people gathered in Haymarket Square to listen to speeches, many given by well-known anarchists. Chicago police, fearing an uprising, dispatched approximately 180 officers, who marched into the square. The captain said, "In the name of the people of the State of Illinois, I command this meeting immediately and peaceably to disperse." At that moment, a bomb flew through the air and exploded directly in front of a group of police, killing

The Haymarket Square Riot, *May 4, 1886.*

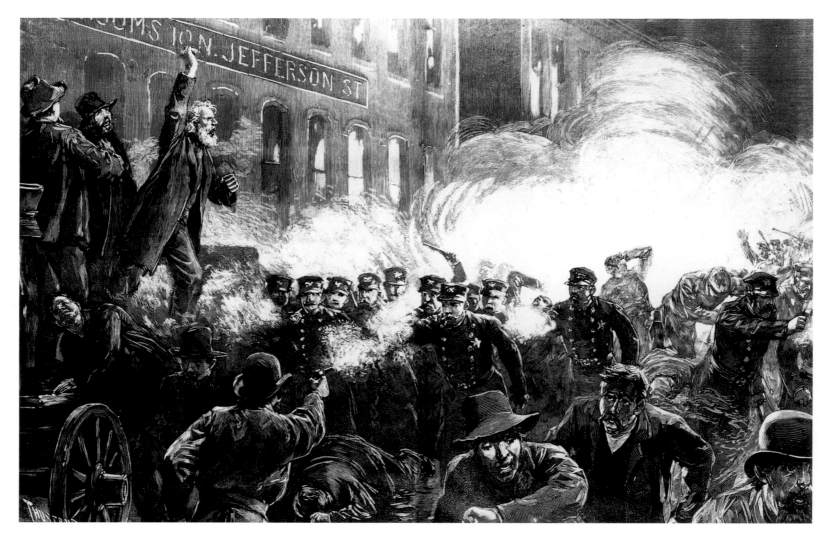

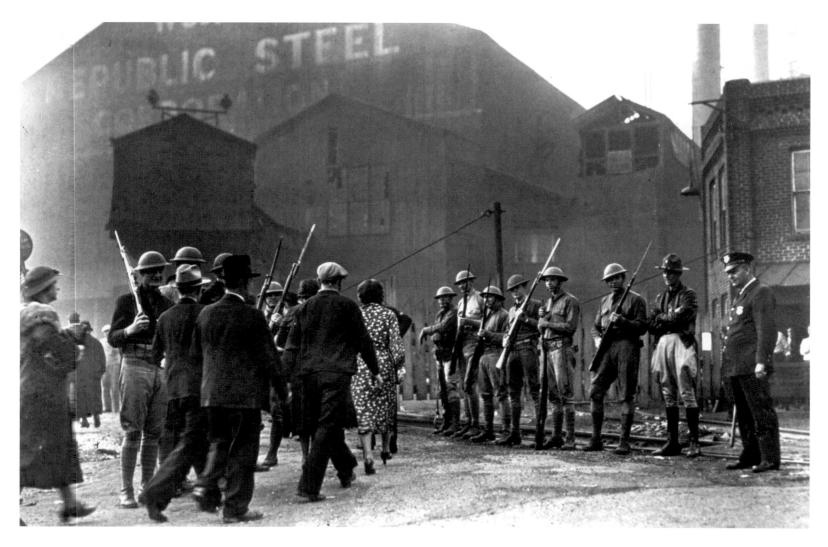

seven and injuring more than sixty. After a moment of shocked silence, the police opened fire into the crowd, killing and wounding dozens of workers, many of whom were fleeing in panic.

Immediately after the bombing, many Americans blamed the anarchists, or "Reds," for the violence, and the police jailed more than two hundred people who were known to be supporters of the anarchists. Eight men were charged with participating in the bombing and with conspiracy to murder. Though the men had a clear alibi to prove they had not thrown the bomb, they were considered to be part of a conspiracy because they had advocated the overthrow of the government at one time or another. One man was found guilty of a minor role, and the remaining seven were sentenced to die.

Both the Illinois Supreme Court and the Supreme Court of the United States refused to overturn the convictions. As the date of the execution approached, pressure was brought to bear on the governor of Illinois. Would he grant clemency? In the end, he commuted to life imprisonment the sentences of two prisoners who had expressed remorse. One prisoner committed suicide by exploding a dynamite cap in his mouth, and the four remaining men were to be executed.

On November 11, 1887, the four men were led onto a scaffold. Their ankles were tied with a leather strap, a noose was placed around each neck, and then a hood. Before the

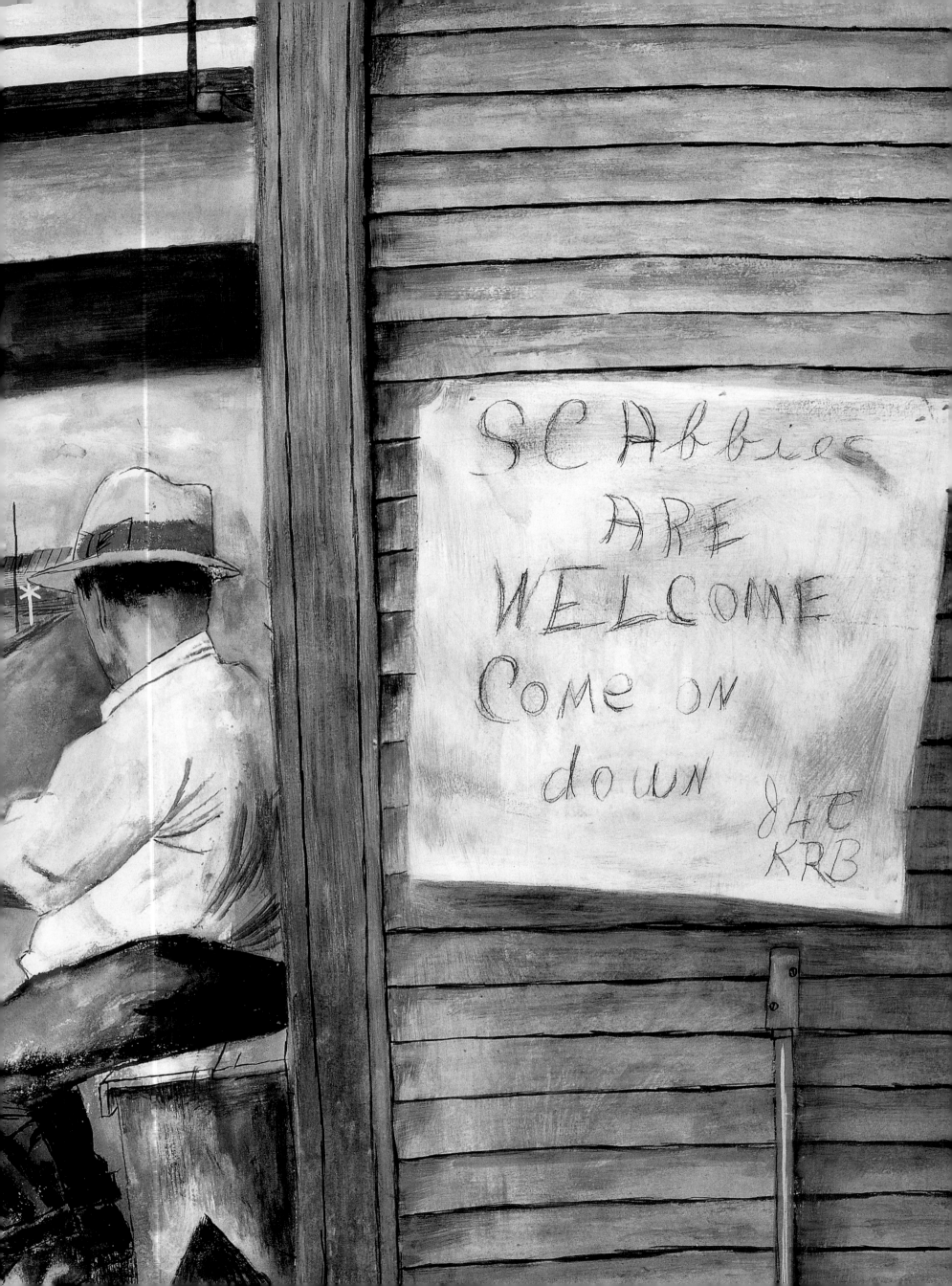

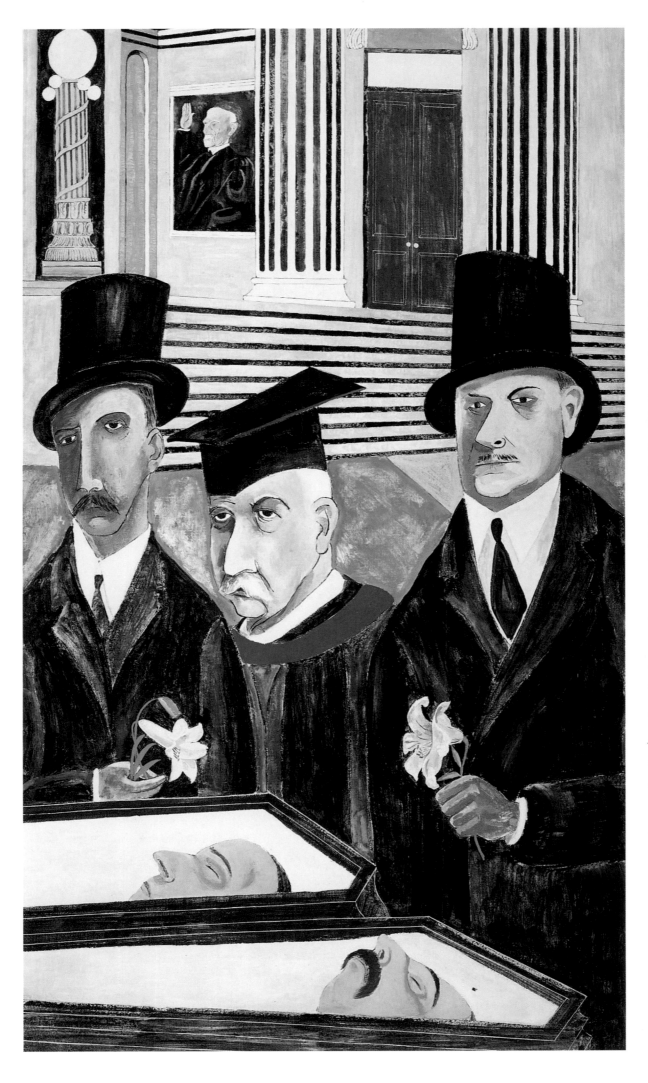

trap door was opened beneath them, the first man cried out, "Hurrah for anarchy!" in German, the second repeated the cry in English, and the third said, "Let the voice of the people be heard!" At that moment, the door sprang open and the four men plunged to their deaths. More than twenty thousand people followed the funeral procession, and many Americans believed that the trial was unjust.

RADICALISM

SACCO AND VANZETTI

Several other famous trials in American history stirred interest because they occurred in politically conservative times and featured politically radical defendants. For example, American fears of Communism were central to the events of the Red Scare of the 1920s, during which many Americans still feared that Communists and anarchists were plotting a violent takeover. At the height of this antiradical fervor, known anarchists Nicola Sacco and Bartolomeo Vanzetti were arrested for a robbery and murder in South Braintree, Massachusetts.

During the trial, the prosecution attempted to prove Sacco and Vanzetti's guilt through eyewitness testimony placing them at the scene of the crime, and technical experts who linked them to the weapon. The defense also called eyewitnesses, who denied seeing Sacco and Vanzetti at the crime scene. The jury found both men guilty, and they received the

Sacco and Vanzetti arrive at court, April 19, 1927.

mandatory death sentence for first-degree murder. While the defense's appeals were pending before the Massachusetts Supreme Court, another man named Celestino Madieros confessed to the Braintree robbery and murder. Even in light of this new evidence, the judge refused to grant a new trial.

For many Americans, as the case moved through the judicial system, the guilty verdict came to symbolize injustice and intolerance due to the persecution of anarchists, and many believed in Sacco and Vanzetti's innocence. Even future Supreme Court justice Felix Frankfurter weighed in on the matter, publishing an article in a 1927 edition of the *Atlantic Monthly*, in which he argued the men were innocent, and that their trial had been unfair.

In the midst of intense interest in the case, the Massachusetts Supreme Court denied the appeals, leaving the question of Sacco and Vanzetti's execution to the governor. Governor Alvan Fuller accepted the guilty verdict, and Sacco and Vanzetti were executed in August of 1927. Worldwide demonstrations failed to stop the execution, and on the day of Sacco and Vanzetti's death, thousands of mourners gathered to follow the funeral carriages.

Sixty years later, scholars still debate the outcome. Were Sacco and Vanzetti guilty as charged, or were they persecuted for their anarchist beliefs? In the late 1970s, a Freedom of Information Act lawsuit resulted in the release of additional evidence that led one historian to conclude that, yes, Sacco and Vanzetti were probably innocent. Certainly, given all the material available at the time, not enough evidence existed to prove their guilt beyond a reasonable doubt. Recent findings also reveal that prosecutors concealed evidence that may have helped the defense, serving to underscore the importance of future Warren Court decisions that compel prosecutors to reveal exculpatory evidence. Sacco's and Vanzetti's executions remain powerful reminders that fear and prejudice can influence the outcome of a trial and perhaps cause a miscarriage of justice.

ETHEL AND JULIUS ROSENBERG

American fears of Communism did not die with Sacco and Vanzetti. In fact, they are evident in another famous trial, in which Ethel and Julius Rosenberg were accused of treason against the United States. After the Soviet Union exploded their first atomic weapon in 1949, amid the first rumblings of the Cold War, American intelligence officers discovered that information about the U.S. atomic weapons program had been leaked to the Soviets. A fervent search for the source led agents to an employee of a British atomic agency, who in turn led agents to the Rosenbergs. Julius had worked as an engineer for the Army, and both Rosenbergs came under suspicion because of their admitted Communist sympathies.

The prosecution's chief witness during the 1951 trial was David Greenglass, who had worked as a machinist at Los Alamos. Greenglass, in exchange for a reduced sentence,

admitted passing secrets to the Soviets and declared he was recruited by his sister, Ethel, and her husband Julius Rosenberg. Since Greenglass testified that atomic secrets were exchanged during wartime, the Rosenbergs could receive the death penalty under the Espionage Act of 1917.

The prosecution established that information had reached the Soviets, but failed to fully prove that the Rosenbergs were in any way involved. In fact, Greenglass was the only person who claimed to have any knowledge of the Rosenbergs, and it is rare that an admitted felon's uncorroborated testimony is given such credence. Unfortunately, the defense did not capitalize on this and other weaknesses in the prosecution's case. In addition, when the Rosenbergs took the stand, they refused to answer questions about their membership in the Communist Party, tainting them in the eyes of the jury and the judge. Both Rosenbergs were found guilty, and both received the death penalty.

Much like Sacco and Vanzetti, the fate of the Rosenbergs attracted emotionally charged international attention. The case was appealed all the way to the United States Supreme Court, but the Court declined the hear the case. President Eisenhower denied clemency,

A handcuffed Julius and Ethel Rosenberg kiss in a prison van after their treason arraignment in New York City, September 1950.

even though President Auriol of France, Pope Pius XII, and Albert Einstein asked him to pardon the Rosenbergs. Defense attorneys pleaded with the Supreme Court to reconsider, but the Court refused. Even when the Court finally agreed to rule on the case, it voted 6 to 3 to allow the execution to proceed, and, amid intense media visibility, on June 19, 1953, Julius and Ethel Rosenberg were put to death in the electric chair.

McCARTHYISM

American fears of Communism in the postwar period were evident not only in the trial and execution of the Rosenbergs, but also in anti-Communist campaigns conducted by Senator Joseph McCarthy and the House Committee on Un-American Activities (HUAC). In 1953, McCarthy was put in charge of the Senate's Permanent Subcommittee on Investigations, and he hired Roy Cohn as chief counsel. Cohn did much of the committee background work as it investigated suspected Communists.

Senator McCarthy became well-known for his anti-Communist campaign, in which he expounded fiery anti-Communist diatribes in print and in the new medium of television. McCarthy claimed to have a list of Communists working for the government,

including the secretary of state and, ridiculously, Secretary of Defense George Marshall. Those who disagreed with McCarthy's claims or tactics would not openly criticize him for fear of looking "soft" on Communism.

Beginning in 1945, HUAC searched for Communists in Hollywood, academia, the federal government, and labor unions. People who were called to testify before HUAC and its Senate counterpart, the McCarran Committee, were not only required to renounce Communism, but also to "name names" of other Communist sympathizers. Those who refused would plead the Fifth Amendment, but that in itself would call their loyalty into question.

Due to McCarthy's activities, this period in American history has been described by historians as the "Second Red Scare," or the era of McCarthyism. Many prominent actors, producers, academics, and scientists were either jailed for refusing to cooperate, or saw their careers ruined. Even the threat of being summoned before HUAC led one scientist to commit suicide. Additionally, HUAC collected information on over sixty thousand people, which they furnished to employers, and more than fifteen thousand federal employees and thousands of teachers were forced to resign when they would not

Wisconsin Senator Joseph McCarthy standing before the Army-McCarthy hearings. June 9, 1954.

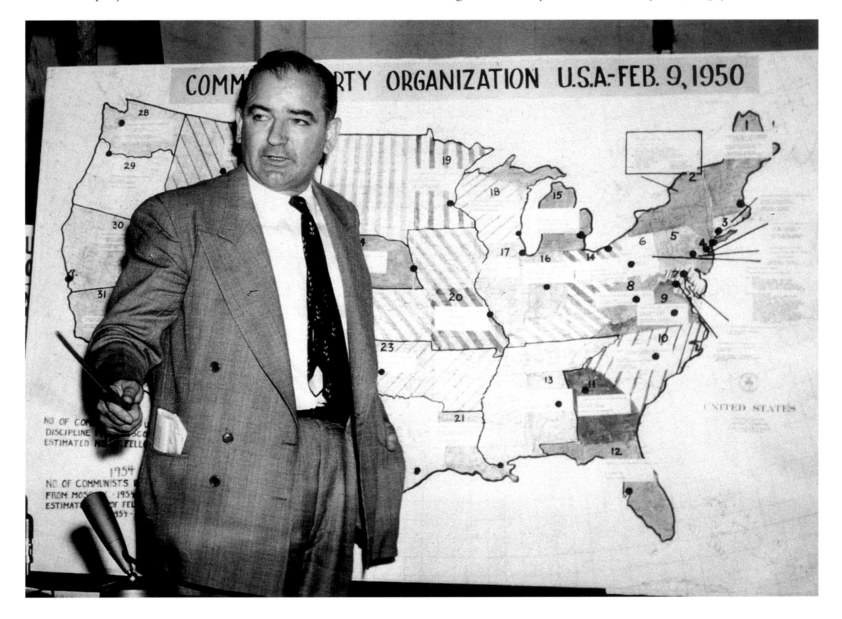

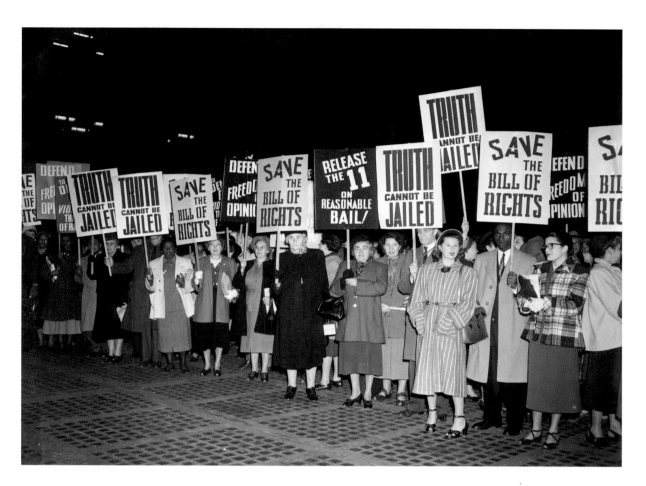

sign a loyalty oath. Even the Cincinnati baseball team temporarily changed its name
from the Reds to the Redlegs, in order to avoid an association with Communism. For
many Americans, particularly those who were fired or disgraced during this period, anti-
Communist hysteria carried deadly serious repercussions.

THE CHICAGO SEVEN

By the 1960s, however, turmoil over American involvement in the Vietnam War had
shifted the spotlight to the political stage, as student radicals made their positions clear
in the streets. Tension over the war simmered during the summer of 1968, during which
the Democratic Party held their convention in Chicago. Well-known activists such as
Jerry Rubin, Abbie Hoffman, and Tom Hayden publicized their intent to conduct
demonstrations at the convention, while at the same time, Mayor Daley broadcast his
intention to restrict the protests. Five thousand demonstrators were met by almost
twenty thousand police officers, who soon began to break up the protests through the
use of violence, akin to a "police riot." As the violence continued over several nights and
was broadcast live on network television, America's attention turned from the political
events inside the convention hall to the war zone developing outside.

In March 1969, Dave Dellinger, Rubin, Hoffman, Hayden, and four others were indicted
for conspiracy under the 1968 Civil Rights Act, which made it a crime to cross state
lines with the intention of inciting a riot. After Bobby Seale's defense was separated, the
defendants became known as the "Chicago Seven." The defendants hoped the trial
would focus attention on the immorality of the Vietnam War, while the prosecution
attempted to demonstrate the existence of a left-wing radical conspiracy.

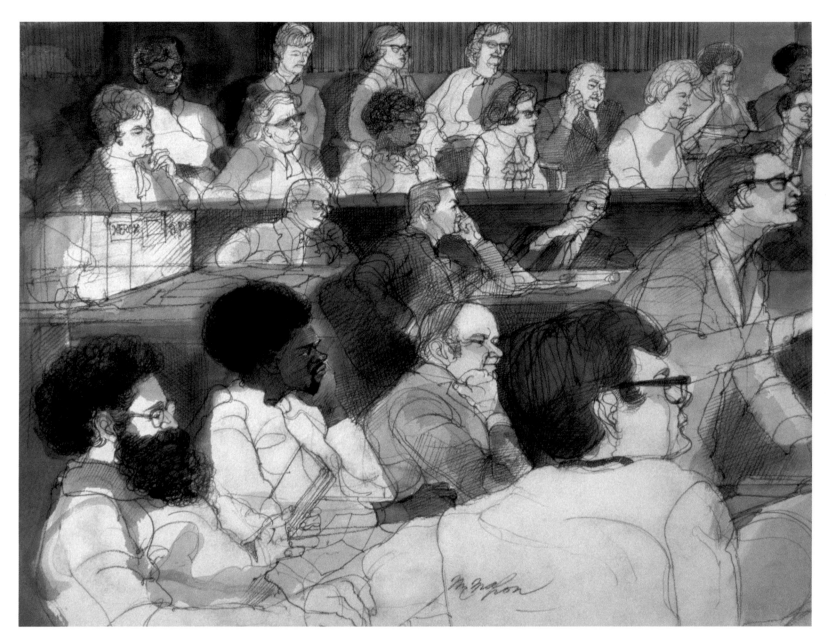

From the beginning, the defendants faced an uphill battle. The judge, Julius Hoffman, presided over a jury selection that resulted in, as one trial observer put it, a jury that looked like "the Rolling Meadows Bowling League lost on their way to the lanes." William Kunstler and Leonard Weinglass, the defense attorneys, had submitted a lengthy list of questions for jury selection, but Hoffman utilized only one of their questions. Consequently, after the trial, biased jurors voiced opinions that the defendants should have been convicted "on their appearance, their language, and their lifestyle." One juror even suggested that the activists should have been "shot down by the police."

Not surprisingly, given the personalities of the defendants, the Chicago Seven trial often resembled a circus. For example, the defendants would sometimes shout directly at the judge, show up for trial attired in blue jeans and beads, sit with their feet on the table, eat jelly beans, or sleep. The defense suggested that aspects of the prosecution's supposed conspiracy were merely jokes—the defendants' threat to put LSD in the Chicago water supply, for instance. The defense also suggested that it was ridiculous to even imagine all of the activists reaching an agreement on basic tactics, let alone working together, as Abbie Hoffman said, "Conspiracy? Hell, we couldn't agree on lunch."

Courtroom drawing showing the Chicago Seven trial, 1969.

The jury initially deadlocked, but after stern instructions from the judge to try again, they compromised and found the defendants guilty of crossing state lines to incite a riot, but not guilty of the conspiracy charges. Judge Hoffman sentenced each to five years in prison, in addition to the stiff sentences he imposed for their 159 counts of contempt of court. Interestingly, defense attorney Kunstler also received a sentence of four years and thirteen days for contempt. All convictions would eventually be overturned by the Seventh Circuit Court of Appeals, based largely on the unfair method by which Judge Hoffman selected jurors.

William M. Kunstler and demonstrators at a rally protesting the conspiracy trials of the Chicago Seven and the Panther 21.

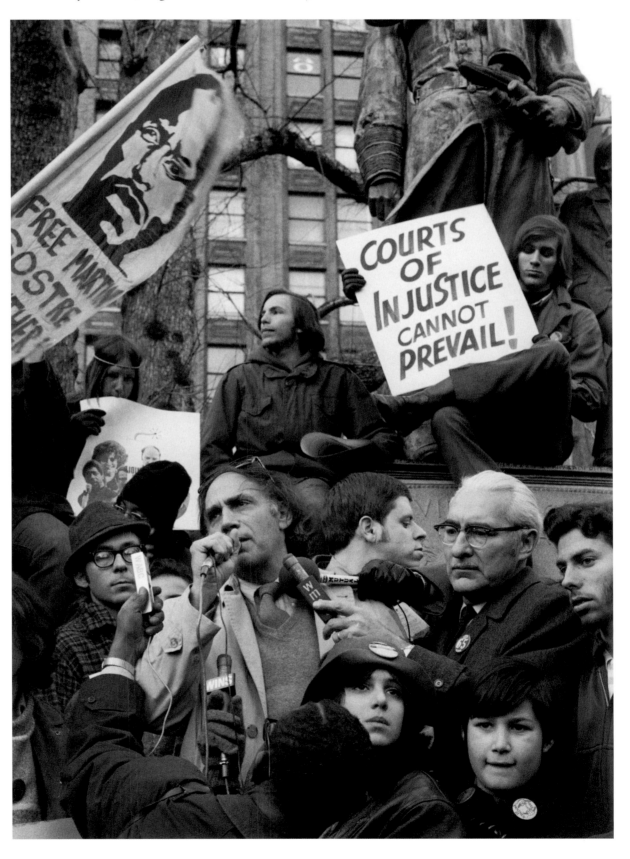

THE AMERICAN JURY SYSTEM

Courtroom sketch of the
Chicago Seven jury, 1969.

The jury system is at the heart of American law and our democratic system of government, enshrined in the Constitution. It transfers judicial fact-finding power from elite individuals and groups to ordinary citizens. Jurors are the only members of the judicial process who are not legal professionals. The lawyers argue the case, and the judge rules on matters of law and what the jury may be allowed to hear and see, but the jurors maintain the ultimate power of deciding the facts: what is true and what is not true; who is guilty and who is not; who is imprisoned and who goes free. It is a tremendous amount of power and rests on a belief that victims and accused criminals will be treated most fairly when judged by the combined wisdom of their peers.

Origins of the jury system can be traced all the way back to the Greeks, although their concept of a jury, which comprised a group of several hundred men deciding a trial, is substantially different from the six- and twelve-member jury panels in contemporary America. The use of juries in deciding English cases continued to evolve from the time of William the Conqueror and reached a significant turning point in 1670, when jurors refused to convict William Penn and William Mead of preaching in public, even though the judge had informed the jurors that the defendants had broken the law. An appeal of a fine imposed on the jurors was overturned, establishing the right of jurors to acquit criminal defendants without risking punishment.

The English brought the jury system with them to the American colonies, and it was used by the colonists to defy the authority of the Crown. In one notable case, John Peter Zenger, accused of seditious libel for criticizing the royal appointed New York governor, was acquitted by a jury, defying the instructions of the court that truth was not a defense to such charges. Later, the right to a trial by jury was mentioned both in the Declaration of Independence and in two amendments to the United States Constitution. The Sixth Amendment states in part, "In all criminal prosecutions, the accused shall enjoy the right to a speedy and public trial, by an impartial jury of the State and district wherein the crime shall have been committed." The right to jury trials in civil suits is addressed in the Seventh Amendment: "In suits at common law, where the value in controversy shall exceed 20 dollars, the right of trial by jury shall be preserved, and no fact tried by a jury, shall be otherwise re-examined in any Court of the United States, than according to the rules of common law." State constitutions included similar rights to jury trials.

The notion of what is meant by an impartial jury of one's peers evolved slowly in America. For most of our nation's history, peers were considered to be white males. African-Americans were routinely excluded from juries by prejudiced local officials, even after the Supreme Court explicitly banned such practices. The result is that black defendants were far more likely to be found guilty by all white jurors, especially if the victim was white. Similarly, women were excluded from juries in most states well into the twentieth century. As recently as 1975, women had to volunteer for jury service in some states, where men were automatically drafted.

American juries today are much more reflective of American society. Juries are required to be drawn from a cross-section of society and are randomly selected from public records, such as drivers' license databases. Also, the Supreme Court has ruled that juries do not always have to include twelve members. Six-member jury panels are acceptable for civil cases and for some minor criminal cases. The jury system is costly and used less and less in both criminal and civil trials. At the federal level, only about 10 percent of the tried criminal cases use a jury. Most criminal cases are settled through a plea bargaining agreement. On the civil side, only about 2 percent go to jury trial.

Sitting on a jury is perhaps the only time when most ordinary citizens can take part directly in the legal process, but the truth is most people do not show up eagerly when called for jury duty. The national rate of no-shows for jury service is estimated to exceed 50 percent, even though they can be cited for contempt of court. Nevertheless, the right to trial by jury is a basic and fundamental part of the American justice system and is likely to remain so.

CHAPTER V

THE COURTS

America's court system is intended to provide a fair, open, and impartial means for settling disputes. The disputes may involve individuals, businesses, or governments, but in each situation the goal is for an impartial decision-maker to resolve the dispute. How American society has structured the judicial process reflects the tensions at the heart of the American legal and political systems. While the judicial branch is one of the three co-equal branches of government machinery, as the arbiter of laws enacted by the legislature and enforced by the executive, the judicial branch may in fact be the most powerful. Questions of who has access to courts, which issues can be bought to a court, and who hears and decides the cases are all answered by the courts based on cultural assumptions and traditions. The courts in America not only play a role in resolving private disputes, they also are part of the political system and help resolve public, political disputes.

When the courts or the judiciary are mentioned in the United States it is not uncommon to think first of the United States Supreme Court. This is the court that sits at the top of the judicial hierarchy in America, but it is only one court in an interwoven system of federal and state courts. While the U.S. Supreme Court heads the federal judicial hierarchy, similar hierarchies are found in each of the fifty states. Even at the federal level, courts are not geographically centralized like the executive and legislative branches. Rather, the judicial branch has a wide presence throughout the country at both the federal and state level.

In the American judicial system, trial courts are the foundation of the judicial process. This is the forum where disputed facts are decided. These courts hear the testimony of witnesses, examine the evidence, evaluate the merits of the case according to legal precedents, and resolve the dispute. A party unhappy with the outcome of the trial court might appeal its decision to another higher, appellate court. However, appellate courts accept the facts as determined by the trial court below, and rarely hear new evidence. Instead, the appellate court determines whether or not a mistake has been made in how the law was interpreted and applied, based upon the record brought up from the trial

Opposite: Witness Stand. Greene County Courthouse, Greensboro, Georgia, 1848–49.

court. While appellate courts serve as a check to ensure a fair trial, few cases are appealed; for most Americans, the trial courts, not the appellate courts, are the primary means of settling disputes.

Similarly, the vast majority of disputes, whether civil or criminal, are resolved in state rather than federal courts. State courts are separate and independent from the federal judicial system, and are governed by the constitution and laws of the individual states. This system allows for wide latitude in the structure of court systems and judicial processes from one state to another, so that local customs and legal traditions may be reflected in the system of each state. In New York, for instance, the court known as the Supreme Court is actually a trial court, and the highest court in that state is known as the New York Court of Appeals. But more often than not the court systems of the different states do adopt proven rules of judicial process from other jurisdictions. For example, the Federal Rules of Evidence initially adopted for application in federal trial courts are now followed by most state court systems as well.

Trial courts, whether state or federal, are of either general or limited jurisdiction. A trial court of general jurisdiction has the broad power to hear a wide variety of cases. At the federal level, the trial court of general jurisdiction is the district court, and federal district court judges are appointed with lifetime tenure to insulate them from political influence. Courts of limited jurisdiction include specialized courts that hear limited categories of

cases. Most citizens are familiar with the names or concepts of some state courts of limited jurisdiction. At the state and local level these courts include traffic court, juvenile court, justices of the peace, small claims court, family court, and probate court. Less familiar are some of the specialized federal courts, such as bankruptcy, admiralty, or tax courts. Other specialty courts, such as military courts or territorial courts, while significant, are rarely encountered by anyone other than those intimately involved with the respective systems.

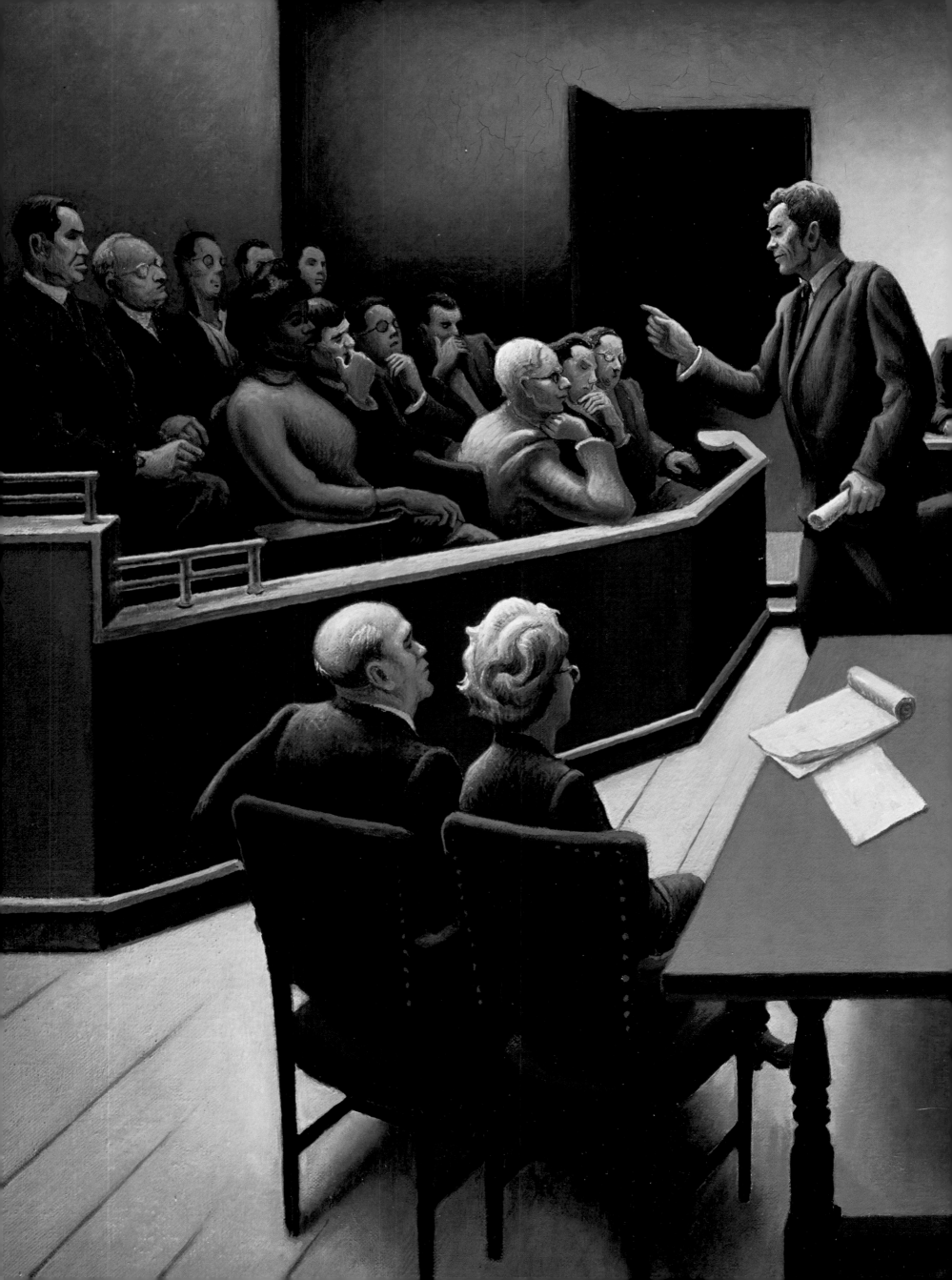

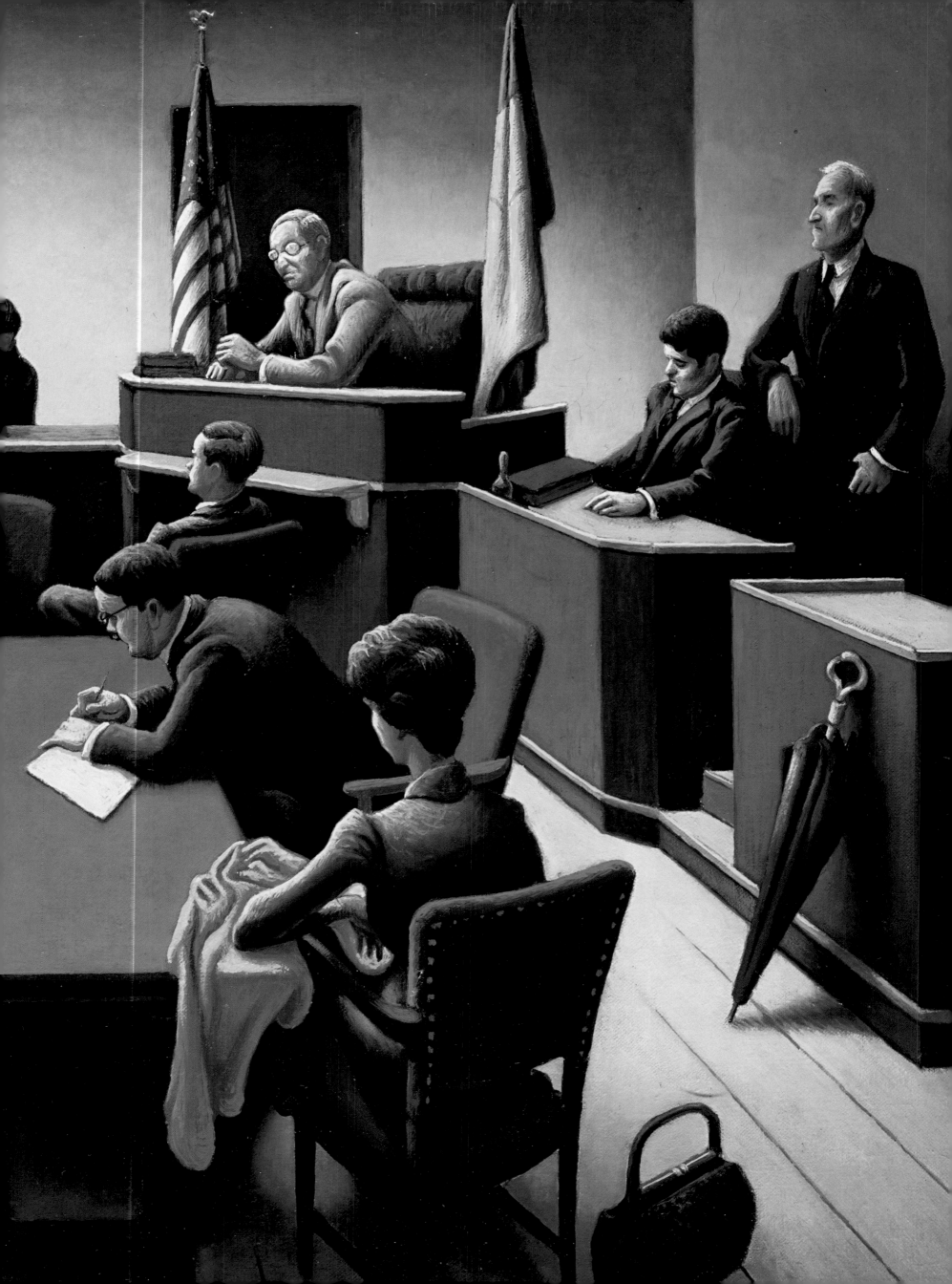

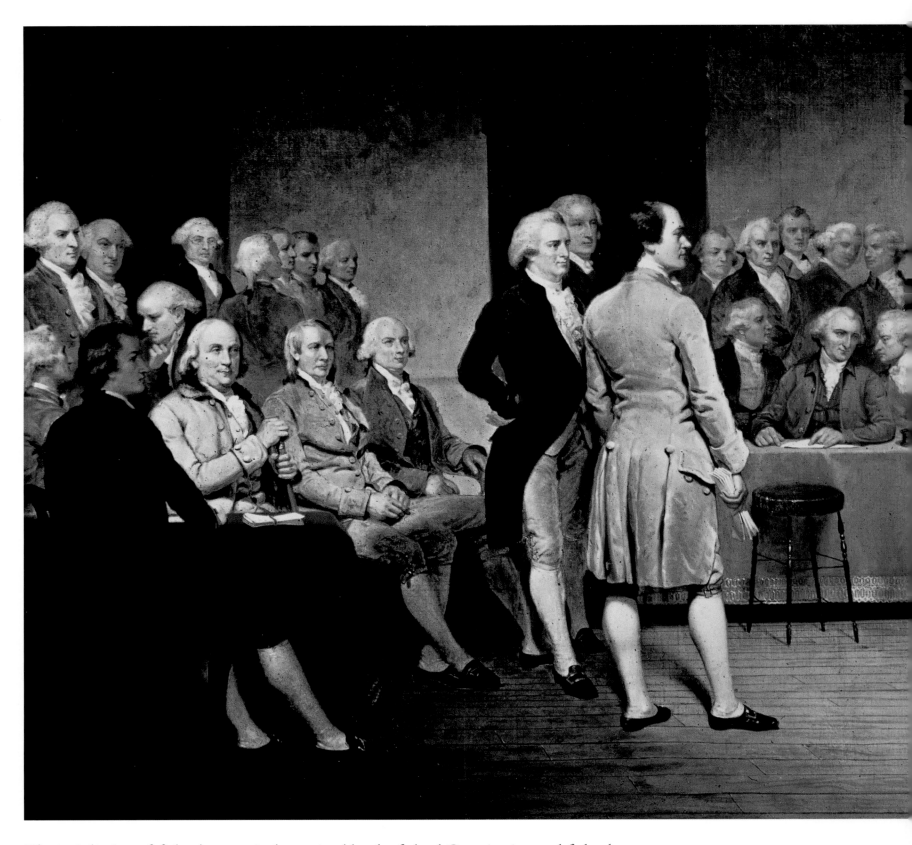

The jurisdiction of federal courts is determined by the federal Constitution and federal laws. Article III of the Constitution states, "[t]he judicial Power of the United States, shall be vested in one supreme Court, and in such inferior courts as the Congress may from time to time ordain and establish." These inferior courts were established by the Judiciary Act of 1789, which provided for the establishment of federal trial and appellate courts. The Judiciary Act also established two basic methods for obtaining federal court jurisdiction: diversity jurisdiction and federal jurisdiction. Diversity jurisdiction pertains to conflicts arising between two or more states or their citizens; federal jurisdiction covers cases arising under the Constitution and laws of the United States. While attempts have

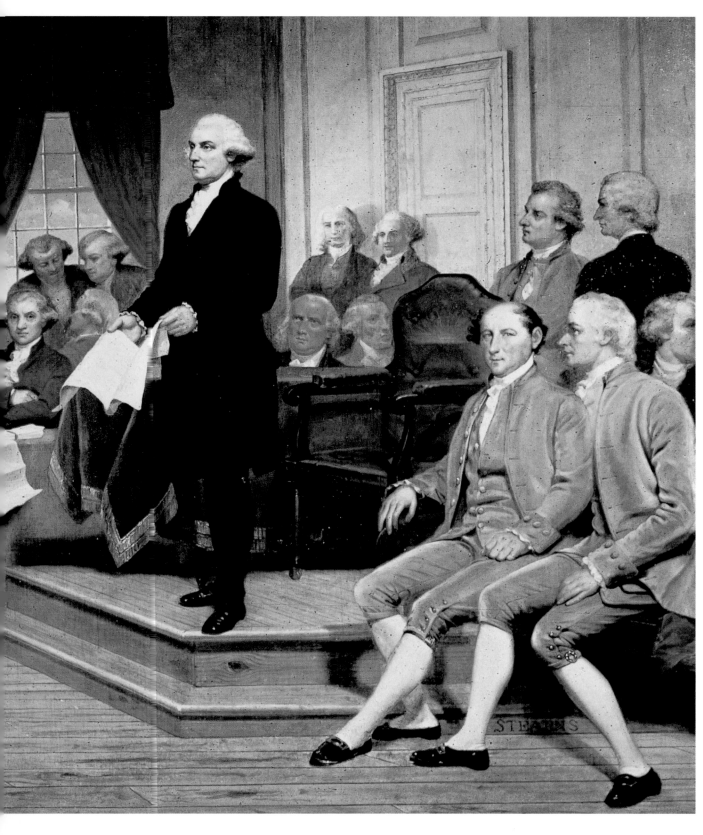

Junius Brutus Stearns. *Washington as Statesman at the Constitutional Convention. 1856. Oil on canvas. 37 ½ x 54 in. (95.3 x 137.2 cm). Virginia Museum of Fine Arts, Richmond. Gift of Edgar and Bernice Chrysler Garbisch.*

been made to curb diversity jurisdiction, these two fundamental types of jurisdiction remain in force today. On the other hand, court structure and rules of evidence and procedure have been subjected to constant change.

Even though federal and state court systems are separate from one another, they often interface at various levels. In some instances, the party bringing an action may have a choice of filing in either federal or state court, when both systems have jurisdiction. For example, this would apply to diversity jurisdiction cases. If the defendant does not like the plaintiff's choice of forum, he may be able to remove the case from state to federal court.

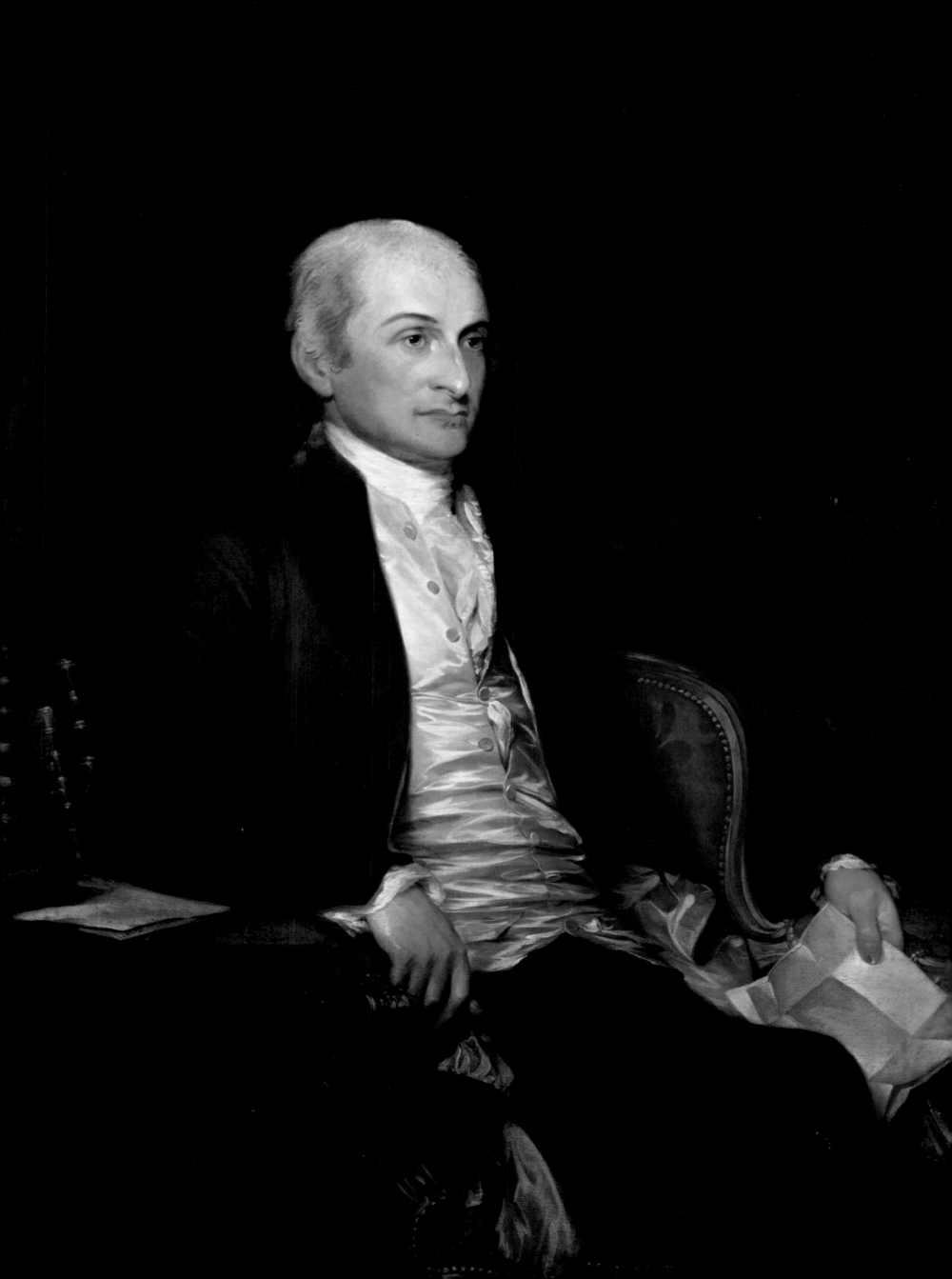

Additionally, cases begun in state court sometimes reach the United States Supreme Court when the petitioner argues that rights guaranteed by the United States Constitution have been violated and were not remedied in the state's courts. Section 25 of the Judiciary Act gives the U.S. Supreme Court appellate authority to review state court decisions involving federal questions and the federal Constitution.

The modern American court system developed from experimentation with a wide variety of legal systems reflecting the diverse cultures and traditions of the early inhabitants of our country. Certainly England had the most profound influence on the development of our system of justice, but even the British colonists did not reproduce the complicated, overlapping jurisdictional British courts, and most early colonies established a simpler court structure.

Each state has its own judicial and legal structure that reflects the history of that individual state. The legal systems differed according to the background of the colonists who settled that particular part of America. In states originally settled by the Dutch, French, and Spanish, the European civil code system of law was well established. When British immigrants subsequently settled in these areas with their pre-existing laws and customs, conflicts naturally arose over what law to apply and what judicial structure best enforced those laws. Civil law did not provide for trials by juries, and differs in many respects from English common law. Today, Louisiana is the only state in the country still governed by civil law derived from the Napoleonic Code. Common law, derived from the British legal system, exists in every other state and the federal government, often in an uneasy alliance with some local traditions remaining from civil law.

After the American Revolution, a legal debate arose over whether English common law should be rejected, followed, or modified. Neither Congress nor the Supreme Court could agree on what extent to apply common law or European civil law. The changing theories of jurisprudence were reflections of the changing economic and political times. The very role of the judge differed under the two systems: under the civil law system a judge is limited solely to interpreting legislation or the Constitution, while under the common law system a judge creates law. Consequently, the choice between common law and civil law involved objections to unelected individuals making law versus allowing an independent judiciary to react quickly to changing economic circumstances. The choice of jurisprudence also depended upon the political advantages of a strong federal judiciary versus the freedom advocated by those in favor of strong states' rights. In 1798, the Supreme Court held that since the common law varied from state to state there could be no federal common criminal law, assuaging early concerns that allowing federal criminal common law would allow a national Supreme Court to overwhelm state courts. Not until *Erie Railroad v. Tompkins* did the Supreme Court declare "(t)here is no federal general common law."

When Congress and the Supreme Court adopted English common law for the federal civil system, they created an immediate area of conflict with states and territories

Opposite: Gilbert Stuart. Believed to have been begun and finished by John Trumbull. Portrait of John Jay, c. 1783. 1804–1808 National Portrait Gallery, Smithsonian Institution/Art Resource, New York. John Jay was appointed first chief justice of the Supreme Court by George Washington in 1789.

without the tradition of trial by jury. The legal legacies reflected by each state's history led to conflict with the federal government's mandates in several areas, such as trial procedures. The attempts of various territories to modify the number of required jurors, or allow verdicts on less than a twelve-person jury, or do away with a jury altogether, came into conflict with the federal recognition of the right to a common-law jury, i.e., twelve men and a unanimous verdict. The attempt to resolve these various issues kept early territorial courts busy, but few records of these lower courts still exist. Even today these tensions can be seen in attempts to modify the jury system in both civil and criminal cases.

Some areas of the new republic were no more concerned with the type of jurisprudential theory than with having a judicial system at all. The perception of the "Wild Wild West" as lawless was accurate in the sense that a good portion of the West did not have a legal or judicial system. While the Northwest Ordinance ostensibly provided for territorial legal systems, many federal leaders felt the Northwest Ordinance was unconstitutional and would not enforce it. As president, Thomas Jefferson refused to appoint any judges to hear cases, leaving litigants little means of a peaceful resolution to conflicts. Appointments were made in Washington, D.C., often to individuals who knew little about any aspects of the territories they were to control. Settlers did not know what law applied to them and did not have a means to enforce the law or to redress grievances. When hearings were held, the judges were not necessarily impartial and may have known little about either the law or the circumstances; furthermore, their decisions were final, since for many years there were no means of appeal.

The conditions under which the territorial judges worked would appall many today. Often they did not have copies of the legislation they were interpreting, few legal materials or libraries were available, and even the question of whether or not the federal Constitutional Bill of Rights extended to the territories went unresolved.

No description of the history and growth of the federal and state court systems could exist without also discussing the tension between Federalists and states' rights advocates. Federalists felt the new country needed a strong federal court system, while Anti-federalists felt the well-developed system of state courts and laws were sufficient. While judicial independence was deemed important, many attendants at the Constitutional Convention were leery of the idea of unelected, appointed-for-life federal justices, considering the institution to be anti-democratic. Eventually a compromise was made allowing Congress to retain some democratic control: the president nominates appointees for the judiciary, while the appointees must be approved by a two-thirds majority of the Senate. This Advice and Consent power of the Senate created a method by which elected representatives could influence the executive and judicial branches. The two-thirds requirement for approval has led to bitter and contentious nomination hearings as the Senate has attempted to use its Advice and Consent powers to control either the Supreme Court or the president.

Ralph Earl. Portrait of Oliver Ellsworth and Abigail Wolcott Ellsworth. *1792. Oil on canvas. 75 ¹⁵⁄₁₆ x 86 ¾ in. (192.8 x 220 cm). Wadsworth Atheneum, Hartford. Gift of the Ellsworth Heirs. Photograph: Joseph Szaszfai. Oliver Ellsworth, second chief justice of the U.S. Supreme Court appointed by George Washington, favored a strong federal government, but suggested a compromise plan of shared power: part-federal, part national.*

In the early days of the republic, many citizens considered the judiciary the least powerful branch. This perception of the Supreme Court as a weaker, less prestigious branch made it difficult to find appointees willing to serve. Most of the early appointees had been deeply involved in the Revolution or the Constitutional Convention so their opinions were known both to the president and the Senate that approved them.

The early appointees were split between Federalists, who favored a strong federal government, and Anti-federalists, who would restrict the Supreme Court's power. In the end, the Federalists won. Both the first and second chief justices of the Supreme Court were appointed by George Washington, and helped set the groundwork for a strong and independent federal judiciary. When John Jay was appointed first chief justice by Washington in 1789, he had already served as president of the Continental Congress and as a diplomat to Spain. As chief justice, Jay refused to rule in advance on whether certain proposed government actions were legal, thereby helping to establish the independence of the Court. Jay resigned from the Court to become governor of New York in 1795. When George Washington appointed Oliver Ellsworth as the second chief justice, he knew Ellsworth would favor strong federal judicial power. Ellsworth's influence on America's judicial system continues today. It was Ellsworth who at the Constitutional Convention suggested the compromise plan of government: part federal, part national. As senator, he chaired the Judiciary Committee and was the principal author of the Judiciary Act of

1789, implementing Article III of the Constitution. While serving as chief justice for only six years, he started the tradition of one majority opinion, later adopted by Justice Marshall. Generally, Ellsworth upheld Congress's power to determine the jurisdiction of the federal courts and emphasized the adoption of English common law.

From the beginning, the Supreme Court was dominated by Federalists seeking stronger national power, but the third chief justice, John Marshall, is the one whose name is most closely associated with the expansion of the power of the federal judiciary. Chief Justice Marshall accomplished this expansion of power in several ways. First, he controlled how decisions were issued by continuing and strengthening Ellsworth's policy of majority opinions. Issuing only one opinion requires greater consensus and so appears to speak with a stronger voice, rather than the former British method of seriatum opinions issued by every justice. While hotly protested by some attorneys, the system of majority opinions led to a perception of unity of judicial thought. Marshall also influenced which cases were accepted on appeal, favoring cases highlighting conflict between the federal government and state governments. Marshall further increased federal power, and especially the Supreme Court's power, through the actual decisions that were rendered. Marshall's numerous opinions, as well as his strong personality, helped to establish the tradition of referring to the Court according to the tenure of the chief justice.

The Anti-federalists' concerns about a strong national Supreme Court were valid since almost every opinion of Marshall's term emphasized federal government over states' rights. *Marbury v. Madison* created a firestorm when Marshall declared that the judicial branch had the final decision on the constitutionality of Congressional legislation and ruled a legislative act unconstitutional.

Congress's influence over the Supreme Court extends beyond attempting to control the judiciary through the Senate's Advice and Consent powers and the Congressional power of impeachment. Congress's most important power is the ability to enact legislation establishing the federal courts' jurisdiction. Congress controls what types of cases the Court hears, and whether the Supreme Court acts as a trial court or solely an appellate court. While the Judiciary Act of 1789 establishing jurisdiction is still in effect today, there have been numerous attempts to revise and restrict the Supreme Court's jurisdiction.

Originally, Supreme Court justices rode circuits to hear trials as well as appeals in their appointed states. Congress established these circuits and traditionally left it to the chief justice to assign them, generally to minimize the justices' travel. Given the poor transportation system at the time, riding circuit was an uncomfortable, often arduous trip. Indeed, riding circuit was so disagreeable that Congress occasionally reassigned circuits to punish justices with whose opinion it disagreed. Finally, in 1891, Congress created circuit courts of appeals, which allows the Supreme Court justices to sit as circuit judges, but did away with the requirement that they do so.

The Senate's Advice and Consent power requires two-thirds approval of any presidential nominee to the federal judiciary. This two-thirds requirement has led to bitter hearings on the qualifications of these appointees. Recent Supreme Court nominations have become media events, with televised hearings and passionate opinions aired nationally. Though media coverage has increased, such controversies are not just a modern phenomenon. Disputes and contentious hearings have surrounded Supreme Court appointments since the earliest days, when President Washington's nominee John Rutledge was defeated. The bitter controversies between Federalists and states' rights' advocates were evident throughout the 1800s. The Civil War is foreshadowed by the nomination battles between 1840 and 1860, when over one-half of all Supreme Court nominees were rejected. The Senate uses its Advice and Consent powers much less today, with only about 20 percent of Supreme Court nominees rejected.

President Ronald Reagan's attempts to influence the Supreme Court by appointing conservative justices led to some contentious Senate hearings. In what was described as "[t]he most contentious confirmation battle in American history," D.C. Circuit Court of Appeals Judge Robert H. Bork was denied confirmation. Bork was a constitutional scholar whose confirmation hearings took place during the celebrations of the bicentennial year of the Constitution. The nationally televised hearings provided an opportunity for the entire nation to hear, discuss, and debate the Constitution as applied to modern life. While previous hearings were covered by the media, the extensive coverage of these rancorous hearings gave an unprecedented opportunity for the American public to become involved in influencing the Senate's confirmation vote. Bork became a living

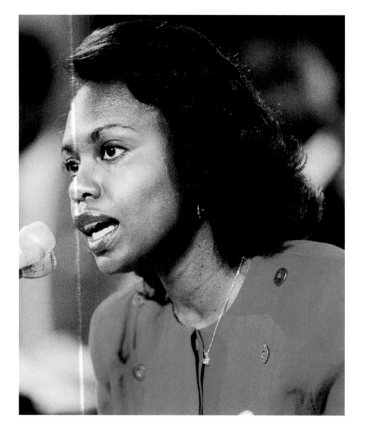

embodiment of the conflicting views of the role of the judiciary and methods of Constitutional interpretation. Ultimately, the Senate listened to the polls and the nominee, deciding that Bork's ideological views were not appropriate to the United States Supreme Court.

Most presidents attempt to appoint justices who they hope will vote according to the president's viewpoints. President Reagan, more than other presidents, required strong, expressed ideological affiliations from all his judicial appointees, regardless of the court. Nominees were scrutinized and nominated or rejected for their legal philosophies. Due to happenstance and the length of his term in office, President Reagan appointed more judges than any other president in history. By the time he left office, over half of all sitting judges had been appointed by Reagan. Altogether, he appointed more than four hundred federal judges, including four Supreme Court justices.

Above: Anita Hill during testimony before the Senate Judiciary Committee. 1991.

Right: Mike Peters. "Watch out when he offers to show you his briefs."

President George Bush appointed Clarence Thomas to the Supreme Court in 1991 to replace Thurgood Marshall, who was the first African-American appointed to the high court and had a reputation as a strong civil rights advocate. During the confirmation

hearings of the Senate Judiciary Committee, most of the dispute revolved around civil rights groups' objections to Thomas's conservative views. Just before the vote of the full Senate, however, Anita Hill's allegations of sexual harassment were leaked to the press. The Thomas hearings were reopened and televised to an avid, polarized national audience. Once again citizens had a chance to directly influence their representative's vote on an appointment to the Supreme Court. Eventually, Thomas was confirmed in the closest confirmation vote of this century: 52–48.

The Senate exerts more than Advice and Consent power over the judiciary; it possesses the power to remove federal judges from office through impeachment. In 1804, the Senate impeached U.S. Supreme Court Justice Samuel Chase, giving him the dubious honor of being the only Supreme Court justice ever impeached. George Washington had appointed Maryland's Samuel Chase to the Supreme Court in 1796. While he had an impressive history of public service, including signing the Declaration of Independence, Chase also had a controversial, discordant past. Chase, like other judges of his time, sometimes used his judicial powers for political purposes. He was so disliked during his tenure as justice that while riding circuit, lawyers in Philadelphia refused to practice before him. On January 5, 1804, the House voted 81–40–6 to decide whether to adopt articles of impeachment. The House ended up adopting eight articles of impeachment. But the motivation behind these proceedings was largely political, and one senator implied that Chase was merely the first Supreme Court justice to be tried, with perhaps Chief Justice Marshall next. After heated debate, the Senate found Chase guilty of two of the eight charges, but by less than two-thirds majority, leaving Chase in office.

Justice Chase's political legacy was to restrict the use of judicial impeachment for purely political differences. During Chief Justice Earl Warren's tenure, however, the Senate again tried to use impeachment for political purposes. While Warren is considered by many scholars to be the most influential chief justice since John Marshall, his constitutional opinions conflicted sharply with many senators. The Warren Court used the authority of the Fourteenth Amendment, which had lain virtually unused since the Civil War, to require states to afford civil rights previously only considered at the federal level. In *Brown v. Board of Education*, Thurgood Marshall guided the Supreme Court in its unanimous decision to overturn legal precedent and declare school segregation on the basis of race to be unconstitutional. In subsequent opinions, the Warren Court extended the procedural rights and protections of criminal law defendants. These decisions enraged states' rights advocates, who argued that the Court had veered into judicial legislation and away from Constitutional restraint. Eight state legislatures requested that Congress impeach Justice Warren. Bumper stickers declaring "Impeach Earl Warren" appeared around the country. While Congress did not begin impeachment proceedings, the outcry did lead to Congressional attempts to change the Supreme Court's jurisdiction. From 1956 to 1960, seventy bills were introduced attempting to curb the Supreme Court's jurisdiction,

Group portrait of the United States Supreme Court, Washington, D.C. April 20, 1982.

change requirements for appointees, or reduce the independence of the judiciary. Supporters of the Warren Court controlled the Senate, so none of the bills were enacted, although sometimes only by a single vote. Justice Warren eventually resigned from the Court due to ill health in 1969.

Together, the Chase impeachment trial and the call for Warren's impeachment serve to emphasize the importance of an independent judiciary in the American political process. Without the assurance of independent decision-making, a judge serves only at the whim of the legislature. If a judge can be removed for an unpopular opinion, there would be no check on legislative or executive powers.

Other than the right to appoint judges and justices, the president has little direct control over the judiciary. Disputes between the president and the Supreme Court are legion through American history. With little Constitutional power, the president must persuade Congress to use its legislative powers to control the courts. The classic example of the president's ability to persuade Congress to change the Supreme Court was when, in 1937, President Franklin Roosevelt tried to pack the Supreme Court in order to uphold New Deal legislation.

SAVE Our Republic

IMPEACH EARL WARREN

FOR INFORMATION WRITE . . .

President Roosevelt's attempts might constitute the notorious rift between the chief executive and the Court, but he was not the first president hostile to sitting federal judges. President Thomas Jefferson was passionately hostile to Chief Justice John Marshall and much of the federal judiciary. The partisan rivalries evident elsewhere in the early republic were vividly displayed during Jefferson's tenure. While Jefferson's Republican party dominated Congress in 1801, the Federalists still controlled the judiciary. In response, Jefferson attacked the federal judiciary on several fronts. His party repealed the Judiciary Act of 1801, which had created federal circuit courts, with judicial positions all filled by Federalists. Jefferson encouraged the House in impeaching New Hampshire District Court Judge Pickering, and then suggested the House begin impeachment proceedings against Justice Samuel Chase. After Chase was impeached but not removed, President Jefferson's direct attacks on the Federalist judiciary subsided.

At times, legislative actions directed at the Supreme Court are merely the result of bitter controversies between the president and Congress. For example, during Andrew Johnson's presidency, Congress and the president were constantly at odds. Andrew Johnson was such an unpopular president that when he tried to fill a vacancy on the Supreme Court his nominee was rejected. After letting the vacancy sit for two years he tried again. This time Congress not only denied confirmation of his nominee, it also immediately voted legislation reducing the size of the Court. To be safe, Congress reduced the number of justices by two, refusing to allow Johnson a nominee for the current vacancy, or any new one likely to arise before the end of his term.

The Supreme Court is the final arbiter of Constitutional interpretation, but it has no separate authority to enforce its decrees. Generally, the Court's orders are followed, but at times parties have refused to submit to the federal court's authority. In these instances of non-compliance, any enforcement action must be undertaken by another branch of government.

Historically, the executive branch has enforced Supreme Court decisions regardless of the president's own personal opinions. Rarely does the president or Congress refuse to comply with a judicial order. Such cases usually involve political disputes going to the nature of the checks and balances that exist at the heart of America's political system. In one recent case, President Richard Nixon refused to comply with a legislative subpoena ordering him to produce tapes then under Congressional investigation. Citing executive privilege, Nixon argued Congress had no power over the executive branch. Then the special prosecutor, acting in a judicial capacity, subpoenaed the tapes. Finally, in *U.S. v. Nixon*, the Supreme Court unanimously held the president had to obey the special prosecutor's subpoena. Article III of the impeachment charged Nixon with violating the presidential oath of office by failing to comply with the House Judiciary subpoena. Nixon's resignation left unresolved the question of whether the legislative branch has the political authority to subpoena the executive branch. The

Right: Courtroom drawing showing the Supreme Court of the United States hearing U.S. v. Nixon, 1974.

Page 156: Andy Warhol. Ten Portraits of Jews in the Twentieth Century: Louis Brandeis. 1980. One from a portfolio of ten screenprints and colophon. 40 x 32 in. (101.6 x 81.3 cm). The Andy Warhol Foundation, Inc. / Art Resource, New York. © 2001 Andy Warhol Foundation for the Visual Arts / ARS, New York.

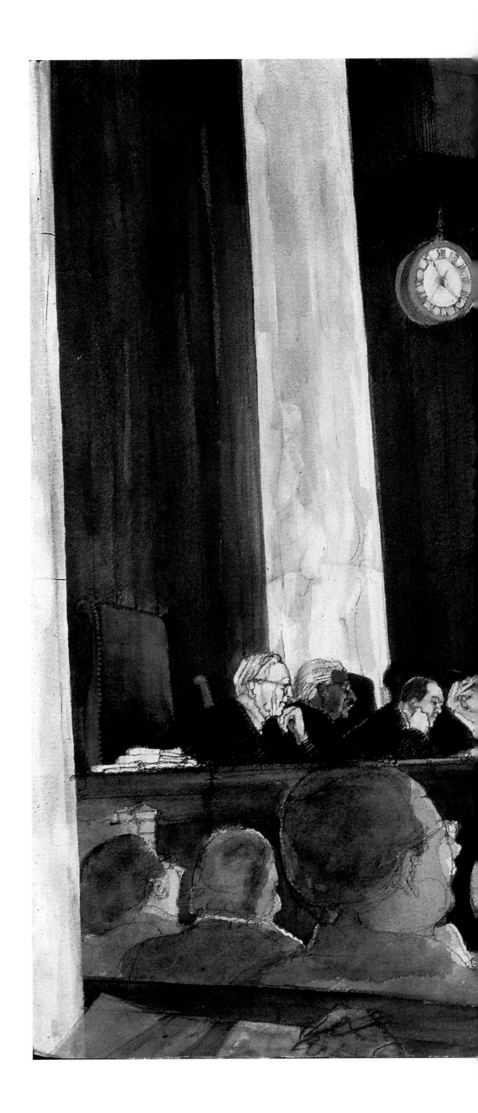

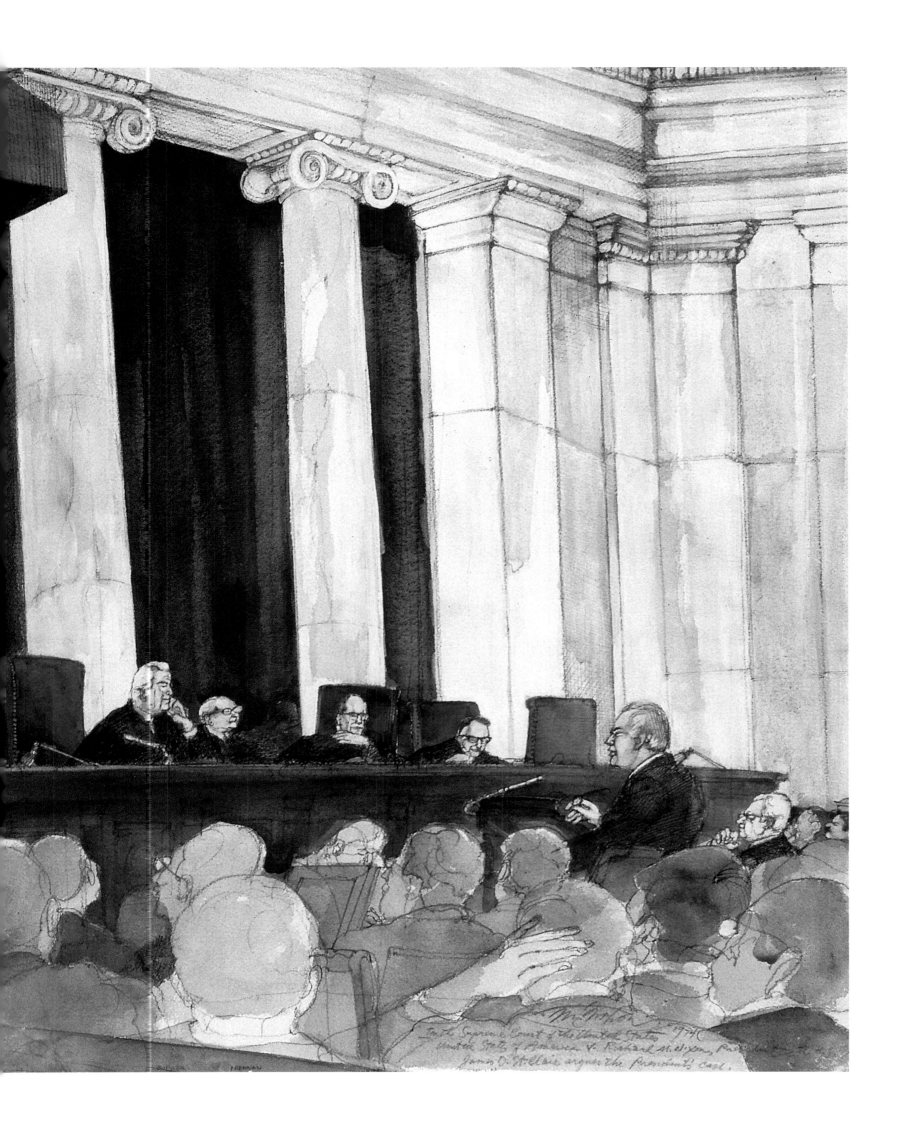

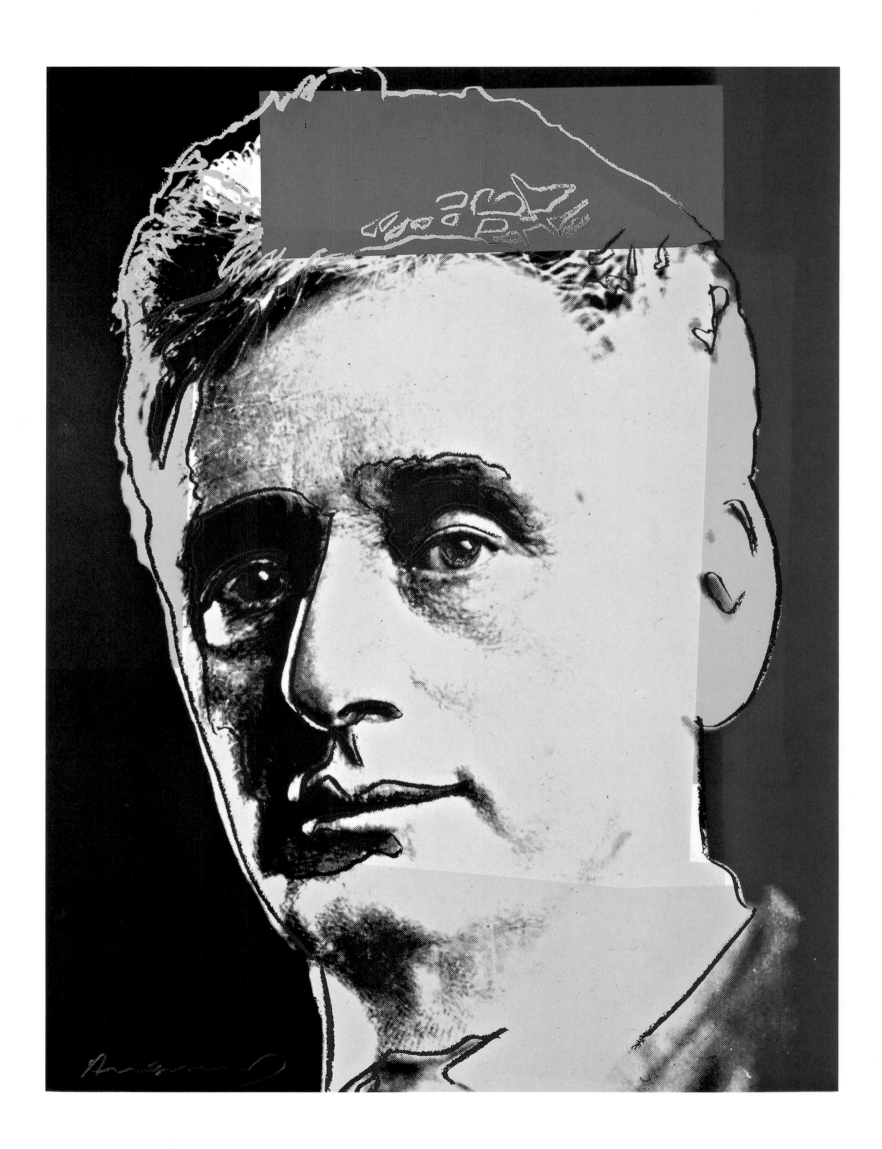

Supreme Court only declared its judicial orders must be obeyed, which Nixon ultimately did. Other judicial decisions, however, are allowed to languish without enforcement. For example, while *Brown v. Board of Education* ordered desegregation "with all due speed," the other branches of government did little to ensure desegregation was actually accomplished.

The most extreme example of a United States president refusing to enforce a Supreme Court decision arose as a result of the Court's opinion in *Worcester and Butler v. Georgia*. Justice Marshall and the Supreme Court ruled that the Cherokee nation was an independent nation with full sovereignty over all its land. However, Georgia refused to recognize the Supreme Court's judicial authority, declining to even argue the case before the Court and openly flouting its decision. Justice Marshall's decision implied that it was the president's responsibility to enforce federal treaties. President Andrew Jackson is alleged to have said, "John Marshall has made his decision; Let him enforce it if he can." The president not only refused to acknowledge the Court's decision, he assisted the state in contravening it by ordering federal troops to help state troops evacuate the Indian tribes. President Jackson used his executive power to override the decision of the Court and make possible the seizure of Cherokee nation lands by forcibly removing its Indian inhabitants from the southern states of Georgia and Florida. The evacuation is commonly referred to as the Trail of Tears due to the numbers of Indians that died as a

Judge Thurgood Marshall in discussion with President Lyndon Baines Johnson, following Marshall's Supreme Court appointment, the first African-American to hold a post on the nation's highest court. August 21, 1967.

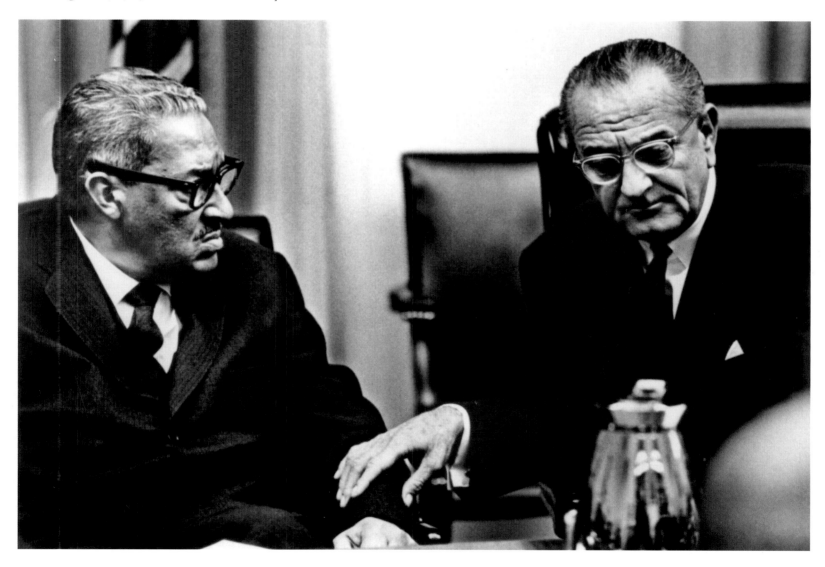

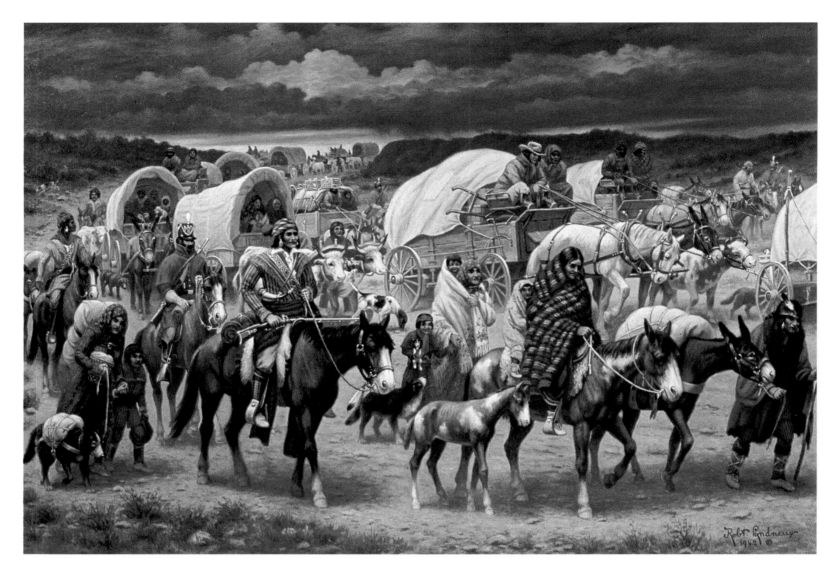

result of the harsh, cruel conditions of the forced winter march. No other president has so explicitly and flatly denied the enforcement of a Supreme Court decision.

America's courts reflect the social progress of the nation, seen both in terms of the composition of its judges as well as the decisions they render. In the early republic, since the country was politically divided along geographic lines, diversity in the judiciary was synonymous with and limited to geographic diversity. At the Supreme Court level, geographic diversity also had the practical effect of minimizing the justices' circuit travel. Otherwise, the Supreme Court consisted entirely of white, Protestant men of wealth and education, and the lower court judges came from similarly narrow backgrounds. Over time, the judiciary began to reflect the broader economic, cultural, and ethnic makeup of the nation.

Roger B. Taney, appointed chief justice of the United States Supreme Court in 1836, following John Marshall, was the first non-Protestant Supreme Court justice. It was nearly another century before the first Jew was appointed to the high court, with President Woodrow Wilson's nomination of respected lawyer and social crusader Louis D. Brandeis to the Supreme Court. Anti-Semitism was a strong factor in the heated four-month confirmation battle that followed this nomination, but the Brandeis appointment was ultimately affirmed. Afterwards, Brandeis continued to confront

Robert Lindneux. Trail of Tears. *Oil on canvas. Woolaroc Museum, Bartlesville, Oklahoma. It is estimated that nearly 3,500 Creek and 4,000 Cherokee Indians died as a result of the Indian Removal Act of 1830, forcing eastern Indians to cede their traditional homelands to the U.S. and relocate west of the Mississippi. The 800-mile journey, by rail, boat, wagon, and foot, came to be known as the "Trail of Tears."*

bigotry on the Court as well, and Justice James McReynolds would actually leave the room whenever Brandeis spoke during conferences. No official photograph of the Supreme Court of 1924 exists because McReynolds refused to be seated next to Brandeis, as was required by seniority.

While African-American attorneys were admitted to the bar shortly after the Civil War, restrictive laws soon followed restricting minorities and women's access to the practice of law. A hundred years went by before African-American judges started being appointed to the federal judiciary. When the African-American civil rights leader Thurgood Marshall was originally appointed to the Second Circuit Court of Appeals, southern senators on the Judiciary Committee dragged out the hostile confirmation proceedings for eleven months. In 1967, when President Johnson nominated Marshall to the Supreme Court after a less prolonged hearing, Marshall became the first African-American appointed to serve on the Supreme Court.

President Reagan fulfilled his presidential campaign promise to appoint a woman to the Supreme Court with his nomination of Sandra Day O'Connor as the first women to sit on the Court. Between O'Connor's moderate conservatism and the increasing cultural acceptance of women lawyers, she was approved unanimously by the Senate. When President Clinton appointed Ruth Bader Ginsberg as the second women to sit on the Supreme Court, little objection was made regarding having two women on the Court at the same time.

The increased importance of a multicultural society guarantees that it is only a matter of time before more "firsts" are appointed. The judiciary is a reflection of the passions and demands of its times. As the legal mechanism by which disputes are resolved, the court system constantly adapts to current needs while still retaining the traditions and customs of the past. New methods of dispute resolution are always evolving, from arbitration and mediation to revisions of procedures and new selection methods for judges.

America's multiple overlapping system of state and federal courts is sometimes deplored as unnecessarily confusing, but the differences allowed by multiple jurisdictions provide a number of benefits. The multiple systems act as a social laboratory in which it is possible to experiment with new models of social structures without endangering the country as a whole. Should the model prove successful, other states or the federal judiciary may replicate it; if not so successful, they may modify it or altogether refuse it. This opportunity for experimentation has made it possible to move forward with less risk in areas as diverse as allowing cameras in the courtroom and reducing the size of juries in civil cases, to exploring alternative means of dispute resolution and devising new rules of procedure and methods for selecting judges.

Above: The current justices of the U.S. Supreme Court. Top left: Associate Justices Ruth Bader Ginsburg, David Souter, Clarence Thomas, and Stephen Breyer. Bottom left: Associate Justices Antonin Scalia, John Paul Stevens, Chief Justice William Rehnquist, Associate Justices Sandra Day O'Connor, and Anthony Kennedy.

Opposite: President Franklin Roosevelt prepares to deliver his first Fireside Chat, March 12, 1933.

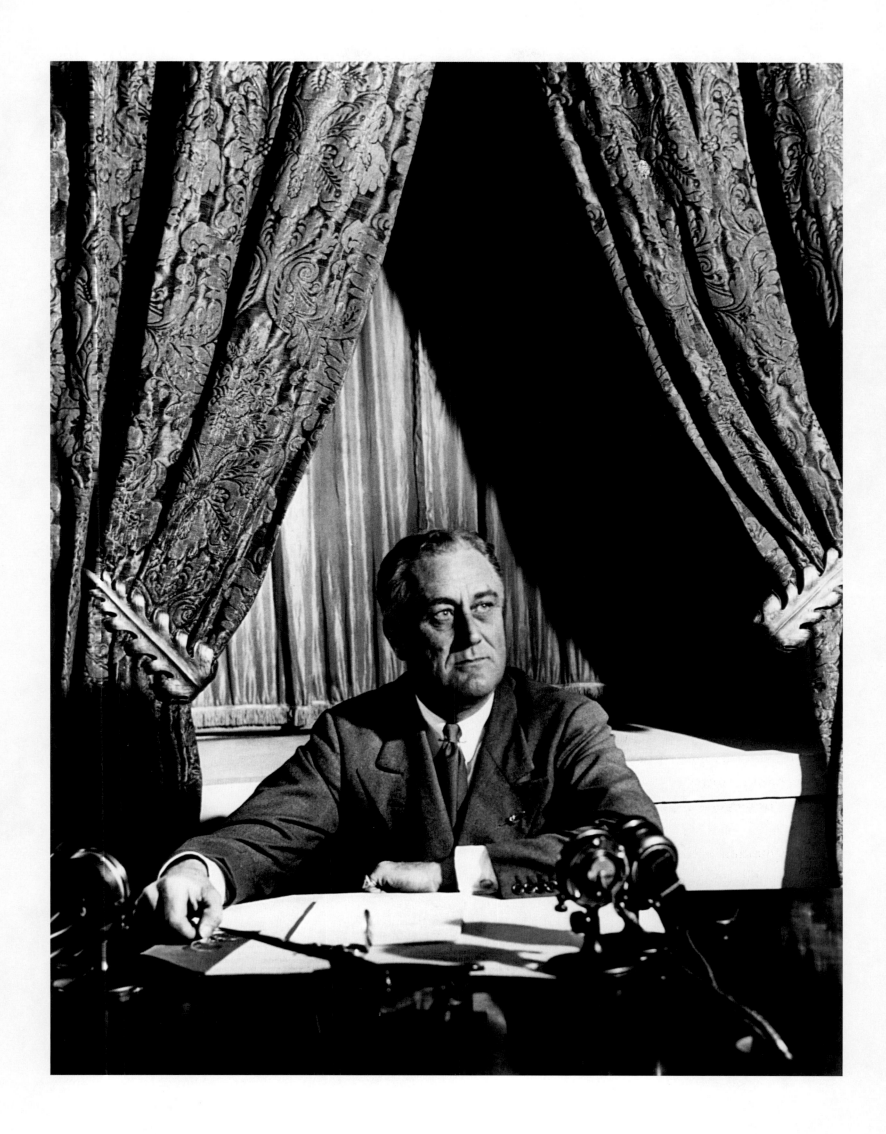

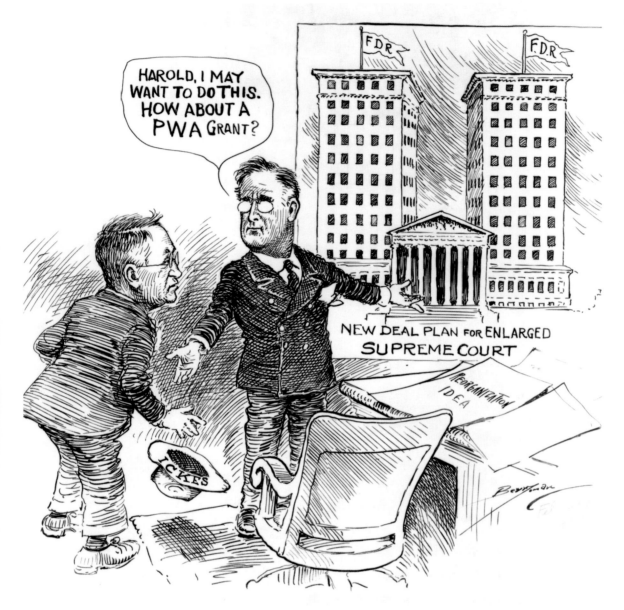

Clifford Berryman. "New Deal Plan for Enlarged Supreme Court." 1937. © 1937 The Washington Post. Reprinted with permission.

FDR'S COURT-PACKING PLAN

President Franklin Roosevelt's effort in 1937 to increase the number of justices on the U.S. Supreme Court, known as the "Court-Packing Plan," was a highly controversial attempt to save New Deal programs from the hostile action of the conservative Court that had struck down major elements of the president's program. Efforts to clip the wings of the Court were nothing new. Over the decades, Congress had changed the membership from five to six in 1801, to nine in 1837, to ten in 1863, and to seven in 1866. Since 1879, the number has been nine. By 1937, six of the justices were over seventy years old. Roosevelt's plan would give the president authority to appoint a new justice for every one on the bench who reached the age of

seventy and refused to retire. Congress, however, saw the plan as an attempt to destroy the independence of the judiciary and upset the balance of powers. Seen within the context of contemporary events in Europe, where dictators were warping democratic constitutions to give themselves extraordinary powers, the American public was alerted to this scheme. Then, some three months after Congress received the proposal, the Court reversed itself and supported important New Deal legislation, thought of as "the stitch in time that saved nine." In addition, one of the most conservative justices, Justice Willis VanDevanter, resigned just as Congress refused to pass the bill. The proposal is thought of as the most serious miscalculation—indeed an egregious blunder—of Roosevelt's long political career.

Political cartoon by J. N. "Ding" Darling depicting Franklin Roosevelt's "Court-Packing Plan" and the opposition to it. 1937.

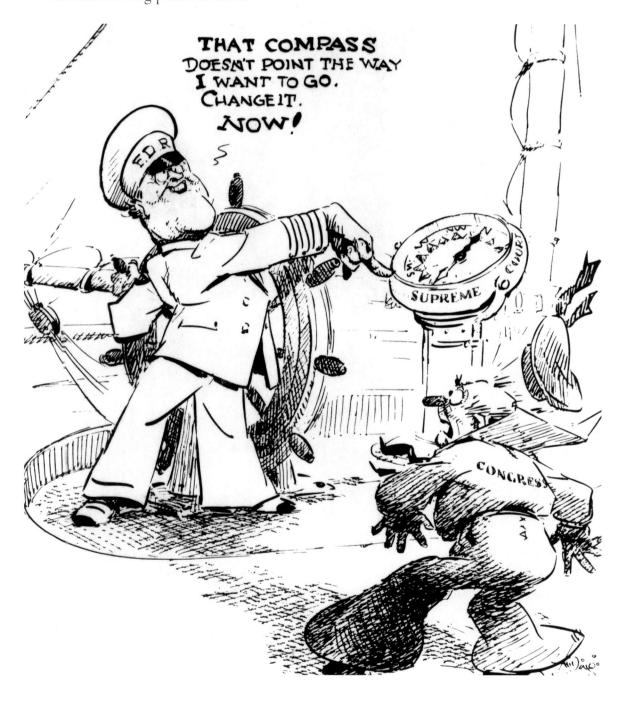

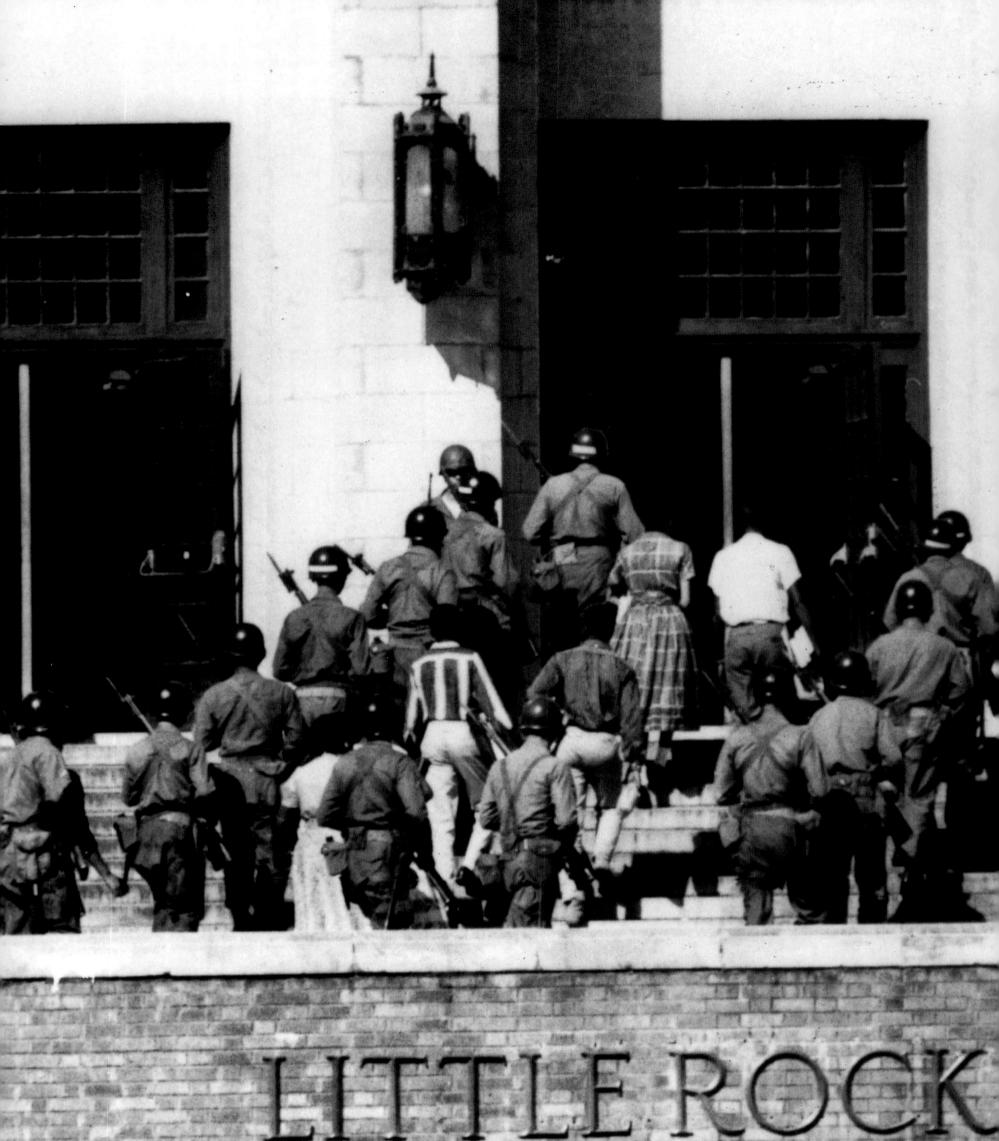

LITTLE ROCK

CHAPTER VI

LANDMARK CASES

John Marshall, chief justice of the Supreme Court from 1801 to 1835, was a politician as well as a jurist. His influence lay in the area of broad national policy, and his modus operandi was constitutional interpretation. A promulgator of principles, Marshall wrote whole opinions of deep significance without citing a single precedent. Through the force of his intellect and sharp political skills, further enhanced by his commanding physical presence and gregarious personality, Marshall managed to make most of the Supreme Court decisions unanimous. Before sitting on the high court, he had practiced law in Virginia during the last quarter of the eighteenth century, was a member of the state convention that ratified the Constitution in 1788, and was John Adams's secretary of state.

The following three cases, all unanimously decided with opinions by Marshall, established constitutional principles and economic policy fundamental to the American system. Of primary significance is Marshall's logical construction and articulation of the concept and rationale for judicial review in *Marbury v. Madison*, his statement of the immutability of contracts in the *Dartmouth College* case, and his expansive interpretation of congressional power in *McCulloch v. Maryland*. No chief justice over the whole sweep of United States history comes close in significance to "the great chief justice."

MARBURY v. MADISON (1803)

The case of *Marbury v. Madison* arose out of the partisan political battles of a new nation struggling to survive. Thomas Jefferson and the Republicans won the elections of 1800, taking from John Adams and the Federalist Party both the executive and the legislative branches of the new national government.

The old lame-duck Federalist Congress was determined to establish a partisan bulwark in the judicial branch to counter the new Jeffersonian Republican government. To that end, Congress hurried to put in place sixteen new circuit court judges and an unlimited

Opposite: Integration at Central High School, Little Rock, Arkansas, September 25, 1957 (detail).

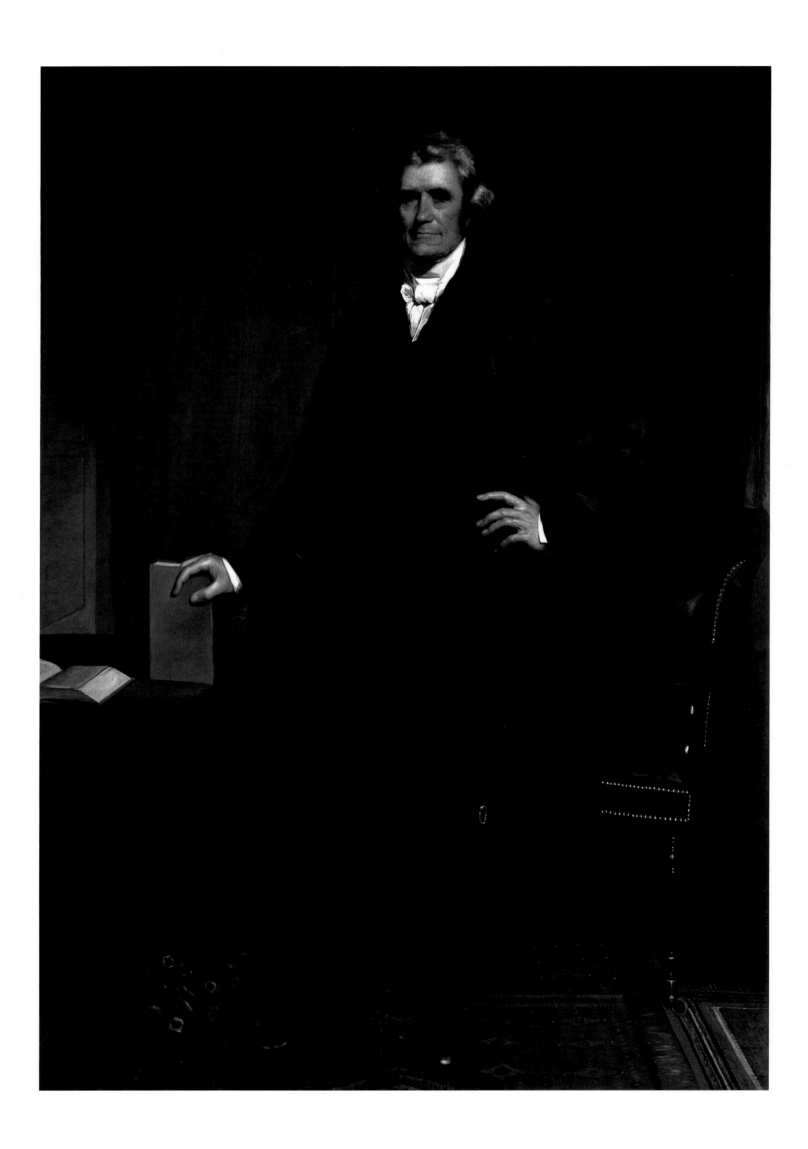

number of local justices of the peace for the District of Columbia. Adams appointed forty-two of them, along with scores of miscellaneous marshals, clerks, and doorkeepers.

On his last day as president, Adams still needed to find, appoint, and seek Senate confirmation for all these judicial functionaries. By his usual bedtime of 9:00 on March 3, the job was done, and the sleepy president sent the commissions over to the State Department, where the secretary of state would affix the official seal. That, too, was done. But the process was not complete; one more crucial step needed to be taken. The commissions had to be delivered.

The chore fell to a laid-back Virginia gentleman, soldier, politician, and moderate Federalist of the Adams persuasion, a decided and life-long enemy of Thomas Jefferson. This was John Marshall, forty-five years old, Adams's secretary of state, and a Federalist from Virginia. Not only was Marshall secretary of state in the Adams administration, he was also Adams's appointee for chief justice of the U.S. Supreme Court. But Marshall still occupied the secretary of state office for a couple of weeks into Jefferson's presidency because, despite their deep mutual animosity, Jefferson asked him to carry on briefly while his secretary of state–elect, James Madison, stood vigil by the bedside of his dying father.

Marshall's relaxed southern habits betrayed him because he dallied, not seeing to the chore of delivering Adams's last minute justices' commissions. Among those left in the secretary's office when Madison took over was that of William Marbury. When Jefferson realized the extent of the Federalist rearguard action, he ordered Madison—now fully functioning as secretary of state—to withhold the commissions. Marbury went to court—to the U.S. Supreme Court—where John Marshall now sat as chief justice. Acting under a provision of the Judiciary Act of 1789 giving the Court original jurisdiction in cases involving "persons holding office under the authority of the United States," Marbury asked the court to issue a writ of mandamus ordering Madison to deliver the commission.

Of course Marbury had a right to his commission, Marshall declared in his opinion. It had been signed and sealed; non-delivery did not invalidate it. But leaving it at that left Marshall face to face with Madison and Jefferson in a confrontation he knew he could not win. What to do?

Marshall had an agenda, one element of which was to assert the authority of the judicial branch vis-à-vis the other two "political" branches. While leaving wide latitude for executive discretion as to the limits of its own authority, Marshall laid down principles of what we know now as negative judicial review. By doing just that, Marshall could articulate and perhaps canonize the Court's role as the ultimate voice on what the Constitution means—and at the same time keep that authority safely in the hands of Federalist partisans for a long time to come.

The U.S. Constitution says in Article III, Section 2, that, "In all Cases affecting Ambassadors, other public Ministers and consuls, and those in which a State shall be a Party, the Supreme Court shall have original jurisdiction. In all other cases . . . the Supreme Court shall have appellate Jurisdiction." But the Judiciary Act of 1789 extended original jurisdiction to "persons holding office under the authority of the United States." Wasn't that an alteration of the Constitution? And wasn't Congress limited by the terms of that document? The answer was yes.

In the American legal hierarchy, the U.S. Constitution stands at the top: "A law repugnant to the Constitution is void." Thus, though Marbury's commission was legitimate, and he had a legal right to it, the Marshall Court found that the U.S. Supreme Court could not issue the writ of mandamus ordering Madison to deliver it. The Judiciary Act of 1789 violated the Constitution by altering the terms of the original jurisdiction of the Court; that jurisdiction, under the Constitution, did not extend to "persons holding office under the United States." Marbury, ultimately, lost his case.

Within a political context in which he was a major player, and with an administrative error he himself perpetuated, Marshall found the materials to assert the Court's authority to declare congressional acts void. *Marbury v. Madison* thus became the foundation for all subsequent judicial review of state and national legislation, cited by name to this very day in virtually every case where judges overturn misbegotten statutes.

TRUSTEES OF DARTMOUTH COLLEGE v. WOODWARD (1816)

Chief Justice Marshall handed down an equally far-reaching decision in the *Dartmouth College* case. When the War of 1812 was over, local manufacturing that had grown while British imports were prohibited needed all the help they could get. Subsidies, tax breaks, and monopoly charters were lavished on them by state legislatures, but still the youthful American system of private capital and free enterprise was stressed. Investors needed encouragement.

The best thing states could do for eager but struggling entrepreneurs and their potential investors was to grant them corporate charters with liberal terms. But did such grants guarantee long-term freedom from legislative interference? How safe would corporations be from the fickle whims of annually elected state legislatures? And what exactly was a corporate charter? Was it, too, a contract? That question would be answered in the crucial case of *Dartmouth College v. Woodward* in 1816.

In 1815, a long-simmering squabble between John Wheelock, president of Dartmouth College since 1779, along with his treasurer, William H. Woodward, on one side and most of the faculty and trustees of Dartmouth on the other became public and political. Wheelock was fired by the trustees. But he persuaded the New Hampshire legislature to incorporate a new institution by the name of Dartmouth University. Twenty-one of

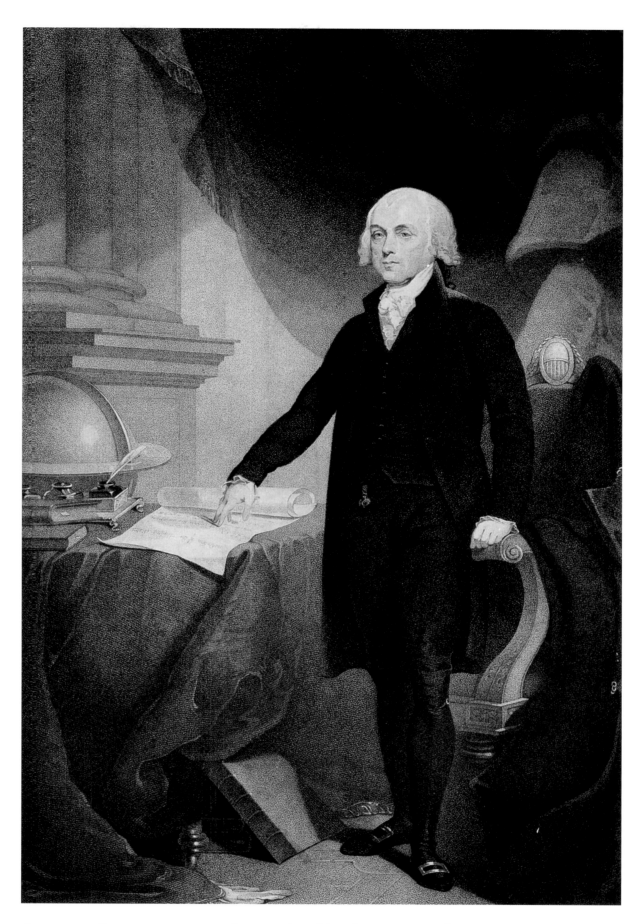

David Edwin, after Thomas Sully, after Gilbert Stuart. James Madison. 1810. Stipple engraving. 19 ¹³/₁₆ x 13 ½ in. (50.3 x 33.3 cm). National Portrait Gallery, Smithsonian Institution/ Art Resource, New York. Madison was secretary of state under Thomas Jefferson when Marbury v. Madison *challenged the jurisdiction of the court.*

the twenty-five trustees were to be appointed by the governor, thus turning a private college into a public university.

Over the next three years, the old trustees boycotted the meetings of the new ones; some students enrolled in one institution and some in the other, and they all rioted over possession of the library and other buildings. Wheelock and Woodward hung on to the

college records and funds though they were legally officers of the university. Finally, they both died. In the meantime, the trustees of the old college had instituted a suit that went on appeal to the U.S. Supreme Court. The outcome would answer the question whether American constitutional law would foster unfettered private free enterprise or leave room for government restriction and interference at legislative discretion. In short, what was to be the scope of private enterprise in the United States?

Dartmouth College v. Woodward fed into two of the objectives of Chief Justice John Marshall: to restrict the scope of state legislatures in general, and to protect private property rights from legislative encroachment in particular. But first, one sticky point needed some clarification.

The Dartmouth charter was not a grant of the New Hampshire legislature, but, rather, had been given to John Wheelock's father in 1769 by no less than George III. Now, two generations and a revolution later, was that charter still sacrosanct? Marshall made short shrift of that matter —a mere technicality: "It can require no argument to prove, that the circumstances of this case constitute a contract. An application is made . . . The charter is granted, and . . . property is conveyed. Surely in this transaction every ingredient of a complete and legitimate contract is to be found."

Is it, however, a public charter, like that given to towns and cities, which could be altered? Not at all, declared Marshall. Dartmouth College is a "private eleemosynary institution" and "endowed by private individuals." It is a private institution holding a private charter. The charter, then, is a contract, and the state of New Hampshire is barred by the U.S. Constitution from impairing it.

The outcome of this case, decided at a propitious moment is American history when business enterprise was burgeoning and corporate charters were just coming into their own, made safe the projections of capitalists and guaranteed to potential stockholders that their investments would be free of legislative interference.

McCULLOCH v. MARYLAND (1819)

In the case of *McCulloch v. Maryland*, Marshall answered a question that had arisen a generation earlier. President Washington had been an attentive listener at the Philadelphia Convention; he knew that giving Congress authority to establish a national bank had been proposed and rejected. Now, as president in 1790, he wondered if such a project would be constitutional. Washington turned to his secretary of state, Thomas Jefferson, who was something of a states rights man and feared an overweening centralizing authority. Jefferson told the president that this power was clearly outside the purview of Congress. Nothing could be found in the Constitution to support it and, most emphatically, the power to establish a bank could not possibly be implied by the so-called elastic necessary and proper clause. Surely there was nothing necessary about establishing a national bank.

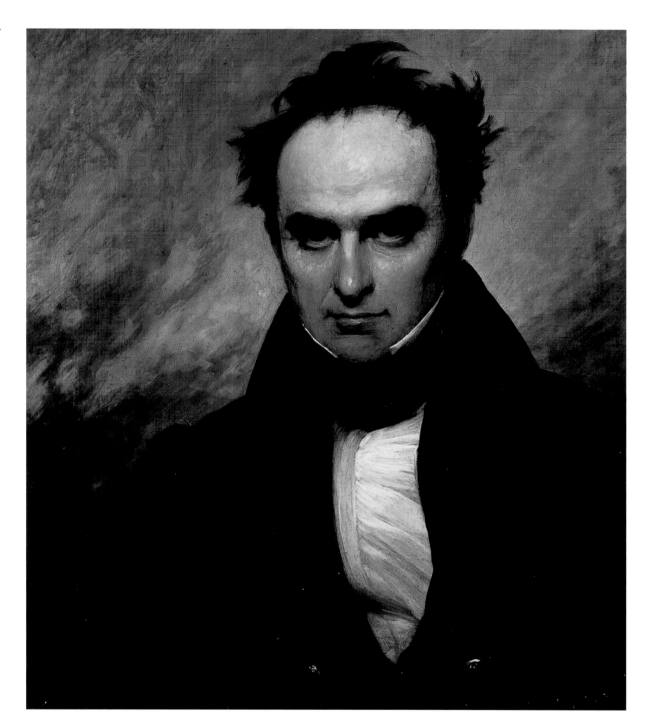

Nonsense! said Alexander Hamilton, the energetic, brilliant, and aggressive secretary of the treasury. Hamilton had submitted a broad-scale fiscal program for the new nation. A bank was essential. And, according to Hamilton, "necessary often means no more than needful." In the end, Washington was persuaded by Hamilton, and the bank was established. But the battle was not over.

Though the bank became a reality, it remained controversial for years, and when it began to establish branches in major cities in competition with local state-chartered banks, the controversy became hotly political and, ultimately, constitutional. It arrived at the U.S. Supreme Court in 1819 as *McCulloch v. Maryland.* A Bank of the United States branch in Baltimore was close to running the local state-chartered bank out of business. The Maryland legislature levied a tax on every bank note issued by the BUS. McCulloch, the branch treasurer, refused to pay it and was arrested. His case came to the Supreme Court.

Chief Justice Marshall found that the state of Maryland had no right to tax the BUS, an arm of the national government, based on the argument that the power to tax involved the power to destroy. Marshall said that Congress had the power to do anything that was useful, conducive to, or even just appropriate to carrying out its responsibilities. "Let the end be legitimate," Marshall wrote, ". . . all means which are appropriate . . . are constitutional." Thus emerged a broad constitutional interpretation establishing the supremacy of the federal government over the states.

DRED SCOTT v. SANFORD (1857)

Roger Brook Taney followed John Marshall as chief justice. Appointed by President Andrew Jackson, he would serve over twenty-eight years and die during the Civil War, a conflict for which he must accept a share of the responsibility. In 1857, Taney, eighty years old and sick and broken by the death of his wife and daughter within hours of each other, rendered the Dred Scott decision, which served to feed a firestorm of controversy that ultimately resulted in the outbreak of the Civil War. The consensus on the Dred Scott opinion for the entire period since 1857 has been negative, on grounds of both constitutional reasoning and policy judgment. Taney's reputation has been darkened beyond recovery by this great judicial cloud.

Louis Schultze. Dred Scott. 1881. Oil on canvas. 27 x 30 in. (68.6 x 76.2 cm). Missouri Historical Society, St. Louis.

United States citizenship was not defined with any precision until the Fourteenth Amendment was added to the Constitution after the Civil War in 1868. For white Americans, state citizenship was enough for most purposes, and in a general sense citizens of a state were citizens of the United States when, for instance, traveling abroad.

Slaves could not be citizens anywhere in the U.S., and state and federal courts had affirmed that fact often in the years preceding the Dred Scott decision. By the 1830s, the question of the extension of slavery into the western territories was central to American politics, and the nation looked to the courts for an authoritative decision as to whether free blacks could be citizens and what the implications were for the further spread of slavery.

Dred Scott was owned by a Missouri military physician who was assigned to posts in Illinois and Minnesota, where slavery was illegal. When Scott returned to Missouri,

Eyre Crow. Slave Auction. Oil on canvas. Private Collection. Photograph courtesy of Kennedy Galleries, New York.

Engraving of Dred Scott, his wife, and children from Frank Leslie's Illustrated Newspaper, *June 27, 1857.*

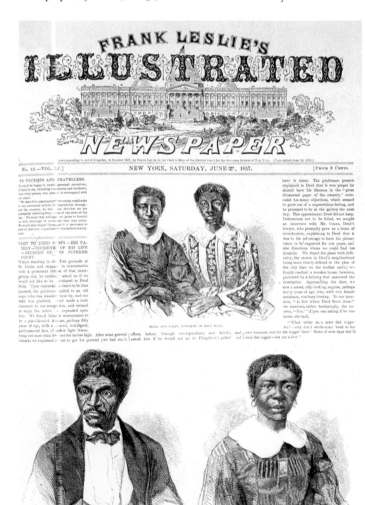

he sued for his freedom on the grounds that a sojourn in a free state or territory had the effect of emancipating him.

At the moment the case came before the Supreme Court, emotions across the nation could hardly have been more intense. North and South stood at loggerheads over the slavery issue. Taney now felt he could safely and forever resolve tensions by a sweeping opinion in the case of *Dred Scott v. Sanford.* But the exploding bombs at Fort Sumpter four years later would signal how badly out of touch the old justice was with reality.

Taney declared that Negroes in America "had no rights which the white man was bound to respect." African-Americans were not citizens, and neither Congress nor any state could make them citizens. Slaves were property, and Congress by mere legislation could not divest slaveholders of it, not in the territories, not in the states. Congress could not authorize territorial legislatures to outlaw slavery.

The outcome of *Dred Scott v. Sanford* did not cause the Civil War, but it was a central episode in the events that brought on the bloodiest of all American conflicts. And it shaped the wording of the Fourteenth Amendment, which explicitly overrode the Dred Scott decision: "All persons born or naturalized in the United States, and subject to the jurisdiction thereof, are citizens of the United States and of the State wherein they reside."

THE SLAUGHTERHOUSE CASES

(Butchers' Benevolent Association of New Orleans v. The Crescent City Livestock Landing and Slaughterhouse Co.) (1873)

The Civil War was over in 1865, but the struggle over civil rights for the Freedmen had just begun. Efforts by Congress to assure fair and equal treatment of African-Americans had come up in the Supreme Court previously, but none so fundamentally devastating as that rendered in the Slaughterhouse Cases.

The principal constitutional result of the Civil War was the Fourteenth Amendment to the U.S. Constitution. This amendment, ratified in 1868, altered the American federal system by shifting the balance of power from the states to the United States. While the primary objective was to guarantee Freedmen the rights of citizenship, a secondary objective was to nationalize protections of commonly agreed fundamental rights. The Court's initial—and therefore most significant—interpretation of the Fourteenth Amendment came in 1873 in the Slaughterhouse Cases.

The facts, interestingly, have nothing to do with former slaves. The government in Louisiana granted an exclusive charter for butchering animals to a single slaughterhouse in all of New Orleans. The avowed justification was to protect the health and welfare of the good people of Louisiana by making inspection of such places more efficient. This may have been reasonable, but at the same time the statute deprived about a thousand butchers of their livelihoods—certainly one of the fundamental rights guaranteed to all Americans under natural and common law traditions. The abused butchers sued in a string of cases collectively known as the Slaughterhouse Cases.

The Fourteenth Amendment says: "All persons born or naturalized in the United States and subject to the jurisdiction thereof, are citizens of the United States and of the State wherein they reside. No State shall make or enforce any law which shall abridge the privileges or immunities of the citizens of the United States." The plaintiffs' principal argument rested on this privileges of immunities clause. The Court did not dispute that the right to practice one's trade was without question one of those privileges.

But the Court saw other principles in the butcher's calamity. It pointed out that the amendment distinguished United States citizenship from state citizenship. Each had its own set of rights. United States rights extended to such things as the right to petition the national government, and to protection on the high seas and when abroad. The great body of traditional rights, claimed Justice Samuel Miller, inhered in persons because of their state citizenship. The right to practice a trade was one of those state rights. The amendment said only that no state shall deprive a person of the "privileges or immunities of citizenship of the United States." If the butchers of New Orleans had a complaint, their only recourse was to the courts of the states, a most discouraging prospect for the abused butchers.

There were four dissenters and three dissenting opinions. In the long run, these dissenting opinions were more significant than the majority decision. That of Justice Stephen J. Field, for instance, claimed that such a basic right—and by extension many others—was so fundamental as to require no explicit statement and should be protected by the national government against any state abridgement. He invoked the equal protections and due process clauses, and applied them in a way that foresaw the expansion of federal protections of rights in the twentieth century.

But that was for the future. What the *Slaughterhouse* decision meant was that states could violate at will all sorts of civil rights considered to have no federal basis. One of these privileges and immunities is the right to vote; another is the use of public facilities. Many states under this doctrine of dual citizenship found the means to deprive millions of citizens—mostly black or female—of the right to vote, to practice law and other professions, to an equal education, to marry persons of a different race, and numerous other of the conditions that allow all Americans to pursue their happiness.

J. Kepple- The Bosses of the Senate. Enormous trusts wielding power over the economy had significant influence on Congress as well.

NORTHERN SECURITIES CO. v. UNITED STATES (1904)

Whereas the *Slaughterhouse Cases* in the Court sanctioned a government-created private monopoly, in *Northern Securities Co. v. United States*, the U.S. government would for the first time dismantle one of the monster corporations that controlled much of the American economy.

THE BOSSES OF THE SENATE.

Industrial growth following the Civil War resulted in the emergence of tens of thousands of small entrepreneurs. At the same time, new technology vastly increased the cost of establishing business. Thus, the cost of a primitive oil refinery in the 1850s was about $500, but had grown, with technological complexity, to $72,000 when J. D. Rockefeller bought his first refinery in 1865. The result was combinations of industries. Industrialists found more and more ingenious ways to combine for the purpose of eliminating cut-throat competition. Not only were there trusts in sugar, oil, and steel, but also in bicycles, playing cards, whiskey, coal, salt, cotton seed, and more. By the 1880s, it was clear to the public and to the business community that some controls had to be put in place by the federal government.

Astride them all, stretching from Chicago to San Francisco, were three great railroad networks: the Northern Pacific, the Union Pacific, and the Chicago, Burlington & Quincy. The first of these was controlled by the financial czar of Wall Street, J. Pierpont Morgan. He was allied with J. J. Hill, who controlled the Great Northern, which in turn closely patrolled the Northern Pacific. South of these was Edward Harriman's Union Pacific. Whoever could get control of the Chicago, Burlington & Quincy could control transcontinental transportation out of Chicago, which meant virtually everywhere. First Harriman and then Hill went to work to gain control of the Burlington. When it looked like the dust would never settle, the combatants declared a truce, joined together, declared a collective victory, and set up a mammoth trust capitalized at $400 million, called the Northern Securities Company. That arrangement, launched in May 1901, was not completed until November. In the meantime, someone shot President William McKinley, and Teddy Roosevelt, "that darned cowboy" (as McKinley supporter Mark Hannah characterized him), became president. Roosevelt had different ideas.

Roosevelt was determined to assert the force of government, as much to make the point of who was boss as to remedy the problem of monopoly. He charged his attorney general, Philander C. Knox, with the job of bringing the Sherman Antitrust Act to bear on the Northern Securities combine. On March 10, 1902, suit was filed. The legal issue came down to the question of whether a "mere" stock trade constituted interstate commerce under the terms of the Sherman Act. In the end Northern Securities lost in a 5–4 decision. The Court's close decision was not a death blow to monopolistic consolidations. Consolidations continued, though much abated.

Teddy Roosevelt's successor, William Howard Taft, launched many more "trust busting" suits than did Roosevelt. More by effective creation of a symbolic episode than by practical results, Teddy Roosevelt had made his point: the United States government and, in the end, Teddy Roosevelt, were bigger than Northern Securities and J. P. Morgan.

SCHENCK v. UNITED STATES (1919)

Perhaps no Supreme Court justice has written a phrase better known by the American public than Oliver Wendell Holmes's "shouting fire in a crowded theater" comment. The words were in the case *Schenck v. United States*, and the subject was freedom of speech.

Wars and insurrections tend to provoke panic in civilian populations; for instance, Lincoln's suspension of civil rights during the Civil War and the callous internment of Japanese-Americans in the wake of Pearl Harbor were measures taken as a result of waves of panic. World War I was no exception, and, in fact, unreasoned panic may have been more widespread and intense in 1917 and 1919 than it was in 1861 or 1941. A deep and prevailing suspicion by Americans of perceived enemies within—Germans, especially, but also anarchists and communists—existed in 1917 because it was not only the year of the United States' entry into the war, but also of the Bolshevik coup d'état in Russia.

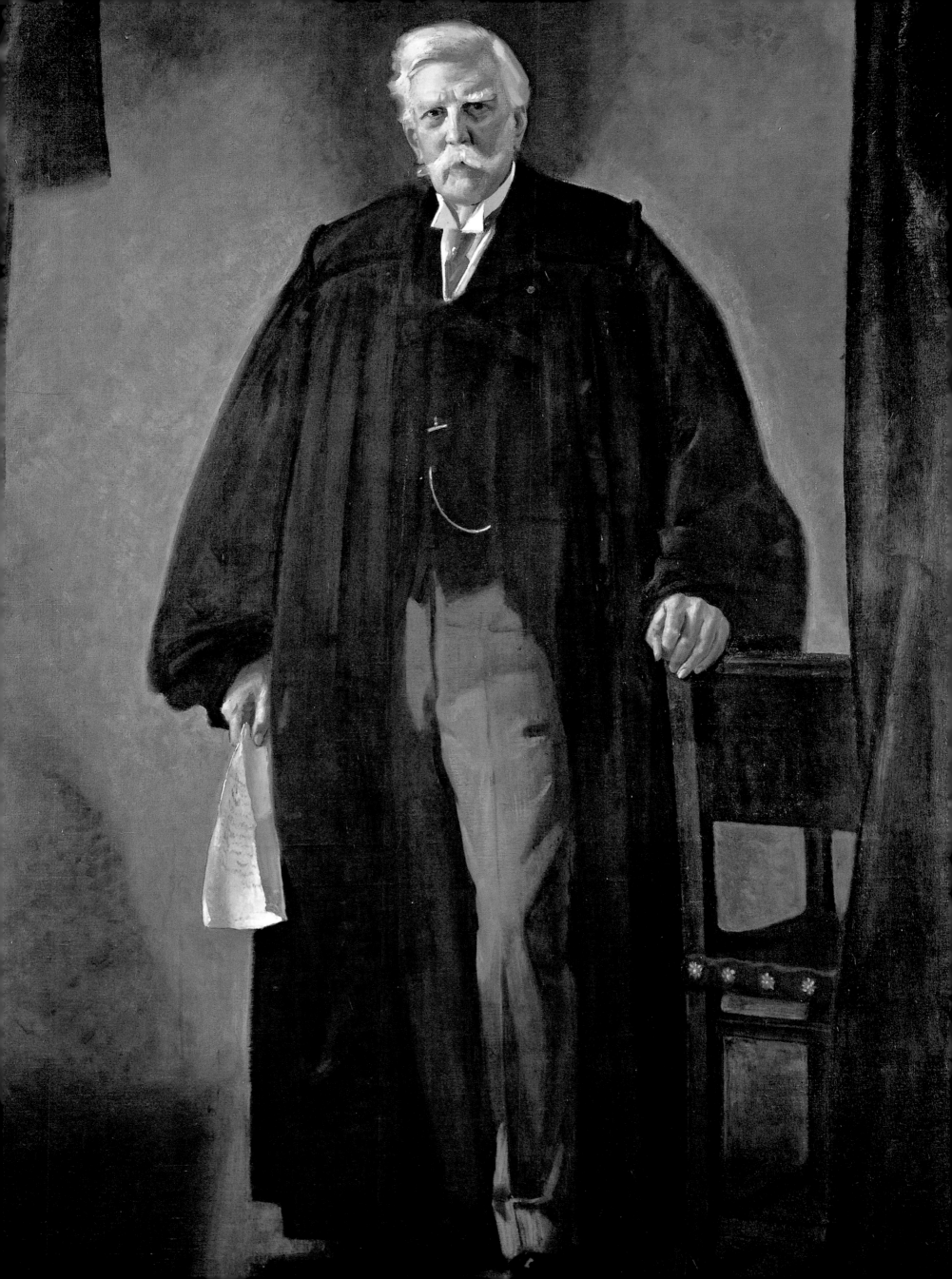

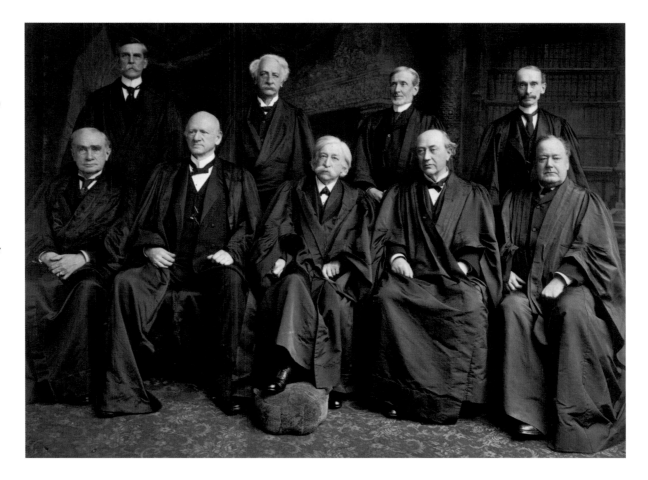

Congress enacted the Sedition Act of 1918, providing for the punishment of any attempt to impede the war effort. The postmaster general was given authority to ban offending publications, and certain issues of journals like *The Saturday Evening Post* and *The New York Times* fell under his authority.

The words of the Sedition Act were sweeping, making it illegal to "incite mutiny or insubordination in the ranks of the armed forces," to "disrupt or discourage recruiting or enlistment service, or utter, print, or publish disloyal, profane, scurrilous, or abusive language about the form of government, the Constitution, soldiers and sailors, flag, or uniform of the armed forces, or by word or act support or favor the cause of the German Empire or its allies in the present war, or by word or act oppose the cause of the United States."

Under its terms, the government arrested Charles T. Schenck, the general secretary of the Philadelphia Socialist Party, who had mailed fifteen thousand pamphlets to men who had passed their draft physicals. The pamphlets depicted the war as a capitalist conspiracy, cited the Thirteenth Amendment's prohibition of involuntary servitude, and in passionate language urged the men not to submit to the draft, since that might lead them to combat in Europe, where they would have to shoot people who were simply defending their homelands. Schenck and his colleague, Elizabeth Baer, were arrested and found guilty. The case arrived at the U.S. Supreme Court and was decided in March 1919, while the war was still raging and the American Expeditionary Force was moving forces from the U.S. to Europe. The decision was written by Oliver Wendell Holmes, and remains one of his most important.

Holmes, for a unanimous Court, upheld Schenck's conviction on the grounds that wartime circumstances justified the curtailment of First Amendment free speech rights. It was here that he wrote, "The question in every case is whether the words used are used in such circumstances and are of such a nature as to create a clear and present danger that they will bring about the substantive evils that Congress has a right to prevent." The right to freedom of speech and press are not absolute, he said: "The most stringent protection of free speech would not protect a man in falsely shouting fire in a theater, and causing a panic." But for Holmes, the wartime circumstances were such that merely intending to obstruct the draft without actually having any affect was enough to convict Schenck and Baer.

Later that year, one Jacob Abrams, along with some friends, all Russian immigrants, stood at an upper story window in a building at Second Avenue and Eighth Street in Manhattan tossing down pamphlets, some printed in Yiddish and others in English. The pamphlets railed against the intervention of five thousand American Marines dispatched to Vladivostok and Murmask in Russia to impede the revolution there, and urged a general strike. After a flight across the rooftops, Abrams was caught, confined, and convicted of violating the Sedition Act. The war was still on, but in this case Holmes had a change of mind.

To convict these "poor and puny anonymities" involved in speech that created no real danger to national security did, in fact, violate the clear and present danger doctrine. The decision included the most widely quoted passage in all the annals of the history of American freedom of speech and press. Holmes penned:

> Now nobody can suppose that the surreptitious publishing of a silly leaflet
> by an unknown man, without more, would present any immediate danger
> that its opinions would hinder the success of the government arms or have
> any appreciable tendency to do so. But . . . the ultimate good desired is
> better reached by free trade in ideas—that the best test of truth is the
> power of the thought to get itself accepted in the competition of the
> market, and that truth is the only ground upon which their wishes safely
> can be carried out. That at any rate is the theory of our Constitution.

BROWN v. BOARD OF EDUCATION OF TOPEKA (1955)

Freedom of the press is a bedrock institution in a democracy, but it is worthless if citizens cannot read and write. Though the Supreme Court says there is no federal right to education, every state does guarantee public schooling for all its young citizens and voters-to-be. If a state offers an education, declared the Court in the case of *Brown v. Board of Education of Topeka*, it follows that it must offer an education that is equal for everyone.

During the two decades before a unanimous Supreme Court handed down its decision in the hallmark case of *Brown v. Board of Education* in 1954, the brilliant young lawyers of the

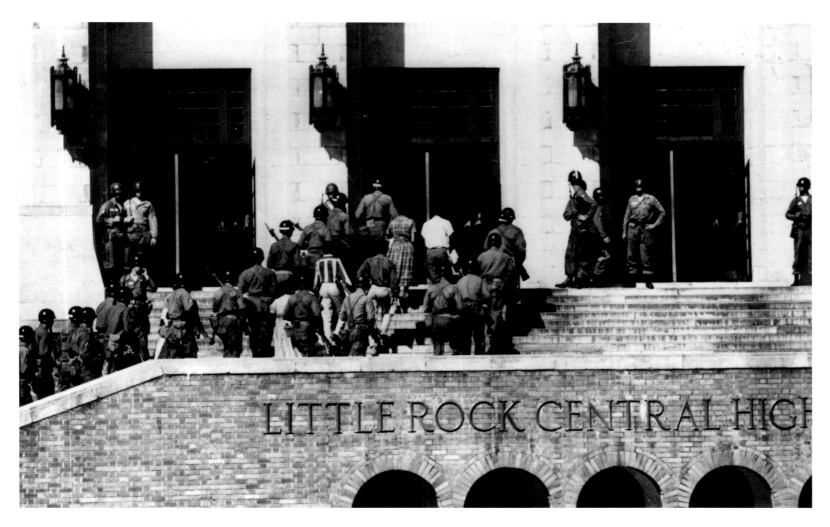

Nine Negro students are escorted by armed members of the 101st Airborne Division as they enter Central High School, Little Rock, Arkansas, on the first full day of integration. September 25, 1957.

Pages 182–183: *Norman Rockwell. The Problem We All Live With. 1963. Oil on canvas. 36 × 58 in. (91.4 × 147.3 cm). Collection of the Norman Rockwell Museum at Stockbridge. Reproduced by permission of the Norman Rockwell Family Trust.*

NAACP, including future justice Thurgood Marshall, were chipping away at the Court's now infamous opinion in *Plessy v. Ferguson.* This 1896 opinion established the constitutional legitimacy of the "separate but equal" doctrine, allowing the southern states to legalize racial segregation as long as equal facilities existed.

Efforts by southern states to fulfill the "equal" part of the "separate" doctrine at first forced them to pay the out-of-state tuition for African-Americans to go elsewhere for their training, but when this scheme was struck down in 1938, segregated states began to establish local public facilities for African-Americans. This mode of enforcing racial parity finally reached an extreme when, in 1950, Texas set up a law school for a single individual virtually overnight.

The NAACP's efforts to persuade southern states to adopt a gradual approach to integration, including elementary and secondary schools, met stony intransigence. The stage was then set, as Thurgood Marshall later said, "to wage all-out war in the courts on segregated schools at every level." Suits were entered in three federal district courts— South Carolina, Virginia, and Kansas—in 1951. These were Fourteenth Amendment suits under the equal protections clause, and the plaintiffs claimed that by its very nature separate education was not and could not be equal. Thus, the principle at the very heart of *Plessy v. Ferguson* was attacked. Predictably, all the suits failed on grounds that *Plessy* was still the reigning precedent and that all the school districts at issue either had or were moving toward equal facilities.

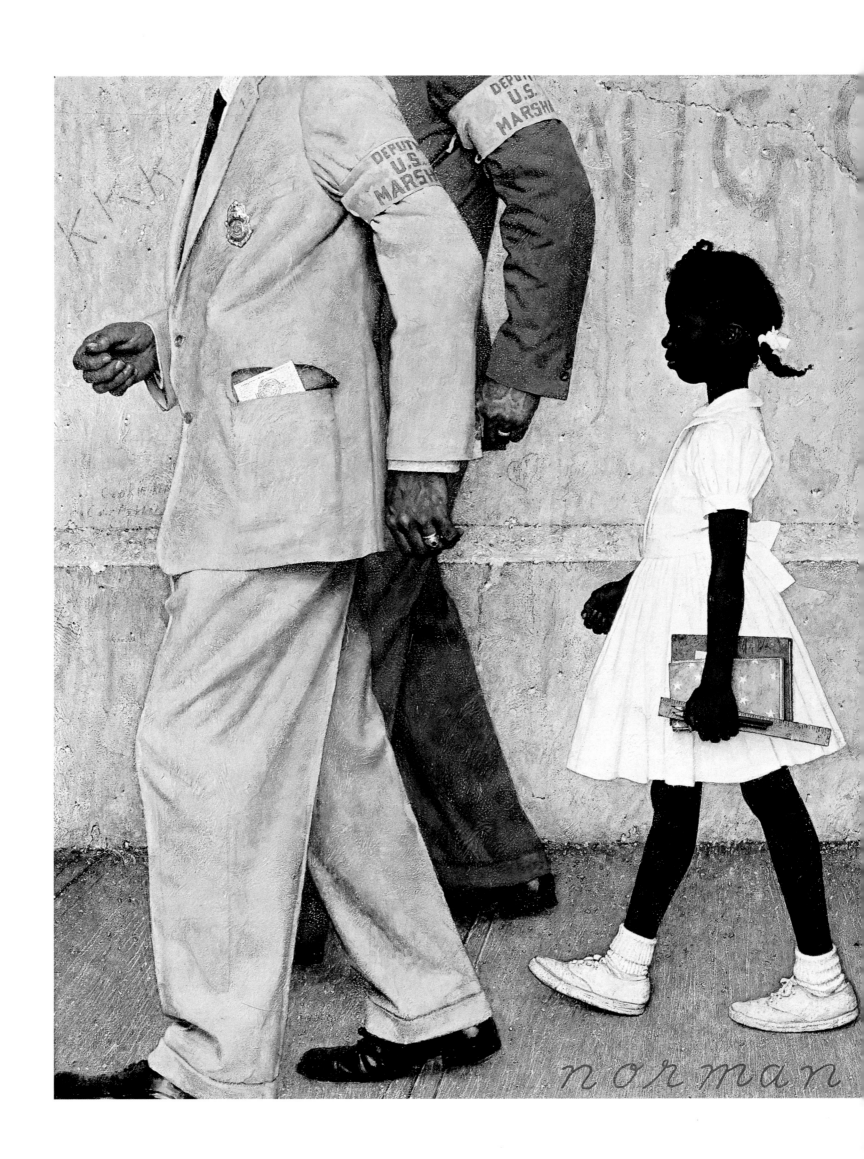

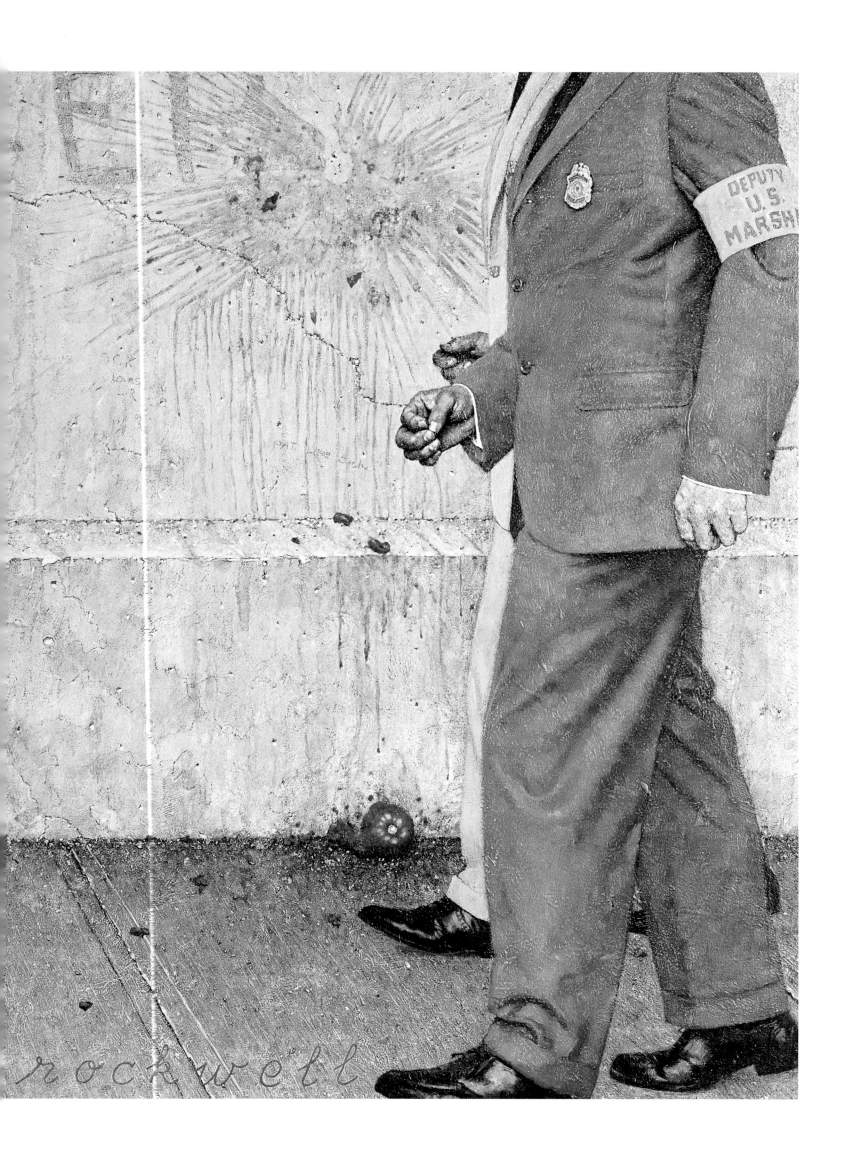

rockwell

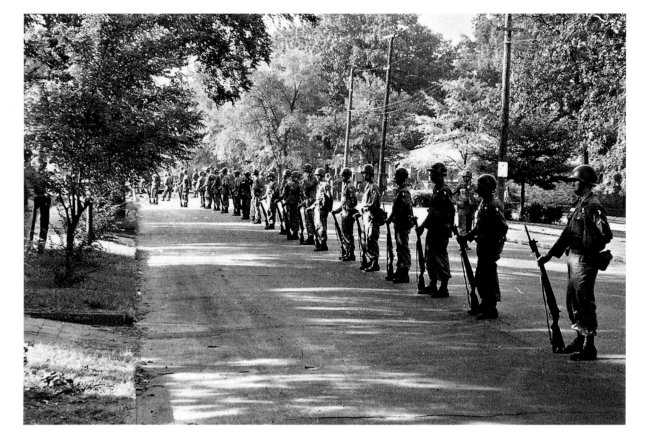

These three suits, along with a parallel suit from the District of Columbia and one from the Delaware state courts, were joined and heard by the U.S. Supreme Court in 1952. The Court heard arguments from both sides. President Truman's attorney general, Edward T. McGranahan, joined Marshall from the NAACP with an amicus curiae, and 1924 Democratic presidential candidate John W. Davis argued for the defendant school districts. In an unusual procedure, after six months of individual thought and collective conversation, the Court, instead of handing down a decision, asked each side to brief a long series of historical questions related to the context and original intent of the Fourteenth Amendment. Marshall sensed that the Court wanted to undermine or overturn *Plessy*, if only it could find a juridically plausible justification.

Again John Davis argued for the school districts and Marshall for the plaintiffs. By this time Dwight Eisenhower was president and, though personally opposed to any peremptory integration of public schools, let his attorney general, Herbert Brownell, argue as an amicus curiae with the plaintiffs. Brownell agreed that legally segregated schools violated the equal protections clause of the Fourteenth Amendment. But he also believed that such a revolutionary change as to integrate at that time would be profoundly disruptive and would be violently opposed in those districts where segregation prevailed. He urged the Court to go slowly. Oral argument by Marshall and Davis was heard on December 8, 1953. Interruptions from the bench were frequent. Finally, a unanimous decision was handed down on May 17, 1954: "We come then to the question presented: Does segregation of children in public schools solely on the basis of race, even though the physical facilities and other 'tangible' factors may be equal, deprive the children of the minority group of equal educational opportunities? We believe that it does."
And therefore, "Any language in *Plessy v. Ferguson* contrary to this finding is rejected."

The end of *Plessy*, however, was not the end of the debate. The Court gave the sides time to generate remedies to the now unconstitutional condition of segregated schools, and a year after *Brown* there was a *Brown II*, in which the Court ordered segregated school districts to follow local court-ordered integration plans "with all deliberate speed." The most "deliberate" part of the matter was the reluctance and even the recalcitrance of some of the districts to carry out these orders. But the principle was stated and heard loud and clear throughout the nation in what many contend was the single most significant Supreme Court decision of the twentieth century.

BAKER v. CARR (1962)

Central to the *Brown* decision was the Fourteenth Amendment's equal protections clause—the lever that lifted so many neglected Americans to equality in the civil rights movement of the 1960s. Some of the people were the nation's citydwellers, for decades ruled by state governments stacked with legislators from the rural areas. Yet another important case focusing on the equal protections clause of the Fourteenth Amendment was to come before the U.S. Supreme Court in 1962 in *Baker v. Carr*.

Martin Luther King, Jr., delivering his "I Have a Dream" speech at the Lincoln Memorial for the March on Washington. 1963.

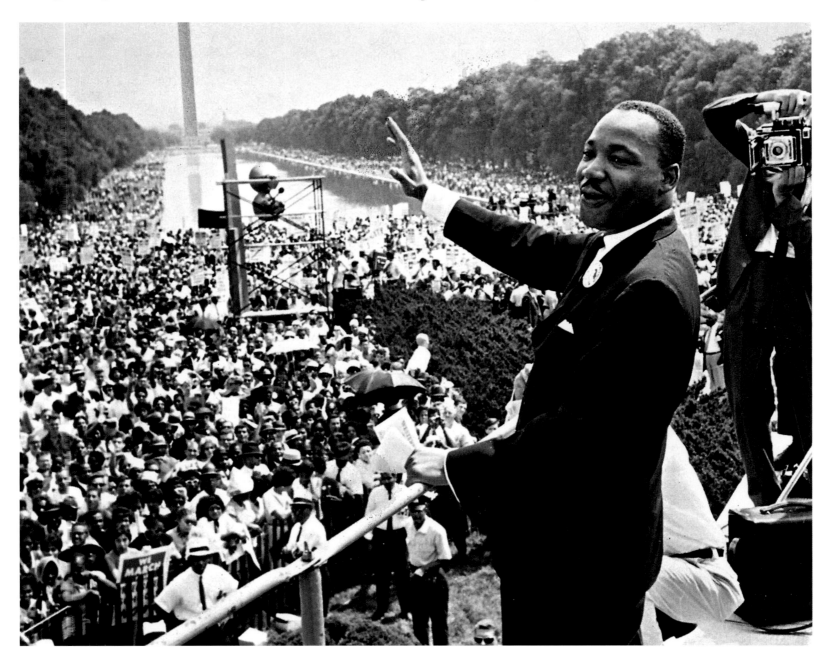

Portrait of Felix Frankfurter,
U.S. Supreme Court Justice
(1939–1962) and co-founder
of the American Civil Liberties
Union. c. 1950.

The urbanization of the United States, which peaked at the beginning of the twentieth century, created a number of grotesquely malapportioned congressional districts on the national level, and legislative districts on the state level—a problem that took decades to correct. In 1960, for instance, Connecticut's largest city of 164,000 sent two deputies to the general assembly, and so did its smallest town of 480 people.

Suits brought to the federal courts under the equal protections clause of the Fourteenth Amendment were routinely rejected following the precedent in *Colegrove v. Green* of 1946. In that case, the U.S. Supreme Court refused the reapportionment of U.S. congressional districts and by extension, reapportionment in state legislatures. Justice Felix Frankfurter

considered these to be "political questions," not justiciable in the courts—in fact, the whole issue a "political thicket."

But times were changing, and by the 1960s, political activism had swept the nation, the U.S. Supreme Court included. The equal protections clause of the Fourteenth Amendment had been given new force in a number of high-profile cases, and the majority on the Court was ready to dump *Colegrove v. Green* into the waste bin of judicial history.

The opportunity came in a case from Tennessee, where the state legislative districts had not been reconfigured since 1901 despite a fourfold increase in population and a very decided shift toward cities. Indeed, 37 percent of the voters—mostly rural— elected nearly two-thirds of the upper house, and 40 percent elected nearly two-thirds of the lower house. And things were much worse in other states. In Alabama, in 1960, 104,767 people in one county had the same representation as 6,731 in another; in Vermont similarly, the largest city with a population of 35,531 had the same representation of the smallest village of 38 folks.

In *Baker v. Carr*, the Court rejected Frankfurter's warning about political thickets. These grotesque imbalances certainly distorted the elective process, and the plaintiffs' cause should be heard, thus the precedential barrier that blocked judiciability—the so-called political questions doctrine—was blasted. The issue of remedies was left up to the district court. The remedy of course was "one man, one vote," or "one person, one vote." As a follow-up *to Baker v. Carr*, Justice William O. Douglas's opinion in a Georgia case (*Gray v. Sanders*, 1963) established that all voters deserved equal votes. The upshot was a shift in balance from the formerly over-represented rural areas of the states to areas that had become urbanized over the course of the previous century.

NEW YORK TIMES CO. v. SULLIVAN (1964)

Freedom of speech and press are often seen as rights precious to isolated individuals with unorthodox views. Sometimes, however, it is that very individual whose honorable reputation is threatened by those very freedoms. How to balance the freedom of a huge corporate press with an individual's protection against libel was the question faced by the Court in *New York Times Co. v. Sullivan*. On Monday, March 9, 1964, when Justice William Brennan read his opinion for a unanimous Court in the case, he revolutionized the law of libel in the United States.

It had been a long four years since L. B. Sullivan, the city commissioner in charge of police in Montgomery, Alabama, had filed suit against *The New York Times*. Sullivan sued because of a full-page advertisement in the *Times* by the Committee to Defend Martin Luther King and the Struggle for Freedom in the South. The committee numbered among its officers Sidney Poitier and Harry Belafonte; A. Philip Randolph, legendary black leader of the Brotherhood of Sleeping Car Porters was chairman; the treasurer was Nat King Cole. The ad was endorsed by thirty-five black and white notables including

Eleanor Roosevelt, Shelley Winters, Sammy Davis, Jr., and Norman Thomas. These names were listed prominently above the names of an additional twenty black ministers, all leaders in the escalating civil rights movement in the South. (L. B. Sullivan was nowhere mentioned.) The ad was a response to the physical and economic harassment of black leaders in Alabama, particularly Martin Luther King, Jr.

Commissioner L. B. Sullivan took the matter personally. Everyone in Montgomery, he believed, knew that charges against the police there amounted to a personal attack on him. He fired off a registered letter to the *Times* demanding a "full and fair retraction" of the implied charges. The *Times*, of course, refused. Sullivan sued.

The law of libel was almost entirely a matter for state adjudication in 1960. The U.S. Supreme Court routinely held that First Amendment protections of speech and press did not protect against libelous statements. In most states, however, truth was a defense against charges of libel. Unfortunately for *The New York Times*, the offending ad included several false statements. For instance, it claimed that police had "ringed" the Alabama State College campus, when in fact the police had merely been stationed in various places in the area; and King had not been arrested seven times—only four.

Witnesses attested to the fact that Montgomery citizens naturally associated the attack on the police with L. B. Sullivan, and it was clear that his professional reputation had been damaged in the community. The statements, then, were "libelous per se," and Sullivan did not have to demonstrate any tangible loss. The Montgomery jury awarded him $500,000.

Sullivan's success brought additional suits against the *Times* ultimately amounting to over five million dollars. Not only was the civil rights movement in the South threatened, but so was the very existence of *The New York Times*. The publishers took their case to the U.S. Supreme Court under First Amendment protections.

The *Times* wanted the Court to declare that no criticism of public officials should ever be actionable. They got three judges to agree—but only three. Brennan, assigned to write the opinion, had to qualify the finding so as to bring in at least two more. He worked at the job all through the 1964 term, and finally got not just a majority, but unanimity.

The Court declared that statements about public officials had to be published with "actual malice," which they defined as "knowledge that [the statement] was false or [made] with reckless disregard of whether it was false or not." The conditions had to be established by the plaintiff by "clear and convincing proof."

Sullivan's claims could not stand up to these new conditions; his suit failed. The *Times* was saved, but more significantly, so was Martin Luther King and his crusade for civil rights. The law of libel was given a federal umbrella under the U.S. Constitution's First Amendment.

GRISWOLD v. CONNECTICUT (1965)

Legislative conservatism is no doubt a reflection of public opinion in most situations, but sometimes it is the result of cowardice. A singular case in point is the refusal of the general assembly in Connecticut to repeal a statute that outlawed the use of birth control devices and prohibited advising anyone to use them. The U.S. Supreme Court articulated that most famous of all unenumerated rights alluded to in the Ninth Amendment—privacy.

Phineas T. Barnum, the famous circus impresario and representative from Bridgeport to the Connecticut General Assembly, could hardly have known that his sponsorship of the Comstock Law in 1879 would, eight decades later, be at the center of a constitutional breakthrough that virtually defined the 1960s. Anthony Comstock, a neighbor of Barnum's, got the Connecticut legislature—and that of many other states—to forbid the use of any drug or article to prevent conception, and also forbid anyone to assist, abet, counsel, or hire in order to prevent conception. The law, the fruit of the Victorian mind, did not outlaw the sale of condoms or other birth control devices, and they were sold more or less openly in Connecticut drugstores. But anyone who used one faced a fifty dollar fine and a year in jail.

Meanwhile, thousands of married and unmarried women, mostly poor and ignorant of birth control methods, bore children they could not care for, patronized illegal and dangerous abortionists, and died from the effects of childbirth. Out of these conditions

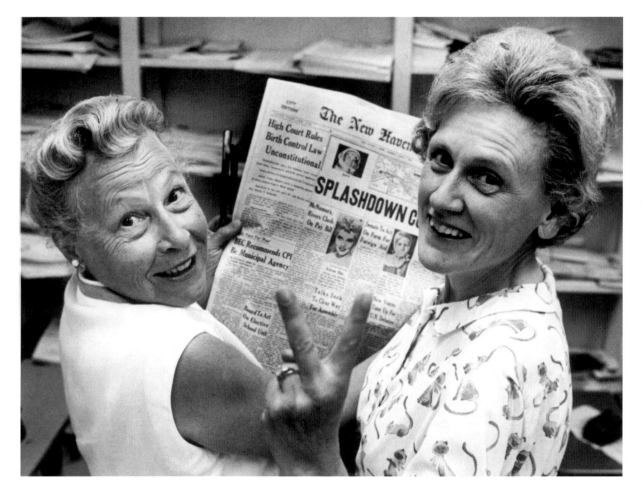

was born Margaret Sanger's birth control movement, the inspiration in 1923 for the formation of the Connecticut Birth Control League, which became Planned Parenthood of Connecticut.

PPC opened birth control clinics where devices and advice were dispensed around the state, and for a few years carried on their work unmolested by the long arm of the law. But in 1939, some zealous policemen raided a clinic in Waterbury, and all the clinics shut down in response.

For years, Connecticut PPC had been trying to get the birth control law amended or repealed. But Connecticut's legislature, now significantly peopled by urban Catholics, wouldn't touch it. It was time to try a different tack, and the arrest of the physicians and their aids in Waterbury opened the door to the judicial edifice. Surely the court would strike down such an archaic statute. But it didn't. On a calculated technicality the Connecticut Supreme Court dismissed the charges and prevented an appeal to the U.S. Supreme Court.

PPC executive director Estelle Griswold enlisted the aid of C. Lee Buxton, the chairman of the Department of Gynecology and Obstetrics at the Yale Medical School. Their attorneys were first, Fowler V. Harper, a professor at the Yale School of Law, and, when he died in 1963, the renowned First Amendment scholar Thomas I. Emerson, also of the Yale Law faculty. So involved were Yalies that this effort to overturn the Connecticut statute was known locally as the Yale Project.

Mrs. Griswold and Dr. Buxton were once again arrested, tried, found guilty, and appealed to the state supreme court in 1964, which predictably upheld the law—unanimously. The court held that the Comstock Law was intended to discourage adultery, premarital intercourse, and other immoral acts, and certainly the general assembly had acted within its constitutional authority to support it. But this time—on the eve of the great cultural revolution that included calls for free speech and acts of free love—the U.S. Supreme Court could no longer dodge the issue. Nor did most of its members want to.

The seven-man majority struck down Connecticut's ancient Comstock Law as an "uncommonly silly law" on June 7, 1965. Justice William Douglas reflected the liberal activism of the Court and found more or less comfortable support from Justices Warren, Goldberg, Harlan, White, Brennan, and Clark. Earlier courts had articulated the right of association as a necessary implication of free speech and assembly; and in those associations the right of privacy, too, surely was implied. And too, zones of privacy grew out of the enumerated rights to speech and thought; privacy was implied in the Third Amendment's protection of the inviolability of the home, which was supported in turn by the Fourth Amendment outlawing unreasonable searches. Even Fifth Amendment protection against self-incrimination cast shadows that overlaid those of the other relevant amendments. These were the "penumbras, formed by emanations that give life and substance to . . . specific guarantees in the Bill of Rights," wrote Douglas. "Would we allow the police to search the sacred precincts of marital bedrooms for telltale signs of the use of contraceptives? The very idea is repulsive to the notions of privacy surrounding the marriage relationship." Finally, the Ninth Amendment, with its clear implication of unenumerated rights, supported the whole logical edifice.

MIRANDA v. ARIZONA (1966)

The necessity for the existence of the Fifth Amendment enjoys perhaps the most colorful history and underpinnings of any of our revered Bill of Rights. Stories of tortures by the Star Chamber administered to obtain often false confessions were legion and were well known by our eighteenth-century forefathers. The right to not be a witness against oneself did not amount to much if suspects were coerced, tricked, or otherwise goaded into confessions in the back rooms of local police stations. Of course, many of these victims did not know their rights. In 1966, the Court tried to make sure they would from then on.

It is not widely known that the U.S. Bill of Rights, by long-standing judicial precedent dating to 1833, barred only Congress, not the states, from violating its sanctions. In the period since the 1920s, a process of nationalizing the Bill of Rights took place through judicial determination. This nationalization depended on incorporating the Bill of Rights into the Fourteenth Amendment's restrictions on state action.

By the 1960s, most of the essential rights guaranteed under the first five constitutional amendments had been extended to the states. It became an objective of the Supreme

Ernesto Miranda (right) talks to his attorney, John J. Flynn.

Court under Chief Justice Earl Warren to bring criminal procedures in state courts into conformance with the rules that federal courts were required to follow. In particular, the rule excluding illegally obtained evidence, establishing a right to counsel, and freedom from self-incrimination had all been extended to the state courts by 1964. As the U.S. Supreme Court turned its attention to local station-house procedures, confessions obtained by torture had been thrown out, but the right to remain silent and the right to consult an attorney had not been reviewed. The Court took up this question in the case of *Miranda v. Arizona*, with a decision handed down in 1966.

Ernesto Miranda, a twenty-three-year-old schizophrenic with a ninth-grade education, was picked up by the Phoenix police and accused of a kidnap-rape. He was taken to the station house interrogation room, and within an hour the police emerged with a signed written confession. He was convicted, and on appeal the Arizona Supreme Court confirmed the conviction.

The "Miranda Warning."

The Warren majority evinced deep distrust of police methods in cases like this, and wanted assurance that confessions were in fact voluntary and absolutely without duress. They wanted assurance also that the accused had counsel present during the interrogation, or at least had the right to remain silent until counsel had been consulted.

Elaborate procedural safeguards—pretty much the same as those already employed by the F.B.I. in federal cases—were outlined, resulting in the now widely known statements read

WARNING AS TO YOUR RIGHTS

You are under arrest. Before we ask you any questions, you must understand what your rights are.

You have the right to remain silent. You are not required to say anything to us at any time or to answer any questions. Anything you say can be used against you in court.

You have the right to talk to a lawyer for advice before we question you and to have him with you during questioning.

If you cannot afford a lawyer and want one, a lawyer will be provided for you.

If you want to answer questions now without a lawyer present you will still have the right to stop answering at any time. You also have the right to stop answering at any time until you talk to a lawyer. P-4475

to suspects. Less known is the fact that the Miranda Rules apply only under a rather narrow set of station-house conditions, and the Supreme Court since the 1960s has further limited the circumstances under which persons taken into custody can claim the Miranda Rules. Nevertheless, *Miranda* marks an important high-water mark of expanding Federal Bill of Rights protections to the states.

ROE v. WADE (1973)

Throughout most of the history of the United States, the Supreme Court has been that "one great anchor," a force reminding Americans of fundamental principles and generally slowing change. But sometimes the Court gets ahead of public opinion—or at least a major portion of it. A case in point is the Court's intervention into a matter that was under state jurisdiction since the 1820s. Having extended the privacy rights developed in *Griswold* in 1965, the Court would only a few years later articulate another of those unenumerated rights protected by the Ninth Amendment, a woman's right to choose to abort a pregnancy. The Court's bold stand in *Roe v. Wade* remains a point of deep emotional contention more than two generations after its opinion was heard.

Norma McCorvey was a down-on-her-luck, twenty-five-year-old Texan in 1969 when a passing romantic attachment left her pregnant, single, and poor. Rebuffed at every turn by doctors and clinics in her efforts to obtain an abortion, she finally turned to the law. One of the doctors McCorvey had consulted referred her to two recent graduates of the Texas Law School, Linda Coffee and Sarah Weddington, themselves pioneers, having been two among only five female students in the law school. Their pioneering determination lead finally in 1973 to the U.S. Supreme Court in *Roe et. al. v. Wade, District Attorney of Dallas County*.

State restrictions on abortion had developed steadily over the previous century, but by 1900, all states had them in place. By the 1960s, regulations varied, from New York, where there were no restrictions at all for the first twenty weeks of pregnancy, to the very strict rules in Texas, where it was a crime to perform an abortion unless the purpose was saving the life of the mother. By the time of *Roe*, about one in four or five married women had experienced at least one abortion, and as many as 90 percent of premarital pregnancies ended in abortions—mostly illegal.

State regulation was a problem for physicians because most guidelines were too vague to help doctors in making judgment calls; judging wrongly could result in criminal prosecution. Much of the legislative lobbying to relax the restrictions was done by state medical associations and individual physicians.

Certainly, doctors were not, however, the people most concerned with this issue. It was women in general and those of child-rearing age in particular who had the most to gain or lose in the matter. Norma McCorvey was distinctly one such woman. Given the social currents of the 1960s, the focus of what came to be known as the pro-choice movement

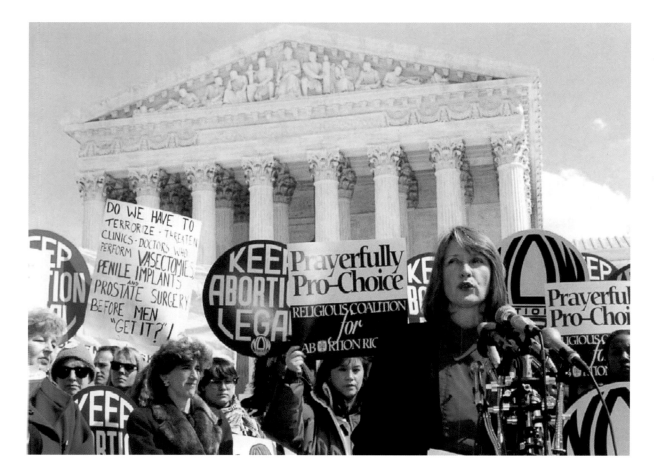

shifted emphatically from doctors to women. Though Coffee and Weddington drew on a wide range of constitutional strategies to undergird their case, the brunt of their argument rested on the Fourteenth Amendment as interpreted in *Griswold v. Connecticut*. That case established a right to privacy—especially marital privacy and the right to decide whether to conceive and bear children. By extension, that right would include a woman's choice to carry a fetus to full term, or not. *Roe v. Wade*, however, turned not so much on the question of whether a woman has an individual and personal right to an abortion, but, rather, if under the U.S. Constitution the state has the authority to allow her to do so.

By the late 1960s, medical science had established that abortions during the first trimester were statistically safer than childbirth itself. The state of Texas claimed, however, that it had a compelling interest in protecting the rights of the unborn and that such rights began at the moment of conception.

The Court claimed that an unborn fetus did not come within the definition of a person as understood in the Constitution. The question of when—if ever—a fetus becomes a person remained undecided since, said Justice Harry A. Blackman for the Court, "the judiciary, at this point in the development of man's knowledge, is not in a position to speculate as to the answer." But what the Court did decide, with Blackman speaking for a 7–2 majority, was that the "right of privacy . . . is broad enough to encompass a woman's decision whether or not to terminate her pregnancy."

Nevertheless, Blackman continued, medical vicissitudes being what they are, at a certain point the state does have a compelling interest in both the safety of the mother and the

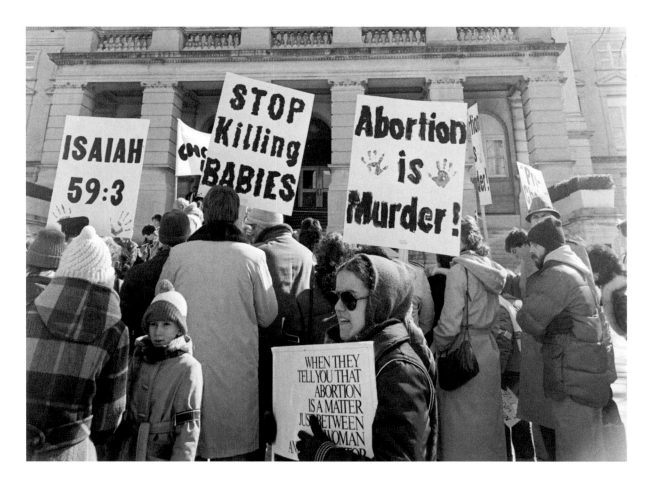

welfare of the yet unborn. The first interest permits the imposition of some medical restrictions after the first trimester; and the second after the fetus becomes "viable," that is, capable of life outside the womb.

The Court's ruling was as controversial as *Dred Scott* in the 1850s and *Brown v. Board of Education* in the 1950s. Even today, it is still a bitter pill the vocal opponents of abortion cannot digest. On repeated occasions, the Court has not backed away from Blackman's formulation, though it has not liberalized it either. As for Norma McCovey, she gave birth to a baby girl, and by prior arrangement gave it up immediately for adoption.

UNIVERSITY OF CALIFORNIA REGENTS v. BAKKE (1978)

Like abortion, affirmative governmental aid to sectors of the citizenry discriminated against in the past remains a contentious issue. In 1978, the best the Court could do to balance equitable assistance with the rights of those not so aided was the decision in *University of California Regents v. Bakke*, in which one justice cobbled together parts of different opinions by each of two four-justice minorities. The result satisfied almost no one, and facing recent split lower court decisions on this issue, the court will soon address the matter of affirmative action again.

In the Bakke case, the protagonists could not even agree on terminology: was it benign affirmative action, or punitive reverse discrimination? Was the U.S. Constitution color blind, or were racial distinctions permissible in an increasingly diverse society? Did racial quotas establish "benign discrimination," or was that very phrase itself an oxymoron? What's the difference between a quota and a goal?

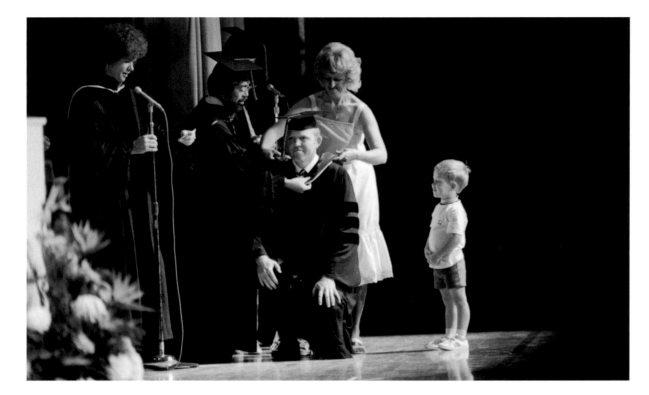

Allan Bakke receives his doctorate shawl from the University of California, Davis, during graduation ceremonies, June 6, 1982.

The man who provoked one of the hottest debates over race in America was Allan Bakke. Nearly six feet tall, with the blue eyes and blond hair of his Norwegian forbears, Bakke personified old-line white America. Beyond his physical attributes, Bakke boasted an academic and professional biography characteristic of the upwardly mobile middle-class American. Financing his engineering education at the University of Minnesota by service in the National Guard, he fulfilled his obligation to the military by four years of duty, including two in Vietnam. On separation, he got a job with NASA, married, and had a family. Allan Bakke, however, held a personal ambition widely different from his engineer colleagues: he wanted to become a physician.

Bakke prepared for the admissions process by taking courses in chemistry and biology, volunteering in hospitals, notably by working in the emergency wards in contact with the victims of the most gruesome accidents. In 1972, at age thirty-three, he applied to the new medical school at the University of California at Davis. He scored in the ninetieth percentile—the top 10 percent—on his MCATs; his undergraduate and work records were exemplary; his recommendations were strong. He was rejected. He tried again the next year, in 1973. The result was the same. Bakke sued.

The focus of his ire and his constitutional stand was a program at the Davis Medical School that set aside sixteen slots for minority candidates—Asians, African-Americans, Mexican Americans, and American Indians. The MCAT score among the applicants admitted through the special program was the thirtieth percentile. Bakke was outraged. "A new racial bias in favor of minorities," he insisted, "is not a just situation." The California Supreme Court agreed with him, and the university appealed to the U.S. Supreme Court.

Four justices would uphold the Davis system set aside for minority candidates; four justices would reject any race-based system of affirmative action. There was one balance weight:

the Virginian Lewis F. Powell. Powell had been appointed to the Court by Richard Nixon in 1972 after a career in private practice in Richmond, where he had also been chairman of the board of education that desegregated the school after *Brown*. His conduct and decisions had been characterized as "pragmatic conservatism." The fate of affirmative action in American education—and potentially other spheres of life—rested in his hands.

Powell wanted to strike down any quota system like that at the University of California at Davis, but he did not want to end affirmative action programs entirely. His solution seems simple in retrospect, but in fact it was the tortured result of eighteen months of argument among the nine justices and a similarly long debate among Powell's four clerks and the justice himself. Four justices joined Powell in condemning quotas and college admissions systems that singled out race as the defining element. That made a majority against Davis and in favor of Allan Bakke: Bakke won his case. However, four justices concluded that it was permissible to allow considerations of race as one element in a constellation of characteristics, talents, and accomplishments that would bring to campuses a much-sought-after and educationally enriching diversity. That made a majority in favor of affirmative action. In the end, Bakke had won, but so had affirmative action.

Landmark cases in America have for the most part reflected issues of domestic concern—matters of constitutional interpretation that require definition in our lives, and within our borders. As the new century begins, however, geographic borders between countries will become increasingly blurred as rapidly developing technology expands the American community into a more global one. Landmark cases of the twenty-first century are sure to include the resolution of disputes over intellectual property rights and determining the boundaries of international law. The twenty-first-century American lawyer will need broad expertise and a sound knowledge of both American and international law.

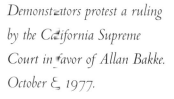

Demonstrators protest a ruling by the California Supreme Court in favor of Allan Bakke. October 8, 1977.

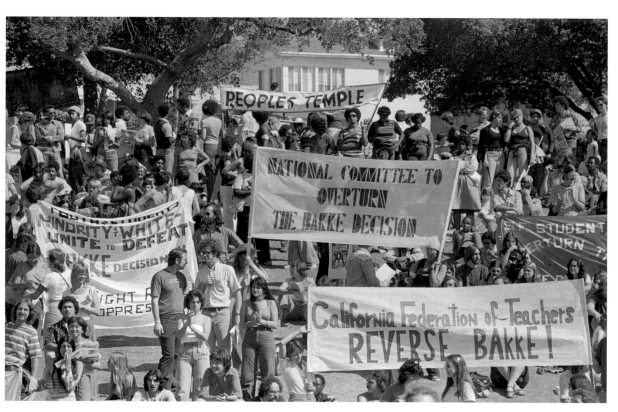

AMENDMENTS TO THE CONSTITUTION

The framers of the Constitution included what was thought to be relatively easy amendment procedures in Article V: "On application of two-thirds of the states, Congress is to convene a convention to write changes, or Congress itself by a vote of two-thirds of each house may propose changes." Then, when ratified by three-fourths of the states, the amendment becomes part of the Constitution. Efforts in the first Congress to integrate amendments into the body of the document were beaten back in favor of leaving the Constitution exactly in the form in which it was ratified, adding amendments at the end. Though seemingly an uncomplicated process, the Constitution has seen relatively few changes—only twenty-seven amendments in more than two hundred years.

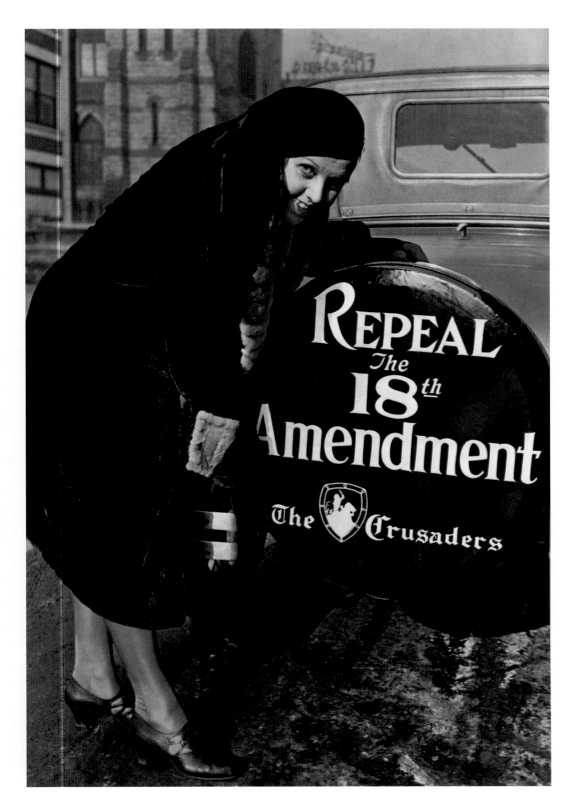

A member of The Crusaders puts a tire cover on her car that demands the repeal of the Eighteenth Amendment.

The first ten, of course, constituting what has come to be called the Bill of Rights, were added in 1791, two years after the inauguration of the government. Two others attempting to protect states from suits and altering the electoral college followed within the next decade. There were none between 1804 and 1865, when the three "Reconstruction amendments" relating to slavery and the rights of the freedmen became law in 1865, 1868, and 1875.

Other than the Bill of Rights, only one amendment has made a fundamental alteration in the federal constitutional system. The Fourteenth Amendment greatly restricts state activity and has proven to be the major bulwark against state limitations of individual liberty. The other amendments alter the American system of government by legitimating an income tax, providing for direct election of senators, prohibiting states from excluding women and minors over eighteen from the suffrage, and limiting the president to two terms. One amendment stands out as a classic case of constitutionalizing what should be merely a legislative matter. The eighteenth amendment prohibited "the manufacture, sale, or transportation of intoxicating liquors." The proof of the folly of this action is the Twenty-first Amendment, which repealed the Eighteenth in 1933 after only thirteen years.

LIFE

The Love and Terror Cult

The man who was their leader
The charge of multiple murder
The dark edge of hippie life

Charles Manson,
cult leader

DECEMBER 19 · 1969 · 40¢

CHAPTER VII

MEDIA SENSATIONS

What sets certain crimes and trials apart and makes them media sensations? Those that garner the most attention need not be legally significant, but they must have an element to pique the interest of the public. More often than not, they are, or stem from, crimes of passion—emotionally charged actions of people triggered by common human feelings such as jealousy, hatred, greed, anger, hurt, and fear. The media acts as the curious onlooker in all of us, and the more extreme or unbelievable the actions of criminals, police, lawyers, judges, and juries at the time, the wider and more dramatic the coverage. Each crime and trial featured in this chapter was the subject of intense media attention. Some featured famous defendants or notorious victims, while others displayed the talents of well-known attorneys. Many were notable for their subject matter, whether they stemmed from politically motivated crimes, or prompted the public to debate more weighty issues such as evolution or assisted suicide. Finally, some were only briefly—but very visibly—in the glare of the media spotlight.

In nineteenth-century America, the "media" consisted of the local newspaper or simply word of mouth, and crimes and trials were basically local events. Those that generated widespread coverage were usually of tremendous national significance. The assassination of President Abraham Lincoln was certainly one such event.

On April 15, 1865, President Lincoln prepared to attend a play at Ford's Theater in a much deserved celebration of Union victory in the Civil War. John Wilkes Booth and his accomplices, aware of Lincoln's plans for the evening, began to make plans of their own. Once the Lincolns were seated and enjoying the play, Booth crept up behind them and fired a bullet into Lincoln's head. Booth then attempted to leap off the balcony railing, but his boot became entangled and caused him to fall onto the stage below. He escaped through a side door before Mary Lincoln's scream could alert everyone. The chase was on for the assassin and rewards were offered. Americans paid close attention to newspaper coverage of the hunt.

Opposite: Charles Manson on the cover of Life *magazine, December 19, 1969.*

SURRAT. BOOTH. HAROLD.

War Department, Washington, April 20, 1865,

$100,000 REWARD!

THE MURDERER

Of our late beloved President, Abraham Lincoln,

IS STILL AT LARGE.

$50,000 REWARD

Will be paid by this Department for his apprehension, in addition to any reward offered by Municipal Authorities or State Executives.

$25,000 REWARD

Will be paid for the apprehension of JOHN H. SURRATT, one of Booth's Accomplices.

$25,000 REWARD

Will be paid for the apprehension of David C. Harold, another of Booth's accomplices.

LIBERAL REWARDS will be paid for any information that shall conduce to the arrest of either of the above-named criminals, or their accomplices.

All persons harboring or secreting the said persons, or either of them, or aiding or assisting their concealment or escape, will be treated as accomplices in the murder of the President and the attempted assassination of the Secretary of State, and shall be subject to trial before a Military Commission and the punishment of DEATH.

Let the stain of innocent blood be removed from the land by the arrest and punishment of the murderers.

All good citizens are exhorted to aid public justice on this occasion. Every man should consider his own conscience charged with this solemn duty, and rest neither night nor day until it be accomplished.

EDWIN M. STANTON, Secretary of War.

DESCRIPTIONS.—BOOTH is Five Feet 7 or 8 inches high, slender build, high forehead, black hair, black eyes, and wears a heavy black moustache.

JOHN H. SURRAT is about 5 feet, 9 inches. Hair rather thin and dark; eyes rather light; no beard. Would weigh 145 or 150 pounds. Complexion rather pale and clear, with color in his cheeks. Wore light clothes of fine quality. Shoulders square; cheek bones rather prominent; chin narrow; ears projecting at the top; forehead rather low and square, but broad. Parts his hair on the right side; neck rather long. His lips are firmly set. A slim man.

DAVID C. HAROLD is five feet six inches high, hair dark, eyes dark, eyebrows rather heavy, full face, nose short, hand short and fleshy, feet small, instep high, round bodied, naturally quick and active, slightly closes his eyes when looking at a person.

NOTICE.—In addition to the above, State and other authorities have offered rewards amounting to almost one hundred thousand dollars, making an aggregate of about TWO HUNDRED THOUSAND DOLLARS.

"Wanted" poster for the assassins of President Abraham Lincoln. 1865.

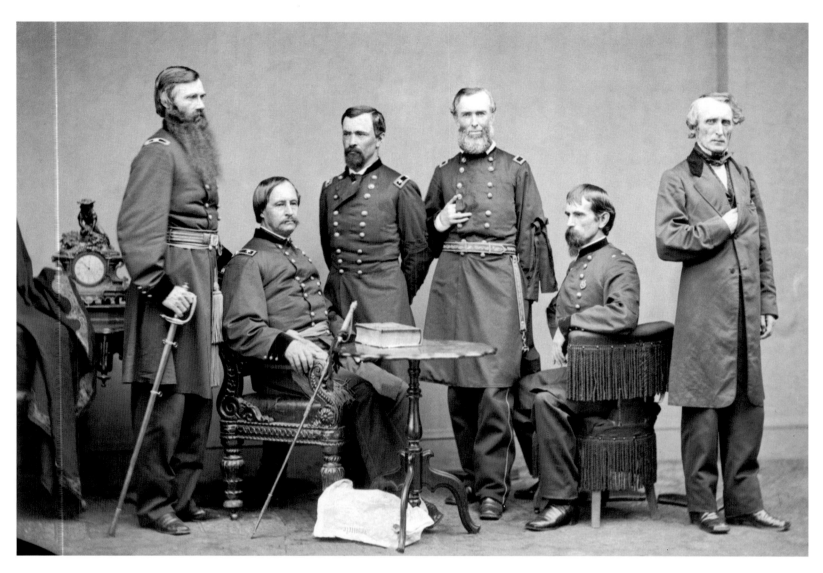

Members of the military commission that tried Lincoln's assassins c. 1865.

After Booth's accomplices were located and captured, during what became known as the Great Conspiracy Trial of 1865, details of Booth's plan began to emerge. Booth and his accomplices had originally planned to kidnap Lincoln, bring him to Richmond, and demand ransom from the North, including the return of Confederate prisoners, the donation of military supplies, and renewed negotiations from a position of Southern strength. The jury convicted four accomplices—Lewis Paine, George Atzerodt, Davy Herold, and Mary Surratt—of conspiracy to murder, and they were hanged for their crimes. Two others were given life sentences.

The assassin himself, however, was not part of this trial, since Booth did not live to see his day in court. After leading his pursuers through winding roads in rural Virginia, he attempted to hide in a remote farmhouse. Accounts of Booth's demise vary widely, but it is likely that he died as a result of bullet wounds sustained when he resisted arrest. Nonetheless, the intense media attention paid to the politically motivated assassination of the president, and those responsible for it, has ensured that history will never forget the name John Wilkes Booth.

Almost thirty years later, in 1892, a murder of a very different nature occurred in Fall River, Massachusetts. This crime, which also generated extensive media coverage at the time, has almost become the stuff of legend, and is even well-known for its reference in

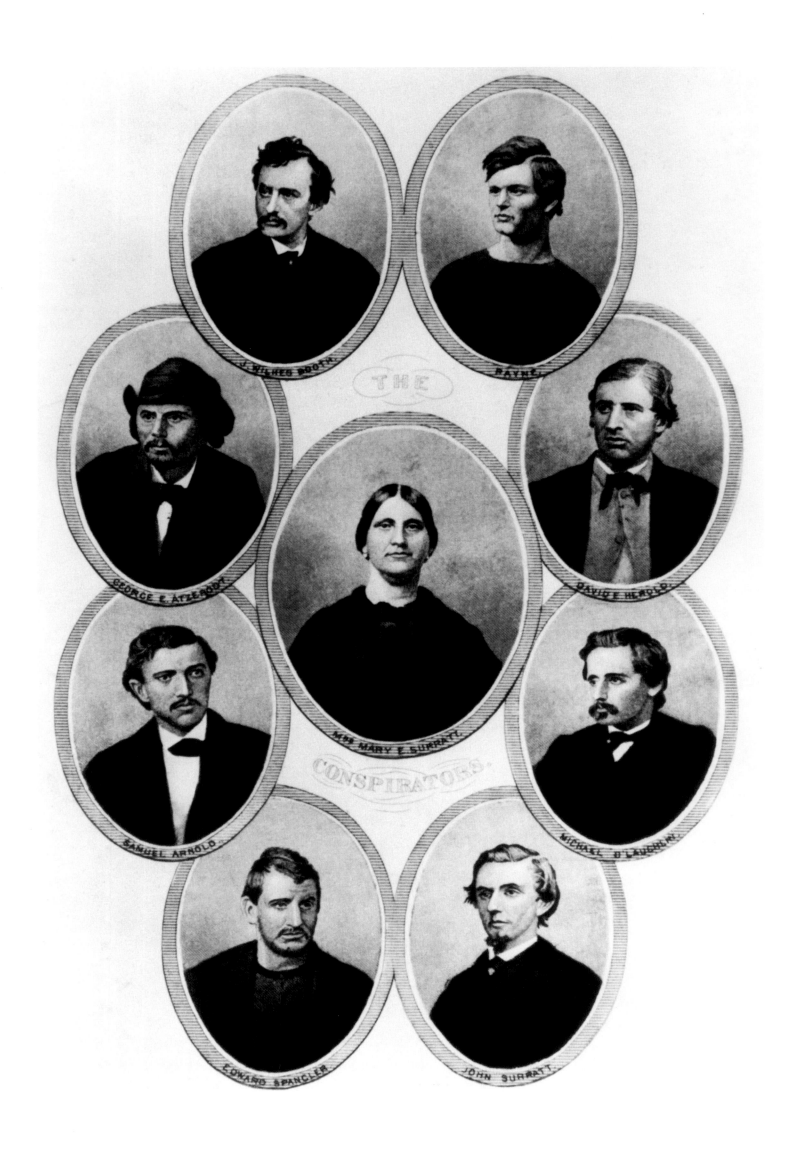

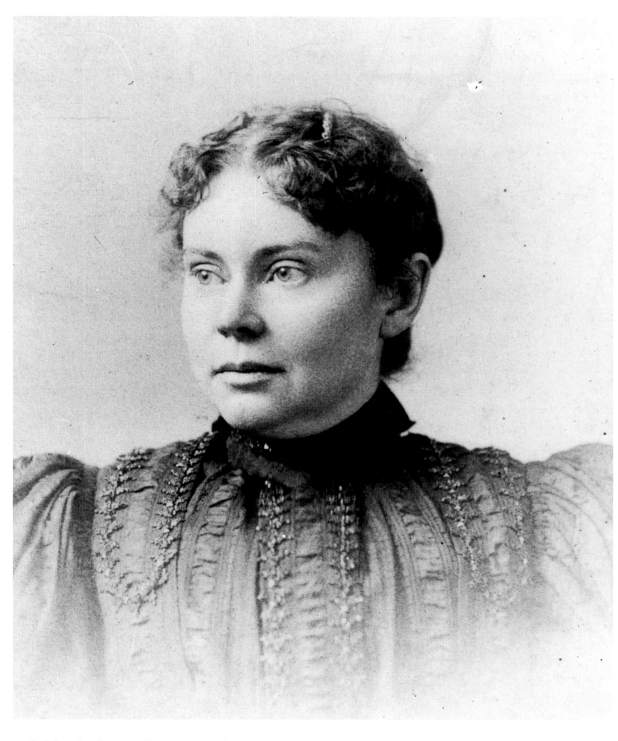

a children's rhyme: "Lizzie Borden took an ax and gave her mother forty whacks; when she saw what she had done, she gave her father forty-one!" Certainly, the rhyme contains elements of truth—Mr. and Mrs. Borden *were* brutally murdered during a fateful morning in August. But, although all signs pointed to their daughter Lizzie's guilt, we may never be sure what actually transpired that day.

Andrew Borden, who was very wealthy, lived with his second wife Abby and his two unmarried daughters from his first marriage, Lizzie and Emma, aged thirty-two and forty-two. On the morning of August 4, Emma was away on vacation. Andrew left for work, and the maid, Bridget, went outside to wash the windows. The only two people remaining in the house were Lizzie and her stepmother. Due to an unbearable heat wave, Andrew came home from work at around eleven o'clock and rested in the parlor. Bridget, too, was resting in her room in the attic. She was awakened by Lizzie shouting,

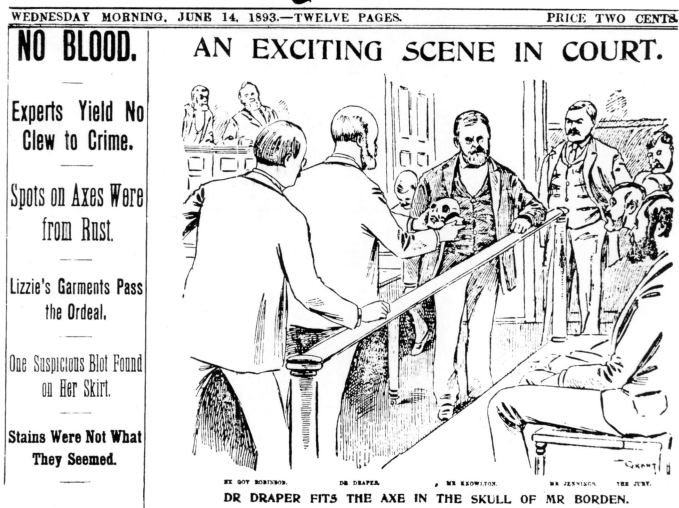

Daily Globe.

WEDNESDAY MORNING, JUNE 14, 1893.—TWELVE PAGES. PRICE TWO CENTS.

NO BLOOD.

Experts Yield No Clew to Crime.

Spots on Axes Were from Rust.

Lizzie's Garments Pass the Ordeal.

One Suspicious Blot Found on Her Skirt.

Stains Were Not What They Seemed.

AN EXCITING SCENE IN COURT.

EX GOV ROBINSON. DR DRAPER. MR KNOWLTON. MR JENNISON. THE JURY.

DR DRAPER FITS THE AXE IN THE SKULL OF MR BORDEN.

"Come down quick! Father's dead! Somebody came in and killed him." Andrew had been killed by numerous blows from an ax, and soon thereafter, Abby's body was found upstairs. Later, an ax with a broken handle was discovered in the basement.

Media attention soon focused on these gruesome events in Fall River, and the Borden murder became front-page news across the nation. Although the police investigation was cautious because of the prominence of the Borden family, Lizzie was arrested two days later. Investigators felt she was the only person who could have committed the crimes, because it was unlikely another culprit could have crept into the house unseen by Lizzie. And, in fact, Lizzie did nothing to help her own situation. She gave different explanations for her location during the murders, the most unlikely being that she was "eating pears" inside a closed barn loft to escape the heat wave.

The media expressed horror at Lizzie's arrest—not because they believed the accusation, but, rather, it was inconceivable that such a well-bred, wealthy, grief-stricken young woman would even be suspected of such a crime. During this period, most newspapers and magazines regularly featured articles about a woman's "natural" characteristics, such

Front page newspaper illustration of the Lizzie Borden trial from the Boston Daily Globe, June 14, 1893. Collection of the Fall River Historical Society.

as fragility, docility, and gentleness. The extensive media attention given to these matters helped to create a picture in the public's mind of Lizzie as a typically bereaved woman who was incapable of murder. In fact, public sentiment expressed support for Lizzie, and prominent clergy spoke out on her behalf.

The newspapers continued to provide lengthy coverage of the events surrounding Lizzie's trial, which began in New Bedford in June 1893. It attracted reporters from across the nation and drew so many spectators that fences were needed around the courthouse. At the outset, Lizzie's case was helped by Judge Dewey's ruling that her inconsistent testimony regarding her location during the murders, which had been presented at the inquest, was inadmissible. Additionally, the prosecution had to contend with the jurors' disbelief that a frail young woman could commit such a crime.

The prosecution presented experts who testified that a woman does possess sufficient strength to wield the fatal weapon, and that the blood could have splattered away from the assailant, thus explaining Lizzie's clean dress after the murders. The defense responded by urging the jury to rely on their own common sense, not scientific information. The jury returned with their verdict in less than an hour, shouting "Not guilty," to the obviously immense relief of Lizzie Borden. Certainly, the prosecution's case was based largely on circumstantial evidence that might not have proven her guilt beyond a "reasonable doubt," though reporters later learned that the jury did not even debate the evidence. After the trial, Lizzie spent her considerable inheritance on a fancy house and fashionable clothes. She lived in isolation until her death at the age of sixty-five and left behind one of the great murder mysteries in American history. Did she really kill her parents? If so, why? And was she wrongly freed because of the media, who proclaimed her fragility and innocence?

In September 1922, Americans again focused their attention on a grisly and perplexing crime. The bodies of Edward Hall, an Episcopal rector, and Eleanor Mills, a choir singer, were found under a tree in New Brunswick, New Jersey. The murders immediately attracted attention because of the scandalous love letters scattered around the bodies, and the violent nature of Eleanor's death—both victims had been shot, but Eleanor's throat was slashed numerous times, and her tongue and vocal cords were removed. Vendors sold refreshments nearby as hundreds came to gawk at the scene of the discovery of the bodies.

The crime seemed to be a result of a scandalous affair between the two victims. Both Edward and Eleanor were married—Edward to the only daughter of one of the wealthiest families in town, and Eleanor to a shoemaker. Their affair was common knowledge in their town, but suspicion initially did not fall on either of the spurned spouses. It was not until mid-October that the "Pig Woman" came forward to offer her eyewitness account of the crime. Jane Gibson, who raised pigs on her farm, spent the evening of the murders lying in her cornfield watching for corn thieves. Gibson reported seeing Edward's wife and her two brothers at the scene of the crime. Even with the "Pig Woman's" testimony, however, the grand jury opted not to indict.

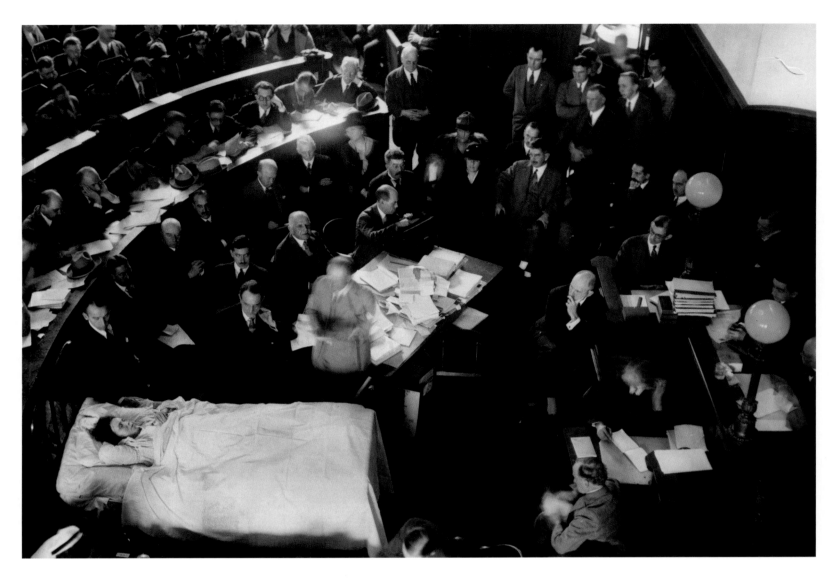

The case languished for four years until a new witness came forward with incriminating evidence about Edward Hall's wife and her brothers. The media again latched onto the case and it reappeared on the front page, which subsequently prompted local officials to take action and get an indictment. The trial of Mrs. Hall and her brothers featured new testimony from eyewitnesses who had not previously come forward. The "Pig Woman," now ill with cancer, gave dramatic testimony at the trial from a hospital bed. The defense questioned her credibility, and also argued that Hall and her brothers were refined, Christian people incapable of such a crime. The jury voted for acquittal. This crime, which still remains unsolved, and which kept the nation transfixed for a brief, intense moment in the 1920s, has since faded from the nation's memory.

On the afternoon of May 24, 1924, multi-millionaire Jacob Franks, who lived in Chicago, received some terrifying news. His young son Bobby had been kidnapped, and the kidnappers were demanding a ransom of ten thousand dollars. Franks was preparing to deliver the money when a street crew worker discovered Bobby's body in a culvert. Police investigators soon found a crucial piece of evidence next to the body: a pair of glasses in a frame that belonged to only three people in the whole city of Chicago. That evidence led police to Nathan Leopold, and then to his friend, Richard Loeb.

This case gained attention in the media as the gruesome details about Bobby Franks's death were revealed. Leopold and Loeb had lured him into their car, and then clubbed

Courtroom scene of the prosecution's star witness, Jane Gibson, known as the "Pig Woman" for the livestock she raised, testifying from a hospital bed at the Hall-Mills murder trial. Somerville County Courthouse, New Jersey.

him to death with a chisel. Next, they burned his body with hydrochloric acid to prevent identification. The case attracted even more attention when famous attorney Clarence Darrow was hired to defend Leopold and Loeb. Surprisingly, given his considerable skills as a trial attorney, Darrow elected to have his clients plead guilty to murder and kidnapping for ransom, both of which carried the death penalty. Darrow then asked the judge to spare their lives, expressing his intense opposition to the death penalty. Darrow's closing statement, which was heavily covered in the media, lasted twelve hours and is memorable for its dramatic eloquence. Five thousand people waited in the street for the verdict to be read. Darrow's argument prevailed, and the judge sentenced both men to life in prison. While serving his sentence, Loeb was stabbed to death in a prison shower in 1936. Leopold was paroled in 1958 and moved to Puerto Rico, where he lived until the age of sixty-six.

The media called Leopold and Loeb's case the "crime of the century" not only because of the prominence of the victim's family, but also because Americans could not understand why two intelligent young men—Loeb graduated from the University of Michigan at seventeen, and Leopold from the University of Chicago at eighteen—would commit such a terrible crime. Historians have labelled Leopold and Loeb monsters, or portrayed them as victims of a poor upbringing, while others have argued that Leopold and Loeb killed solely for the excitement and the challenge of committing the perfect crime.

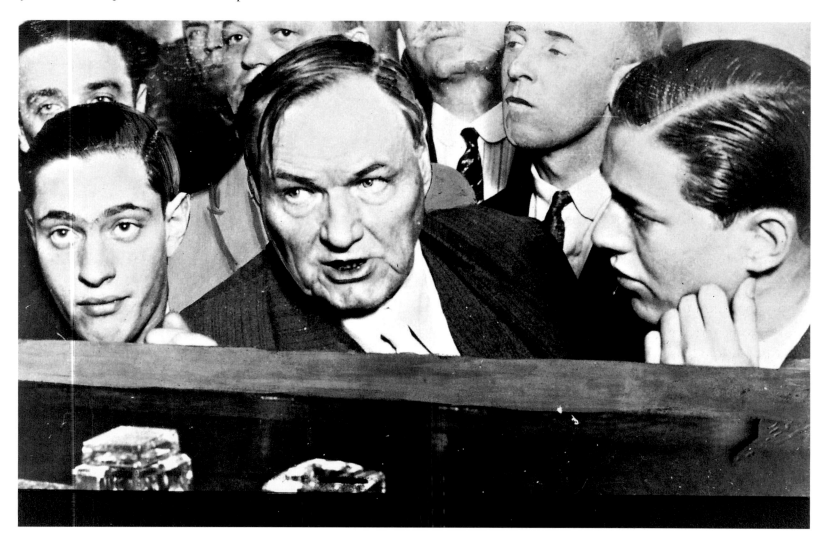

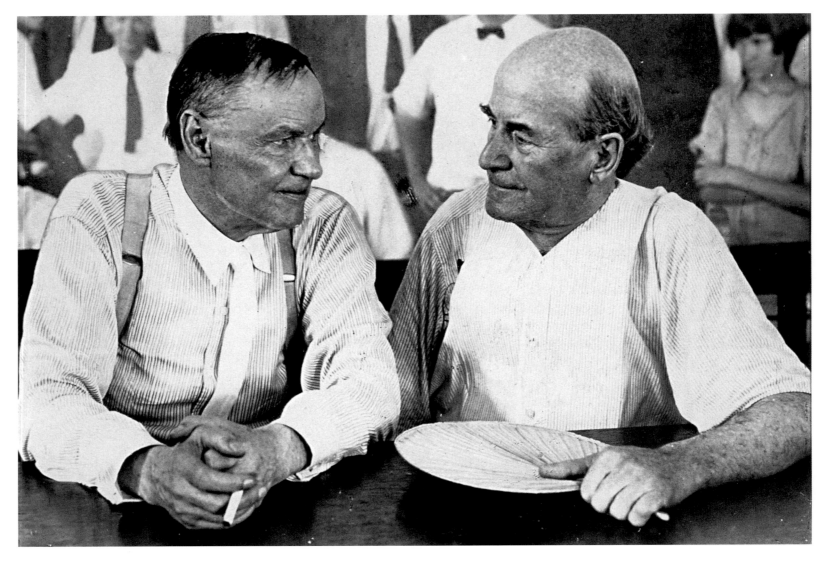

Less than a year after the media covered the drama of the Leopold and Loeb case, a trial of a different nature stormed onto the scene. The Scopes "Monkey Trial" became a media sensation because it addressed a controversial issue and sparked intense public debate. In March 1925, a group of city officials in Dayton, Tennessee, spotted an advertisement placed by the American Civil Liberties Union (ACLU) seeking a teacher to act as a test case for the Butler Act, a Tennessee law that made it illegal to teach evolution in public schools. The town officials hoped that hosting such a trial would make Dayton famous. They approached a local biology teacher named John Scopes, who agreed to participate.

Media interest in the Scopes trial grew rapidly when William Jennings Bryan, popular fundamentalist Christian speaker and former presidential candidate, offered to assist the prosecution. Clarence Darrow, who had recently finished his arguments in the widely publicized Leopold and Loeb case, offered to defend Scopes for free. Darrow's interest in

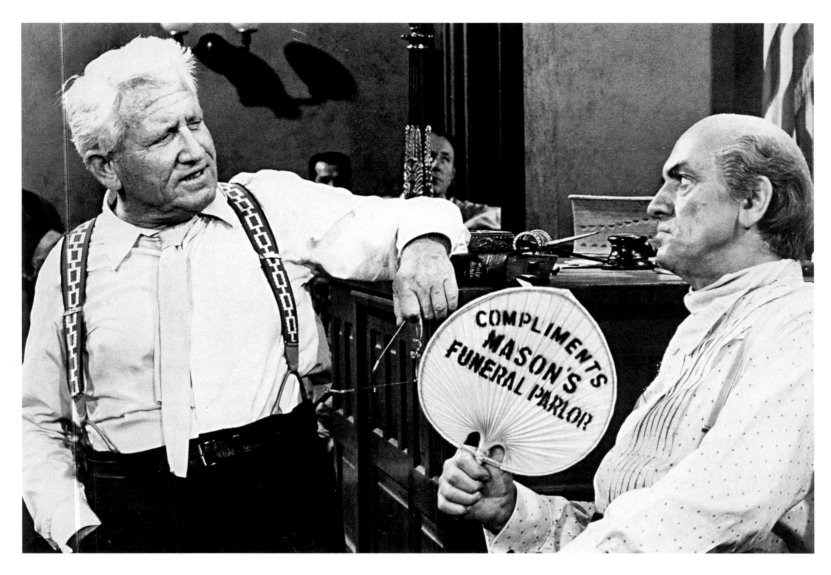

Above: Actor Spencer Tracy (left) cross-examines Fredric March (right) who fans himself, in a still from a courtroom scene in director Stanley Kramer's 1960 film "Inherit the Wind," based on the 1925 Scopes "Monkey Trial."

Opposite, bottom: Portrait of John Scopes, biology teacher in the Dayton public schools, who agreed to participate in challenging the Butler Act.

the case was motivated by his belief that the Butler law challenged individual and religious freedom. Even before the first gavel, the stage was set for a media extravaganza.

The trial began on July 10, 1925, with more than one thousand spectators in attendance, including many journalists. Microphones were used in the courtroom to broadcast the trial over the radio. For the first time in history, Americans could follow a trial as it happened. The defense hoped to argue for the validity of Darwin's theory of evolution, but Judge Raulston ruled that the jury should only debate whether Scopes had, in fact, taught evolution.

Darrow began his defense by admitting that Scopes had violated the law. From there, he hoped to argue that teaching evolution did not directly contradict creation, that the two ideas could co-exist. The judge undercut that strategy when he ruled that Darrow could not call scientific experts to testify. So Darrow shifted his course and, in a surprise move, called William Jennings Bryan to the stand. Darrow wanted Bryan to testify about his belief in the literal interpretation of the Bible. Bryan became flustered during Darrow's relentless questioning, and Judge Raulston had to step in and halt the proceedings. In the end, Darrow requested that the jury find Scopes guilty so the case could go forward in an appeal. Five days after the conclusion of the trial, Bryan died of a heart attack—some suggested he died of a broken heart after witnessing the attack on his cherished belief in

the literal interpretation of the Bible. In 1926, the Tennessee Supreme Court heard the Scopes case and overturned the verdict on technical grounds, but it was not until 1967 that the Butler Act was repealed.

The Scopes trial was generated for the sole purpose of attracting media attention to the issue of teaching evolution. Dayton's town officials also participated in a public relations move for their town. Thus began a trend that continues today, with the media treating trials as newsworthy events, and even broadcasting gavel-to-gavel coverage of the proceedings as they happen.

The entire nation was stunned and grief-stricken at the circumstances of the kidnapping in 1932 of the infant son of one of our greatest heroes. On March 1, famed aviator Charles "Lucky Lindy" Lindbergh sat in front of a roaring fire with his wife, Anne. They were unaware that their son, Charles Jr., was being abducted from his nursery upstairs. A nursemaid went to check on the sleeping baby and was shocked to see an empty crib. The Lindberghs discovered the nursery window open, a ladder leaning next to the building, and a ransom note on the windowsill demanding fifty thousand dollars.

News of the kidnapping spread, and hundreds of reporters and photographers descended on the Lindbergh estate. As concerned Americans attempted to help bring the Lindbergh baby home, the police were deluged with suggestions, tips, and false leads. A man in the Bronx named John F. Condon offered to help pay the ransom, and published his statement in his hometown newspaper. To his surprise, he was contacted by the kidnappers, who arranged with Condon for delivery of the ransom. In exchange, Condon received a note telling the Lindberghs their son was on a boat named "Nelly." Sadly, the information proved false—they were not able to find the boat, or the baby.

Two months after the kidnapping, the baby's body was found in the woods near the Lindbergh home. Americans were horrified, and investigators redoubled their efforts to find those responsible. Eventually, the police were able to locate one of the bills paid in the ransom. As more of the bills began to appear around the metropolitan New York area, investigators got a lucky break when one of them showed up with the license "4U-13-41" written on it, which was registered to a man named Bruno Richard Hauptmann.

Police searched Hauptmann's home and found $14,000 in bills from the ransom, binoculars, New Jersey maps, and a sawed-off floorboard that matched the wood used to

WANTED

INFORMATION AS TO THE WHEREABOUTS OF

CHAS. A. LINDBERGH, JR.

OF HOPEWELL, N. J.

SON OF COL. CHAS. A. LINDBERGH

World-Famous Aviator

This child was kidnaped from his home in Hopewell, N. J., between 8 and 10 p. m. on Tuesday, March 1, 1932.

DESCRIPTION:

Age, 20 months	Hair, blond, curly
Weight, 27 to 30 lbs.	Eyes, dark blue
Height, 29 inches	Complexion, light

Deep dimple in center of chin
Dressed in one-piece coverall night suit

ADDRESS ALL COMMUNICATIONS TO
COL. H. N. SCHWARZKOPF, TRENTON, N. J., or
COL. CHAS. A. LINDBERGH, HOPEWELL, N. J.

ALL COMMUNICATIONS WILL BE TREATED IN CONFIDENCE

March 11, 1932

COL. H. NORMAN SCHWARZKOPF
Supt. New Jersey State Police, Trenton, N. J.

The United States Department of Justice entered the Lindbergh baby kidnapping case by distributing this poster to police chiefs in over 1,400 U.S. Cities. March 13, 1932.

Right: Courtroom artist Paul Frehm sketched this dramatic courtroom scene of Amandus Hochmuth, aged neighbor of the Lindberghs, who points to Hauptmann as the "man with fierce eyes" whom he saw at the Lindbergh estate the morning of the kidnapping. The wavering finger of the rheumatic witness was not definite enough to satisfy the defense, so he was asked to step down from the stand and place his hand on Hauptmann.

Below: Bruno Richard Hauptmann, accused kidnapper/murderer of Charles A. Lindbergh, Jr. January 18, 1935.

make the ladder outside baby Lindbergh's window. Hauptmann was questioned by the police for two days, during which he was beaten until he collapsed. But he did not confess. Instead, he claimed a friend of his named Isidor Fisch had given him a shoebox with the bills in it before Fisch returned to Germany. Fisch had since died of tuberculosis, so there was no way to verify Hauptmann's incredible story.

Hauptmann was indicted for murder, and his trial began on January 2, 1935. The Hearst Corporation, in exchange for exclusive rights to Hauptmann's story, paid for a defense lawyer named Edward Reilly. New Jersey's attorney general David Wilentz prosecuted the case. Public interest in the case had not subsided, and six hundred members of the media gathered daily around the courthouse, collectively telegraphing over three hundred thousand words every day. The courtroom was also filled with spectators, literary figures, motion picture cameramen, and radio broadcasters.

The prosecution, building on a public perception that Hauptmann was guilty, presented a strong case, including witnesses who saw Hauptmann with a ladder in his car, and another who saw Hauptmann walking in the woods near the Lindbergh estate. Even Condon identified Hauptmann as the person who took the ransom. Although Hauptmann's lawyer tried to defend his client, he did not successfully refute the prosecution's case, and the jury found Hauptmann guilty and sentenced him to death. He was executed on April 3, 1936, almost four years after the Lindbergh baby had disappeared.

This case continues to attract attention to the present day, and scholars have scoured FBI files obtained under the Freedom of Information Act. Although Hauptmann did possess the ransom money, FBI files reveal that many of the prosecution's witnesses should not have been trusted—one witness was practically blind, and witnesses who might have

Dr. Sam Sheppard, accused of murdering his wife in 1954, leaves court with his defense attorney F. Lee Bailey.

Dr. Sam Sheppard being questioned by coroner Samuel Gerber, July 23, 1954.

aided the defense were persuaded not to testify. For several months after his arrest, police had access to Hauptmann's apartment, and ample opportunity to manufacture evidence. Additionally, legal scholars debate the legitimacy of the felony-murder charge used to execute Hauptmann. Although the ransom money could have linked Hauptmann to the kidnapping, it did not prove he committed the murder.

Sam Sheppard was not a famous man in 1954 when his wife Marilyn was attacked and beaten to death in their suburban Cleveland home. But his story would soon become well-known as the basis of the popular 1960s TV series "The Fugitive," which was also made into a 1993 movie starring Harrison Ford, as well as a current TV series. The premise behind the original television show was that the title character fled justice in order to find the "one-armed man" who had killed his wife. In reality, Sam Sheppard claimed to have struggled with a "bushy-haired" intruder the night his wife was murdered. Sheppard claimed that on the night of the murder, July 4, 1954, he was awakened by his wife's terrified voice. Running to her aid, he struggled with the intruder and was knocked out. When he woke up, he found his wife had been murdered. The police found no signs of an intruder, and arrested Sheppard for the crime. His trial began in October, and he was convicted and sentenced to life in prison. When Sheppard's lawyer died in 1961, the family hired prominent attorney F. Lee Bailey to press for an appeal. Bailey was ultimately successful, convincing the U.S. Supreme Court that the extensive media coverage of Sheppard's trial had biased the jury. After twelve years in prison, Sheppard was released and he prepared to face a second trial.

Judge Francis Talty, who presided over Sheppard's second trial, issued severe restrictions on the media, as well as sequestered the jury. This time around, Sheppard was found not guilty. Unfortunately, his life would never be the same. He became addicted to drugs and alcohol and his second marriage failed. He died in 1970 from liver failure. His son, Sam Jr., took up his father's cause and began a campaign to prove to the American public that his father was innocent.

In 1993, investigators found an important item among the trial exhibits: a vial containing a small blood-stained sliver of wood that could be tested for DNA. Sheppard suspected Richard Eberling, who had access to the Sheppard home as a window washer, of being the real killer. Eberling, who was serving time in prison for another crime, gave a blood sample. Forensic scientists found Eberling's blood to be "consistent" with the blood found on the sliver, but Eberling claimed he cut himself while washing windows. Sam Sheppard, Jr., called on prosecutors to re-open the case, since it was technically listed as an unsolved crime, and in early 2000, he received another chance to prove that his father was wrongly convicted.

Over a ten-week period, a Cleveland jury heard evidence in the Sam Sheppard case, including seventy-six witnesses and hundreds of exhibits. Sheppard's lawyer, Terry Gilbert, faced an uphill battle when the judge ruled that the defense could not mention Eberling as a possible suspect unless they tied him directly to the scene of the crime. On April 20, 2000, after less than six hours of deliberations, the jury returned with their verdict. Much to the surprise of courtroom observers and Sam Sheppard, Jr., the jury upheld the original conviction, which meant no one on the jury had been sufficiently convinced that Sheppard was innocent. Although we now have more information about the crime, we may never know for certain who killed Marilyn Sheppard.

In 1969, Americans would again be riveted to news of a gruesome crime. A series of murders in San Francisco initially attracted the attention of the nation because one of the victims was actress Sharon Tate, but as the case was uncovered, it revealed a terrifying truth about political and personal power. Tate, who was married to director Roman Polanski and pregnant with their child, was one of seven people shot and violently stabbed over two separate nights. Investigators did not initially link the crimes, but in December, a jail-house confession by Susan Atkins provided the necessary information. Atkins told her cellmate about a man named Charles Manson, and how she and her fellow "Manson Family" members had murdered Sharon Tate, just as Manson had instructed them.

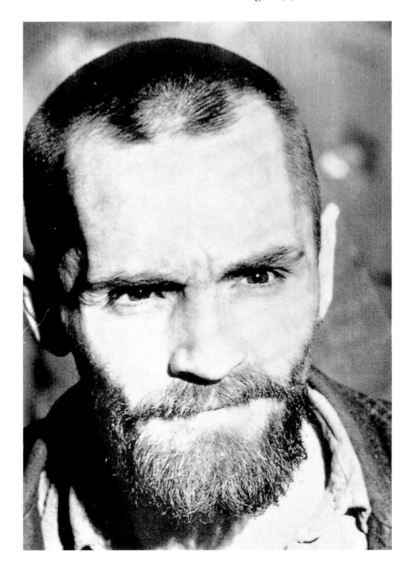

Charles Manson, at the time of his trial for the "Sharon Tate Killings." 1971.

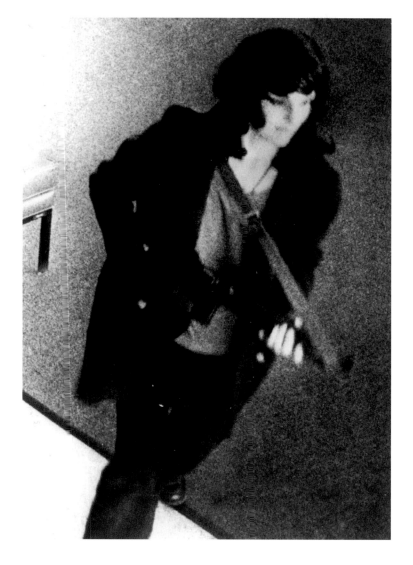

Heiress Patricia Hearst, seen from a video surveillance camera, wielding a machine gun during a robbery in which she participated, either voluntarily or by coercion, with the SLA. 1974.

Americans were spellbound as the details began to emerge. Charles Manson and his "family" lived together in a commune, where Manson indoctrinated them with drugs and his philosophy, which included a belief that his family would rule the world after an apocalyptic race war had ravaged the country. Manson hoped that the murders he ordered would be blamed on African-Americans, thus igniting the race war.

Manson and three female members of his group stood trial beginning in June 1970. The prosecutor, Vincent Bugliosi, faced the difficult task of proving that Manson family members were under Manson's direction when they committed the murders. The trial lasted nine months. Each bizarre turn of events was heavily covered by the media, such as the daily vigil kept in front of the courthouse by Manson family members with shaved heads, and their occasional threats to set themselves on fire. Even President Nixon weighed in on the Manson trial, calling Manson "guilty, directly or indirectly, of eight murders without reason." The media criticized Nixon for pronouncing the guilt of someone still presumed to be innocent.

On January 15, 1971, the jury began deliberations, and nine days later they found all four defendants guilty of murder and sentenced them to death. Since the California Supreme Court abolished the death penalty in 1972, the convicted Manson family members are presently serving life sentences. Although Charles Manson regularly applies for parole, appearing at his hearings with a swastika carved into his forehead, it is certain he will never be released from prison. The intense media attention paid to Manson's crimes and trial, including Bugliosi's own chilling account in his book, *Helter Skelter,* alerted the American public to the frightening ability of one man to completely control another.

In the turbulent years of the early 1970s, the media covered another legal drama, which had all the elements of an action movie—the wealthy heiress who is kidnapped and held for ransom, is eventually imprisoned herself, ultimately released, and ends up living in the suburbs. But this was not a story—it was fact, and the media reported on it almost daily. The public could tune in any time for an update on a case that had everyone wondering what one of the richest young women in America was really up to.

It all began when a politically radical group named the Symbionese Liberation Army (SLA) decided to make a name for themselves by kidnapping Patty Hearst, daughter of the well-known publishing mogul. On February 4, 1974, Hearst was dragged from her Berkeley, California, apartment by the SLA and kept in a closet for two months. Soon

after her abduction, the SLA began issuing demands, namely that Randolph Hearst give millions of dollars to feed the poor. Each communiqué from the SLA was printed, as per their instructions, in its entirety in national newspapers, contributing to the intense media interest in Hearst's situation. Although their initial demands were met, the SLA did not release Hearst. Instead, much to everyone's surprise, Patty issued a statement that she had chosen to stay with the SLA and join their fight.

Soon, Hearst, who had changed her name to Tania, became a wanted criminal for her participation in an armed robbery, but she evaded capture for months. The FBI finally located Hearst and arrested her, and the trial began two years after her kidnapping. Hearst, who was defended by famed attorney F. Lee Bailey, claimed she had been coerced into committing the robbery, and that during the entire nineteen months she spent with the SLA, she was living "under duress." The press coverage of the trial was extensive, with both national and international media in attendance. The jury did not believe Hearst, and they sentenced her to seven years in prison, but she was released after two years when President Carter commuted her sentence in 1979. In January 2001, President Clinton issued her a presidential pardon. Even today it is still unclear whether Hearst participated in criminal activity because she truly believed in the SLA's goals, or whether she was experiencing residual trauma from her captivity.

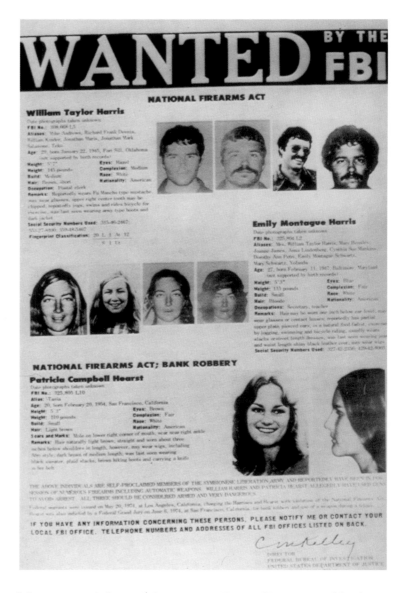

"Wanted" poster issued by the FBI calling for the capture and arrest of Patty Hearst and others associated with the SLA. 1974.

Americans were also debating more weighty legal issues in the 1970s. One of the first cases to fall under public examination of the complex question of a person's "right to die" was that of Karen Ann Quinlan. In early 1975, Quinlan consumed a mixture of tranquilizers and alcohol that caused her breathing to stop. She fell into a coma and never regained consciousness. After three months, her parents asked the doctors to remove her from her respirator and allow her to die naturally. The doctors refused, and Quinlan's case ended up before the New Jersey Supreme Court. Since this was the first time a United States Court would wrestle with the issue of a "right to die," the case attracted national and international media attention.

In presenting their case, Quinlan family attorneys argued that doctors should not force the Quinlans to keep Karen alive "after the dignity, beauty, promise, and meaning of earthly life have vanished." A court-appointed guardian argued that Karen's parents could not be sure she would not recover, so they had no right to commit euthanasia. In July 1976, the Court issued its ruling: the Quinlans prevailed and Karen's respirator was turned

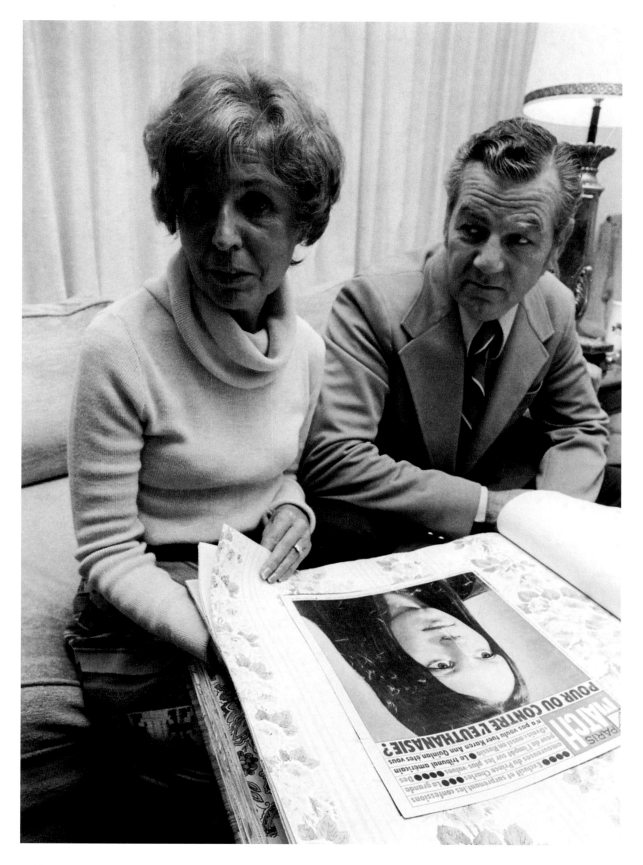

The parents of Karen Ann Quinlan leaf through a scrapbook containing national and international media coverage of their daughter's "right to die" case. 1977.

off. Much to everyone's surprise, Karen's body began to breathe on its own, and she remained alive for nine more years. Although the Quinlan decision did not immediately change her situation, Karen Quinlan's case has come to stand for a person's right to refuse medical treatment, as well as a family's right to make certain decisions for an incapacitated patient.

Trials for income-tax evasion rarely attract much public debate, nor are they heavily covered in the print and television media. However, when the person on trial is known as

the "Queen of Mean," people start to take notice. In August 1989, Leona Helmsley stood trial for evading $1.7 million in federal income taxes. In particular, the prosecution argued that Helmsley charged personal expenses such as cosmetics, lingerie, and a $37,000 stereo system to her hotel business. Many wondered why someone worth more than $40 million would bother concealing $1.7 million in taxes from the federal government? The prosecution's answer: simply, greed. Helmsley's trial garnered daily coverage in the media because of her notoriously nasty behavior toward her employees. In the end, the jury agreed with the prosecution and sentenced Helmsley to four years in prison.

In 1992, famed Harvard Law professor Alan Dershowitz agreed to handle Helmsley's appeal. After being granted a new trial, Dershowitz attempted to prove that Helmsley was unaware of tax evasion, since it was conducted by her subordinates and her accountant. Also, Dershowitz contended that Helmsley was prosecuted because she made such a sensational target for then-U.S. attorney Rudolph Giuliani. Dershowitz was unsuccessful, and Helmsley eventually served eighteen months in jail. She was paroled in January 1994. Leona Helmsley was out of prison, but it was obvious the ordeal had taken its toll on her. The public that watched the proceedings unfold saw the financial—and personal—downfall of a woman who thought her wealth kept her above the law.

Hotel "Queen of Mean" Leona Helmsley, accompanied by her attorney Alan Dershowitz, enters New York Supreme Court for her tax fraud hearing. 1990.

*Brothers Lyle and Eric
Menendez during proceedings of
their murder case of the shotgun
shootings of their wealthy
parents. 1991.*

In the late 1980s and 1990s, media coverage of legal topics and criminal trials continued to rise, often focusing on scandalous crimes that momentarily captivated the nation, possibly due to their lurid or unusual aspects. One such crime occurred on August 20, 1989, in the Beverly Hills home of Kitty and Jose Menendez. The couple were watching TV when their two sons, Eric and Lyle, burst into the room and killed them with a shotgun. Investigators initially debated whether the two were murdered by a professional killer, but soon, suspicion began to center upon Eric and Lyle, who were due to inherit over $14 million. Their trial began on July 20, 1993, and although the two brothers admitted shooting their parents, they entered a plea of not guilty. Eric and Lyle's attorney argued the two boys had acted in self-defense after enduring years of sexual abuse. The juries (each brother had a separate jury) were given a choice of verdicts ranging from first-degree murder to involuntary manslaughter. After weeks of deliberations, both were deadlocked. The Menendez brothers would face another trial, which began in August 1995. In the second trial, the prosecution more effectively rebutted the brothers' charges of abuse and argued that their motive for the killing was simple greed. The jury agreed and convicted Lyle and Eric of first-degree murder with special circumstances. The jury spared the brothers from an execution and instead sentenced them to life in prison without the possibility of parole. Although they pleaded to be imprisoned together, they are currently serving out their sentences in separate California prisons.

As powerful a motivator as greed is, the emotions that stem from the eternal "love triangle" can provoke even more outrageous actions, and a waiting media stands ready to capture us at the moment we go over the edge. When Mrs. Mary Jo Buttafuoco answered the door of her Long Island, New York, home in May 1992, a seventeen-year-old woman named Amy Fisher took out a gun and shot her. Mary Jo was gravely wounded and spent nine hours in surgery. When she awoke and described her assailant, her husband Joey identified the assailant as Amy Fisher. After Fisher was arrested, she told police she had been having an affair with Joey, and claimed that Joey himself had suggested the shooting. Joey vehemently denied these charges, but the sordid drama of the "Long Island Lolita" had already attracted national media attention, especially in tabloid newspapers and on television.

On September 23, 1992, Fisher agreed to plead guilty to reckless assault because she feared going to trial for attempted murder. Fisher's plea required that she provide information to investigators, which meant she would help the district attorney's office build evidence to charge Joey with statutory rape. The following April, Joey pled not guilty and was indicted for statutory rape, sodomy, and endangering the welfare of a child. Despite convincing evidence that included hotel bills, Joey vehemently denied having sexual contact with Amy Fisher, and Mary Jo continued to publicly support her husband.

Despite his claims of innocence, Joey accepted a plea bargain in October 1993 and admitted he had sexual relations with Fisher. He served 129 days of a six-month sentence and attended a welcome-home party thrown by his wife. Although this entire case was fodder for the tabloid media, even *The New York Times* covered Joey's homecoming and printed the party menu.

Although the intense media attention paid to Fisher and the Buttafuocos has since faded, they all continue to face repercussions. Most seriously, Mary Jo Buttafuoco, who still has a bullet lodged near her spine, remains deaf in one ear and blind in one eye, and yet she still stands by her husband. Joey hoped to turn his momentary fame into a career as a talk-show host or as an actor, but his plan did not produce much success. Amy was released in May 1999 after serving seven years of her fifteen-year sentence.

A jubilant Lorena Bobbitt after being released from a mental hospital, where she had been under observation since her acquittal by reason of insanity. 1994.

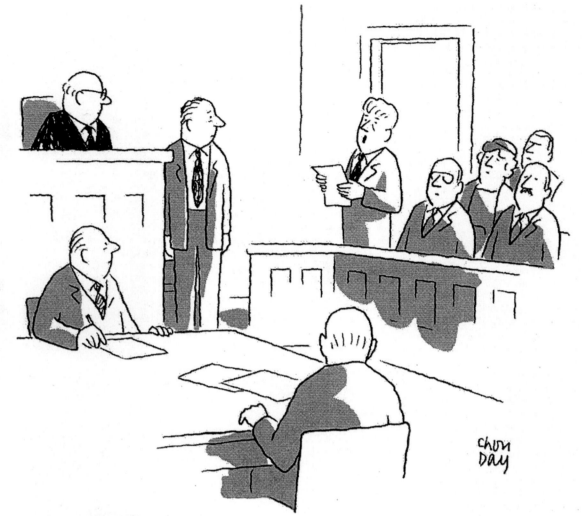

"We find the defendant guilty as charged by the media."

In a bizarre twist to the traditional American boy-meets-girl story, John and Lorena Bobbitt became instantly famous due to the sordid details of their crumbling marriage. On June 23, 1993, Lorena sliced off John's penis, drove away with it, and eventually threw it out the window into a vacant lot. After a search-and-rescue team located the severed organ, doctors were able to reattach it during a nine-hour operation.

Lorena's trial began in January 1994 in Manassas, Virginia. Not surprisingly, the atmosphere outside the courthouse was circus-like, with activists, vendors, and radio stations competing for space in the parking lot. Even the mainstream media, including major networks, came to town to cover the trial. After years of abuse and marital rape, Lorena claimed to have acted in self-defense, and therefore was not responsible for her actions. In fact, in 1993, John had been tried and found not guilty of sexual assault. In Lorena's trial, however, the jury believed her and found her not guilty due to temporary insanity.

Apart from the Buttafuocos and Bobbitts of the world, the media does focus on serious issues that deserve the public's thoughtful attention. Dr. Jack Kevorkian's name became newsworthy during the 1990s for his role in assisting terminally ill people to commit suicide. In June 1990, Kevorkian presided over his first assisted suicide in his

Dr. Jack Kevorkian responds to a question during cross examination by the prosecution during his assisted suicide trial in Oakland County Circuit Court. Kevorkian compared his inventions in helping suffering people end their lives to those of an executioner who upholds the law. March 4, 1996.

old Volkswagen van. Janet Adkins, a vibrant woman who had been diagnosed with Alzheimer's disease, traveled to Michigan where Kevorkian lived, and where there was no law prohibiting assisted suicide. Adkins's death prompted a national debate about the ethics of assisted suicide, which was a featured topic in Op-Ed pages, and on television talk shows.

Despite a judicial ruling forbidding the use of his assisted-suicide machine, Kevorkian presided at two more assisted suicides in February 1991. In response, Michigan suspended his license to practice medicine, and Kevorkian was indicted on two charges of murder. In July, however, the indictment was dismissed because Judge David Breck ruled that Kevorkian had not committed murder, and that assisting at a suicide was not illegal. After two more assisted suicides, the Michigan legislature rapidly attempted to devise a law that would stop Kevorkian. They passed a fifteen-month ban on assisted suicide in order to allow a commission to study the issue further. Before the ban took effect, Kevorkian assisted at eight more suicides. Media attention and debate grew increasingly intense.

Soon after the fifteen-month ban was found to be unconstitutional for technical reasons, Kevorkian continued to assist suicides. By the year 2000, he had attended at over 120. In 1998, Kevorkian attracted even more media attention when "60 Minutes" broadcast a videotape of Kevorkian actually delivering a lethal injection to a terminally ill person. Critics accused "60 Minutes" of airing the video to increase ratings, but the show defended their choice, stating their broadcast had sparked an important national discussion about euthanasia. Kevorkian was arrested and faced trial for murder in early 1999. In April 1999, he was convicted and sentenced to ten to twenty-five years in prison. Judge Jessica Cooper believed the trial was not about the issue of euthanasia, but, rather, she felt the crucial issue was Kevorkian's lack of respect for the legal system. She told Kevorkian after his sentencing, "You had the audacity to go on national television, show the world what you did and dare the legal system to stop you. Well, sir, consider yourself stopped."

In the early 1990s, the issue of police misconduct and racial prejudice became synonymous with the name Rodney King. The now-famous amateur videotape, filmed on March 3, 1991, of four Los Angeles Police Department officers brutally beating King

Rodney King delivers an emotional appeal for the end to the rampant violence that struck L.A. after a jury acquitted four Los Angeles police officers in the trial connected to his widely publicized beating by them.

sparked two separate trials, each of which attracted enormous media attention. In the first trial, which was held in state court, the officers' defense argued that King was perceived to be potentially dangerous, and that the officers were taking appropriate measures to bring him into custody. The jury agreed, and on April 29, 1992, acquitted Stacey Koon, Lawrence Powell, Theodore Briseno, and Timothy Wind of assault. The city of Los Angeles was shocked by the verdict—the videotape had been shown extensively on television, and it was difficult to comprehend how the jury had reached its verdict. Sadly, many reacted with violence and began looting and burning parts of Los Angeles, leaving behind over one billion dollars in damages and a polarized city.

The United States government reacted to the acquittal in state court by bringing federal civil rights charges against the officers, which meant the men would technically not be tried twice for the same crime. In the second trial, federal prosecutors had to prove that the officers deliberately set out to deprive King of his civil rights. When the case was given to the jury for deliberation, Los Angeles braced for the possibility of more rioting. In this case, however, the city greeted the verdicts with calm—Koon and Powell were sentenced to thirty months in prison, and Briseno and Wind were acquitted. The convictions were upheld on appeal, and Rodney King was eventually awarded $3.8 million in damages.

The case that set a new standard as a "media sensation" also occurred in the early 1990s. It all began on June 12, 1994, when O. J. Simpson's ex-wife, Nicole Brown Simpson, and her friend, Ron Goldman, were stabbed to death in front of Nicole's home in Los Angeles. Police officers who went to Simpson's estate learned that the famous football

The Ford Bronco carrying a fleeing O. J. Simpson is pursued by dozens of L.A. police cars during the long pursuit of June 17, 1994, the day Simpson was charged with the murders of Nicole Brown Simpson and Ronald Goldman.

player and television personality had taken a red-eye flight to Chicago. While at Simpson's home, the officers discovered a bloody glove and drops of blood on the driveway. They grew suspicious of Simpson and declared his home to be a crime scene. After O. J. returned from Chicago, he spoke with the police, who later decided to arrest him—but by then, O. J. was nowhere to be found.

Ninety-three million Americans soon knew O. J.'s whereabouts when they turned on their televisions to watch the now-famous car chase. For ninety minutes, O. J. and his close friend Al Cowlings drove slowly around empty Los Angeles freeways in a white Ford Bronco with police cars in pursuit. Negotiators eventually talked them into surrendering, and O. J. was finally arrested and charged with the murders. From that moment on, the media jumped into high gear and the public watched, and watched, and watched as the details of the case were exposed.

Simpson quickly assembled his "dream team" of defense lawyers, including Robert Shapiro, Johnnie Cochran, F. Lee Bailey, and Alan Dershowitz. Although prosecutors Marcia Clark and Christopher Darden were not well-known prior to the Simpson trial, they were soon mentioned almost daily in numerous news bulletins. The lengthy trial began on January 24, 1995, and would continue for a year. Broadcast live on Court TV, the proceedings were frequently interrupted by endless sidebar disputes that Judge Lance Ito was slow to resolve. The trial was also stopped frequently as jurors were replaced with alternates. By the end of the trial, only two out of twelve alternates remained.

Right: Defendant O. J. Simpson confers with his attorney Robert Shapiro during a late afternoon court session of Simpson's murder trial.

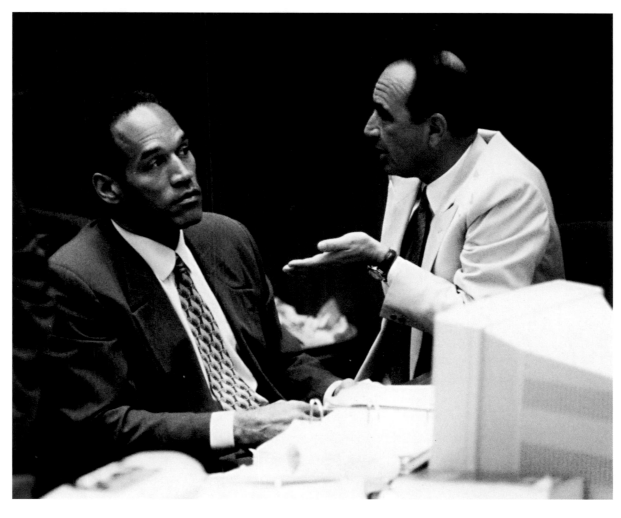

Below: DNA banding patterns show similarities in blood taken from Nicole Brown Simpson and blood found on O. J. Simpson's socks.

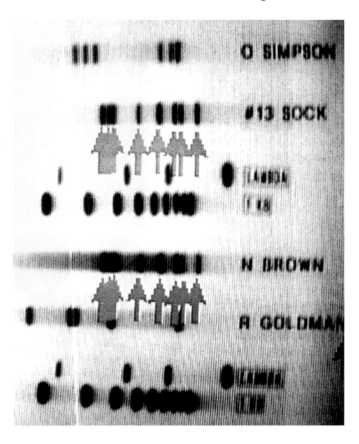

The prosecution attempted to portray O. J. as violent, abusive, and jealous—traits that led him to stab Nicole to death. By contrast, the defense contended that O. J. was framed by an incompetent and racist police department. Their case was strengthened when tape recordings of Officer Mark Fuhrman, a key witness for the prosecution, revealed that Fuhrman lied on the stand about never using racial epithets. The defense also did an effective job of rebutting extensive DNA testimony and demonstrating the "bloody gloves" were too small for O. J.'s hand. Judge Ito gave the case to the jury on Friday, September 29. On Monday they began their deliberations, which lasted only four hours. O. J. was found not guilty.

It is difficult to exaggerate the amount of media coverage devoted to the entire saga of O. J.'s arrest, trial, and acquittal. Both mainstream and tabloid television and the print media provided daily, even hourly, updates. Here was "reality TV" in its infancy, and the public was fascinated, irritated, captivated, and disgusted—all that the media needed to maintain its momentum.

In October 1996, O. J. returned to court for his second trial—Simpson faced a civil suit for damages. In contrast to the first trial, Judge Fujisaki placed a "gag order" on all those involved in

the trial, and he refused to allow cameras in the courtroom. The only moment of media intensity attention came as news of a verdict was released. By coincidence, the verdict was due to be announced just as President Clinton was giving his State of the Union Address. In fact, as soon as the president finished, the networks cut away to the California courthouse. The jury found Simpson to be "responsible" for the deaths of Nicole Brown Simpson and Ronald Goldman, and therefore liable for $8.5 million in compensatory damages and $25 million in punitive damages. O .J. Simpson's experience in the legal system was finally over, but even today Americans continue to debate whether O .J. got away with murder.

While O. J. was standing trial, a crime that was politically motivated but ended up being a national tragedy captured the attention of the nation. Americans were riveted to their televisions as the events of April 19, 1995, unfolded. Early reports indicated that an extremely powerful bomb had exploded in front of the Alfred P. Murrah Federal Building in Oklahoma City. The media rapidly broadcast pictures of the devastation caused by an explosion that claimed 168 lives, including nineteen children. As the news unfolded, it became clear that the bomb had been detonated in front of the building, directly below a day-care center. Federal investigators immediately began their search for the perpetrators. A vehicle identification number on the Ryder truck used in the bombing pointed officials to the truck rental office, where paperwork eventually led them to a man named Timothy McVeigh. McVeigh was arrested and the nation's attention turned to the upcoming trial—what would McVeigh be charged with? Who would prosecute and defend him? Would he be sentenced to die for the act of terrorism he committed? What was his motivation?

Justice Department officials and lead prosecutor Joseph Hartzler elected to charge McVeigh with eleven crimes, all of which carried the possibility of a death sentence, including use of a weapon of mass destruction and the murder of federal law-enforcement agents. From the beginning, Stephen Jones, McVeigh's defense attorney, attempted to use the media to sway public opinion about his client, arranging frequent public appearances to help build a more positive image of his client. thereby making it less likely that McVeigh would be executed. Jones's strategy followed that used in the O. J. Simpson trial, in which the defense attorneys intentionally kept a high profile in the media in the hope of influencing public opinion.

Opening statements in the trial, which was held in Denver, began on April 24, 1997. Hartzler presented an efficient and nearly flawless prosecution, calling witnesses who established that McVeigh planned the bombing, and rented the Ryder truck. The case was not airtight, since there were no witnesses who saw McVeigh make the bomb, nor was he placed at the scene of the bombing. The defense, which trial observers described as ineffective, did not capitalize on these weaknesses, and instead attempted to justify McVeigh's actions due to his anti-government political beliefs. In June, McVeigh was convicted on all eleven counts, and sentenced to die by lethal injection.

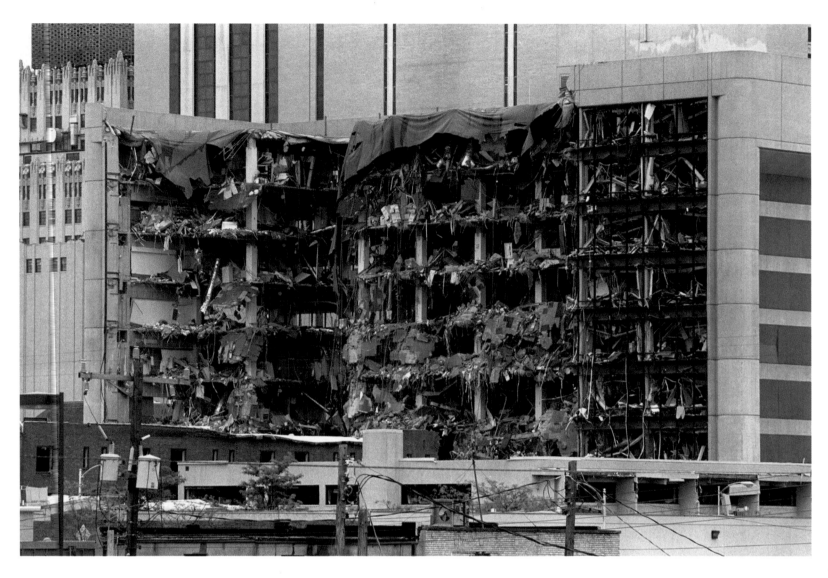

The devastated shell of the Albert P. Murrah Federal Building in Oklahoma City, the worst terrorist attack on U.S. soil.

Although the bombing in Oklahoma City will be remembered as a horrible example of domestic terrorism, trial observers noted that Americans could take comfort in the resolution of the trial. In this case, the judicial system functioned as it was intended, featuring a tough but fair judge, and well-prepared attorneys. And despite a high level of media interest, justice was not side-tracked by a media circus.

In early 2001, the media was, however, brought back to the case, this time as a potential participant. McVeigh requested that his execution, scheduled for May 2001, be televised to the public. His motivation may never be made clear, but it is clear that this man wanted media coverage of his own death—something that would assure him a place in history—but fortunately his request was denied.

How can anyone not be affected by the tragedy of a young child witnessing the death of a parent? In late 1999, America's debate over the issue of refugees from Communist Cuba was brought into the media spotlight when a six-year-old boy, Elian Gonzalez, was rescued from the waters of the Atlantic with two adults on November 25. Elian and his mother, along with twelve other Cubans, had attempted to defect to the United States by sailing to Florida. In a tragic turn of events, the boat capsized and ten people died, including Elian's mother Elisabet. Elian was sent to live temporarily in Miami with Lazaro Gonzales, his great-uncle.

Americans began to argue heatedly about how to resolve Elian's situation. Should he be returned to the custody of his father, who still lived in Cuba? Or should he be allowed to defect and continue to live with his relatives in Miami? While Cubans demanded that Elian be returned to his father, Cuban-Americans argued that Elian's mother had sacrificed her life so Elian could grow up in America. Politicians also joined the debate, both political parties sensitive to the concerns of Cuban-Americans living in Florida, a key state with regard to many issues, and particularly so in light of the upcoming presidential election.

In January 2000, the Immigration and Naturalization Service (INS) ruled that Elian should be returned to his father in Cuba. The Miami relatives disagreed and filed a federal lawsuit, which dragged out the decision for several more months. In the meantime, on April 6, Juan Miguel Gonzalez came to the United States to be reunited with his son, which proved to be more difficult than he had anticipated. The Miami relatives refused Attorney General Janet Reno's request to relinquish custody of Elian. Father and son were reunited only after armed federal agents raided the home where Elian was being held. Television and print media provided extensive coverage of the raid, and the subsequent protests in Miami.

After being reunited with his father, Elian lived in the Washington, D.C., area until his fate could be decided by the legal system. On June 23, the 11th Circuit Court of Appeals denied the Miami relatives' petition for an amnesty hearing, and the United States Supreme Court refused to intervene. Elian and his father left for Cuba on June 29, where their arrival was celebrated by eight hundred school children and a military marching band.

Many questions remain: To what extent did the widespread media coverage influence the outcome of this case? How much was the public really concerned with Elian, and to what degree did they use his situation to voice their political differences? Would this young boy have had to feel the fear of being dragged out of his Miami home by armed men if the media had not been so involved? These are

Six-year-old Elian Gonzales, the subject of a bitter custody dispute between the boy's Miami relatives who wanted him to remain in the U.S. and his natural father who wanted him returned to Cuba, plays in the backyard of his Miami relatives.

The media invade the space outside the Miami home of Elian Gonzales's great-uncle. January 2000.

questions that a responsible media must answer. Our rapidly expanding technology allows us to know what happens in the world around us almost instantly, and while knowledge does improve our lives, it is the media that chooses what we see and hear, and as such must realize the enormous responsibility that comes with its position.

Perhaps no event focused so intently on so many lawyers, judges, and justices as the 2000 U.S. presidential election, where the result turned on how a few votes were to be counted in a single state. The contest pitted the son and namesake of ex-President George Bush against the sitting vice president, Al Gore, in a state where Bush's brother was the current governor. Days became weeks as the decision-making went from state court to federal court and back again. In the end, the Florida Supreme Court, ruling in favor of a manual recount, which would have potentially given the election to Gore, was overruled by a split U.S. Supreme Court, giving the election to George W. Bush. Many people were understandably amazed—and more than a few were dissatisfied—with the results. But, putting aside political preference, here was an instance of the media enabling us to watch step by step the resolution of an important constitutional issue. A potentially disruptive dispute for the presidency was resolved peacefully through the rule of law, and in the end, the public witnessed our Constitution at work.

PRESIDENT CLINTON
AND THE MEDIA

President Bill Clinton is
interviewed by talk show host
Larry King.

O f all our American presidents, Bill Clinton stands out as the master in his
employment of the media to further his cause. His innovative use of town hall
forums to directly address the concerns of the electorate, his selective use of local
broadcast stations to target messages to specific constituencies, parsing his phrases just
so ("it depends what the meaning of *is* is"), using his obvious intelligence, superior
speaking ability, and charisma to win over the opposition and get himself out of the
tightest of political corners time and again were all truly impressive. But the media was
also Clinton's downfall, leading to queries into his personal life that no previous
American president had ever had to endure. Activities in and out of the Oval Office
once off-limits to reporting and deemed irrelevant to the office of president became a
public spectacle of deceit and infidelity for the nation's 42nd president. What changed?

One obvious change was the Internet, which gives anyone with a computer and a
modem the power to instantly reach millions. The Clinton White House employed the
Internet to by-pass the Washington press corps and distribute information directly to
the electorate through its website, but it may not have anticipated the other side of this
new medium of communication. One commentator noted, "The Web was not simply a

convenient conduit for releasing an exclusive story—it was the entity that was driving the media frenzy about the alleged presidential sex scandal." Old media changed their focus from using their websites to repeat already printed news, to now getting a jump on the news and competing with the the Internet world.

Another change was the development of cable news stations, such as CNN and MSNBC, and the increasing popularity of talk news shows on both radio and T.V. Clinton had used these new media outlets to his advantage during the elections, but repeal of the fairness doctrine in 1987 led to a proliferation of conservative-oriented news/talk programs. By 1997, this was by far and away the most popular format on the radio, carried by more than 1,300 commercial stations. By this time, Clinton had angered the White House press corps by his efforts to circumvent them, and Clinton opponents were ready to utilize the new media to spread charges of scandal and demands for impeachment.

Twenty-four-hour news stations needed news to report, and the scandals in the White House fit the bill. MSNBC created a nightly news program called "The White House in Crisis" and ran the program whether or not there was anything new to report. Curiously, throughout the duration of the scandal, Clinton's approval ratings remained high. By the time of the impeachment proceedings, the public were saturated with the news and perhaps wanted it to just go away. The president's 1999 State of the Union Address, given in the middle of the Senate impeachment trial, received a 77 percent approval rating. The Senate soon voted to acquit.

An unidentified reporter watches at his desk in the White House Press Room as the videotaped testimony of Monica Lewinsky is played in the U.S. Senate during the impeachment trial of President Clinton. February 1999.

CHAPTER VIII

THE LAWYER IN AMERICAN POPULAR CULTURE

As human beings we struggle between good and bad—both internally and within a community of others who struggle as well. A society's popular culture reflects such basic human concerns and can be seen through the records it keeps. Undeniably,, American popular culture has been well recorded. By looking at contemporary commentary, literature, and film we are able to see how the important issues of the times—our society's struggles to define what's right and wrong—have been reflected throughout our history. And what better venue to illustrate the eternal struggle between good and bad than the legal profession, which by definition exists to ensure that the rule of law is upheld, that good prevails.

Lawyers enter the legal profession intending to preserve justice and champion individual rights while at the same time ensuring the common good—at least they're supposed to. These are lofty goals considering that lawyers are no less "human" than anyone else, prone to the same abuse of power. By defining the different sides of a particular issue— or aspects of a profession—writers, journalists, artists, and filmmakers provide the reading and viewing public with materials that can both entertain us and make us think. As far as the legal profession is concerned, we see a good lawyer as a reflection of people's hopes, and a bad lawyer as a reflection of people's worst fears. Given the vital importance of the integrity of the law in America, and our natural cynicism when it comes to entrusting our future with an individual, is it any wonder that over the course of this country's history, the legal system in its entirety is more often than not viewed as a slew of rascals, either distorting the law in their own self-interest or sidelining common justice in order to protect criminals and maintain deep pockets. We are especially interested in recognizing the bad, self-serving lawyer because our deepest wish is that if we need a lawyer, we will get one of the good ones!

Judging from the historical record, the trivialization of the lawyer in popular culture appears to be a time-honored theme, stretching as far back as the beginning of the modern period, when the process of consolidating a fragmented legal system into a coherent whole began. A late-seventeenth-century anonymous "legal coat of arms"

Opposite: Jack Levine. The Trial. 1953/54. Oil on canvas. 72 × 63 in. (182.9 x 160 cm). The Art Institute of Chicago. Gift of Mr. And Mrs. Edwin E. Hokin and Goodman Fund, 1954.438. Photograph © 2001 The Art Institute of Chicago. All Rights Reserved. © Jack Levine/Licensed by VAGA, New York, N.Y.

"You'll need to find another attorney. I'm going to prison."

depicts allegorically the purported values and interests of law professionals. The scene presents a fox, hardly a symbol of trustworthiness, surrounded by two figures of questionable character, at least one of them a wealthy client. Following a theme that reappears consistently throughout the history of popular attitudes toward lawyers, the fox spews forth long reams of legal rhetoric in broken Latin, underscoring lawyers' incapacity to "speak the truth" or engage in common-sense dialogue. And as if to drive the satiric dagger deeper still, the reason for such slyness is plain and simple: the deep loyalty to material well-being rather than to the principle of social justice or the defense of the common man. Thus the designs' motto of "DUM VIVO THRIVO," which translates into "Where I live, I thrive."

That is not to say that one common and all-encompassing image of the lawyer can be neatly drawn from the annals of American popular culture. Nor is it possible to say that the history of popular perception of lawyers is a chronicle of a steady fall from grace. In the twentieth century alone, lawyers have seen their popularity rise and fall as new social trends and movements—the expression of what is considered good and bad, right and wrong with regard to the issues of the day—took hold over Americans' lives.

Law and lawyers figured especially prominently in the early literature of the United States, when many great writers took training in the law. In the late eighteenth and early

nineteenth centuries, novelist Charles Brockden Brown, a lawyer by profession, forsook his career in law to focus on literature, a decision that led to disapproval from those closest to him, in a time when law was seen as a natural calling for a man of great ability. Similarly, Washington Irving gave up a career in law to write famous stories—"Rip Van Winkle," "The Legend of Sleepy Hollow," and his satirical comedy, *A History of New-York,* where his assessment of the law is at times startlingly scathing. A list of novelists who have featured lawyers as important characters in one or several books could double as a list of great American writers. Herman Melville's *Billy Budd* tells the tale of a conflicted navy captain who serves as both prosecutor and jury in the case against a beloved

crewman who strikes and kills an officer. William Faulkner, born into a Mississippi family that included many lawyers, frequently created lawyer characters in works both major and minor. Mark Twain, son of a lawyer, wove lawyers and trials into his most famous works, such as *Tom Sawyer* and *Huckleberry Finn.*

The common association between lawyers and money, reflecting the idea of lawyers' monetary elitism and anti-democratic instincts, reached an acme in the early twentieth century, perhaps due to the rise of personal injury cases at the turn of the century as a lucrative sub-specialty of the legal profession. The term "ambulance chasing," after all, was coined by Abraham Gatner in 1917 to refer to the avid pursuit of accident victims willing to press for litigation against their perpetrators, a legal development that would prompt many to criticize such cases for the harm they bestowed upon the public image of state bars. To see the constancy of such perceptions, which feed into current popular perceptions of the law as billboards and television advertise these services, one need only read a 1916 poem by the late Carl Sandburg (1878–1967), a harsh indictment of lawyers perhaps unrivaled by any other American poet:

> When the lawyers are through
> What is there left, Bob?
> Can a mouse nibble at it
> And find enough to fasten a tooth in?
>
> Why is there always a secret singing
> When a lawyer cashes in?
> Why does a hearse horse snicker
> Hauling a lawyer away?
>
> The work of a bricklayer goes to the blue.
> The knack of a mason outlasts a moon.
> The hands of a plasterer hold a room together.
> The land of a farmer wishes him back again.
> Singers of songs and dreamers of plays
> Build a house no wind blows over.
> The lawyers—tell me why a hearse horse snickers
> Hauling a lawyer's bones?

In the 1930s, at the height of America's difficult struggle with the transformation of the marketplace, satirists William Gropper and Jack Levine transformed Depression-era liberalism into an attack on lawyers, who are seen as unduly beholden to the very powerful. In one comic rendering after another, the profession of law was incessantly poked fun at and lawyers reviled as being manipulative, self-serving, insensitive, capricious, excessively materialistic, and overly accommodating to clients without regard to right and wrong.

The so-called golden age of the legal profession, roughly stretching from the end of World War II to the end of the 1960s, stands in sharp contrast not only to the earlier, turn-of-the-century popular disdain for the profession, but to the all-time low estimation that would come to characterize the last two decades of the century. Over a century after Washington Irving wrote his great staples of American literature, Harper Lee left law school early to focus on a career in literature. Lee went on to write one of the twentieth-century's most moving and enduring American novels, the Pulitzer Prize–winning *To Kill a Mockingbird*. The novel tells the powerful story of a girl and her attorney father who successfully defends an innocent black man against a rape charge in small-town America of the 1930s. Lee's novel depicts the law and the lawyer at their best, as ultimately agents of social justice in the hands of an honorable member of the legal profession—Atticus Finch.

Mark Twain, a lawyer's son, often incorporated lawyers and trials into his popular fiction. c. 1885.

The history of American film and television is replete with images of lawyers and the legal system. Twentieth-century fictional cinema, including that based on true life stories, and even documentaries that explore the life and workings of the lawyer in the United States, echo, as did the written and drawn images of the past, the history of American popular culture. In earlier generations of film, as with literature, lawyers' images held a more favorable position than in the waning years of the last century, perhaps in response to clearly defined contemporary moral issues.

In the American mind, World War II was the ultimate victory of good over bad. During the postwar years, the all-American family became the centerpiece of popular film. Is there any story in the archives of American film that better reflects how important the law is to the endurance of American culture than the film that affirmed the existence of Santa Claus, *Miracle on 34th Street* (1947)? Even the most confirmed cynic had to be charmed by every character, from Kris Kringle himself to the young girl who believed, her skeptical mother, and the handsome lawyer who won the case in court when a little boy takes the stand and earnestly asks his daddy, who happens to be the opposing lawyer, whether Santa, the embodiment of everything that is good in the world, really exists.

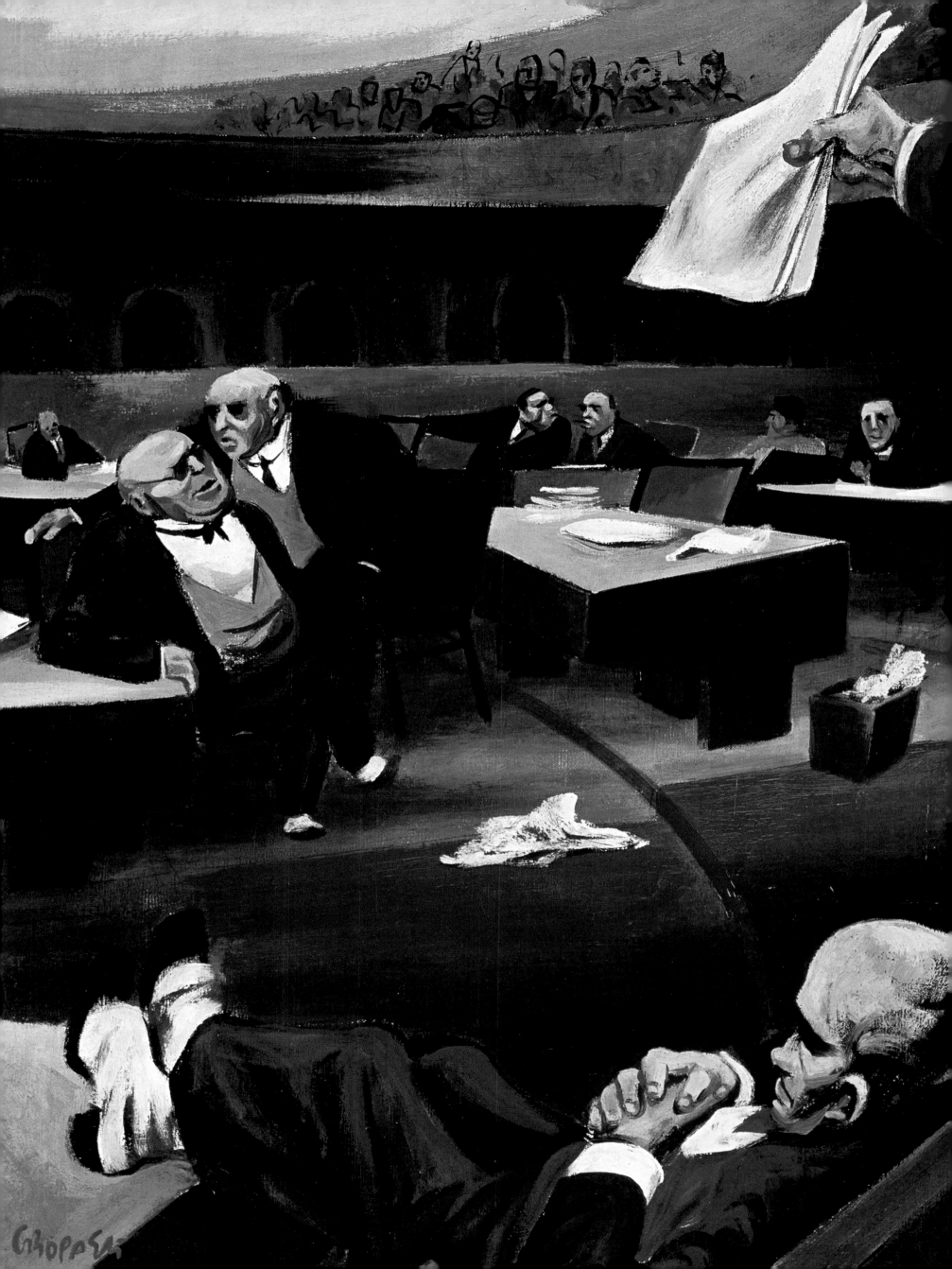

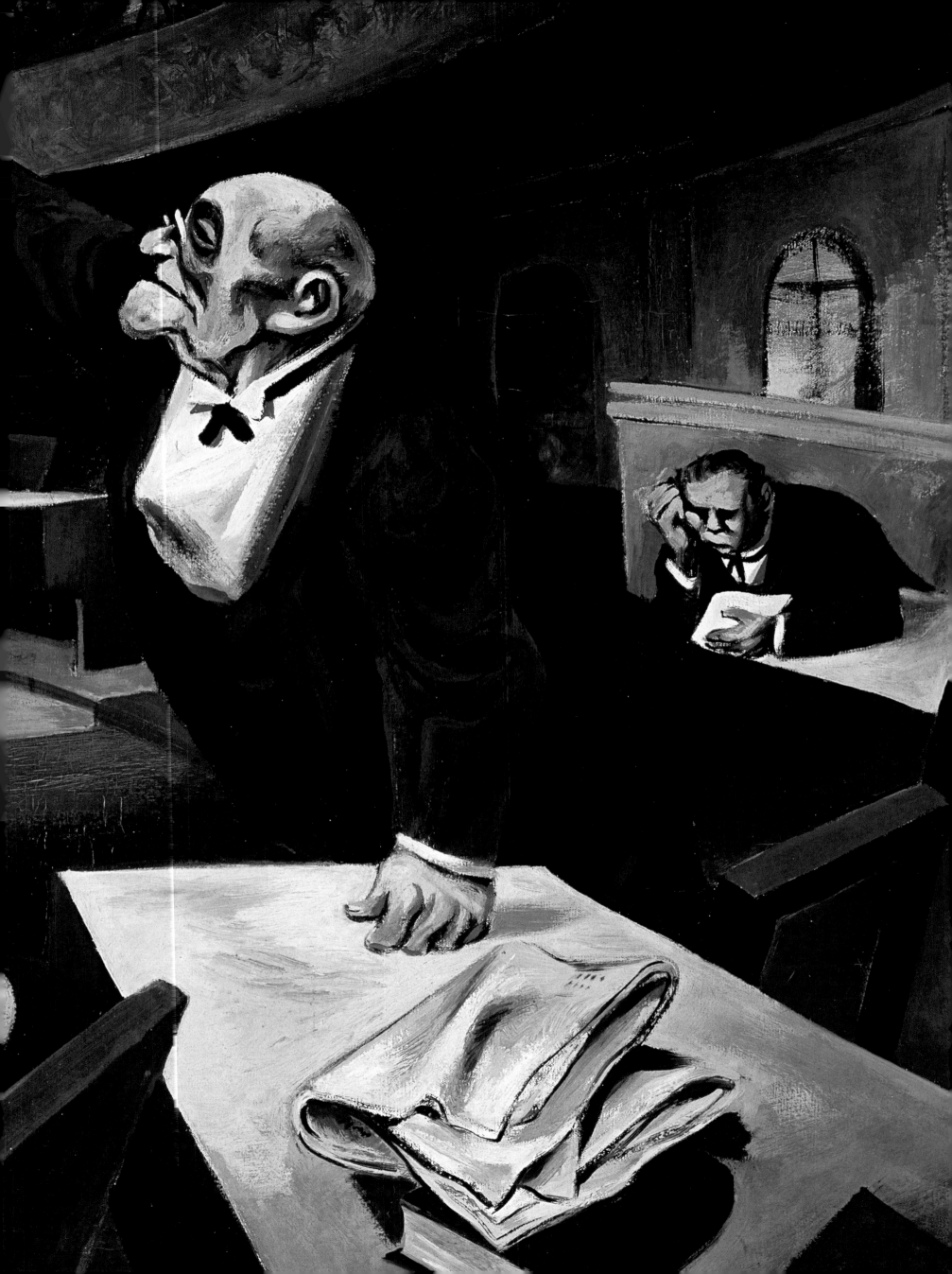

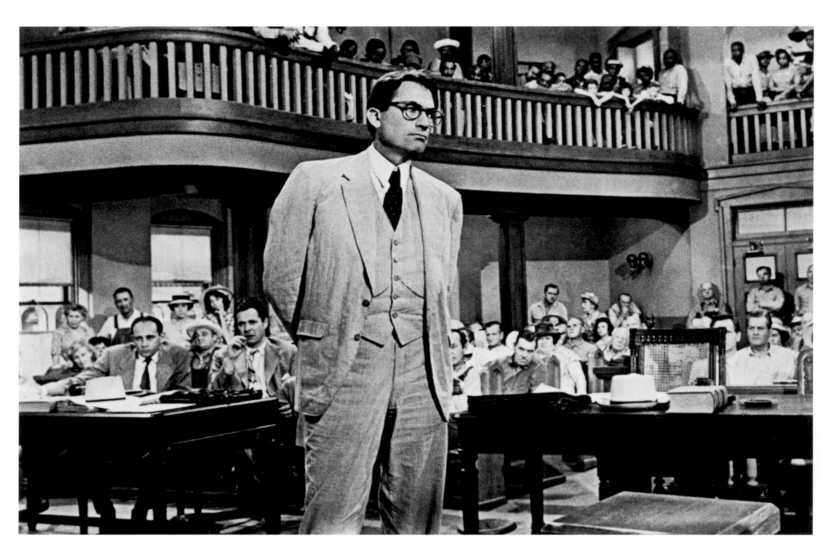

A much more serious issue was given a powerful treatment in the 1961 film *Judgment at Nuremberg*, which featured an all-star cast in a fictional recording of the war crimes trials following the end of World War II. The film may not have always been faithful to the details of the historical events. Still, it was an intelligent and provocative work that offered a largely positive portrayal of lawyers and the appreciation for the ethical dilemmas of defending or prosecuting Nazi members, who even if "just following orders" were responsible for unspeakable atrocities. And in 1962, with the increased visibility of the civil rights movement in America, Harper Lee's engrossing novel, *To Kill a Mockingbird*, was brought to the screen in an especially powerful adaptation. Gregory Peck's portrayal of Atticus Finch remains one of the more memorable performances in American cinema.

Television is the stage on which popular perceptions of lawyers and the legal profession are most flagrantly paraded in all their complexity and contradictions. Unlike the terse, satiric statement of the cartoon, television allows for the unfolding of plot and the development of character. And, unlike cinema, characters develop over time, and viewers establish relationships and attachments to them. That is not to say that lawyers are dealt a more favorable verdict in television than at the drawing hand of the political cartoonist. But by virtue of its capacity to tell a "true" story in compressed time, television expands popular images of the lawyer, embellishing them with humor, suspense, and even at times a bit of sophistication.

Above: A still from the 1962 film "To Kill a Mockingbird," starring Gregory Peck as attorney Atticus Finch.

Pages 242–243: William Gropper. The Opposition. 1942. Oil on canvas. 28 x 38 in. (71.1 x 96.5 cm). Memorial Art Gallery of the University of Rochester. Marrion Stratton Gould Fund.

A still from the 1960s television drama series "Perry Mason," starring Raymond Burr (left) as attorney Perry Mason and Barbara Hale (right) as his secretary, Della Street.

Mention the TV lawyer and the first program to come to mind is "Perry Mason." On air for close to two decades, "Perry Mason" was the first of its kind to replicate the popular subgenre of the detective story (whose roots are in nineteenth-century fiction), but with a lawyer as chief protagonist. Written by Earle Stanley Gardner, a California lawyer who wrote eighty-two Mason novels, the television series of the 1950s and 1960s followed a successful radio run of the 1940s. Gardner's Mason was a figure representing a composite of four lawyers whom Gardner had known while in

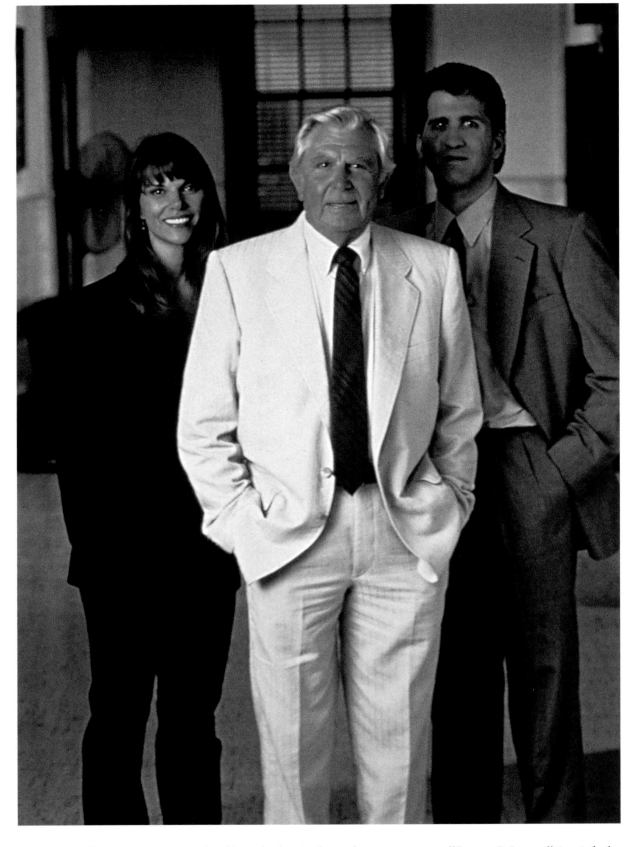

practice, all smart, serious, brilliantly logical, and courageous. "Perry Mason" is rightly considered the father of all subsequent television dramas featuring lawyers.

Where Gardner viewed lawyers in a generally positive, though one-dimensional light, E. G. Marshall, director of the popular early-1960s series "The Defenders," presented lawyers as dramatic grapplers with social issues. These issues were often public policy matters—civil rights, poverty, the draft—and their solutions remained prickly and vague, as in real life, and full of ubiquitous gray areas.

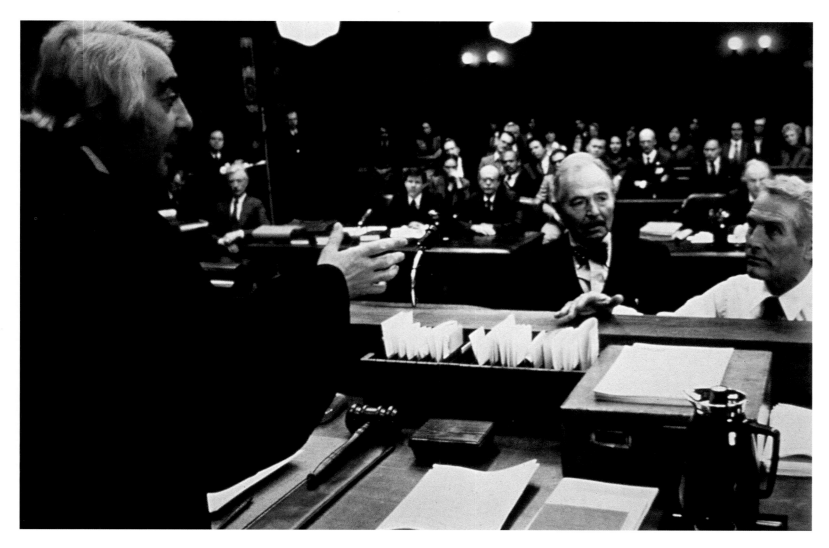

As the anti-Vietnam War movement began to take center stage, other lawyer-focused shows in the 1960s and early 1970s began to reflect the growing concern among Americans about social issues. In "Judd for the Defense," "The Young Lawyers," and "The Protectors," for instance, the attorney exhibited a sensitivity to the needs of the poor, working for legal aid groups and accepting pro bono cases on principle. At the same time, the women's movement, which heightened sensitivity to equal treatment, spawned the appearance of women lawyers in, for example, "Adam's Rib" and "Kate McShane."

It is hard to overstate the influence that such shows have had, not only on Americans' perceptions of the legal system, but on lawyers' perceptions of themselves, not to mention a few prospective law students. Television fomented an image of the legal profession that was glamorous, mysterious, appealing, and often realistic. The divisive strains of Vietnam and Watergate caused the younger generation to look upon traditional symbols of power with increasing cynicism and distaste, a viewpoint that was reflected in contemporary cinema. Lawyers in film were most frequently seen as flawed professionals concerned primarily with wealth, status, and personal vendettas. The Oscar-winning *The Godfather* and *The Godfather Part II* introduced the viewing public to Tom Hagen, the Corleone family lawyer portrayed by Robert Duvall. A likable figure, Hagen is the head legal counsel for the nation's largest fictional mob family, and as such is privy to the tactics of intimidation and violence utilized by the Corleones to retain power.

As the 1970s came to an end, the 1980s brought lawyers to the screen less as idealized symbols—both virtuous and unscrupulous—and more as realistic practitioners and hard-working professionals. In television shows like "Hill Street Blues" and "L.A. Law," lawyers could be seen working through the daily routine of plea bargains and depositions. Even the personal lives of TV attorneys reflected the ups and down of normal life—romance, family, and child rearing. Comedy was offered up as a device for depicting the working lives of lawyers. "Night Court" and "The Associates" presented oddly humorous cases and lightheartedness to the otherwise serious business of the law.

As the twentieth century drew to a close, both the viewing and the reading public continued to see no stone unturned in the quest to expose the undue influence of the legal profession over everyone's lives. Cartoonists still carry on the long-standing tradition of poking fun at legal and courtroom phenomena, any issue with the slightest legalistic touch being fair game—prenuptial agreements, divorce settlements, criminals' rights, victims' rights, campaigns against crime, insanity pleas, jury nullification, and jury tampering, among others, accompany Americans' growing familiarity with the law and the courts.

Law continues to be a common, even favored, subject of popular literature. The public's appetite for law fiction, especially legal thrillers, escalated toward the turn of the century, as demonstrated by the career of lawyer-turned-mainstream-author John

Dan Florek as Dave Meyer (left) and Corbin Bernsen as Arnie Becker (right) from the popular television legal drama series "L.A. Law." 1989.

*Cast portrait for the
1984–1992 television comedy
series "Night Court."*

Grisham. Grisham practiced law and later served in the Mississippi state senate before turning to writing. Established as a mainstay in American popular culture throughout the 1990s with a string of successful novels including *The Firm* and *The Client,* many of Grisham's novels have been converted into films (with varying degrees of box-office success). What Stephen King is to the horror market, and Danielle Steel is to romance, Grisham has become to the legal thriller—a best-seller factory, each novel a guaranteed hit despite critical appraisal sometimes falling short. Grisham's plot-driven novels delve into a world where few institutions of authority

"I suppose we have Judge Judy to thank for all this."

Below: American author, screenwriter, and criminal defense lawyer John Grisham. 1992.

are trusted, not least of which is the American legal system. Grisham has not hidden the fact that he disliked practicing law, and that aversion toward the profession seeps through in his novels, with his elaborate plots revealing lawyers acting in ways antithetical to the ideals of their profession.

One after another of Grisham's stories have translated to the big screen, generally with tremendous success and popular appeal. The 1993 adaptation of *The Firm* most likely owed its box-office appeal as much to Grisham's popularity as a writer as to the draw of the film's star, Tom Cruise. As the young lawyer realizes that his dream job at a prestigious firm is really a hideous nightmare, we are caught up once again in the eternal and always fascinating struggle between good and evil.

John Grisham does not stand alone as the only successful writer of legal fiction today. In fact, the legal thriller is among the most popular genres in American popular fiction. Like Grisham, many authors of the legal thriller are themselves attorneys—a familiar tradition reaching back to early America—today's authors channeling their expertise in law into fast-paced novels that have a wide audience. Harvard-educated Scott

A still from the film
"Presumed Innocent," starring
(from left to right) Raul Julia,
Bonnie Bedelia, and Harrison
Ford. 1990

Turow first achieved prominence with the publication in 1977 of *One L.*, a nonfictional account of his first year at the Harvard Law School. His first novel, *Presumed Innocent*, established him as a legitimate voice in popular fiction. Much of the action of the novel—and the subsequent movie adaptation—occurs in a setting familiar to Turow—the courtroom—and like Grisham, Turow has received criticism for unflattering depictions of many of his characters.

Lawyers in film, however, can still be heroes and heroines—even in the murky moral relativism of late-twentieth-century culture. Many lawyers on the big screen have fought courageous battles to secure justice for their abused clients, as in *The Accused* (1988), in which a concerned and determined prosecutor successfully argues her case against onlookers in a bar gang rape. In *Philadelphia* (1993), we see a common theme—the ethical lawyer fighting the corrupt system—imposed upon a controversial, timely topic. A homophobic black lawyer (played by Denzel Washington) defends a gay lawyer with AIDS (played by Tom Hanks) who has been fired from his firm because of his disease. The battle involves the all-too-familiar heartless, corrupt, powerful law firm, with even Washington's character struggling with his conscience and fear as he defends his client. As

Tom Hanks as an AIDS-stricken attorney facing his own personal discrimination suit in the film "Philadelphia."

is the norm in Hollywood films, the forces of good win out in the end, the legal victory tempered, however, by the tragic death of the plaintiff.

Lawyers in film have not been restricted to "serious" or dramatic cinema. Yet even when comedies center around the legal profession, the humor is usually aimed at the lawyers and their colleagues. Of course, comedies are supposed to be funny, and taking a film like the hilarious 1992 *My Cousin Vinny* as a serious indictment of the legal profession is to miss the entire point of the movie. Joe Pesci and Marisa Tomei are an unforgettable twosome that manage to argue successfully for the innocence of two wrongly accused

boys n a robbery-murder. We meet no real villains here, but the law does take a procedural hit thanks to some truly memorable characters. In the end, truth and right prevail, the boys are freed, and their lawyer Vinny goes on to finish law school—maybe.

Even comedies can mask darker themes of public mistrust of lawyers, however, as evidenced by the 1997 Jim Carrey hit *Liar Liar*, in which Carrey plays a lawyer who is literally unable to tell the truth in seemingly any context. Only when his son blows out the birthday candles and wishes that his father not lie for one whole day does Carrey force himself to be truthful, to great comedic effect. A large measure of the film's success as a comedy comes from an exaggeration of the public stereotype of the lawyer as dishonest, and despite the lightheartedness of the plot, the film raises uneasy questions about the public's image of lawyers.

At the same time, television programming invented a new brood of legal narrative centered on small claims courts, the "People's Court," a late-twentieth-century version of common law with a king (or queen) presiding over conflicting claims. Such shows became wildly popular with television audiences across the country, so much so that

"I know what Ally McBeal would do."

some of its leading stars would come to include a former New York City mayor and an accomplished prosecutor who was catapulted into fame for his defense of former football star O. J. Simpson.

Realism reigned in the 1990s too, with "Law and Order" and "The Practice" showing the often uncomfortable intensity of an attorney's job with a tone of authenticity and drama. "Ally McBeal," on the other hand, offered up the legal soap opera, its central themes tending to poke fun at personal characteristics of an array of lawyer types, and their private-life complications, to the point of characterization—only a short step away from the cartoon, where legal parody all started.

As the year 2000 dawned, the lines between lawyer, author, screenwriter, journalist, and actor were increasingly blurred—Harvard Law professor and news commentator Alan Dershowitz wrote a novel, O. J. Simpson prosecutor Christopher Darden was the co-author of a legal thriller, legal-trained Geraldo Rivera hosted a talk show, and the members of the U.S. Supreme Court suddenly found themselves in the middle of the 2000 national election.

"Before counsel make their final summations, we're going to take some calls from across the country."

The American legal system—varied and diversified as it is—attracts and holds the public's attention, in large part because the process itself is inherently dramatic. The court scene—firey witnesses, brilliant prosecutors, unrelenting cross examinations, electrifying verdicts—is a rich resource for the purveyors of popular culture. The majesty of the Supreme Court, on the other hand, evokes respect, even a sense of awe and mystery, about the traditions surrounding law and justice at its most lofty level. Lawyers themselves, from the crude examples of "ambulance chasers" to the image of the long-suffering advocate for the downtrodden or unjustly accused, seem endlessly interesting in their daily work. And even the lawyer's personal life has formed the basis for popular entertainment. The fact is that Americans are curious, amused, skeptical of, and even worried about the law and its relationship to their lives and to society's problems. And this preoccupation seems never to have been greater than it is today. In a culture where freedom of speech and press are held in high regard, this is not all bad. The public's scrutiny of the law and lawyers through popular culture may be more than just entertainment. It may be how Americans remind themselves that the law of the land and how it is interpreted stands as the guardian of their hard-won liberty and freedom.

IN CLOSING —
HOLLYWOOD'S BEST ENDINGS

While the courtroom has supplied us with a myriad of dramatic scenes in literature and theater, nowhere is the drama literally made larger than on the big screen. Many of Hollywood's most striking examples of thrilling suspense have happened far from the erupting volcano or the jaws of the great white shark.

Humphrey Bogart's depiction of Navy Lieutenant Commander Philip Queeg on trial in *The Caine Mutiny* (1954) surely ranks as one of the most dramatic in cinema history. Queeg's slow descent into neurosis threatens his ship and, after the ship's first officer takes command, a riveting court-martial scene ensues. Gripping is the tension-filled psychological strain endured by the participants and the depiction of how this tension affects sanity, which is manifested especially in the scene of Queeg's nervous fumbling with two marbles as he disintegrates on the stand.

Focusing on the jury itself, rather than the trial, is *Twelve Angry Men*. A murder trial having just ended, the film opens as the jury begins its deliberations on the fate of a son who allegedly killed his father. Character development of the twelve jurors is central to the richness of this 1957 film, but the persuasive power of one juror (Henry Fonda) to open the minds of the other eleven remains as one of the truly stirring moments in film.

E. G. Marshall, Henry Fonda, John Feidler, Lee J. Cobb, Ed Binns, Jack Klugman, George Voskovec, and Joseph Sweeney star as members of the jury in the 1957 film "Twelve Angry Men."

Actors Matthew McConaughey and Samuel L. Jackson in a still from the 1996 film "A Time to Kill," based on the novel by John Grisham.

"You can't handle the truth!" The line forever associated with Jack Nicholson in *A Few Good Men*, the 1992 movie in which two soldiers are tried for the murder of another soldier. Colonel Nathan Jessup, played by Nicholson, spits out the provocative accusation in a courtroom clash with Lt. Daniel Kaffe, played by Tom Cruise, defender of the two accused murderers. The clash between these two in court is so filled with emotion that it is fast becoming a classic in the genre of courtroom drama.

Tom Cruise as Lieutenant Daniel A. Kaffe in a still from the 1992 film "A Few Good Men."

A young black girl in Mississippi is raped by two white thugs. The girl's father, enraged, hunts down and kills the boys. Defending the father in *A Time to Kill* (1996), Jake Brigance, played by Matthew McConaughey, confronts the racial issue in a thrilling courtroom scene when he asks the jury to close their eyes and imagine the black victim as a little white girl. The poignancy of this challenge is so deeply moving that it is burned into our minds as one of John Grisham's most intensely emotional scenes.

These are only a few of cinema's memorable courtroom scenes, but they serve to illustrate how compelling the courtroom is as a setting for the acting out of important social concerns. The sobriety of the issues, the formality of the court, the dignity of the judge, the eloquence of the attorneys, and the suspenseful unfolding of the plot can all generate within us a moving sense that what we have seen and heard is of commanding importance. Add the filmmaker's powerful visual ingredient that adds tone and texture, and cinema becomes one of our most influential sources of social criticism.

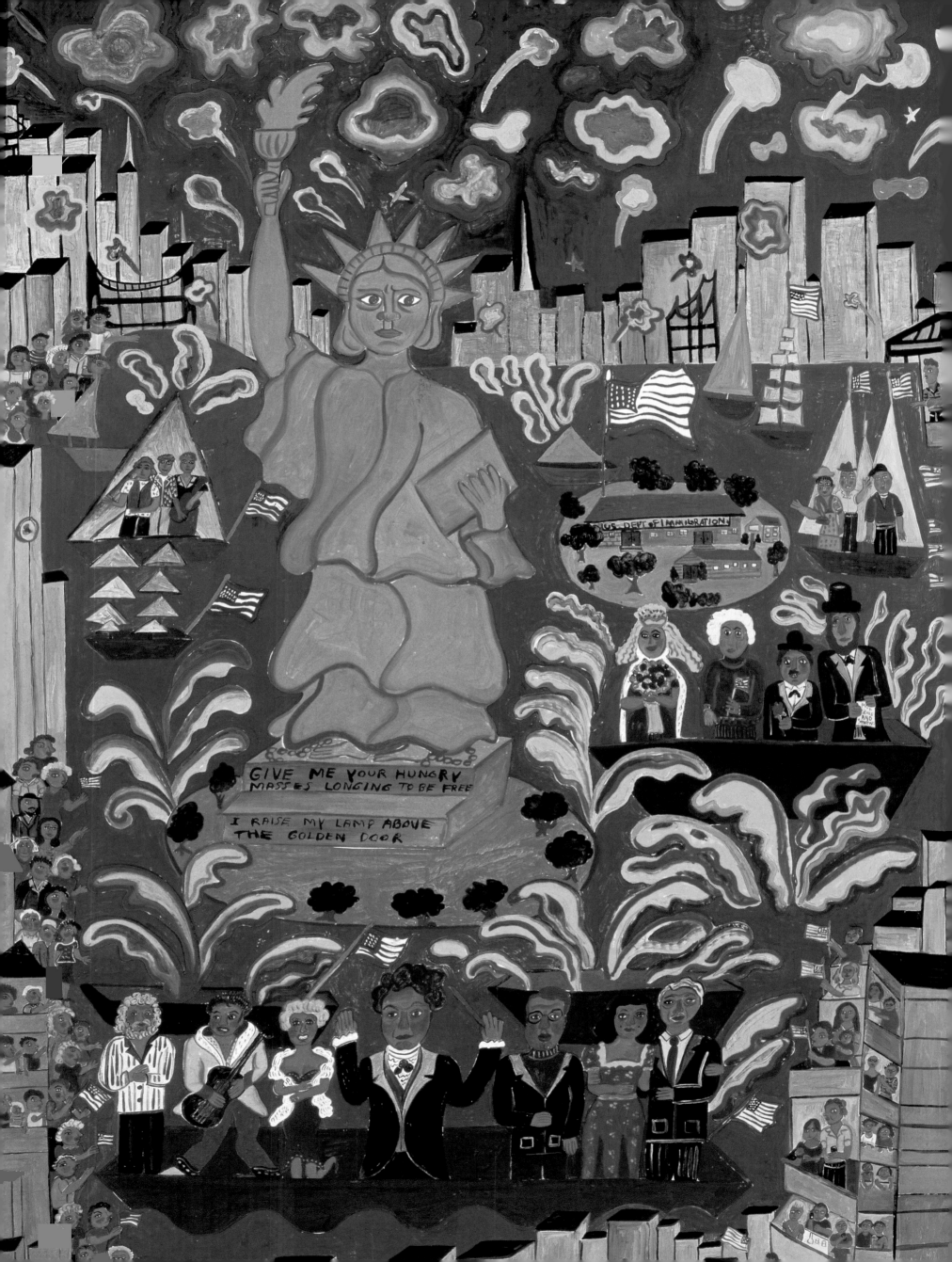

CONCLUSION

Law in America is a reflection of the spirit of its citizens, whose shared core values of independence, democratic government, and individual freedom are repeatedly challenged by changing expectations of privacy, order, and security in an evolving world society. The growth of law and the need for lawyers emerged naturally from the industrialization of the American economy in the late nineteenth century, and today's rapidly expanding technology is accelerating this trend. Throughout history, with each technological advance new social problems developed that demanded new legal rules for their solution, sometimes entire regulatory agencies. The invention of the automobile eventually created a need for vast new areas of law governing everything from rules of the road and traffic regulations to the licensing of vehicles and their operators. The invention of the radio gave rise to the Federal Communications Commission and another entire array of new laws and regulations. Whether or not Bill

Opposite Malcah Zeldis. Miss Liberty. *1987. Oil on corrugated cardboard. National Museum of American Art Museum, Smithsonian Institution, Washington, D.C./Art Resource, New York. © 1987 Malcah Zeldis.*

Right: *The gavel—and the hand of justice.*

Gates is correct in proclaiming the development of the Internet to be more significant than the invention of the automobile, radio, and television combined, the impact of the Internet will have a profound effect on the development of law in the twenty-first century. It is already changing how law is taught, researched, practiced, and portrayed, in addition to necessitating whole new areas of rules and regulations governing everything from copyright to privacy. Current research in genetics, the continued exploration of space, and the expansion of our international economies are all likely to have a similar impact on American law.

Legal questions about the extent of copyright protection due to the rapid move of information to digital formats will no doubt be raised more frequently in landmark cases of the twenty-first century. The new century barely dawned before the issue of free access to much of this information on the Internet became news. The copyright dispute over Napster enabling users to freely swap music files over the Internet pitted the American spirit of freedom and liberty against the right to profit from property ownership in a capitalist-based economy. Developments in genetics and the pharmaceutical industry

Left: This seemingly overabundance of traffic and parking restrictions is an example of the rapid growth of rules and regulations governing many aspects of our everyday lives—an effort, perhaps, to provide some sense of order and security in a swift-moving, fast-changing society.

Opposite: The legal battle for custody of six-year-old Cuban refugee Elian Gonzales forced the American justice department to consider international foreign policy in their interpretation of domestic laws. Cuban President Fidel Castro declared that the return of Elian to his father represented a "truce" between the U.S. and Cuba after 41 years of confrontation.

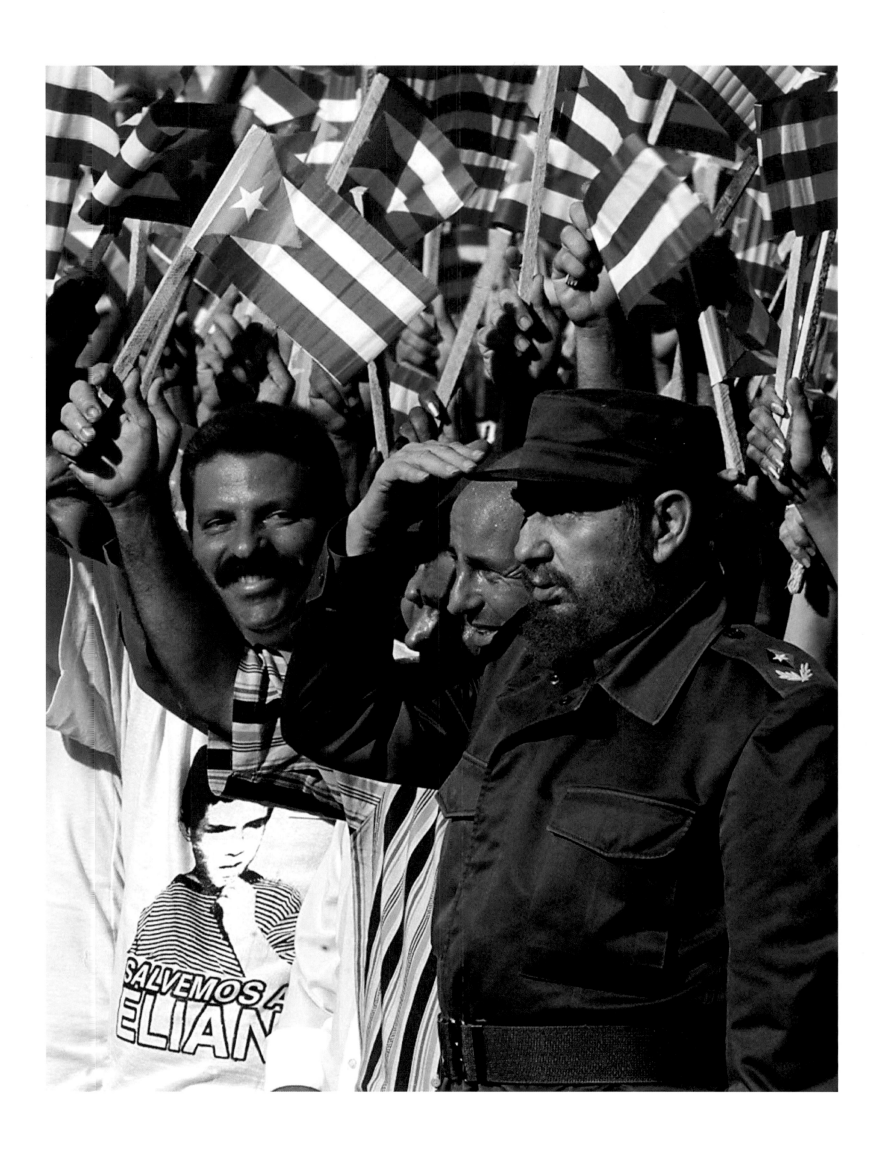

In recent years, the media has played an increased role in molding the image and opinions of Americans and their legal system. Here, television trucks crowd the rear entrance of the Los Angeles Criminal Courts Building during the murder trial of O. J. Simpson, wherein Johnnie Cochran (below), a member of the "Dream Team" defense, was a vocal and highly visible part of the media spectacle.

touch on similar issues concerning patent law, and are complicated further when viewed from a global perspective. For example, to what extent should drugs to combat AIDS and similar borderless health problems be protected against retro engineering by foreign companies who then sell them at affordable prices in third-world countries? Dealing with worldwide problems such as global warming, pollution, and international terrorism raise other issues concerning the boundaries between American and international law. International organizations and legal tribunals are needed to resolve many of these matters, but necessitate surrendering a certain amount of domestic legal sovereignty.

The image of law in America is more often shaped by the media than by landmark cases. The trend in news coverage is to focus on entertainment in order to capture the attention of readers and viewers. What the media find newsworthy and entertaining about the law tends to be confused with increasing

Calista Flockhart is Ally McBeal in the popular television series of the same name.

frequency. The fascination of the American public with the O. J. Simpson trial had far less to do with its legal significance than with the stardom of its defendant and the presence of every form of media in the courtroom. The entertainment value of the law has led to the proliferation of news stories and television entertainment programs focused on legal topics, covering everything from law school experiences to courtroom drama. Real-life courtroom action can be viewed any time on a cable news channel appropriately named "Court TV." Celebrities and public figures turned judge can be viewed across the television spectrum, rendering justice for the entertainment of the viewing public. Lawyers turned scriptwriters have contributed to a wildly fictional version of American law practice in several popular television series. The practice of law is made to appear fast-paced, thrilling, and often sexy. Crossing back over from reality to fiction, one highly regarded law professor and scholar recently received prepayment of $4 million to produce two novels and another $1 million for the movie rights.

No wonder law school applications jumped substantially when "L.A. Law" became a popular television series, and they jumped again when "Ally McBeal" went on the air. Of course, reports that starting salaries for some new lawyers are now close to $150,000 annually, and that the partners at many major American law firms are millionaires can

"You have the right to a client, and if you cannot obtain one, the court will appoint one for you . . . "

only add to the allure of the profession. On the other hand, the apparent failure of justice in highly publicized trials has generated a fair amount of skepticism about the contemporary practice of law. But most aspiring law students continue to be attracted to the profession by the prospect of using their legal skills to help bring about positive social change.

Perhaps the disparity between the image of the American lawyer in popular culture and the reality of law practice contributes to a disproportionate number of attorneys being dissatisfied with their professional careers. Obviously, lawyers play a crucial role in America, and the rewards can be substantial, but there is a wide range in the type of work that lawyers do and much of it does not come close to matching the sexy glamour of a popular television series or legal thriller. The many who begin law school with aspirations to do public interest work often find too few jobs available or the financial implications of accepting one too dire. Those few who graduate at the top of their class from the best law schools may command high-paying positions at large law firms, but may often find that the hours are long and that much of the work is drudgery. Working sixty hours a week as a young associate, with no guarantee of ever making partner, is not uncommon.

The vast majority of new lawyers struggle to make it in an increasingly competitive market. Further, it may be difficult to disassociate from the substantial client problems lawyers deal with on a daily basis. Additionally, a seeming backlash against lawyers among the general public, represented by a steady flow of lawyer jokes and acts of violence against attorneys, detracts from the glamour of the profession. Nevertheless, opportunities for the twenty-first-century American lawyer are better than ever before, as they continue to play an essential role in the shaping of policy in an ever—more interconnected, highly technical, and international society.

Fortunately, contemporary American legal education is stronger and better than ever, and it deservedly attracts the best students and prepares them for careers in law and beyond, including business and teaching. Legal education in America has become more similar to graduate education in other disciplines. Law faculties often hold multiple degrees in a variety of disciplines beyond the law, so that it is not uncommon for law faculty members to hold a Ph.D. as well as a law degree. Likewise, the scholarly habits and expectations for law faculty members have more in common with other graduate level disciplines. In addition to successful classroom performance, regular publishing in scholarly journals is requisite for law faculty at most American law schools. In line with

Moot courtroom at Columbus School of Law, Catholic University of America, Washington, D.C.

this trend, the degree of expertise among faculty members has become more refined, and the course offerings and class sizes at most American law schools have become more specialized and intimate. Large lecture hall–style classes have been surpassed by small seminars on specialized topics of the law.

While American law schools have changed to become more akin to graduate schools, at the same time they have distanced themselves from those who actually practice law. The crossover between practitioners and teachers of the law has become less common. Full-time law faculty members often spend no time practicing law, but more typically begin their teaching careers shortly after graduating from law school and spending one or two years clerking for an appellate court. Further, as the courses taught in law school have focused more on the rules and philosophy behind the law, some have complained that law schools are not focusing sufficiently on the practical skills needed for practicing law. This criticism comes at the same time that the larger law firms have cut back the time spent mentoring newly hired associates. In an effort to fill the gap, most law schools have developed clinical programs, which through a combination of simulated and real hands-on legal experience give law students an opportunity to learn some of the skills they will need in practice. Additionally, bar associations offer special practice-oriented educational programs and workshops for newer and more seasoned attorneys seeking to develop their skills in specific areas. The legal academy sees its primary role as one of preparing aspiring lawyers for a lifetime of learning the law, and to this end most would agree they do a first-rate job.

Today's law students, like these in the Columbus School of Law computer lab, have ready access to up-to-the-minute court opinions, legislation moving through Congress, legislative offices, public laws and U.S. Code, and a host of other useful information via the Internet.

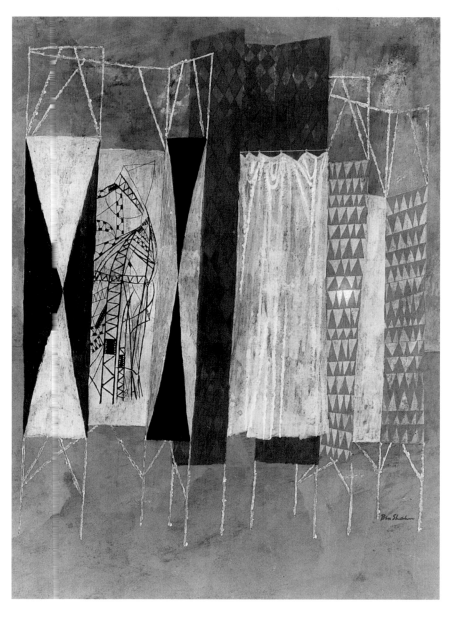

Ben Shahn. Voting Booths.
From the series Great Ideas
of Western Man. *1950.*
Gouache on canvas. 15 ⅞ x
12 in. (40.2 x 30.4 cm).
Gift of Container
Corporation of America.
Smithsonian American Art
Museum, Washington, D.C. /
Art Resource, New York. ©
Estate of Ben Shahn / Licensed
by VAGA, New York, N.Y.

Technology also is changing American legal education, from the design of law school buildings to the way courses are taught. Computer-assisted legal research sources are now an integral part of every law school library, and most newly designed law libraries have data and electrical outlets at many of their study spaces to allow integrated access to both print and online resources. Yet, surprisingly to some, with all of the vast amount of legal information now available through commercial database services, and freely on the Internet, most of the print resources needed by law students and faculty remain available only in print and are not duplicated online. Thus, teaching students how to use this ever-expanding array of resources has become more and more complex, so that it is not uncommon for most law schools to offer courses in advanced legal research, and for libraries to have special training facilities for this purpose. But the effects of technology extend far beyond the law library, touching on nearly every aspect of law school operations, from admissions to placement to alumni relations. Many newer law school buildings have wired their classrooms to allow students to use notebook computers for accessing materials. Course books may be based online. Many law schools have an intranet for distributing web-based materials internally, and most have a presence on the Internet, providing basic information about the law school and the ability to apply online. Increasingly, faculty members use the Internet to post their course syllabi, distribute reading lists, and host out-of-class discussion lists. Some are experimenting with distance learning, offering lectures and even courses from faculty at remote locations. On the cutting edge, but not yet fully accepted by accreditation authorities, at least one new American law school is offering a full law school education via the Internet. In most instances, the new technology has been used more cautiously to enhance the traditionally accepted legal education experience.

Thanks to the Internet, the law in twenty-first-century America is more accessible to everyone than ever before. Anyone with an Internet connection can freely track legislation through Congress, search federal public laws and the U.S. Code, locate administrative agency regulations and decisions, and contact legislative and executive offices directly. Court opinions also are posted directly to the Internet, often the same day they are handed down. The trend is to move more and more public information to the Internet, and a growing body of secondary sources and finding aids also are being published in

this fashion. Nevertheless, lawyers are often needed to understand how the law may apply to a given problem. Artificial intelligence systems may reduce this need further with time.

Technology and the evolving world economy also are affecting the practice of law. In many corporate legal departments and law firms, most of the legal research is done online, often directly by attorneys from their desktop computers, as is communication within and outside the firm. Memoranda, brief files, and other records also may be stored digitally. As these larger firms have expanded, often with an international presence, the quick and easy communication provided via the Internet is an important factor in their continued success. Technology also can benefit American lawyers choosing to practice law in a smaller setting, by providing access to legal resources previously available only to those in the most well-heeled firms. The Internet can be used to retain clients as well, and a few lawyers have attempted to base their practices almost solely on the Internet. But the disparity between law firms and the resources available to those who represent the poor and the rich in America is not being solved by technology.

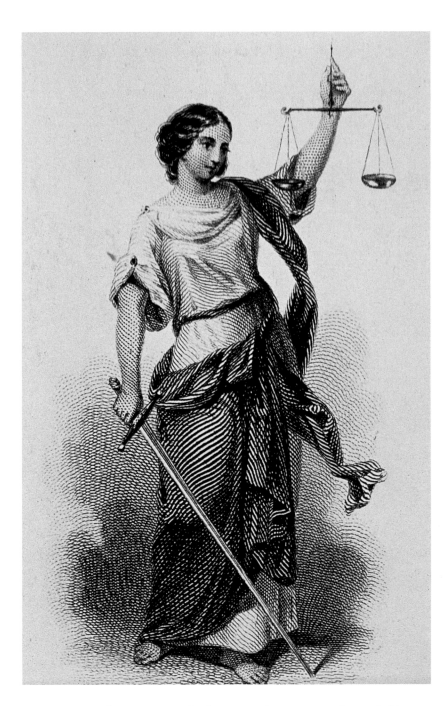

Engraving of Justice holding a scale and sword.

Despite the relatively high number of lawyers per capita in America, access to lawyers by those without financial means remains a significant social problem. Many practicing lawyers regularly take on a certain number of cases at no charge each year as a part of their professional responsibility, but this pro bono work alone is not enough to solve all of the pressing legal problems faced by the poor. Lawyers who choose to work for independently funded Legal Aid Societies or the Legal Services Corporation are paid a small fraction of what their colleagues in private practice command, and the case loads are often staggering. No wonder they frequently burn out in just a few years and move on to some other form of practice. Real funding for these organizations has been substantially reduced in recent decades and never fully restored. Likewise, public defenders assigned to represent criminal defendants typically are paid just as poorly, and would not be able to survive on these fees alone. Additionally, the access to commercial database services by most public interest law firms is far more limited than what is available to those in the private sector.

Nevertheless, many are attracted to law by a desire to use it as a tool for positive social change, and they often manage to follow through on this motivation either directly or

indirectly. Some seek positions in public interest law firms, and at times it even seems that there are not enough positions to meet the demand. Institutionally, many law schools have supported the public interest work of their graduates by offering loan forgiveness programs. A few of these programs have been supported by classmates contributing a portion of their salaries to loan forgiveness funds. But it's not absolutely necessary to work in a public interest firm to do social good as a lawyer.

Interior of the Supreme Court Washington, D.C.

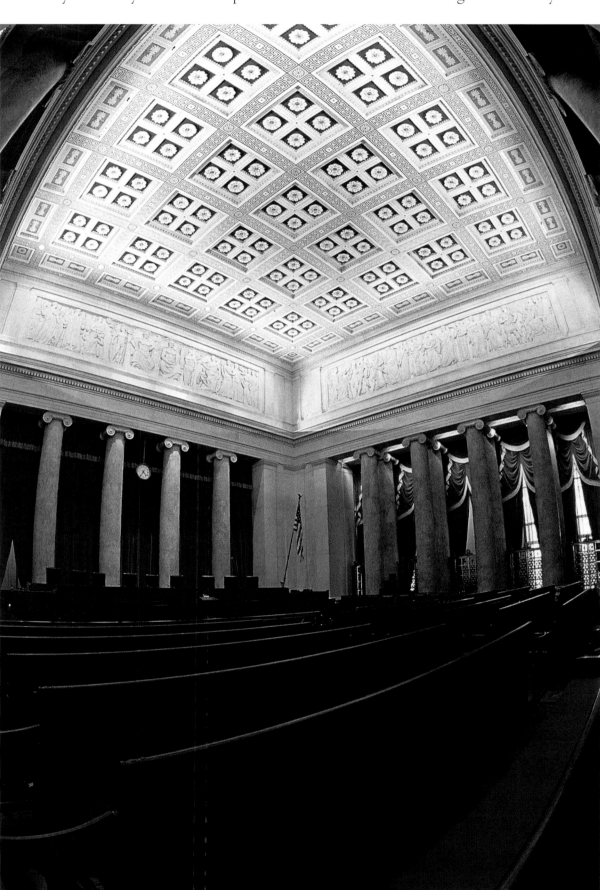

Page 270: *Cochise County Courthouse, Bisbee, Arizona, built in 1882.*

Fortunately, examples of successful lawyers who have contributed to the betterment of society are more common than those who have tarnished the law's reputation.

The law in America is more than the lawyers who are often its centerpiece of attention. It is depicted in the architecture of our law schools, courthouses, legislatures, and other symbols of justice. Its beauty and failings are revealed in our legal thrillers and television dramas, broadcast on nightly news shows, and mocked in cartoons. The law in America was created by Americans for Americans, and the reason the system works is because its spirit is an essential part of every citizen.

Opposite: Jack Levine. The Judge *(detail). 1953–54. Oil on canvas. 41 5⁄16 x 47 7⁄16 in. (104.9 x 120.5 cm). Williams College Museum of Art, Bequest of Lawrence H. Bloedel, Class of 1923. 77.9.60. © Jack Levine/Licensed by VAGA, New York, N.Y.*

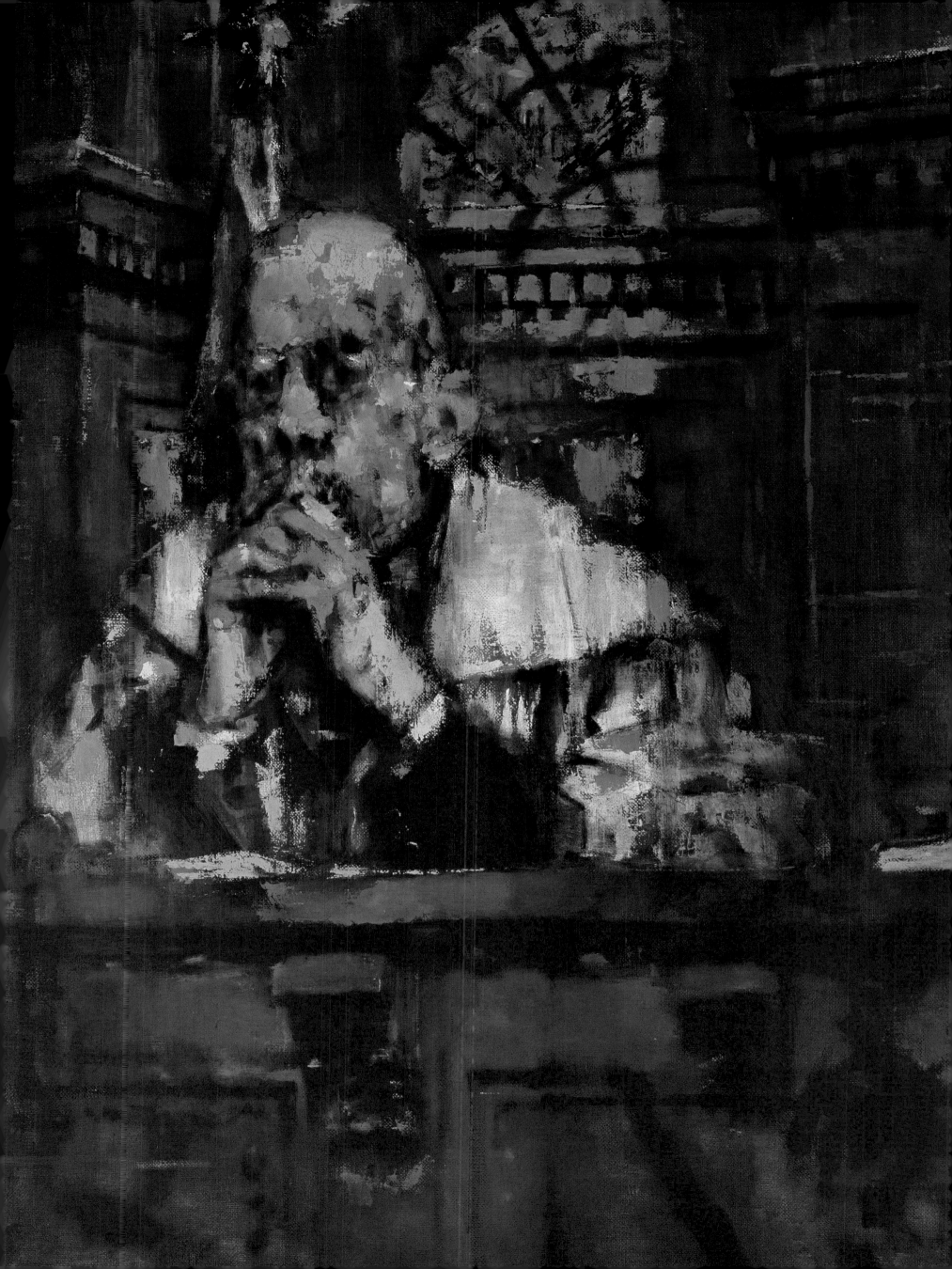

BIBLIOGRAPHY

Abraham, Henry Julian. *The Judiciary: The Supreme Court in the Governmental Process.* New York: New York University Press, 1996.

Bergman, Paul. *Reel Justice: The Courtroom Goes to the Movies.* Kansas City: Anders and McMeel, 1996.

Bloomfield, Maxwell H. *American Lawyers in a Changing Society, 1776–1876.* Cambridge, MA.: Harvard University Press, 1976.

Carp, Robert A. *The Federal Courts.* Washington, D.C.: CQ Press, 1998.

Carp, Robert A. *Judicial Process in America.* Washington, D.C.: CQ Press, 1998.

Curtis, Dennis E. and Resnik, Judith. "Images of Justice," *Yale Law Journal* 96, no. 8 (July 1987): 1727–1772.

Ferguson, Robert A. *Law and Letters in American Culture.* Cambridge, MA: Harvard University Press, 1984.

Friedman, Lawrence M. *A History of American Law.* New York: Simon & Schuster, 1985.

Friedman, Lawrence M. and Scheiber, Harry N. *Legal Culture and the Legal Profession.* Boulder, CO: Westview Press, 1996.

Garraty, John A., ed. *Quarrels That Have Shaped the Constitution.* New York: Percennial Library, 1987.

Gawalt, Gerare W., ed. *The New High Priests: Lawyers in Post Civil War America.* Westport ,CT.: Greenwood Press, 1984.

Geis, Gilbert and Bienen, Leigh B. *Crimes of the Century: From Leopold and Loeb to O. J. Simpson.* Boston: Northeastern University Press, 1998.

Hall, Kermit L., ed. *The Courts in American Life: Major Historical Interpretations.* New York: Garland Publishers, 1987.

Hall, Kermit L., ed. *The Legal Profession: Major Historical Interpretations.* New York: Garland Publishers, 1987.

Hall, Kermit L. *The Magic Mirror: Law in American History.* New York: Oxford University Press, 1989.

Horowitz, Morton J. *The Transformation of American Law, 1780–1860.* New York: Oxford University Press, 1992.

Horowitz, Morton J. *The Transformation of American Law, 1870–1960.* New York: Oxford University Press, 1992.

Kutler, Stanley I. *Judicial Power and Reconstruction Politics.* Chicago: University of Chicago Press, 1968.

Lichter, S. Robert, Lichter, Linda S., and Rothman, Stanley. *Prime Time: How TV Portrays American Culture.* Washington D.C. : Regnery Publishing, Inc., 1994.

McLynn, Frank. *Famous Trials: Cases that Made History.* New York: Readers Digest Association, Inc. 1995.

Posner, Richard A. *Law and Literature: A Misunderstood Relation.* Cambridge, MA.: Harvard University Press, 1988.

Roberts, John W. *Reform and Retribution: An Illustrated History of American Prisons.* Baltimore: United Book Press, Inc., 1997.

Schwartz, Bernard. *A History of the Supreme Court.* New York: Oxford University Press, 1993.

Stevens, Robert Bocking. *Law School: Legal Education in America from the 1850's to the 1980's.* Chapel Hill: University of North Carolina Press, 1983.

Thaler, Paul. *The Spectacle: Media and the Making of the O. J. Simpson Story.* New York: Praeger Press, 1997.

Van Hook, Bailey. "From the Lyrical to the Epic: Images of Women in American Murals at the Turn of the Century," *Winterthur Portfolio.* 26:1.

Wiecek, William M. *Liberty Under Law: The Supreme Court in American Life.* Baltimore: Johns Hopkins University Press, 1988.

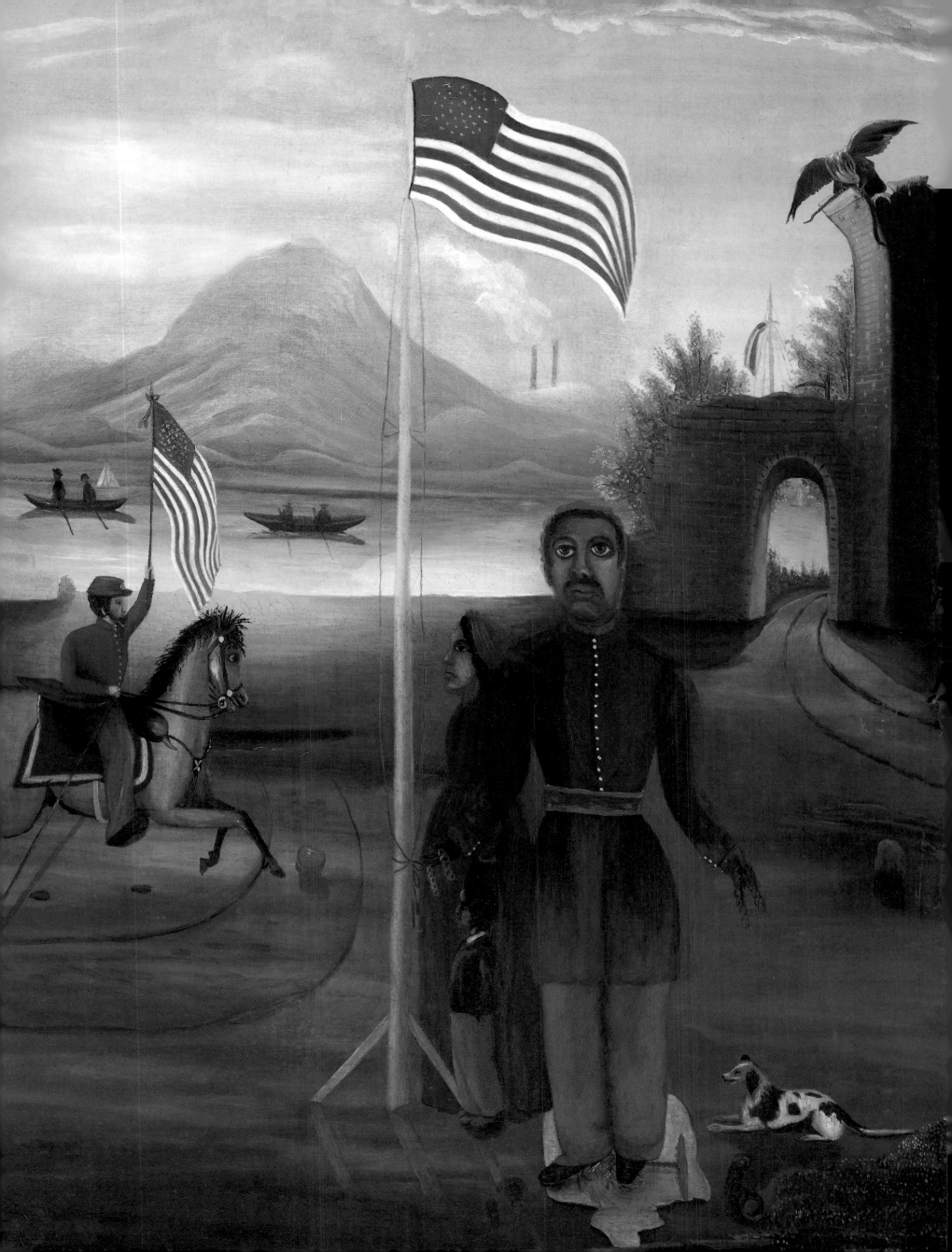

INDEX

PHOTOGRAPHY CREDITS

Page 14, Library of Congress; 15, Riegler/Archive Photos; 16 Lambert/Archive Photos; 17 Archive Photos; 18, Library of Congress; 22, 23, 24, 25, (bottom) Library of Congress; 25, Independence National Historical Park, Philadelphia. Photograph: Robin Miller; 28, Library of Congress; 29, © Ted Spiegel/ CORBIS; 32, © CORBIS; 33, Hulton Getty/Archive Photos; 34 Hulton Getty/Archive Photos; 36 (top), © Michael S. Yamashita/ CORBIS; 36 (bottom), © Nik Wheeler/CORBIS; 41 (top) Library of Congress; 63, © CORBIS; 86, 87, Archive Photos; 88, © CORBIS; 89, Archive Photos; 91, Jim Collison/TimePix; 101 (top), Hulton Getty/Archive Photos; 104, © Bettmann/CORBIS; 105, © CORBIS; 108, 109, © Bettmann/CORBIS; 111, 112, Archive Photos; 115, 116 (top) Library of Congress; 116 (bottom), Blank Archive/Archive Photos; 118, © AFP/CORBIS; 119 (top), Reuters/Tim Aubry/Archive Photos; 119 (bottom), CNP/Arnie Levin/Archive Photos; 120, Library of Congress; 121, Hulton Getty/Archive Photos; 125, © Bettmann/CORBIS; 127, 128, Archive Photos; 129, © Bettmann/CORBIS; 130, © Franklin McMahon/CORBIS; 131, © Bettmann/CORBIS; 132, © Franklin McMahon/CORBIS; 134, 136, Library of Congress; 148, CNP/Archive Photos; 149 (top), Reuters/Rick T. Wilking/Archive Photos; 149 (bottom), © Tribune Media Services, Inc. All Rights Reserved. Reprinted with permission; 151, Archive Photos; 152, © Bettmann/CORBIS; 154–155, © Franklin McMahon/ CORBIS; 157, Hulton Getty/Archive Photos; 159, Hulton Getty/Archive Photos; 160, © AFP/CORBIS; 160, © CORBIS; 162, © 1937 The Washington Post. Reprinted with permission. Photograph courtesy CORBIS; 163, © Bettmann/ CORBIS; 164, © CORBIS/Bettmann-UPI; 173 (bottom), Hulton Getty/Archive Photos.; 175, Library of Congress; 176, 179, Hulton Getty/Archive Photos; 181, © CORBIS/Bettmann-UPI; 184–185, Archive Photos; 186, Katherine Young/Archive Photos;

189, © Henry Diltz/CORBIS; 190, 192 (top),© Bettmann/ CORBIS; 192 (bottom), Hulton Getty/Archive Photos; 194, Reuters/Mike Theiler/Archive Photos; 195, © Bettmann/ CORBIS; 196;, © Roger Ressmeyer/CORBIS; 197, © Bettmann/CORBIS; 198, Hulton Getty/Archive Photos; 199, © CORBIS; 200, © Los Angeles Times Syndicate. Photograph courtesy TimePix; 202, Hulton Getty/Archive Photos; 203, 204, © CORBIS; 205, © Bettmann/CORBIS; 208, © Underwood & Underwood/ CORBIS.; 209, Stephen Black/Archive Photos; 210 (top), Archive Photos; 210 (bottom), © CORBIS; 211, Archive Photos; 212, 213, © Bettmann/CORBIS; 214, © UPI/ CORBIS-Bettmann; 215, 216, Archive Photos; 217, 218, Hulton Getty, Archive Photos; © Bettmann/CORBIS; 220, Reuters/Greta Pratt/Archive Photos; 221, Reuters/Lee Celano, Archive Photos; 222, Reuters/Jeff Christensen/Archive Photos; 223, Reuters/Rick T. Wilking/Archive Photos; 225, Reuters/Rebecca Cook/Archive Photos; 226, Reuters/Lou Dematteis/Archive Photos; 227, Reuters/Sam Mircovich/Archive Photos; 228, © Reuters/ CORBIS; 229 (top), Reuters/Sam Mircovich/Archive Photos; 229 (bottom), Reuters/Kim Kulish/Archive Photos; 231, 232, 233, © AFP/CORBIS; 234, © David and Peter Turnley/CORBIS; 235, © AFP/CORBIS; 241, Hulton Getty/Archive Photos; 244 (top), 245, 247, 248, Archive Photos; 249, Fotos International/ Archive Photos; 250 (bottom), SAGA/Frank Capri/Archive Photos; 251, Warner Brothers/Archive Photos; 252, 253, Fotos International/Archive Photos; 256, Archive Photos; 257, Fotos International/Archive Photos; 259, Archive Photos; 260, Hulton Getty/Archive Photos; 261, AFP/CORBIS; 262, Reuters/Louis Raynor/Fred Prouser/Archive Photos; 263, Fotos International/ Archive Photos; 268, Archive Photos; 269, Santi Visalli Inc./Archive Photos; 270, 272, 273, Library of Congress.